# Total Records

## Photography and the
## Art of the Album Cover

CW00322794

# Total Records

## Photography and the
## Art of the Album Cover

Edited by Antoine de Beaupré, Serge Vincendet, Sam Stourdzé
Text by Jacques Denis
Interview with Jean-Baptiste Mondino

*aperture*

# Table of Contents

# Story of the Eye: Jean-Baptiste Mondino

## Jacques Denis in conversation with Jean-Baptiste Mondino

**When did music first enter your life?**

By the 1960s, music had become an important conduit that allowed my generation to break free and to wake up sexually. It's the story of rock 'n' roll—it all started with the scandal of Elvis and his swiveling hips. In the 1960s, we had a thirst for life, we were full of desire, and this was expressed through creativity. All this happened via African American music.

**What role did images have in the diffusion of music via the media?**

In the 1950s, we obviously had much fewer images; there were no music magazines yet. Images came from the movies! Working-class people didn't go to museums. For someone like me, a choirboy, religious iconography was influential: an unclothed Christ, or stained-glass windows with burning saints. I recognized these later in rock poses, as in the image of bare-chested Jim Morrison with his arms outstretched. I had a revelation when I was eight years old and my sister came home with an Elvis seven-inch single. I can still remember that photo of Elvis: black hair, sexy pose, eyes shut in ecstasy, and a magnificent typeface that was later used again by the Clash for *London Calling*. And when we listened to the music on our record player—another revolutionary object—it was mind-blowing: "Hound Dog"! Then came the [Rolling] Stones, the Beatles, and Bob Dylan . . . While we didn't understand all the words, we knew what the songs were about! An entire generation across the globe tuned into these messages through the sounds and the imagery. Back then, the format was square. Even TVs were square! That was modernity, caught within those few centimeters that we would swap and share. It was the Facebook of the day.

**Had you already identified with the photographers filling those squares, like David Bailey, who photographed the Rolling Stones?**

We never even thought about who'd taken the pictures; we were just touched by their power. Looking back now, certains names come to the fore, of course. I looked a lot at Norman Seeff's work. These record sleeves were like a whole new language, with its own set of authors. We'd listen to music for hours while fantasizing over the picture, a bit like how we watch YouTube today. We'd annotate the covers, cross things out . . . Our pile of records was our Internet. My father was devastated because I'd shut myself away for hours listening to the same record over and over again, *Axis: Bold as Love* by Jimi Hendrix. It was the stuff of dreams. That was when I made up my mind to go to the Isle of Wight.

**At the beginning of the 1970s, England was the rallying point.**

That's where it was all happening. No other country in Europe had such a mainstream creative drive—the key word being "mainstream." The England of Hipgnosis and David Bailey . . . At the time, almost nobody could afford to travel to the United States, but England was within our reach. It was like the holy land, with all the musicians we knew. In France we'd experienced a bit of it at the Amougies Festival organized on the Belgian border by BYG with the cooperation of Pierre Lattés, who I'd been following on José Artur's radio show, *Pop Club*—my bible. We didn't get everything that the Art Ensemble of Chicago or Frank Zappa said but it was so exciting to find ourselves together like that, a bunch of teenagers!

**So France was too constrained to forge an identity, a creativity.**

My passion for music inevitably took me across the Channel, in the same way that the English who felt cramped left home to conquer America and the music scene there. Having that dream allowed me to move forward, and I had my American dream. Then Jim Morrison ended his days in France. France is the land of literature, and we had this approach with music, too: high-level musical analysis, from Yves Adrien to [Alain] Pacadis—the list is long. These days *Les Inrocks* is still the best magazine; we do have a talent for finding those rare pearls. We don't, however, have great aptitude for the collective, which is why we've never had many pop groups. We do individuals: Bashung, Gainsbourg . . . But nothing compared to England. Even Les Charlots, who were a bit like their Yardbirds, quickly turned sour. It's no surprise that

the so-called "French Touch" was the big popular French movement. DJs sort of function like analysts: they're able to take a piece apart, to unearth that little Nile Rodgers gem. The French work in a similar way with cinema. In music we've always had a hang-up, but it's allowed us to develop a great culture.

## So England worked differently.

I went to England in the summer of 1970 and decided to stay in London. I spent my nights at the Marquee, listening to Jimmy Page with Jeff Beck. The streets were overrun with that famous record cover for *Electric Ladyland*; I was literally bathing in it. There was no way I could go back, especially not to Aubervilliers, where I'd come from; there was no future there. Ever since Régine [Zylberberg] came up with the idea of putting two turntables in Le Tabou to get people dancing in France, the culture of discotheques has prevailed over clubs and music pubs. In London there were actually some French clubs: La Poubelle, Le Kilt . . . Thanks to connections, I ended up working in the cloakroom, then one night I substituted for the record dealer (as they called DJs at the time) and got the job. After a few years of living life in the fast lane, I went back to Paris and was offered an assistant job at the advertising agency Publicis. So we left behind the old times.

## What made you pick up a camera?

I'd have photographers' files in my hands without the vaguest notion of the field. I stayed in touch with English people, who'd gone punk by then. I was hanging out with Bijou, [Alain] Bashung; their records were in the process of being made. I suddenly had the idea of photographing their record sleeves and suggested to an amateur photographer friend that we set up a collective. I did Téléphone's first single covers, which were sold on the black market. Then my friend had a car accident and didn't want to carry on, but I had already received requests. I had to sell my record collection to buy a Hasselblad because I couldn't find anyone else to do the pictures. Advertising and fashion photographers weren't interested: rock music wasn't their thing, and on top of that there was no acknowledgment or money to be made. So I learned how to take photos. What interested me was the subject. I got invited to do photography books, but I wasn't that interested. I never go to photo exhibitions! But I was interested in technology; I started using Polaroids early on and was one of the first to go digital. I have no nostalgia for the grain or for film. I prefer the medium that allows me to do the best work the fastest.

## That's your special trait— you're a man of ideas first and then a photographer. You're like a DJ with the 6-by-6 format.

I'm more of an advertising man than a photographer. For me, the image is like a musical scale; there's a contrast of black and white, a more cinematic side, an image that's more pop, one that's more retro . . . It could be irritating because some might see a sort of opportunism in all this. But that's who I am.

## It means you can vary the pleasure.

I don't like repeating myself, although I do end up doing just that when the ingredients are right, when it best suits the subject. It's not being lazy, it's more like a recipe. I can work both in simple and complex ways—I've even come close to finding the artistic photographer inside me. No, I go outside myself: I can be a woman; I can be black or gay; I can multiply myself. I become that which I am photographing. What a pleasure to become those people, even just for an instant.

## So you really feel invested when you're collaborating with an artist. Your mission is to carry them, extend them, and present them in the images.

I am devoted, way beyond any notion of fame. There are those people you have to calm down, others who hide and you need to bring out . . . I would've made a good therapist, I have that quality in me. I like being at the service of people. My place isn't in the foreground; it's just right behind. And I'm happy there. I don't want to have exhibitions; I've never made a film under my name . . . It goes back to the church: I strive to make people iconic because I love them. It's that simple. In fact, I'm very satisfied, and I don't need acknowledgment in the press. I've had a lot of luck, and even today I'm amazed I still get calls. I just did the album for a girl who could be my grandchild. My strength lies in believing that tomorrow will always be better. I'm very optimistic.

## Do you tend to have some downtime before taking a photo?

It happens in spite of myself. I can't work with someone unless I've met him or her beforehand. We have to spend time together. It's pretty amazing, in fact: we'll talk about everything except what we're going to do, and yet that's when it all becomes clear.

## Do you think that artists today are more concerned with their image? Was there a shift in the 1980s?

We're burying the eighties, and that's a good thing. It makes for good compost, and we should celebrate the departed. I get requests for images from those years, and I actually have very few. That's the big difference with today, when everything is photographed and the camera is literally everywhere. People are more vigilant as a result. And then there's this double-edged schizophrenia we have to adapt to: you have to be in the media and nourish the Internet, Instagram, magazines, television . . . There are so many different media and means of broadcasting. The difference between then and now is fear. Before, the future seemed more open. Today, everything is short-term. And everyone asks about durability. I see it in the young people I work with: they admire the fact that I'm still around. It torments them! How does he do it? The only thing I can say to them is that you have to put the hours in. More than being an artist you have to be an artisan. I'm always amazed by people who think they will be celebrated when they have so little to say. Being well-known is great, but when it comes to lasting a long time . . . You have to make good bread. You know, if only three images remain from my work, that would incredible.

## You worked a great deal with Bashung. He's lasted, but his image changed over time. How did you deal with this?

I listened to him. Was his image contradicting the sound inside? Is there such a thing as a record cover that isn't representative of what's inside? No. It was the record that changed first. And thank goodness he evolved.

Bashung is a perfect example: he had the itinerary of an artist searching for himself, and that's normal—he had to eat, too—but he also had desires and a vision. There was no balance so he had to create it, and that required a lot of work. All this nourished him, and then, suddenly, he spat it out. He met the lyricist, and he made the record: thanks to the cut-up, he sang, and it sounded right in French. Like Gainsbourg, who anglicized his language for it to sound right. Things got even better with *Play Blessures*, which has an incredible sound that hasn't aged a bit. But then he fled his success, because he was, without a doubt, scared of becoming mainstream. After that Bashung opened up: he became more of a poet, more literary. But he was also an amazing singer, and he hit it big-time once more with *Osez Joséphine*. And then he made *Fantaisie Militaire*, a record that revealed yet another life change. We were with him until the end, throughout his life—the years, his emotions, the life of a certain era. His path is nothing short of exemplary.

**With Prince you did just one shoot, but it certainly made a mark . . . How did that cover come about?**

Before I met him, I was completely under Prince's spell. There was no one above him. Sure, there were the Talking Heads, Devo, and a few others … But Prince! He was doing pop, electro, funk; he sang like an angel; he could play everything; he had the look; he had Wendy and Lisa … I fell head over heels in love with Prince. He asked me to make a video for him. I spent a week with him, at the time of *Lovesexy*. We were in the studio in Minneapolis, and he said we were leaving the next day for Los Angeles and suggested I do the album cover. We were supposed to talk and come up with ideas on the plane. But then we didn't sit together, and so when we got to L.A., he invited me to come find him at a club that night. And there, he had his Los Angeles entourage: Sheila E., Mike Tyson . . . As the night went on I began to get anxious; I had just booked the studio. Late that night he told me we'd talk over breakfast. Obviously, I didn't sleep a wink. Then my inner choirboy led me to the Sistine Chapel. *In Sign O' The Time* (1987), he had a pretty apocalyptic discourse that was at the same time kind of tantric, where he talked about spirituality and sexuality. I made a little drawing that night, starting from the idea of a nude. In the morning he said, "It's perfect." That same night we chose just one Ekta, which I took back to Paris with me. Then I scanned that photo and used the only retouching machine in Paris. It was my friend Kiki Picasso who had the demo. Prince took a plane, and we all met again in the kitchen, the kids horsing around with his bodyguards. In the end, Prince destroyed everything and said to me, "I think what you did with the flowers was the best." The cover came out and was banned in quite a few states. It's a religious image par excellence.

**The poster you did for [Damien] Saez was recently censored. How do you explain that? How does it make you feel?**

If there were no censoring, I'd have no more work. Censoring confirms that you've hit a raw nerve. For Prince, it was able to shock a large part of puritanical America. For Saez, the idea was to make an image reflecting his "j'accuse" (I accuse): a girl in the pornography of overconsumption. I find the censorship of sex completely absurd. I have no barriers in that area. I'm here to fulfill artists' desires, like Madonna, who wanted to do a very provocative video. My one limit is crime, which I will never promote. I come from a violent enough background to know to stay away from that. There've been very few guns in my work. Seriously, how can we dare to be surprised about the chaos today when all you see are images filled with violence?

**With the birth of music videos, the record cover was pushed to the background . . . What were the financial implications? How did the two media revolve around each other?**

In the 1980s, video did little more than underscore accompanying images with sound, except there was a new dimension: movement. The new generation really got it, people like Les Rita Mitsouko and Étienne Daho. Video required a lot more financial resources, and it wasn't unusual to spend more on it than on the album itself. It was the beginning of marketing, of luxury packaging. I did a lot of work at that time, and in hindsight I feel I did music a disfavor.

**Any regrets?**

No, it's just an observation. Regrets would mean I'd done things dishonestly. These days music is reclaiming its right. There are fascinating music/media adventures on the Internet that go way beyond simple packaging. There's been a veritable transformation, with creations that draw inspiration from contemporary art and create incredible experiences. Except you don't always get to see them! There are several worlds cohabiting on different planes. In the 1960s, the record cover did the same duty: it created an entire language, an awakening, a whole new culture. Parents would see the record covers, but not in the same way as the kids. It's the same thing for the Internet generation.

**Technical evolution clearly inflects your work.**

I've always been very aware of format, of means of diffusion, of technological developments. Even today, as a thumbnail on iTunes, the record cover plays a role: it has to represent an artist's synthesis. That square still has the same function. Then the vertical format arrived with magazines, *The Face* and *i-D* in England, and *Actuel* in France. Today it's 16:9, the format best suited to mobile phone screens.

**And you still thrive on the present.**

I recently threw away tons and tons of photos and negatives. I synthesized them by making books I'd been asked for. I did one every fifteen years; it allowed me to organize and read my work, to see how things had evolved over time. There are things that come back constantly, and then there are evolutions by decades. I was very colorful, a bit pop, and then very sexual—today I'm more into the emotional. Because, ultimately, I simply follow the era—I accompany it—and see the changes in society. You never know what will remain, with time: will Vanessa Paradis just be a summer hit or more than that? Punk was nihilistic and ephemeral, but in the end its spirit survived and even influenced other domains.

# A Circle in a Square

Here is a history of photography through the prism of LPs, or a photographic survey of the history of record covers—it's one *and* the other. Both media, which marked the twentieth century, were associated in every way, from the creation of artwork to illustration, from figuration to experimentation. The diversity of intents and proposals is the basis of this book. Incidentally, the "first" two images published on a phonographic support already suggested that "anything was possible": an "arty" vision of Broadway and a clichéd image of a cowboy. The entire history of photography—almost!—fits into this format.

Thirty-three rpm, a circle in a square. Many have left their mark on these 12 by 12 inches. Photography plays a key role in this musical history. When you look at a record cover, you can almost hear what you see. How many classics were created by photographers? Who hasn't bought a record because of the cover? The image of Abbey Road has traversed the past half century as much as the music it illustrates. This is not the only example: there's also Andy Warhol's zipper sticking to the Rolling Stones' fingers, not to mention the band's other records, illustrated by the greatest names: David Bailey, Hiro, Robert Frank, and others.

Some photographers have created a style for themselves; others created icons. Labels, too, have built their identities on a graphic charter where photography matters most: Francis Wolff's black-and-white photos for Blue Note, ECM's gray nuances, Hipgnosis's surrealist flashes, etc.—they're production companies that have heralded a sound. And conversely, many images that today symbolize the century have adorned record covers: a portrait of Céline, the Great Depression seen through the eyes of Farm Security Administration photographers, shots of May '68, Black Power in the United States, and more. Photojournalism, photomontage, photo booths, photos appropriated or overexposed, photos in photos: every technique can be found within this 12-inch square. The deeper you dig, the more infinite the subject appears.

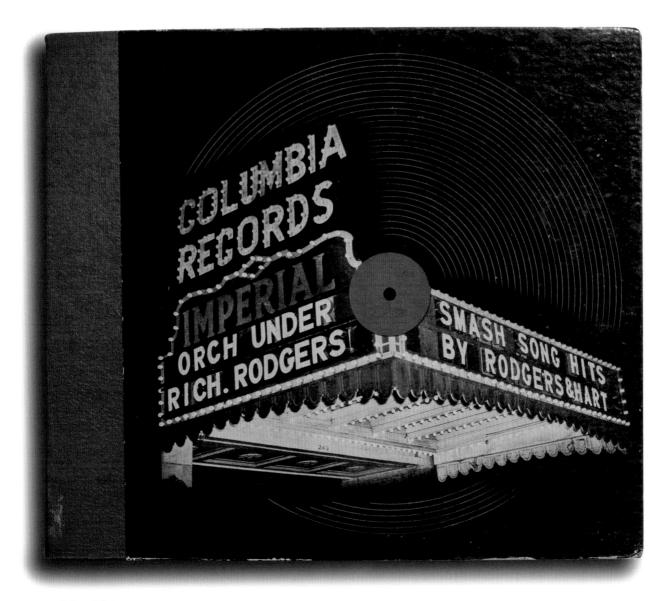

Artist. **Rodgers & Hart**
Title. **Smash Song Hits**
Label. Columbia - C11
Country. USA
Year. 1940
Photo. Unknown
Design. Alex Steinweiss

# The Sound I Saw

Garry Winogrand, Raymond Depardon, Paolo Roversi, Norman Seeff, Martin Parr, and Franco Fontana; how many pages would it take to show them all? How could Pierre Verger and Herman Leonard have been left out? The selection process proved to be agonizing. Several classics from the history of music, now iconic, are missing: John Coltrane's *A Love Supreme*, Serge Gainsbourg's *Histoire de Melody Nelson*, and the first Ramones, and not even Barbara, the star of Nouvelle Chanson made it, even though in her hit "Si La Photo Est Bonne" she sang, "If he looks good in the picture, have the young man brought to me."

Small format, big consequences. The history of music and photography are intertwined: each chapter, from abstraction to portraits, finds an echo in record covers. From Robert Doisneau to William Wegman: all, or almost all, of them have seen their works on an album cover. These squares offer an overview of the history of photography, a time capsule—a logbook of the convergence of the two mediums.

How many times was photography the subject of a song? The Beastie Boys' "Sure Shot" is one. How many albums are entitled *Photograph*? The history of photography is teeming with portraits of musicians: an ambiguous Gainsbourg by William Klein; Miles Davis by Irving Penn, eyes wide open on the front, half shut on the back; Albert Watson's saturated close-up of Yoko Ono wearing dark glasses; Thelonious Monk fading to black by W. Eugene Smith; Nobuyoshi Araki's depiction of Björk in blue tones; Hiro's placement of Mick Jagger in the foreground; and David Hamilton immortalizing the young Claude François. Pierre & Gilles, famous for their heavily staged, dreamlike images, photographed pop icons to make them look more sublime. The variety of approaches matches the diversity of views: straight on, sideways, or in profile, as when Robert Mapplethorpe sculpted the superb Taj Mahal.

"Think of your ears as eyes," Gertrude Stein is reputed to have said. Those words take on a double meaning here: music is another way of seeing, photography another way of hearing. The two have been echoing each other for a century. The medium is the message, as when Bruce Davidson placed the word *Vote* on the cover of Father Father's album. And Bernard Plossu's poetic pyramid does more than merely illustrate Faton Cahen's message in *Piano Rêves*; it prolongs and preempts it. The Bechers' work foreshadowed Kraftwerk's postindustrial music, and in quite a different vein, David LaChapelle's flashy glitz provides the key for listening to Lil' Kim. Pictures and music, two sides of the same coin.

To immortalize their *Physical Graffiti*, Led Zeppelin chose Elliott Erwitt's grainy picture of two gritty tenements in New York's East Village. Despite their differences, the image recalls Robert Frank's *Exile On Main Street* cover with its many grotesque characters. In hindsight, it's impossible to imagine it any different. Guy Bourdin's more conceptual work and Cindy Sherman's postmodernist derision naturally belong in this volume of photographic evolution; they defy Cartesian precepts by reshuffling aesthetic affinities without regard to schools and periods. Shades of Saul Leiter, the pioneer of color tinged with artistic reflections and blurs, and Nan Goldin, the visual poet of tawdry realism, can be found here as well. Josef Koudelka and René Burri's photojournalism, social testimony on a human scale, also have a rapport with the music they accompany. As with Roy DeCarava's *The Sound I Saw*, his triptych here, too, is emblematic.

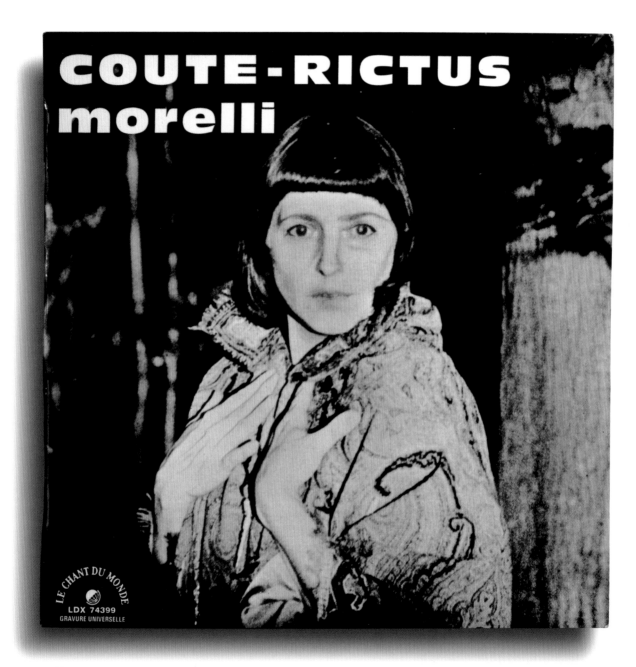

Artist. **Monique Morelli**
Title. **Couté-Rictus**
Label. Le Chant du Monde - LDX 74399
Country. France
Year. 1968
Photo. Robert Doisneau
Design. Unknown

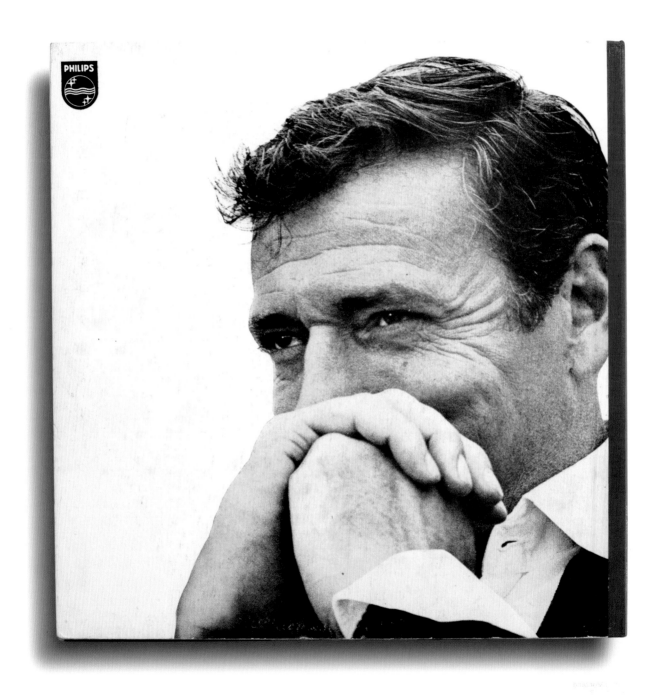

PHILIPS

Artist. **Yves Montand**
Title. **Récital 63**
Label. Philips - B 77.901 L
Country. France
Year. 1963
Photo. Jeanloup Sieff
Design. Robert Laplace

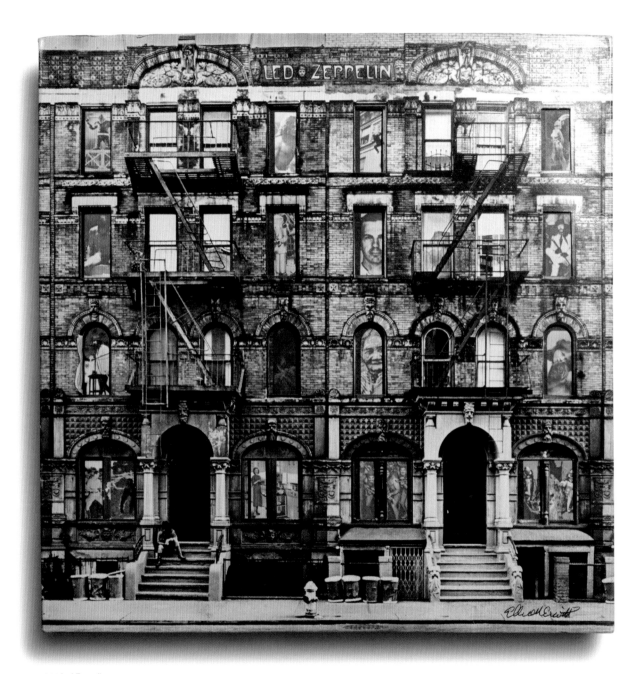

Artist. **Led Zeppelin**
Title. **Physical Graffiti**
Label. Swan Song - SSK 89400
Country. England
Year. 1975
Photo. Elliott Erwitt
Design. AGI/Mike Doud/Peter Corriston

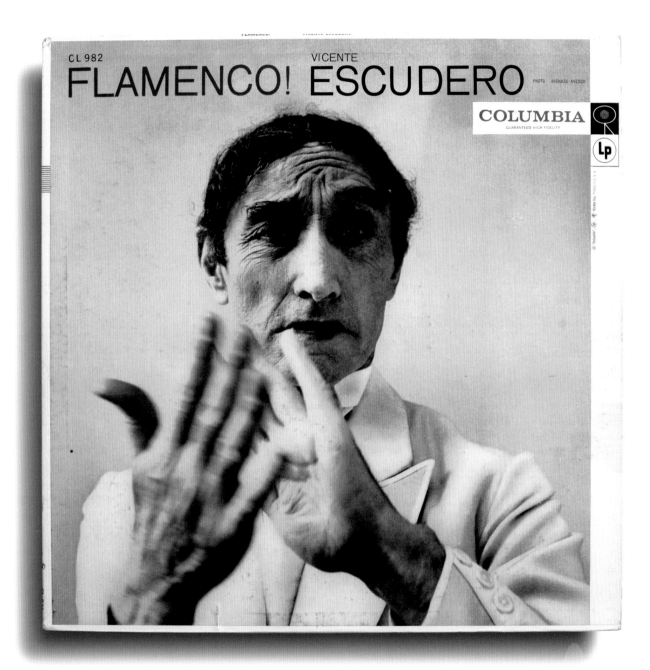

Artist. **Vicente Escudero**
Title. **Flamenco!**
Label. Columbia - CL 982
Country. USA
Year. 1956
Photo. Unknown
Design. Unknown

S.R.P. LP-290

NOMMO

MILFORD GRAVES    DON PULLEN

photo by ROY DeCARAVA

Artist. **Milford Graves/Don Pullen**
Title. **Nommo**
Label. SRP Records - LP-290
Country. USA
Year. 1967
Photo. Roy DeCarava
Design. Unknown

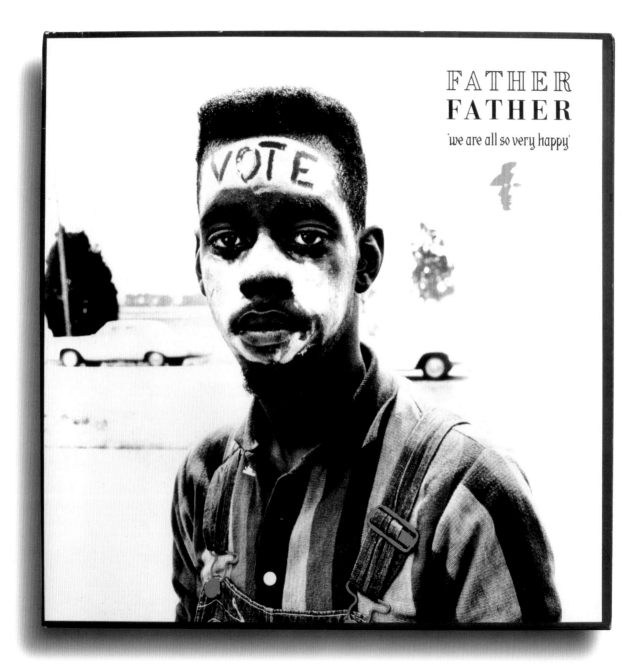

Artist. **Father Father**
Title. **We Are All So Very Happy**
Label. Go! Discs - 828 258-1
Country. England
Year. 1991
Photo. Bruce Davidson
Design. Pethick & Money

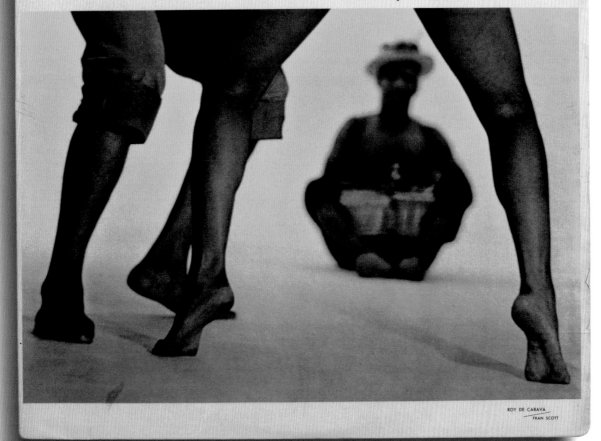

Calypso
Dance Party

with **Candido,** Calypso and Girl

ROY DE CARAVA
FRAN SCOTT

Artist. **Candido**
Title. **Calypso Dance Party with Candido,
Calypso and Girl**
Label. ABC-Paramount - ABC-178
Country. USA
Year. 1957
Photo. Roy DeCarava
Design. Fran Scott

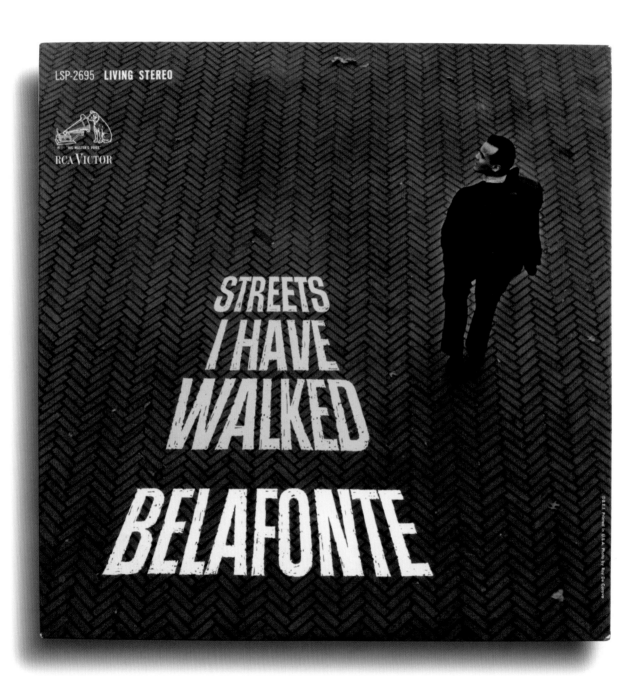

Artist. **Harry Belafonte**
Title. **Streets I Have Walked**
Label. RCA Victor - LSP-2695
Country. USA
Year. 1963
Photo. Roy DeCarava
Design. Unknown

24

COLUMBIA

# JAZZ
# GOES TO JUNIOR COLLEGE
# DAVE BRUBECK QUARTET

PHOTO: GARY WINOGRAND

Artist. **Dave Brubeck Quartet**
Title. **Jazz Goes to Junior College**
Label. Columbia - CL 1034
Country. USA
Year. 1957
Photo. Garry Winogrand
Design. Unknown

ATLANTIC  8014

# Chris Connor: I Miss You So

Artist. **Chris Connor**
Title. **I Miss You So**
Label. Atlantic - 8014
Country. USA
Year. 1957
Photo. Saul Leiter
Design. Marvin Israel

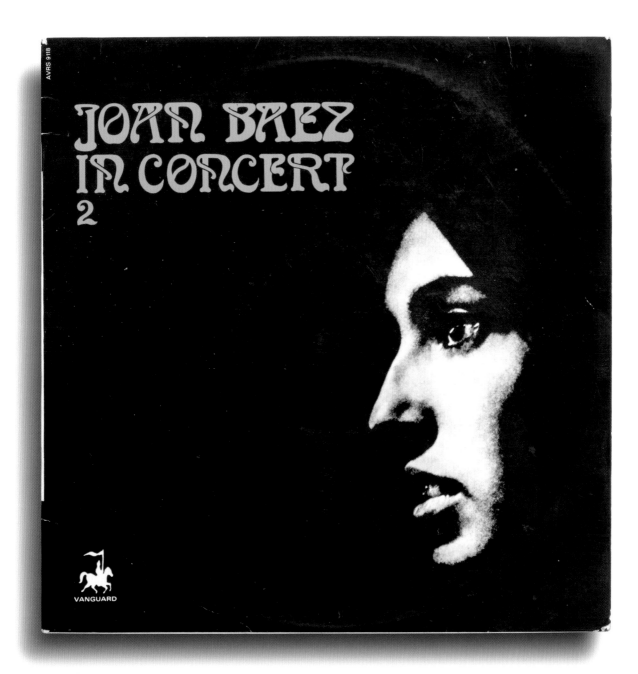

Artist. **Joan Baez**
Title. **In Concert 2**
Label. Vanguard - AVRS-9118
Country. France
Year. 1963
Photo. Danny Lyon
Design. Unknown

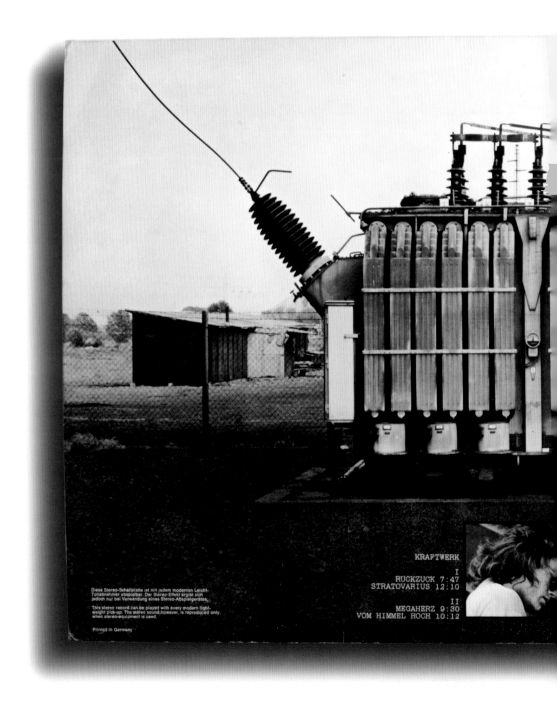

KRAFTWERK

I
RUCKZUCK 7:47
STRATOVARIUS 12:10

II
MEGAHERZ 9:30
VOM HIMMEL HOCH 10:12

Diese Stereo-Schallplatte ist mit jedem modernen Leicht-
Tonabnehmer abspielbar. Der Stereo-Effekt ergibt sich
jedoch nur bei Verwendung eines Stereo-Abspielgerätes.

This stereo record can be played with every modern light-
weight pick-up. The stereo sound, however, is reproduced only
when stereo-equipment is used.

Printed in Germany

30

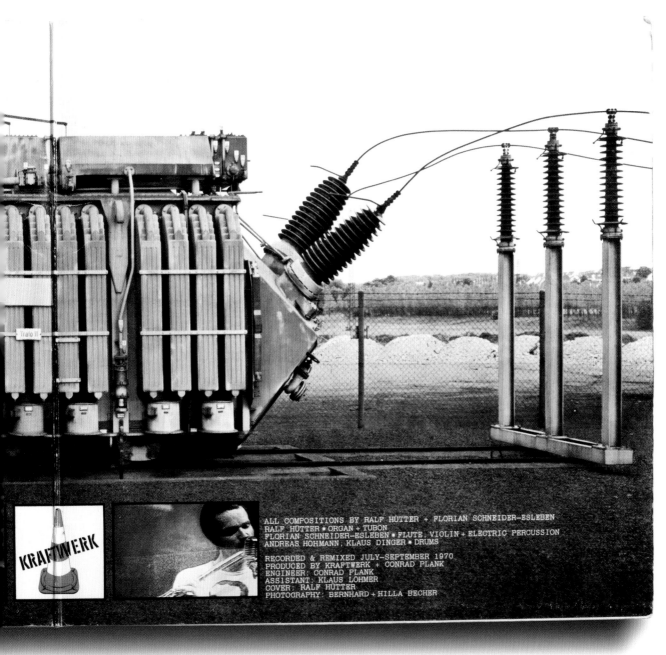

ALL COMPOSITIONS BY RALF HÜTTER + FLORIAN SCHNEIDER-ESLEBEN
RALF HÜTTER ∗ ORGAN + TUBON
FLORIAN SCHNEIDER-ESLEBEN ∗ FLUTE, VIOLIN + ELECTRIC PERCUSSION
ANDREAS HOHMANN, KLAUS DINGER ∗ DRUMS

RECORDED & REMIXED JULY–SEPTEMBER 1970
PRODUCED BY KRAFTWERK + CONRAD PLANK
ENGINEER: CONRAD PLANK
ASSISTANT: KLAUS LOHMER
COVER: RALF HÜTTER
PHOTOGRAPHY: BERNHARD + HILLA BECHER

Artist. **Kraftwerk**
Title. **Kraftwerk**
Label. Philips - 6305 058
Country. Germany
Year. 1970
Photo. Bernd & Hilla Becher
Design. Ralf Hütter

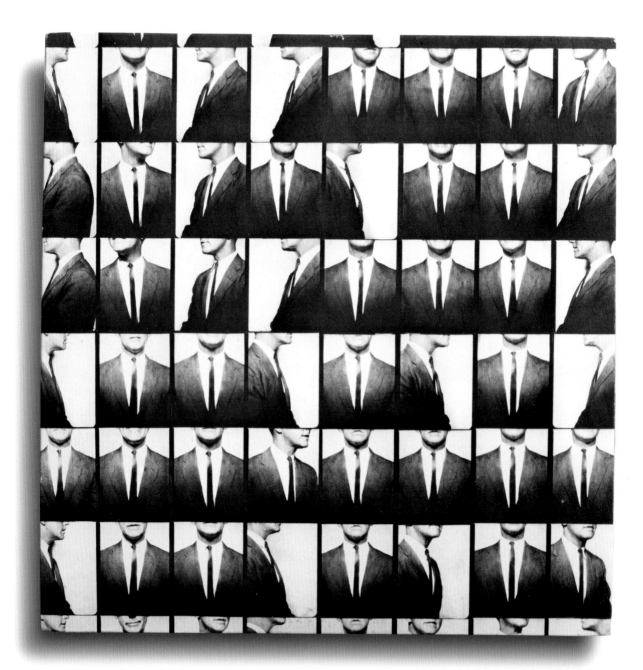

Artist. **John Wallowitch**
Title. **This Is John Wallowitch!**
Label. Serenus Records - SEP 2005
Country. USA
Year. 1964
Photo. Andy Warhol
Design. Irwin Rosenhouse

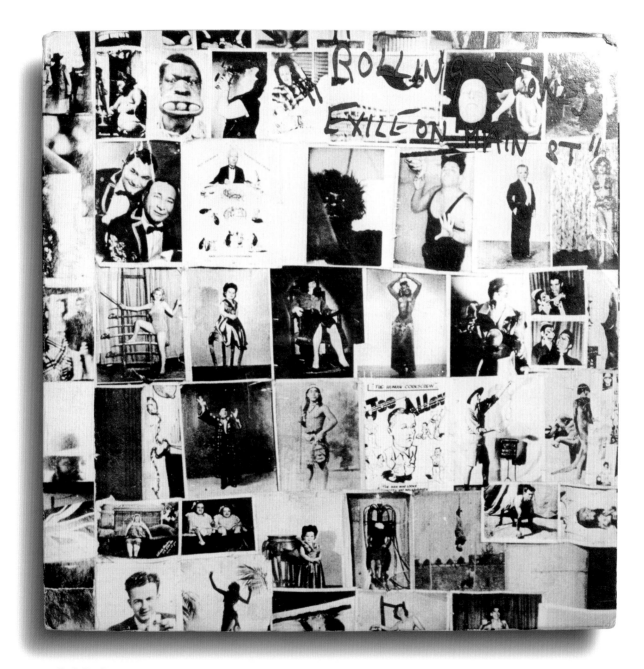

Artist. **The Rolling Stones**
Title. **Exile on Main St.**
Label. Rolling Stones Records - COC 69100
Country. England
Year. 1972
Photo. Robert Frank
Design. John van Hamersveld/Norman Seeff

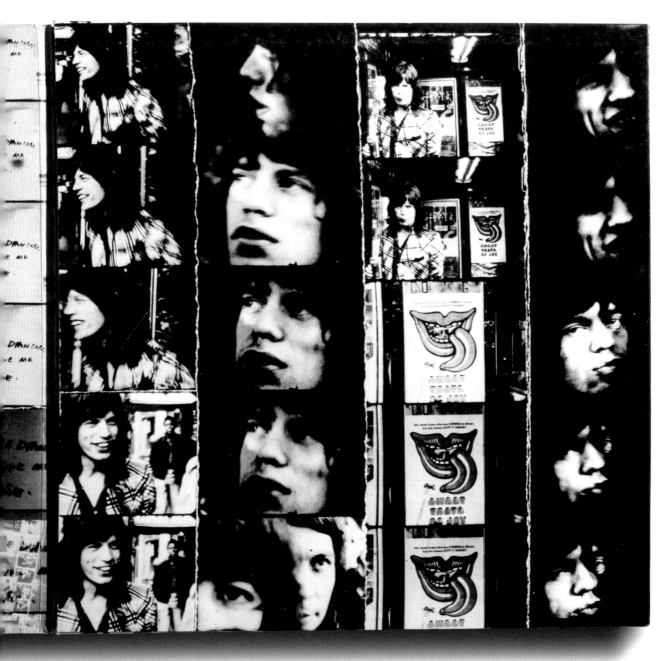

Artist. **The Rolling Stones**
Title. **Exile on Main St.**
Label. Rolling Stones Records - COC 69100
Country. England
Year. 1972
Photo. Robert Frank
Design. John van Hamersveld/Norman Seeff

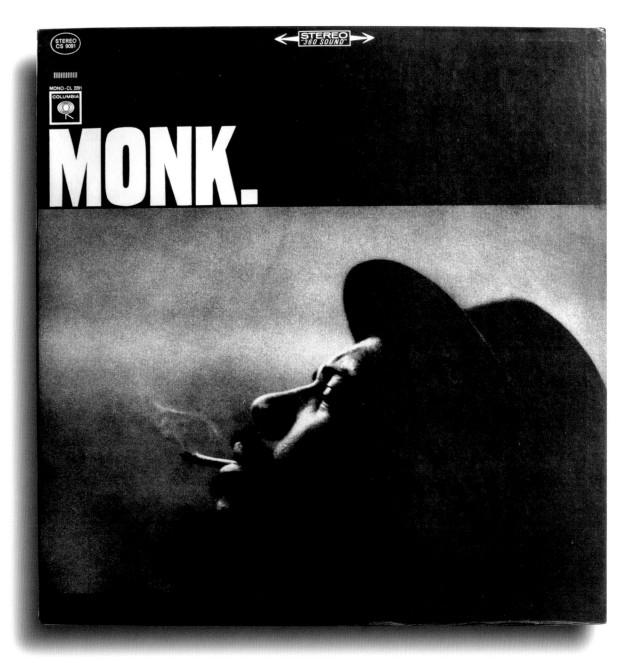

Artist. **Thelonious Monk**
Title. **Monk.**
Label. Columbia - CS 9091
Country. USA
Year. 1964
Photo. W. Eugene Smith
Design. Jerry Smokler

# PAT METHENY GROUP
### AMERICAN GARAGE

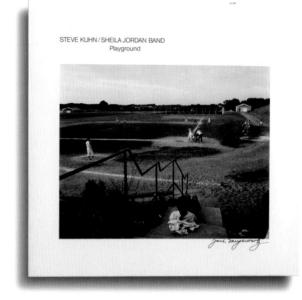

STEVE KUHN / SHEILA JORDAN BAND
Playground

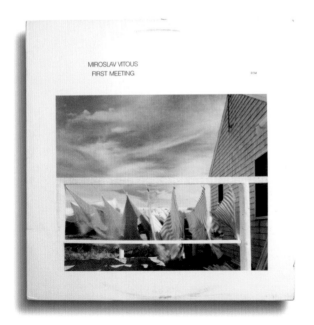

MIROSLAV VITOUS
FIRST MEETING

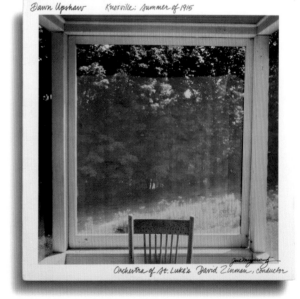

Dawn Upshaw    Knoxville: summer of 1915

Orchestra of St. Luke's  David Zinman, conductor

Artist. **Pat Metheny Group**
Title. **American Garage**
Label. ECM Records - ECM 1155
Country. USA
Year. 1979
Photo. Joel Meyerowitz
Design. Basil Pao

Artist. **Miroslav Vitous**
Title. **First Meeting**
Label. ECM Records - ECM 1145
Country. Germany
Year. 1980
Photo. Joel Meyerowitz
Design. Jürgen Peschel

Artist. **Steve Kuhn/Sheila Jordan Band**
Title. **Playground**
Label. ECM Records - ECM 1159
Country. Germany
Year. 1980
Photo. Joel Meyerowitz
Design. Jürgen Peschel

Artist. **Dawn Upshaw**
Title. **Knoxville: Summer of 1915**
Label. Elektra Nonesuch - LP 79187-1
Country. USA
Year. 1989
Photo. Joel Meyerowitz
Design. Unknown

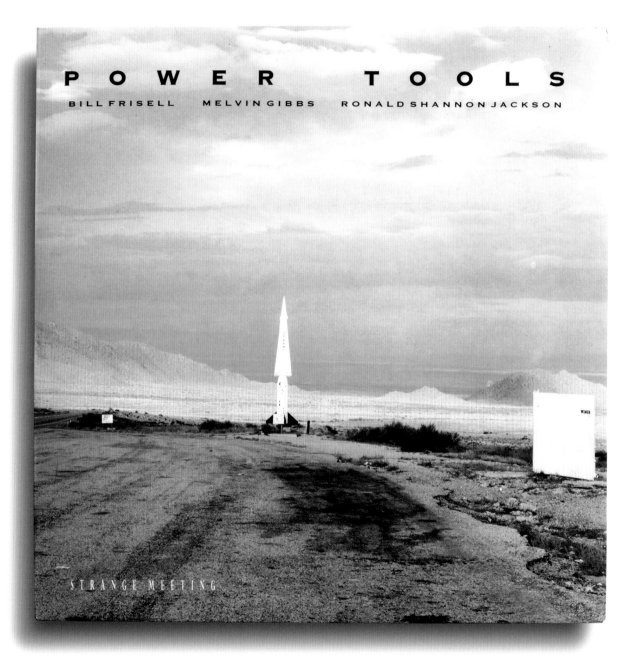

Artist. **Power Tools**
Title. **Strange Meeting**
Label. Antilles New Directions - 90627-1
Country. USA
Year. 1987
Photo. Joel Sternfeld
Design. Patrick Roques

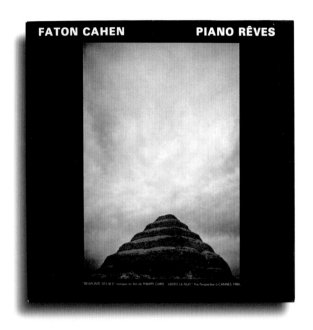

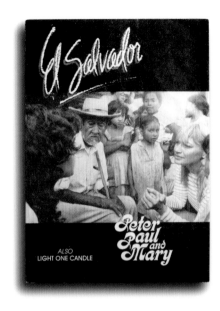

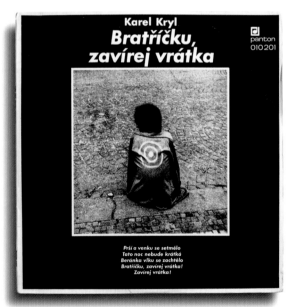

Artist. **Faton Cahen**
Title. **Piano Rêves**
Label. Cryonic Inc. - MAD 3023
Country. France
Year. 1986
Photo. Bernard Plossu
Design. Unknown

Artist. **Karel Kryl**
Title. **Bratrícku, Zavírej Vrátka**
Label. Panton - 010201
Country. Czechoslovakia
Year. 1969
Photo. Josef Koudelka
Design. Leo Novotný

Artist. **Peter, Paul & Mary**
Title. **El Salvador**
Label. Peter, Paul & Mary - PPM-101/102
Country. USA
Year. 1983
Photo. Susan Meiselas
Design. Unknown

Artist. **Kiss in the Dark**
Title. **The Phonecall**
Label. Mercury - 870337-1
Country. Germany
Year. 1988
Photo. Dennis Stock
Design. Werner Jeker

**DOLOREAN**THE UNFAZED

FR21233

Artist. **Dolorean**
Title. **The Unfazed**
Label. Fargo Records - FR21233
Country. France
Year. 2011
Photo. Alec Soth
Design. Unknown

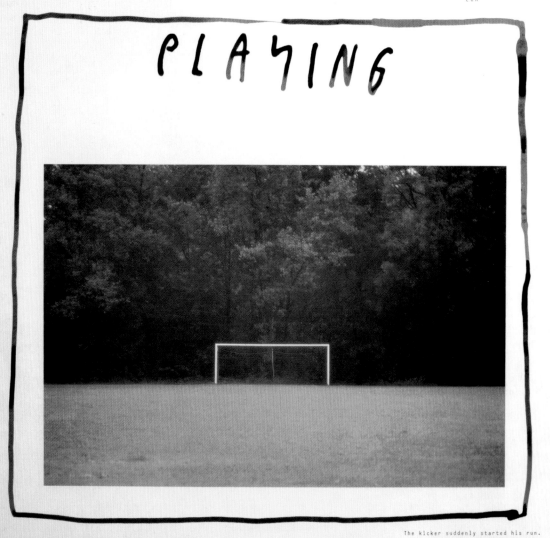

DON CHERRY    DEWEY REDMAN    CHARLIE HADEN    ED BLACKWELL
OLD AND NEW DREAMS                                    ECM

# PLAYING

The kicker suddenly started his run.

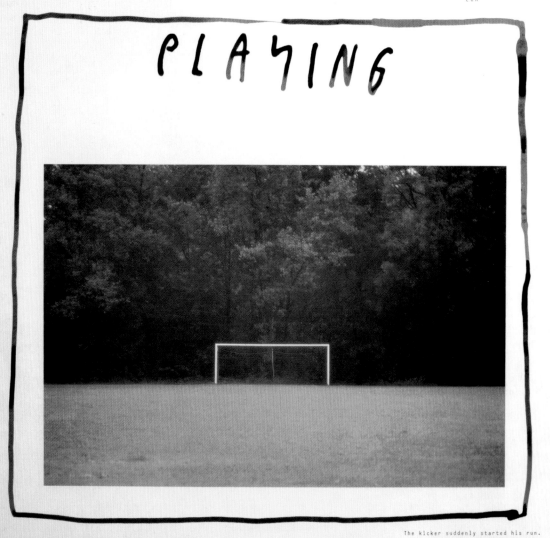

Artist. **Old and New Dreams**
Title. **Playing**
Label. ECM Records - ECM 1205
Country. Germany
Year. 1981
Photo. Luigi Ghirri
Design. Barbara Wojirsch

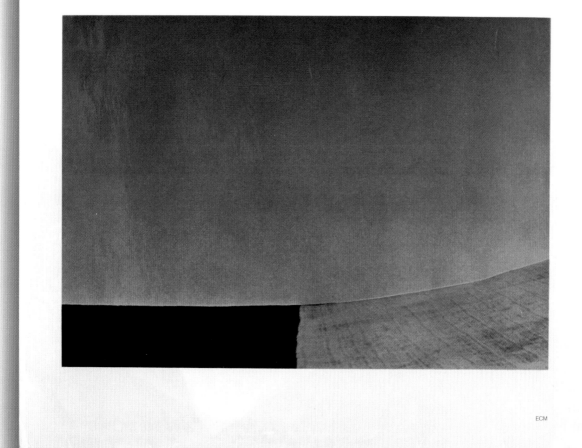

COLLIN WALCOTT
GRAZING DREAMS

ECM

Artist. **Collin Walcott**
Title. **Grazing Dreams**
Label. ECM Records - ECM 1096
Country. Germany
Year. 1977
Photo. Franco Fontana
Design. Dieter Bonhorst

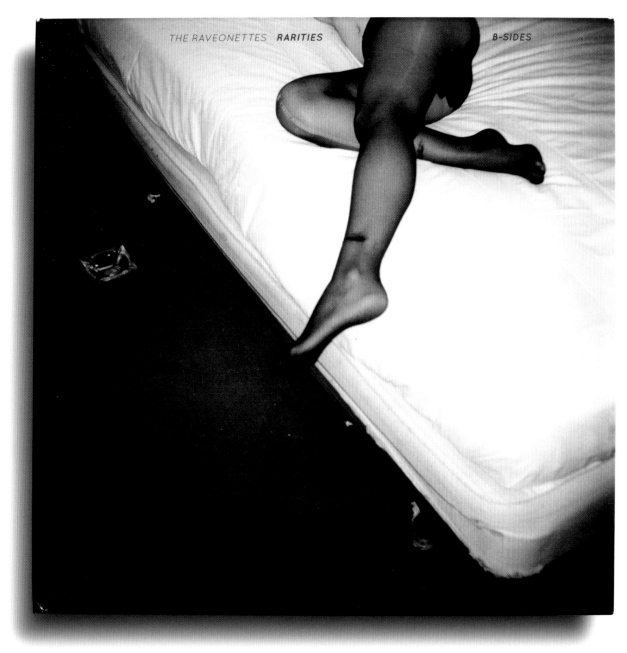

THE RAVEONETTES *RARITIES*                    *B-SIDES*

Artist. **The Raveonettes**
Title. **Rarities/B-Sides**
Label. Self-released
Country. Denmark
Year. 2011
Photo. Todd Hido
Design. Unknown

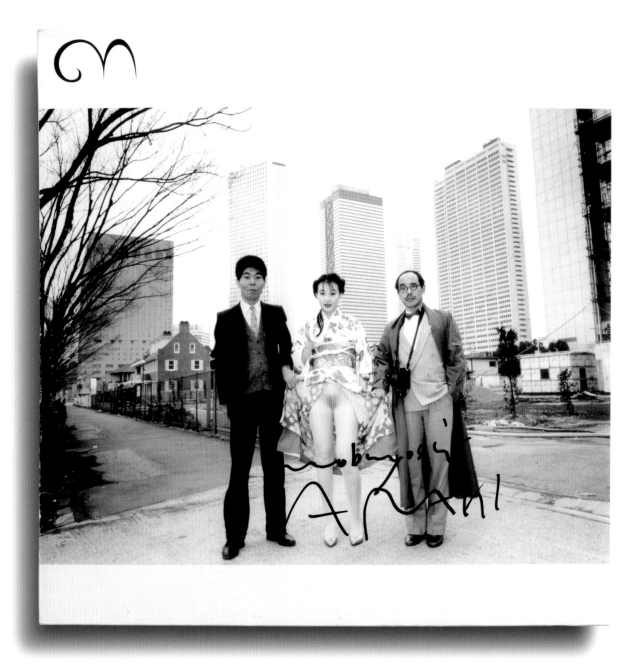

Artist. **Mango Delight**
Title. **Conglomerate of Crazy Souls**
Label. Tender Productions - BAH007LP
Country. Denmark
Year. 2002
Photo. Nobuyoshi Araki
Design. Unknown

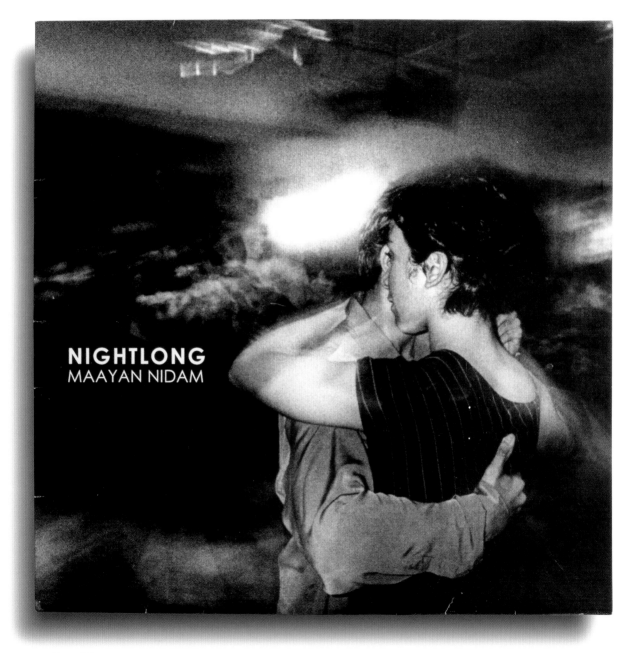

**NIGHTLONG**
MAAYAN NIDAM

Artist. **Maayan Nidam**
Title. **Nightlong**
Label. Power Shovel Audio - PSLP-001
Country. Japan
Year. 2009
Photo. Daido Moriyama
Design. Powershovel Design & Audio

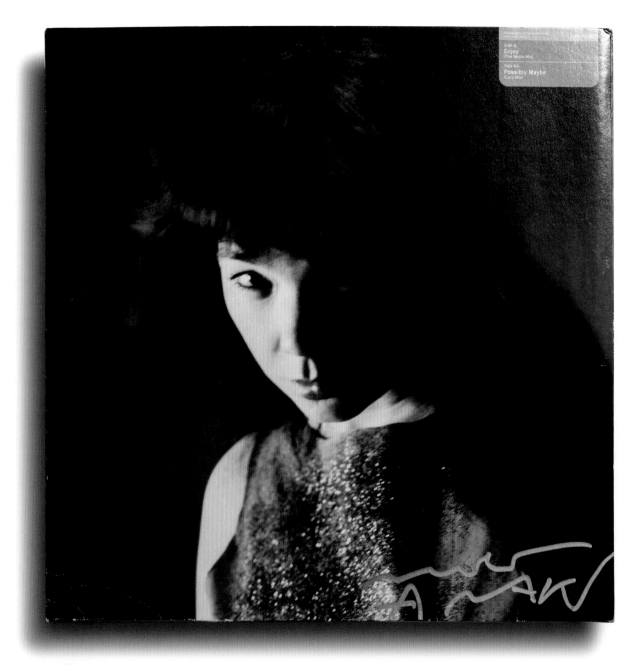

Artist. **Björk**
Title. **Enjoy**
Label. One Little Indian - 193TP12DM
Country. England
Year. 1996
Photo. Nobuyoshi Araki
Design. Me Company

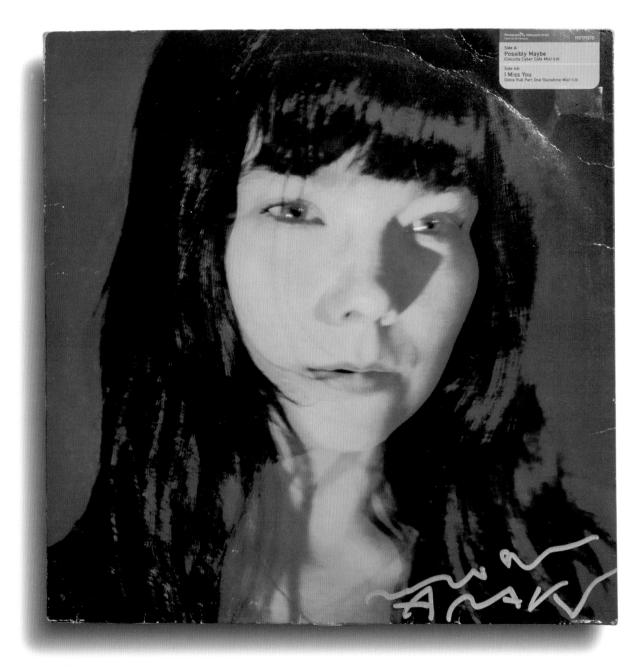

Photography by Nobuyoshi Araki
Cover by Me Company

193TP12TD

Side A:
**Possibly Maybe**
(Calcutta Cyber Cafe Mix) 5:30

Side AA:
**I Miss You**
Dobie Rub Part One (Sunshine Mix) 5:30

Artist. **Björk**
Title. **Possibly Maybe**
Label. One Little Indian - 193TP12TD
Country. England
Year. 1996
Photo. Nobuyoshi Araki
Design. Me Company

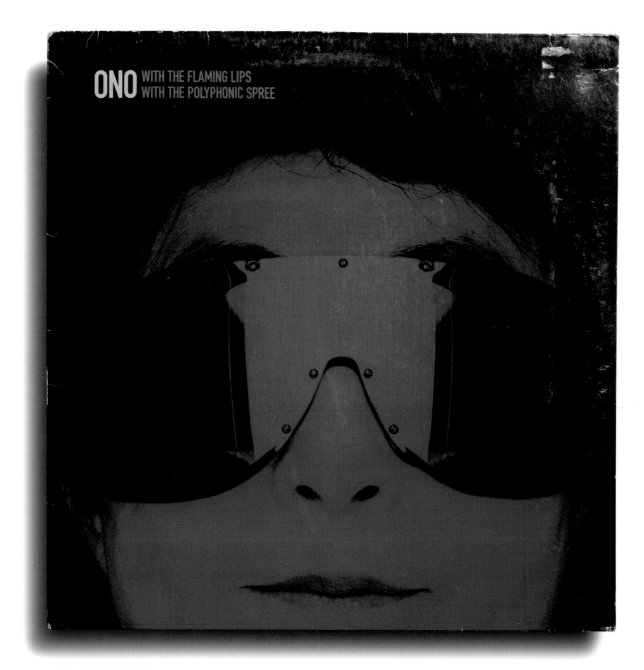

ONO WITH THE FLAMING LIPS
WITH THE POLYPHONIC SPREE

Artist. **Ono with The Flaming Lips
and The Polyphonic Spree**
Title. **Cambridge 1969/2007 / You and I**
Label. Parlophone - ONO1
Country. England
Year. 2007
Photo. Albert Watson
Design. Unknown

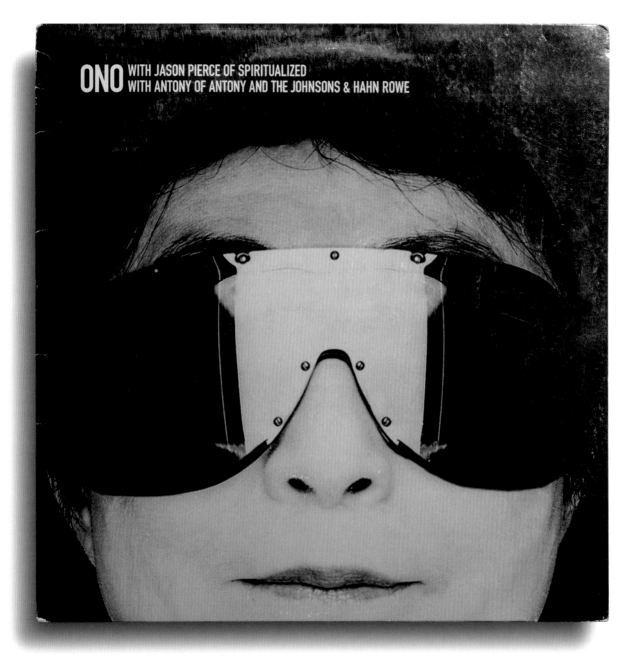

ONO WITH JASON PIERCE OF SPIRITUALIZED
WITH ANTONY OF ANTONY AND THE JOHNSONS & HAHN ROWE

Artist. **Ono with Jason Pierce of Spiritualized
and Antony of Antony and the Johnsons and Hahn Rowe**
Title. **Walking on Thin Ice/Toyboat**
Label. Parlophone - ONO3
Country. England
Year. 2007
Photo. Albert Watson
Design. Unknown

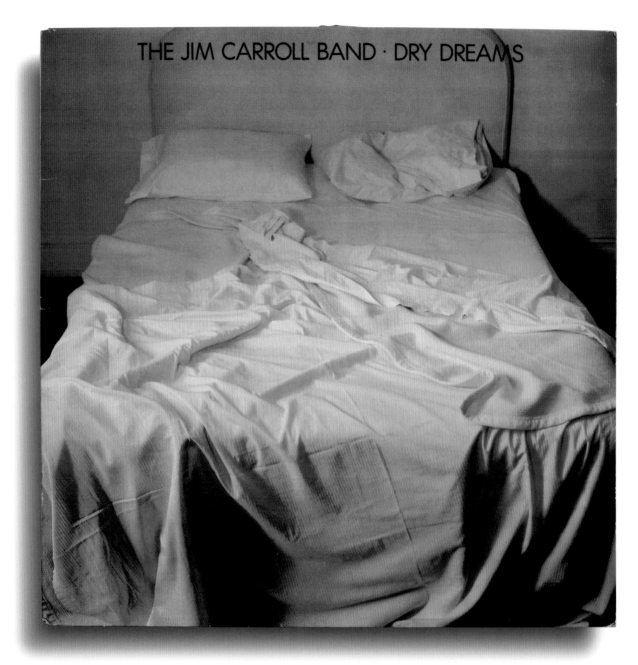

THE JIM CARROLL BAND · DRY DREAMS

Artist. **The Jim Carroll Band**
Title. **Dry Dreams**
Label. ATCO Records - SD 38-145
Country. USA
Year. 1982
Photo. Annie Leibovitz
Design. Unknown

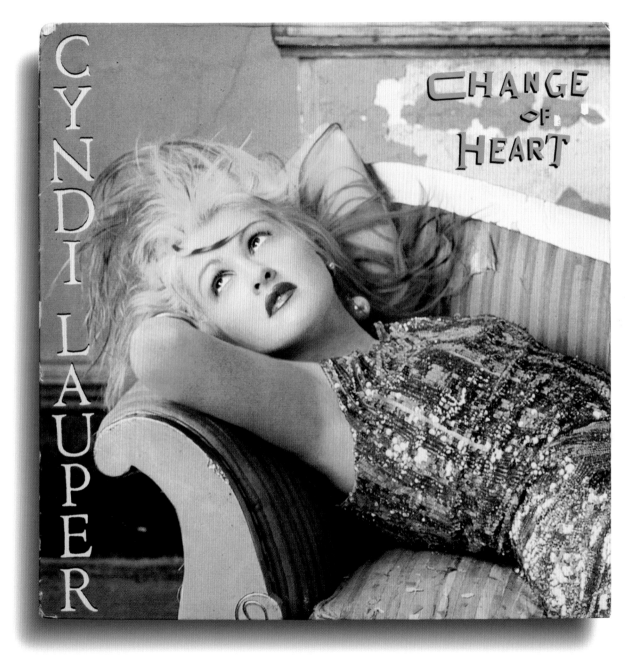

Artist. **Cyndi Lauper**
Title. **Change of Heart**
Label. Portrait - 4R9 05974
Country. USA
Year. 1986
Photo. Annie Leibovitz
Design. Unknown

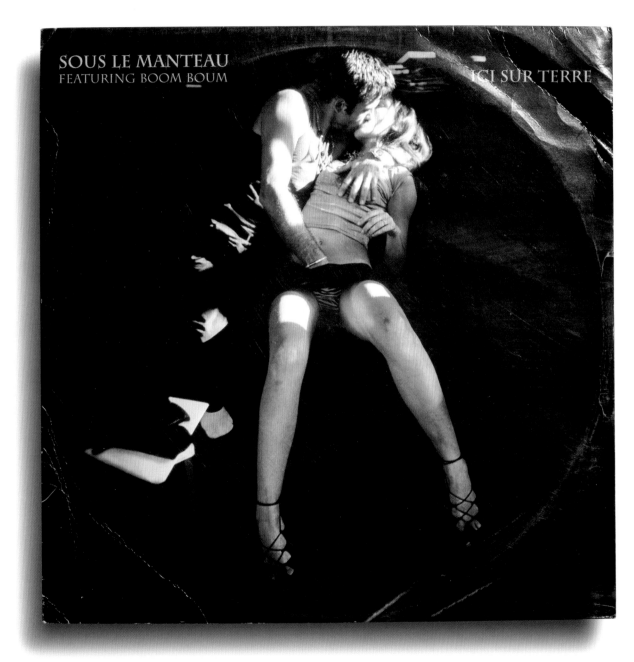

Artist. **Sous le Manteau featuring
Boom Boum**
Title. **Ici Sur Terre**
Label. Gambler Records - G1020-6
Country. France
Year. 2000
Photo. Nan Goldin
Design. FKGB

# GAINSBOURG LOVE ON THE BEAT

Artist. **Serge Gainsbourg**
Title. **Love on the Beat**
Label. Philips - 822 849-1
Country. France
Year. 1984
Photo. William Klein
Design. Unknown

**Hard Times**

*From Boz Scaggs' forthcoming album*

*Photography: Guy Bourdin*

380

Columbia

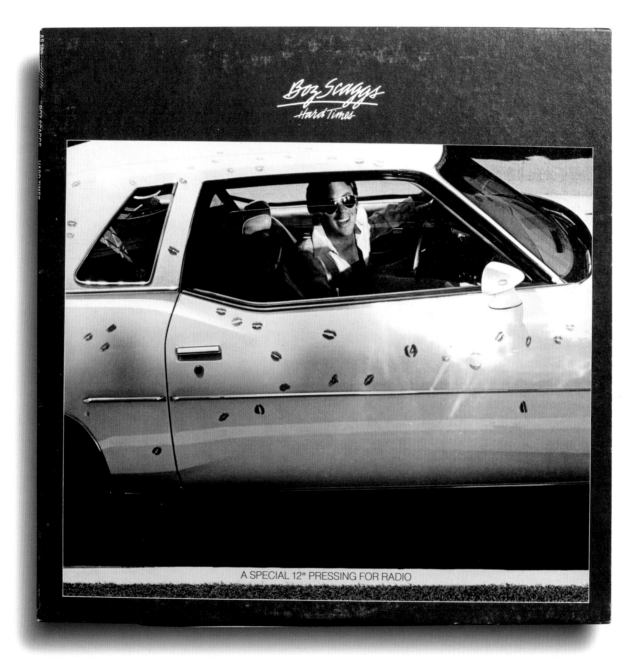

Artist. **Boz Scaggs**
Title. **Hard Times**
Label. Columbia - AS 380
Country. USA
Year. 1977
Photo. Guy Bourdin
Design. Unknown

With the generous authorization
of the Guy Bourdin Estate, 2015.

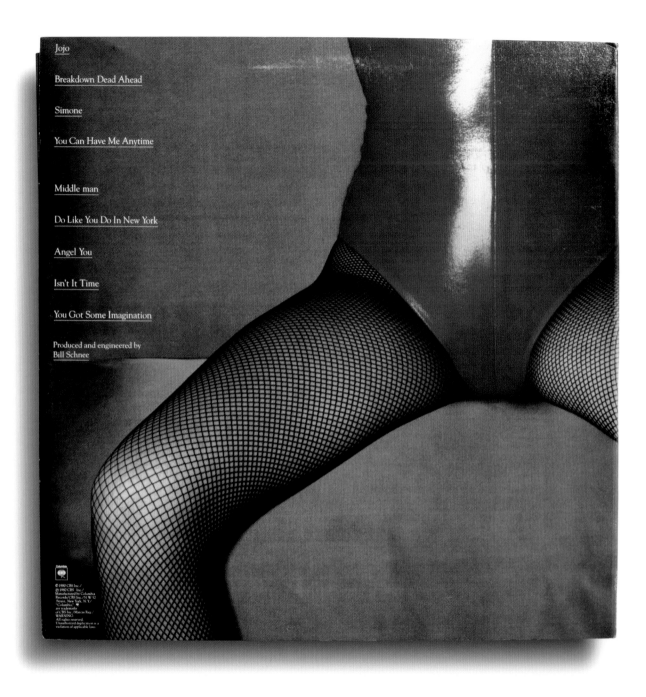

Jojo

Breakdown Dead Ahead

Simone

You Can Have Me Anytime

Middle man

Do Like You Do In New York

Angel You

Isn't It Time

You Got Some Imagination

Produced and engineered by
Bill Schnee

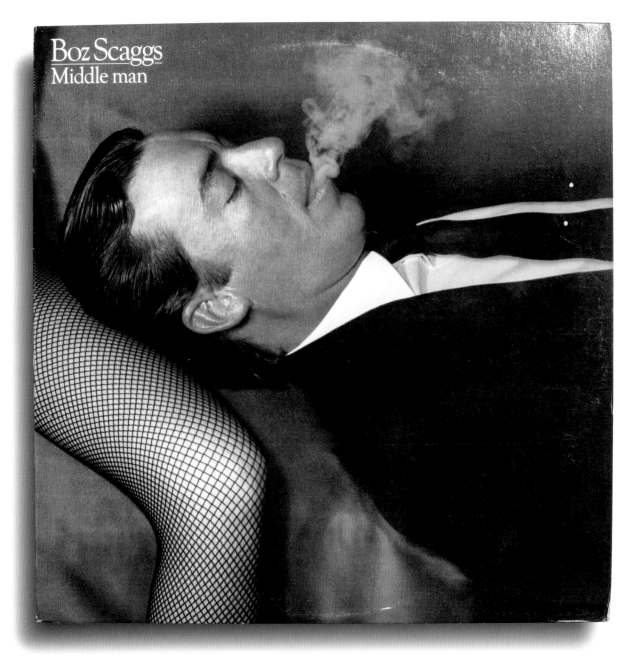

Artist. **Boz Scaggs**
Title. **Middle Man**
Label. Columbia - FC 36106
Country. USA
Year. 1980
Photo. Guy Bourdin
Design. Nancy Donald

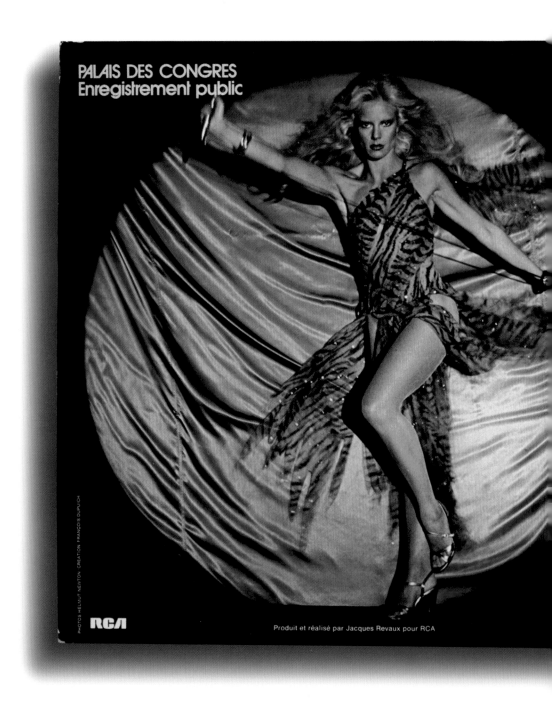

PALAIS DES CONGRES
Enregistrement public

RCA

Produit et réalisé par Jacques Revaux pour RCA

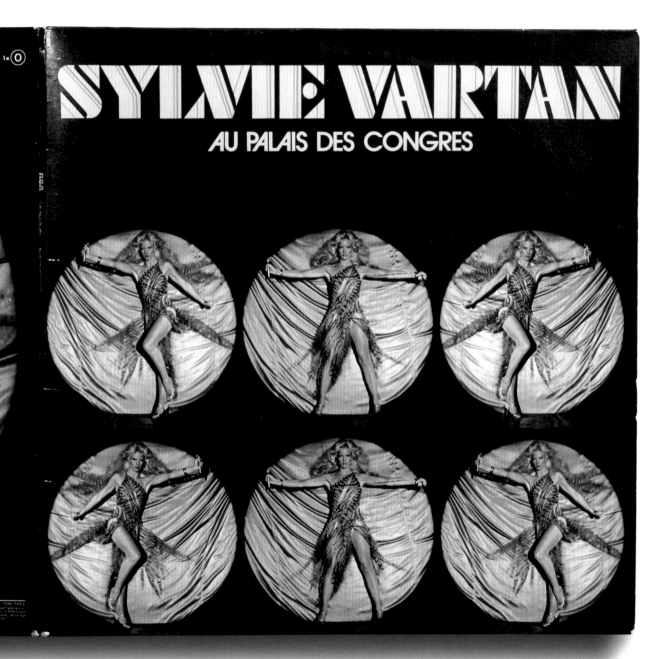

Artist. **Sylvie Vartan**
Title. **Au Palais des Congrès**
Label. RCA Victor - PL 37116
Country. France
Year. 1977
Photo. Helmut Newton
Design. François Dupuich

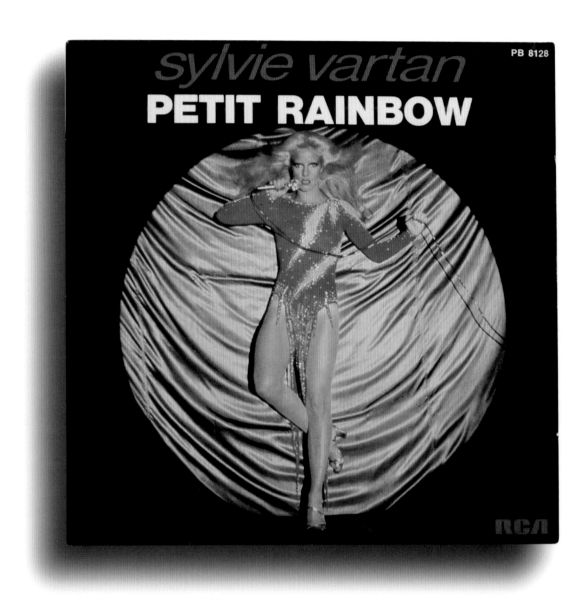

Artist. **Sylvie Vartan**
Title. **Petit Rainbow**
Label. RCA - PB 8128
Country. France
Year. 1977
Photo. Helmut Newton
Design. François Dupuich

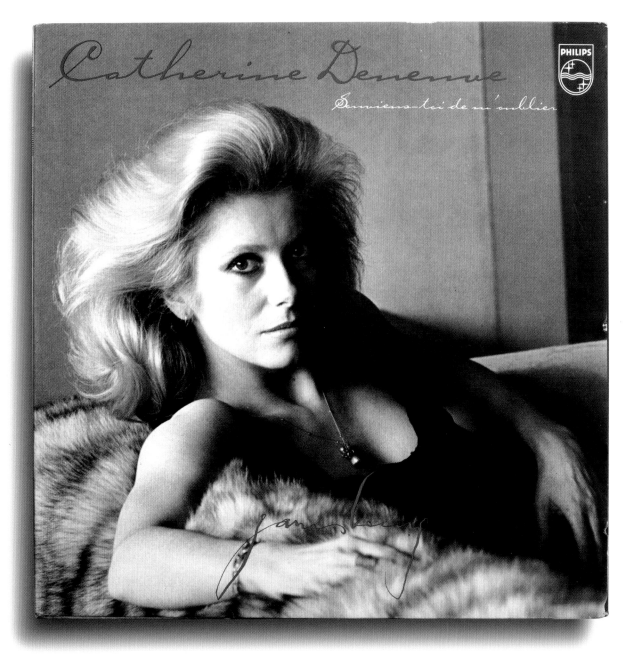

Artist. **Catherine Deneuve**
Title. **Souviens-toi de M'Oublier**
Label. Philips - 6313-172
Country. France
Year. 1981
Photo. Helmut Newton
Design. 50

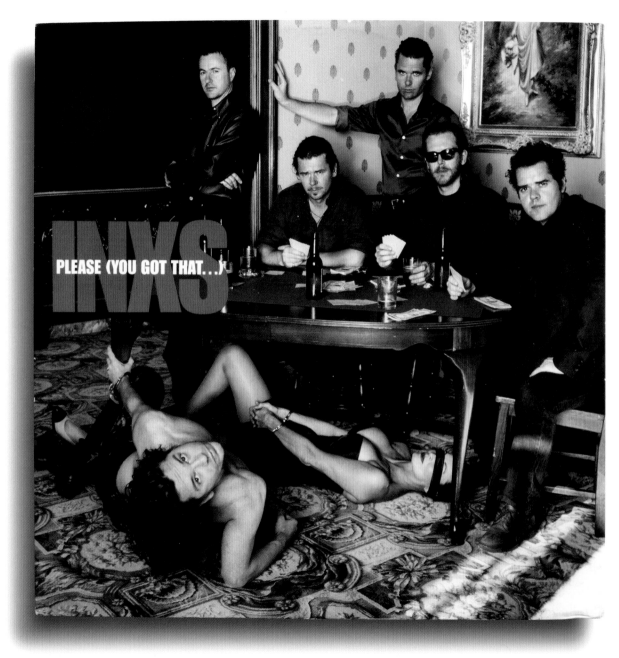

Artist. **INXS**
Title. **Please (You Got That . . . )**
Label. Mercury - INXS 2612
Country. England
Year. 1993
Photo. Helmut Newton
Design. Unknown

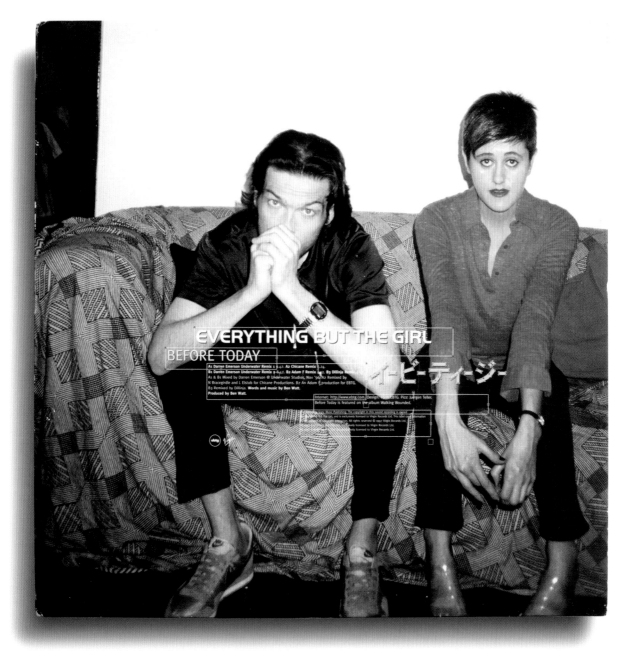

**EVERYTHING BUT THE GIRL**
BEFORE TODAY

A1 Darren Emerson Underwater Remix 1 9.47. A2 Chicane Remix 5.24.
B1 Darren Emerson Underwater Remix 2 9.47. B2 Adam F Remix 4.42. B3 Dillinja Remix
A1 & B1 Mixed by Darren Emerson @ Underwater Studios, Nov '96. A2 Remixed by
N Bracegirdle and L Elstob for Chicane Productions. B2 An Adam F production for EBTG.
B3 Remixed by Dillinja. **Words and music by Ben Watt.**
**Produced by Ben Watt.**

Internet: http://www.ebtg.com. Design: Form/EBTG. Pics: Juergen Teller.
Before Today is featured on the album Walking Wounded.

イービーティージー

Artist. **Everything but the Girl**
Title. **Before Today**
Label. Virgin - VST 1624
Country. England
Year. 1997
Photo. Juergen Teller
Design. Form/EBTG

Artist. **Jonathan Velasquez**
Title. **Jonathan Velasquez Solo**
Label. KillEmAllNKeepMoving - RVLT7
Country. USA
Year. 2014
Photo. Larry Clark
Design. Unknown

Artist. **Iggy Pop**
Title. **Corruption**
Label. Virgin - VUS 155
Country. England
Year. 1999
Photo. Jeff Wall
Design. Unknown

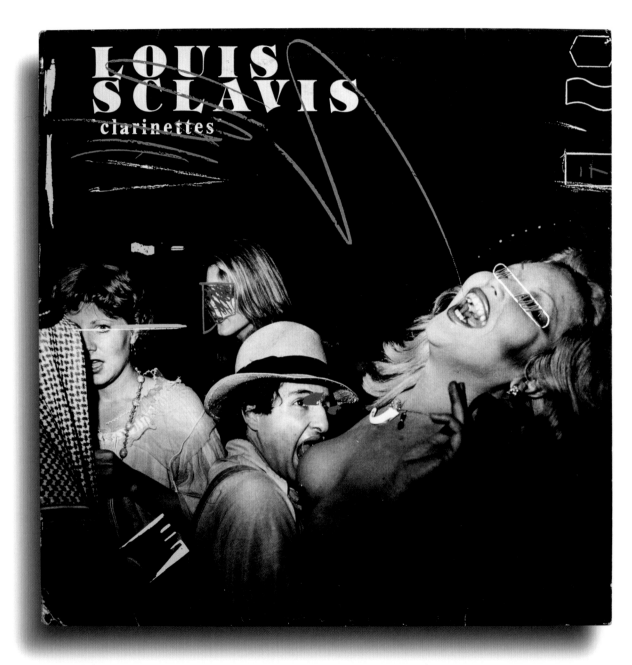

Artist. **Louis Sclavis**
Title. **Clarinettes**
Label. IDA Records - IDA 004
Country. France
Year. 1985
Photo. Guy Le Querrec
Design. Pierre-Noël Bernard

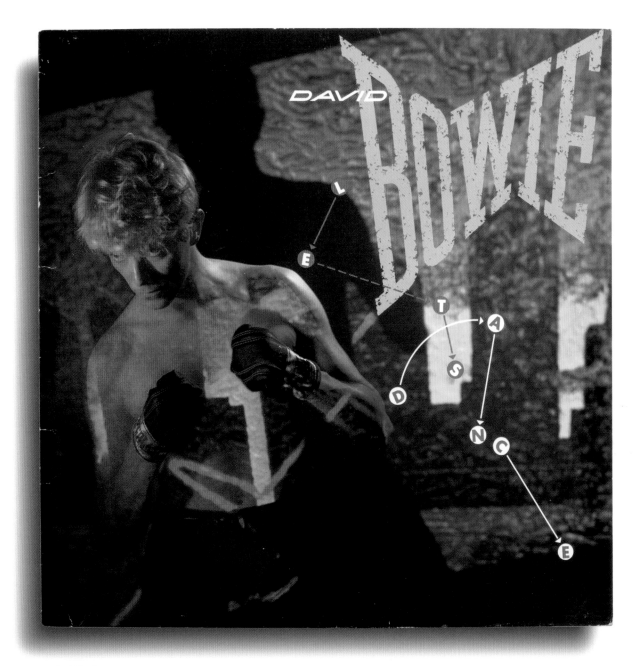

Artist. **David Bowie**
Title. **Let's Dance**
Label. EMI - AML 3029
Country. England
Year. 1983
Photo. Greg Gorman
Design. Mick Haggerty

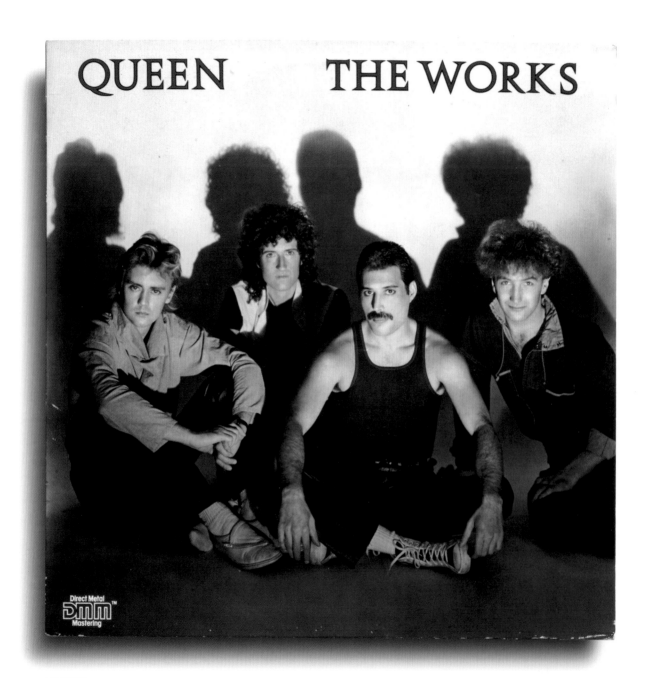

Artist. **Queen**
Title. **The Works**
Label. EMI - 064 2400141
Country. England
Year. 1984
Photo. George Hurrell
Design. Bill Smith

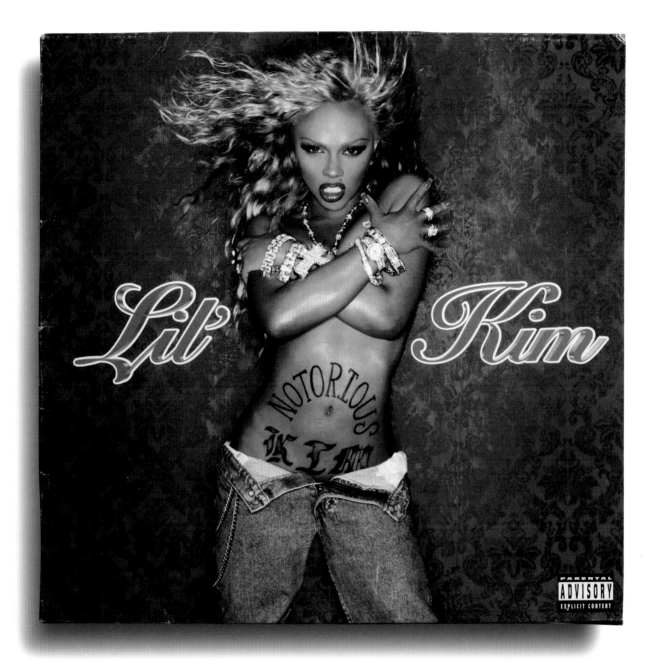

Artist. **Lil' Kim**
Title. **The Notorious K.I.M.**
Label. Atlantic - 92840-1
Country. USA
Year. 2000
Photo. David LaChapelle
Design. Lynn Kowalewski

75

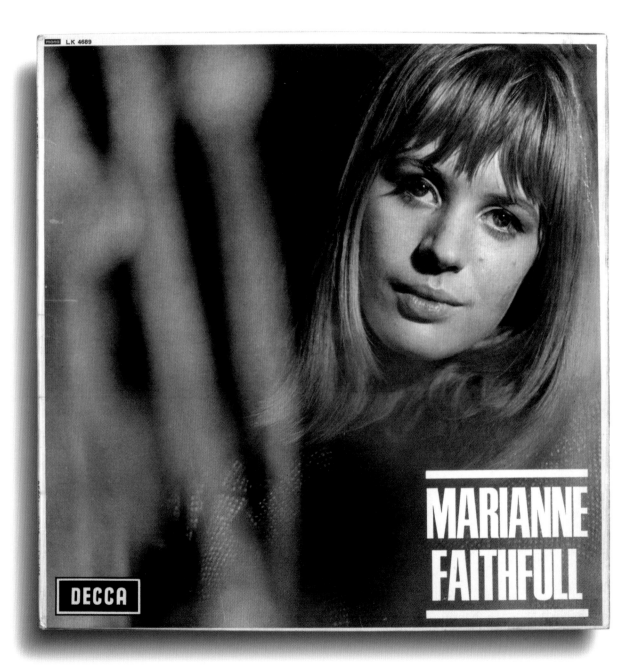

mono LK 4689

DECCA

MARIANNE FAITHFULL

Artist. **Marianne Faithfull**
Title. **Marianne Faithfull**
Label. Decca - LK 4689
Country. England
Year. 1965
Photo. David Bailey
Design. Unknown

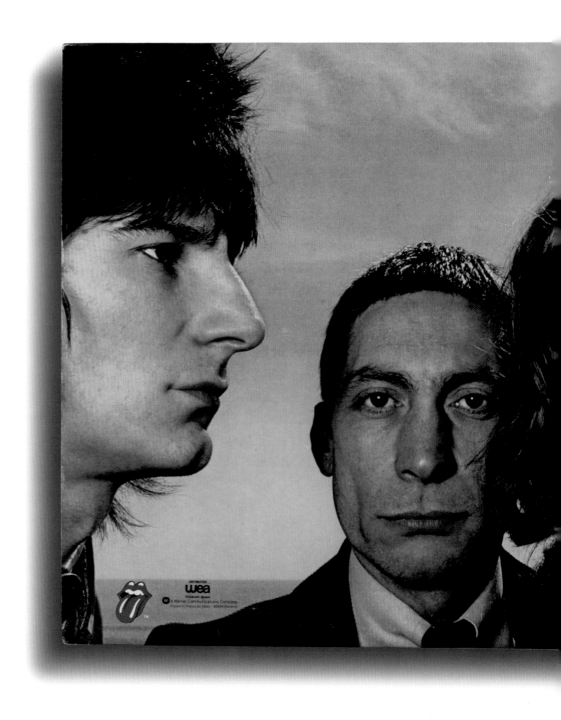

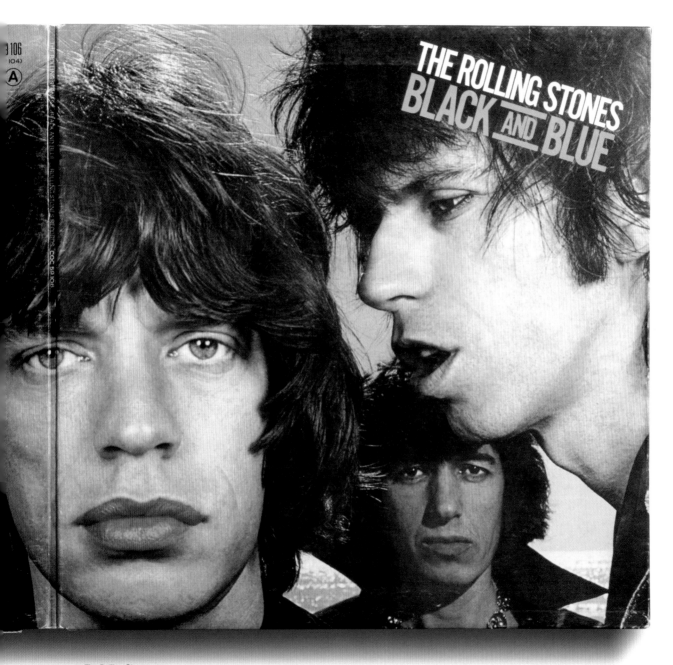

Artist. **The Rolling Stones**
Title. **Black and Blue**
Label. Rolling Stones Records - COC 59106
Country. England
Year. 1976
Photo. Hiro
Design. Bea Feitler

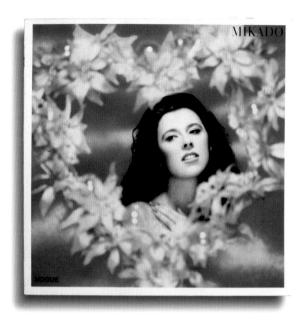

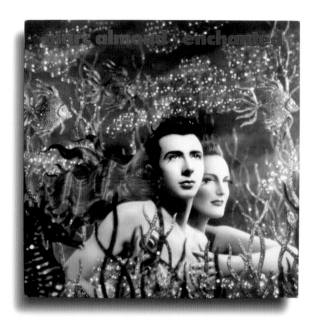

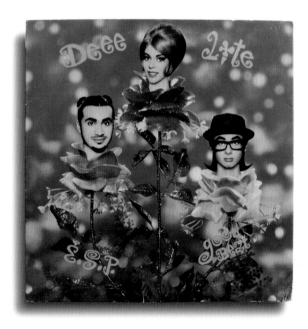

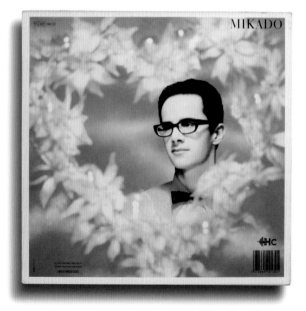

Artist. **Mikado**
Title. **Mikado**
Label. Vogue - 540132
Country. France
Year. 1985
Photo. Pierre et Gilles
Design. Koichi Yoshida

Artist. **Deee-Lite**
Title. **E.S.P./Good Beat**
Label. Elektra Records - 66550
Country. USA
Year. 1990
Photo. Pierre et Gilles
Design. Unknown

Artist. **Marc Almond**
Title. **Enchanted**
Label. Parlophone - 064 79 4404 1
Country. England
Year. 1990
Photo. Pierre et Gilles
Design. Green Ink

Artist. **Mikado**
Title. **Mikado**
Label. Vogue - 540132
Country. France
Year. 1985
Photo. Pierre et Gilles
Design. Koichi Yoshida

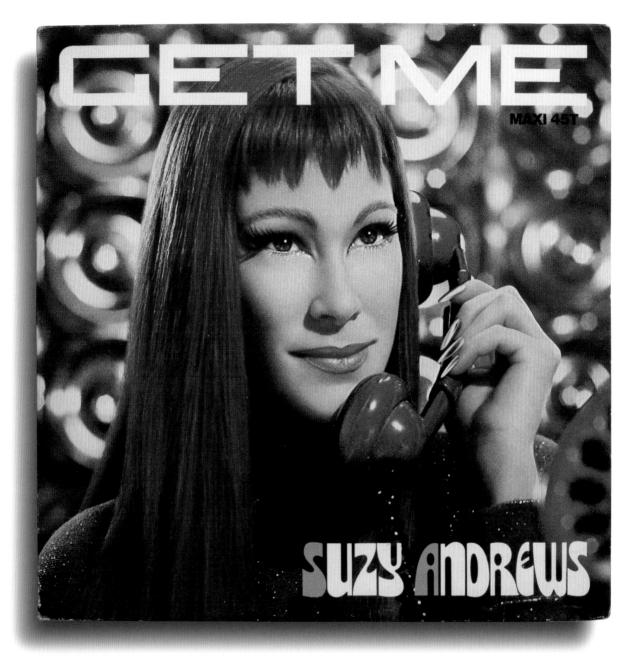

Artist. **Suzy Andrews**
Title. **Get Me**
Label. Ulysse Musique/Phonogram - 6863 316
Country. France
Year. 1987
Photo. Pierre et Gilles
Design. Unknown

Artist. **John Travolta/Olivia Newton-John**
Title. **Two of a Kind**
Label. MCA Records - MCA-6127
Country. USA
Year. 1983
Photo. Herb Ritts
Design. Norman Moore/George Osaki

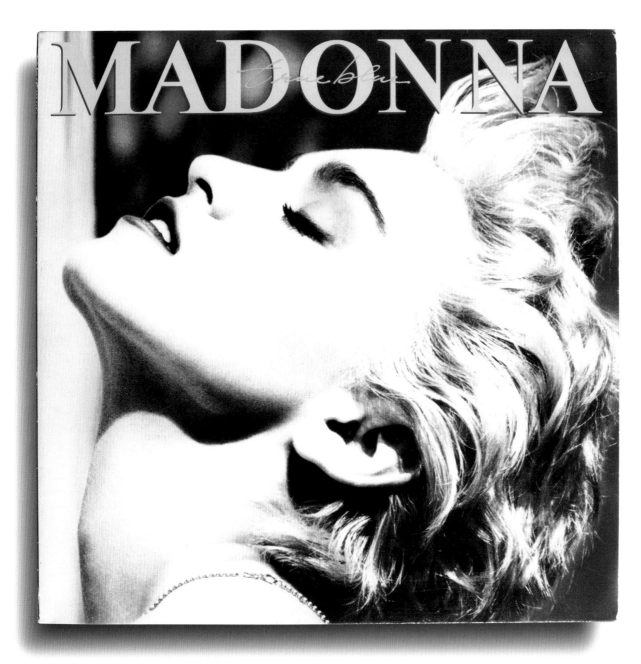

Artist. **Madonna**
Title. **True Blue**
Label. Sire - 1-25442
Country. USA
Year. 1986
Photo. Herb Ritts
Design. Jeri McManus

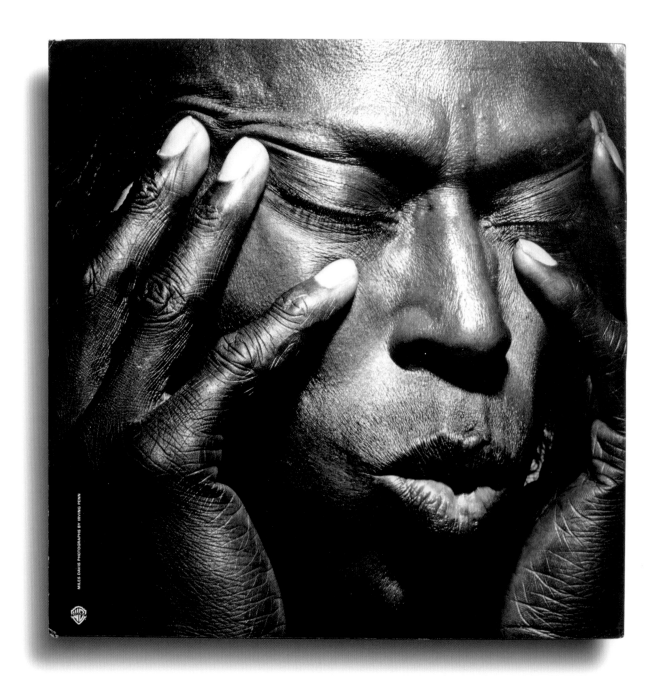

MILES DAVIS PHOTOGRAPHS BY IRVING PENN

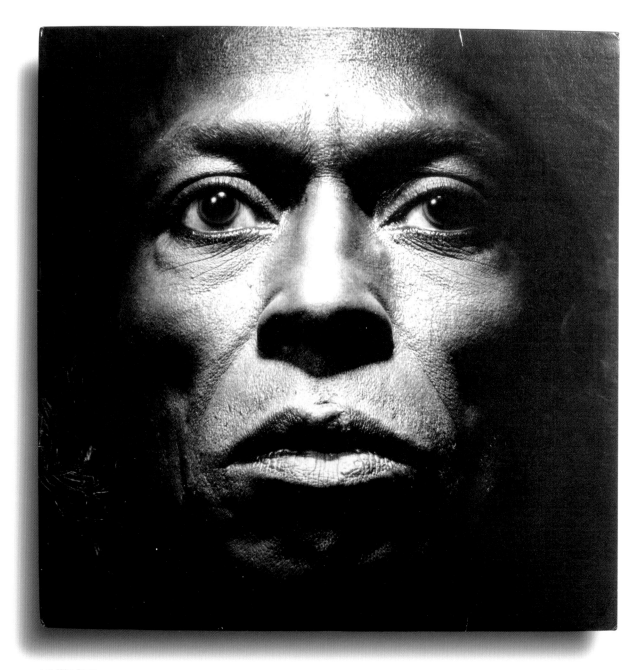

Artist. **Miles Davis**
Title. **Tutu**
Label. Warner Bros. Records - 1-25490
Country. USA
Year. 1986
Photo. Irving Penn
Design. Eiko Ishioka

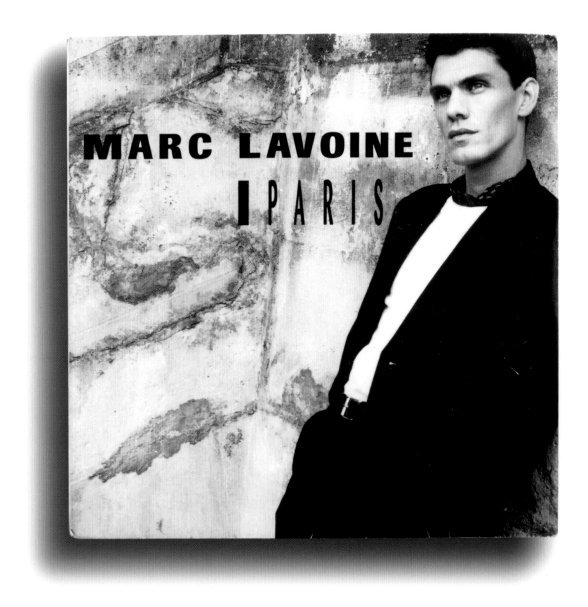

Artist. **Marc Lavoine**
Title. **Paris**
Label. PolyGram - 190 062-7
Country. France
Year. 1991
Photo. Raymond Depardon
Design. Bill Butt/Paul Ritter

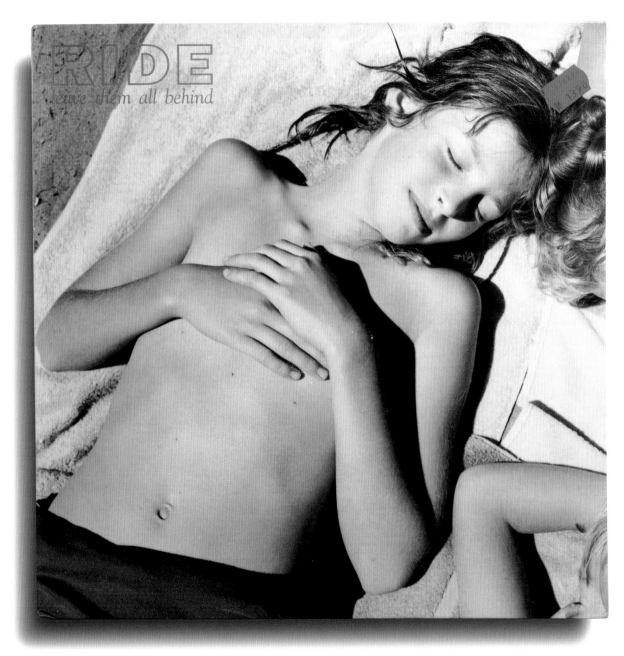

Artist. **Ride**
Title. **Leave Them All Behind**
Label. Creation Records - CRE 123T
Country. England
Year. 1992
Photo. Jock Sturges
Design. Unknown

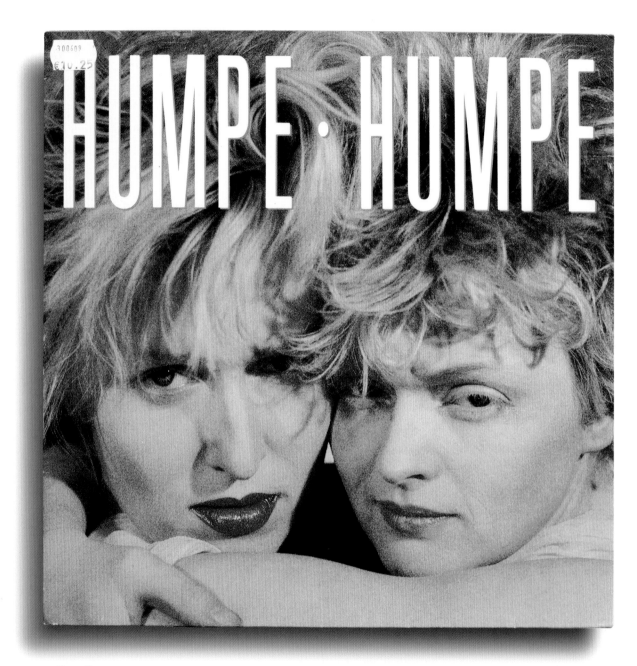

Artist. **Humpe Humpe**
Title. **Humpe Humpe**
Label. WEA - 240 635-1
Country. Germany
Year. 1985
Photo. Peter Lindbergh
Design. Thomas Fehlmann

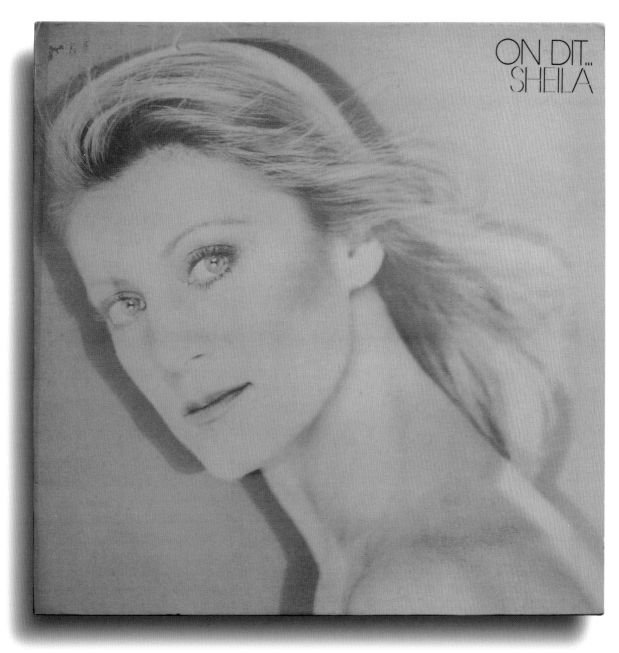

ON DIT...
SHEILA

Artist. **Sheila**
Title. **On Dit . . .**
Label. Carrere - 66 013
Country. France
Year. 1983
Photo. Paolo Roversi
Design. Unknown

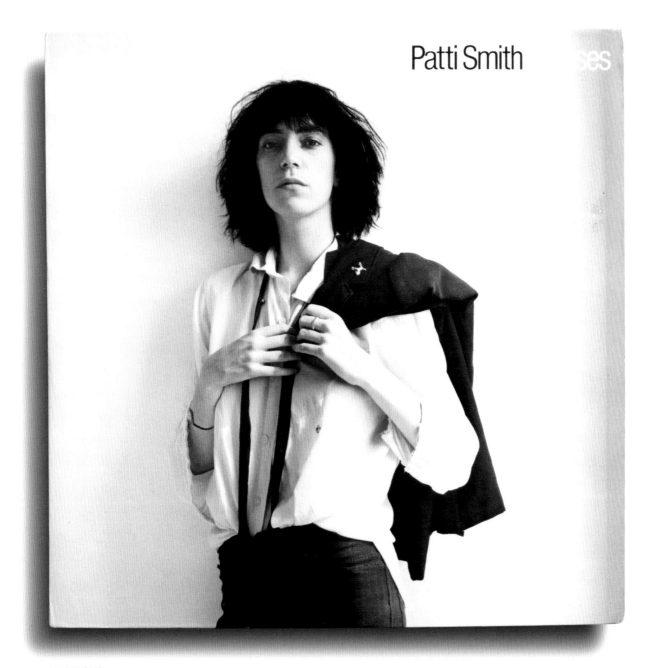

Patti Smith

Artist. **Patti Smith**
Title. **Horses**
Label. Arista - AL 4066
Country. USA
Year. 1975
Photo. Robert Mapplethorpe
Design. Bob Heimall

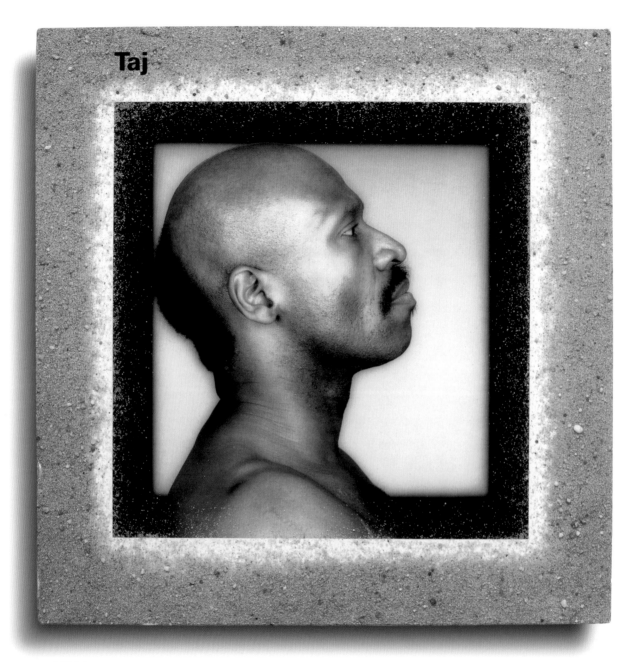

Taj

Artist. **Taj Mahal**
Title. **Taj**
Label. Gramavision - 18-8611-1
Country. USA
Year. 1986
Photo. Robert Mapplethorpe
Design. Chermayeff & Geismar Associates

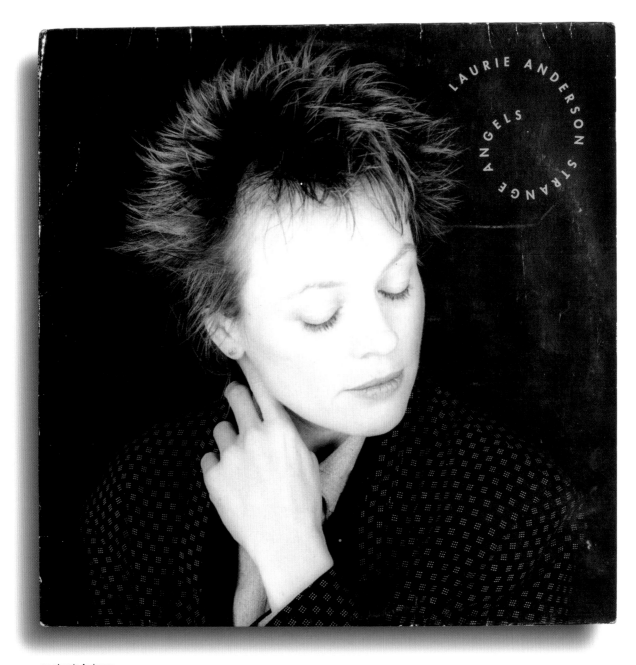

Artist. **Laurie Anderson**
Title. **Strange Angels**
Label. Warner Bros. Records - 9 25900-1
Country. USA
Year. 1989
Photo. Robert Mapplethorpe
Design. M & Co.

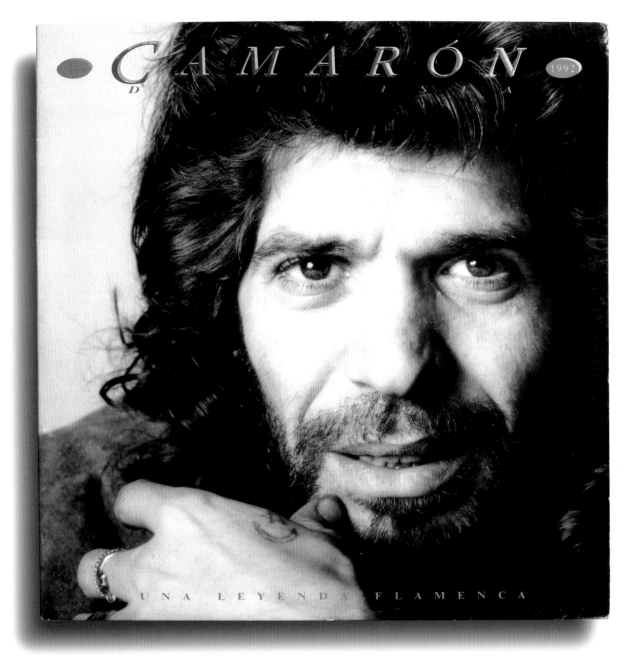

Artist. **Camarón de la Isla**
Title. **Una Leyenda Flamenca (1969−1992)**
Label. Philips - 512822-1
Country. Spain
Year. 1992
Photo. Alberto García-Alix
Design. Pablo Sycet

Artist. **Graham Parker and the Rumour**
Title. **The Parkerilla**
Label. Vertigo - 6641 797
Country. England
Year. 1978
Photo. Brian Griffin
Design. Barney Bubbles

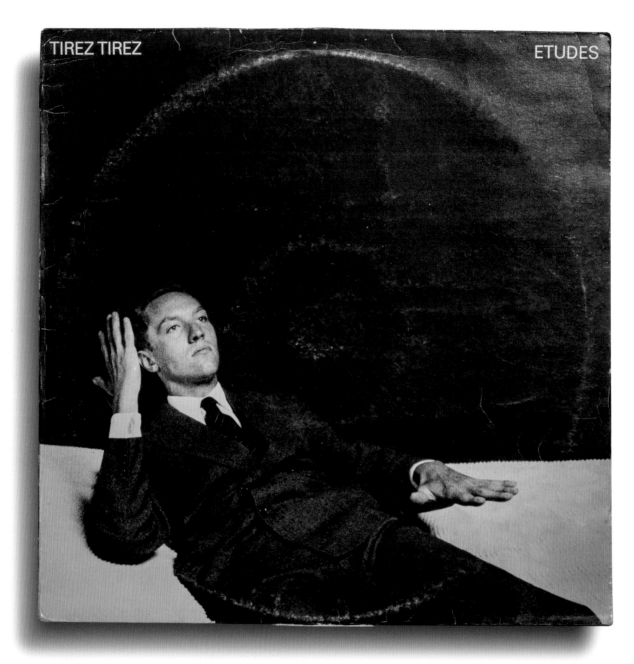

Artist. **Tirez Tirez**
Title. **Études**
Label. Aura - AUL714
Country. England
Year. 1981
Photo. Brian Griffin
Design. Bill Smith

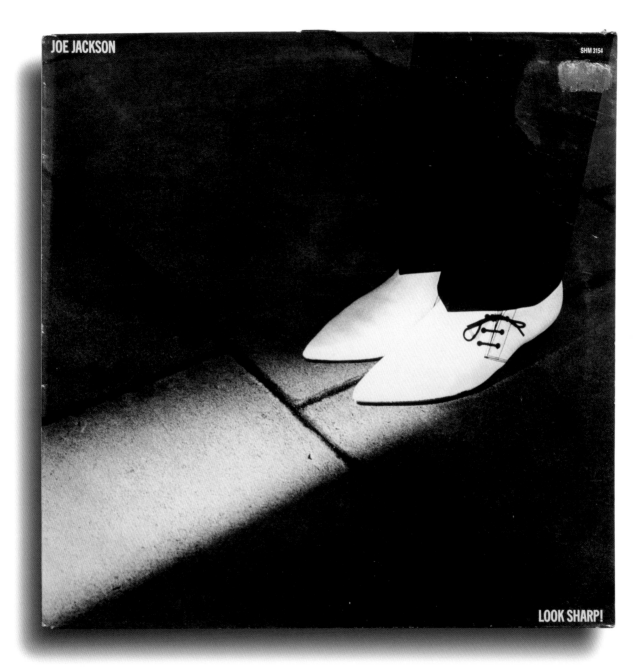

JOE JACKSON

SHM 3154

LOOK SHARP!

Artist. **Joe Jackson**
Title. **Look Sharp!**
Label. A&M Records - SHM 3154
Country. England
Year. 1979
Photo. Brian Griffin
Design. Michael Ross

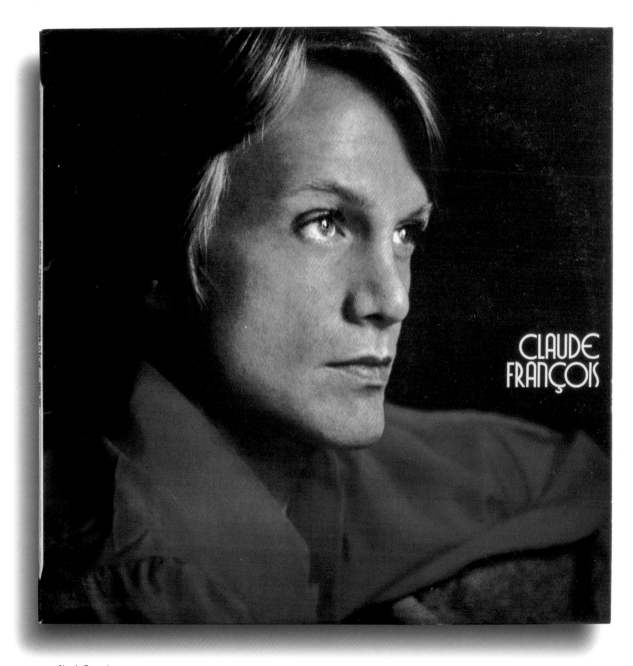

Artist. **Claude François**
Title. **Claude François**
Label. Disques Flèche - 6450 501
Country. France
Year. 1972
Photo. David Hamilton
Design. Unknown

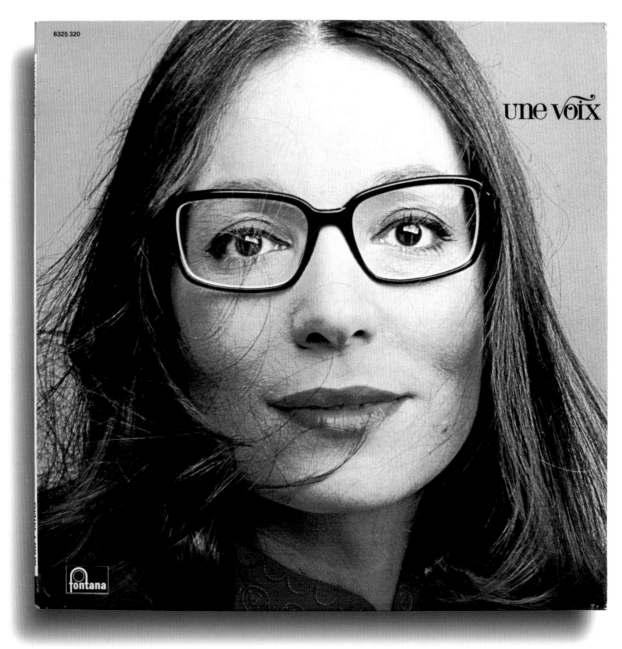

6325 320

une voix

fontana

Artist. **Nana Mouskouri**
Title. **Une Voix Qui Vient Du Cœur**
Label. Fontana - 6235 320
Country. France
Year. 1972
Photo. Just Jaeckin
Design. Unknown

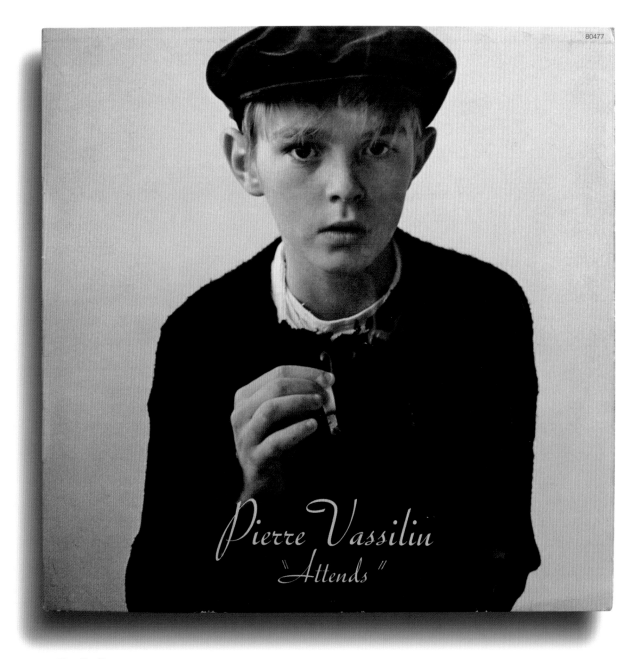

Artist. **Pierre Vassiliu**
Title. **Attends**
Label. Barclay - 80477
Country. France
Year. 1972
Photo. Jean-François Jonvelle
Design. Joël Le Berre

Artist. **Sati de Crem**
Title. **Ocultando**
Label. Rocco - RC 9.999 LX
Country. Spain
Year. 1987
Photo. Chema Madoz
Design. José Ramón Gutiérrez

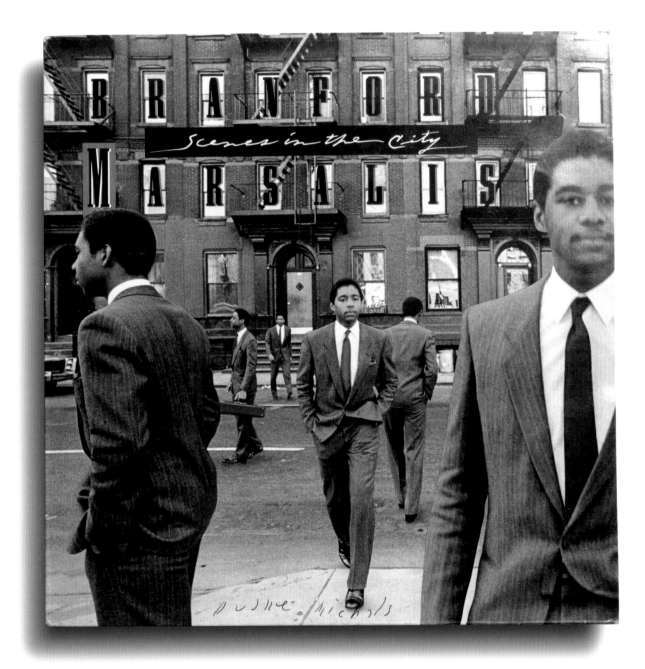

Artist. **Branford Marsalis**
Title. **Scenes in the City**
Label. Columbia - FC 38951
Country. USA
Year. 1984
Photo. Duane Michals
Design. Henrietta Condak

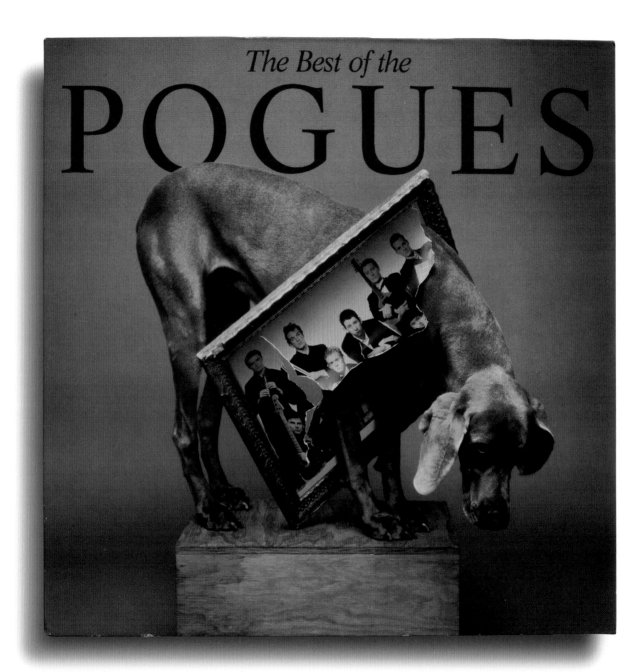

The Best of the

# POGUES

Artist. **The Pogues**
Title. **The Best of the Pogues**
Label. Warner Music UK Ltd. - 9031-75405-1
Country. England
Year. 1991
Photo. William Wegman
Design. Ryan Art

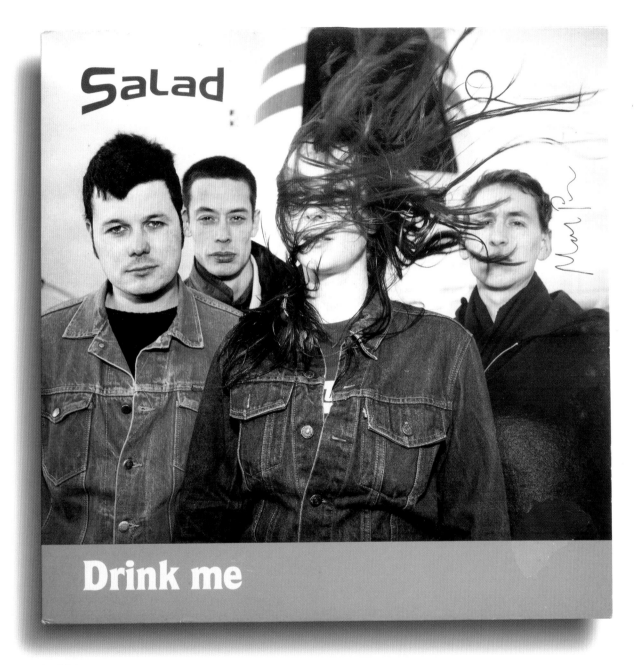

Artist. **Salad**
Title. **Drink Me**
Label. Island Red Label - IRLP 1002
Country. England
Year. 1995
Photo. Martin Parr
Design. DesignPig

# Aural Reappropriation

Photographers have worked with musicians to design album covers, but the relationship goes both ways: musicians have also sifted through photography's rich history searching for powerful images to associate with their music. For a simple EP, Tuxedomoon founder Steven Brown chose Berenice Abbott's famous view of New York. Nostalgia for the future concerns both media: photography and music both communicate among themselves in the present with the goal of capturing an essence, but they necessarily project themselves into the future.

Tomorrow is yesterday. The Paris couple photographed by Brassaï in 1933 was thrust into the early 1980s by the young American muse Rickie Lee Jones. The subtle kiss captured by Elliott Erwitt made its way onto the cover *The First of a Million Kisses* in 1988; the meteoric British band Fairground Attraction went so far as to zoom and reframe this instant from 1950s California, at the risk of being too explicit. Kiss in the Dark also sought to tell a part of history when the band chose the famous picture by René Burri in 1989 for their album *Something Special*. And the couple at the Café Lehmitz from Swedish photographer Anders Petersen's late 1960s Hamburg series ended up on the sleeve of a Tom Waits album fifteen years later.

From William Klein's iconic image to Guy Le Querrec's less-classic one, from Dorothea Lange's poignant realism in the depths of the Great Depression to the "surrealist" portrait for which South Africa's Pieter Hugo won the World Press Award in 2006: the world of music has used photography to declare its discursive intentions. And who else but Jeff Wall would have dared to base a monumental, illuminated retro photograph on the prologue to *Invisible Man*? In 2000, the photographer created a picture that incorporated the smallest details Ralph Ellison described in his novel, even a record player needle in the middle.

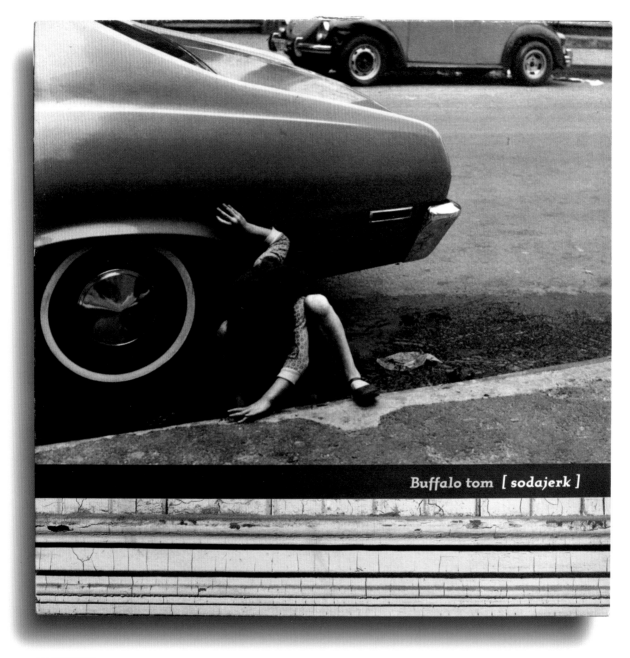

Buffalo tom [ sodajerk ]

Artist. **Buffalo Tom**
Title. **Sodajerk**
Label. Beggars Banquet - BBQ 20T
Country. England
Year. 1993
Photo. Helen Levitt
Design. Bob Hamilton

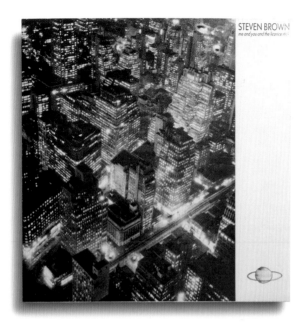

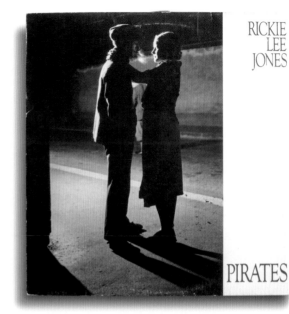

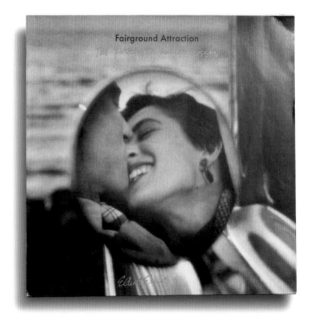

Artist. **Steven Brown**
Title. **Me and You and the Licorice Stick**
Label. Sub Rosa - sub 12002-4
Country. Belgium
Year. 1986
Photo. Berenice Abbott
Design. Waving Ondulata

Artist. **Das Wesen**
Title. **Anyone**
Label. Torso - TORSO 127
Country. The Netherlands
Year. 1982
Photo. Ed van der Elsken
Design. Boudewijn van der Wagt

Artist. **Rickie Lee Jones**
Title. **Pirates**
Label. Warner Bros. Records - BSK 3432
Country. USA
Year. 1981
Photo. Brassaï
Design. Mike Salisbury

Artist. **Fairground Attraction**
Title. **The First of a Million Kisses**
Label. RCA - PL71696
Country. England
Year.1988
Photo. Elliott Erwitt
Design. Laurence Stevens

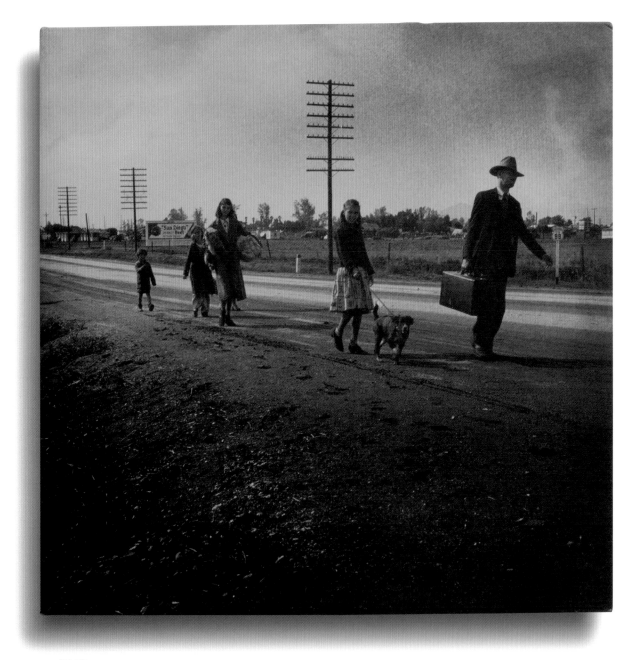

Artist. **I Pilot Dæmon**
Title. **Come What May**
Label. Lacrymal Records/Ruin Your Fun - LYL019/RYF04
Country. France
Year. 2010
Photo. Dorothea Lange
Design. Romain Barbot/IAMSAILOR

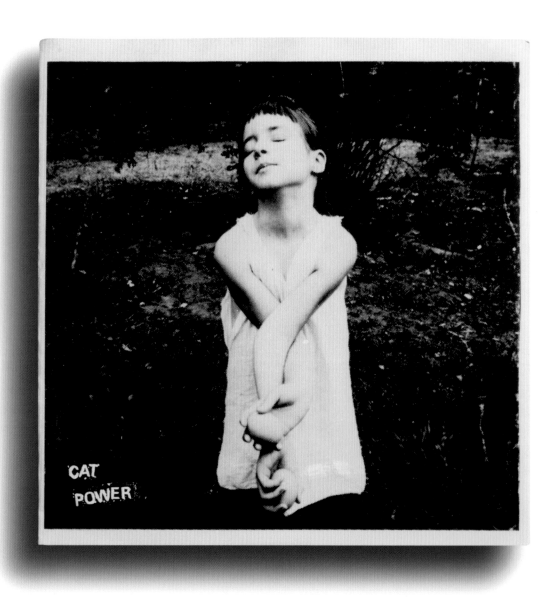

Artist. **Cat Power**
Title. **Headlights**
Label. The Making of Americans - MA-05
Country. USA
Year. 1993
Photo. Emmet Gowin
Design. Unknown

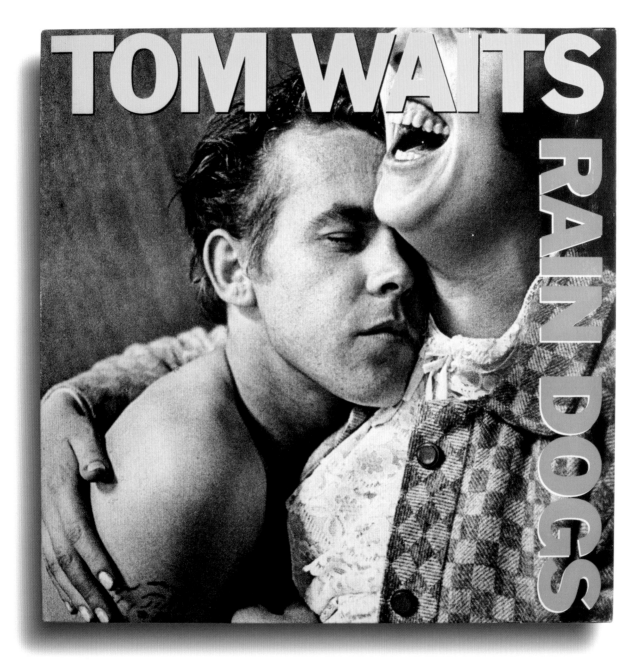

Artist. **Tom Waits**
Title. **Rain Dogs**
Label. Island Records - 90299-1
Country. USA
Year. 1985
Photo. Anders Petersen
Design. Peter Corriston

# Alex Chilton

# Like Flies On Sherbert

Artist. **Alex Chilton**
Title. **Like Flies on Sherbert**
Label. Peabody - PS-104
Country. USA
Year. 1979
Photo. William Eggleston
Design. Unknown

Artist. **Big Star**
Title. **Radio City**
Label. Ardent Records - ADS-1501
Country. USA
Year. 1974
Photo. William Eggleston
Design. Unknown

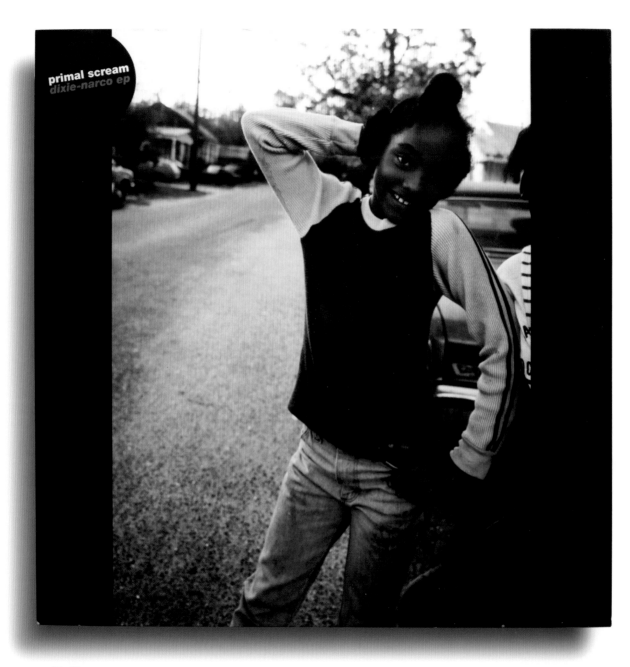

primal scream
*dixie-narco ep*

Artist. **Primal Scream**
Title. **Dixie-Narco EP**
Label. Creation Records - CRE 117T
Country. England
Year. 1992
Photo. William Eggleston
Design. Andrew Sutton

Artist. **Primal Scream**
Title. **Give Out but Don't Give Up**
Label. Creation Records - CRELP 146
Country. England
Year. 1994
Photo. William Eggleston
Design. Mark Bown

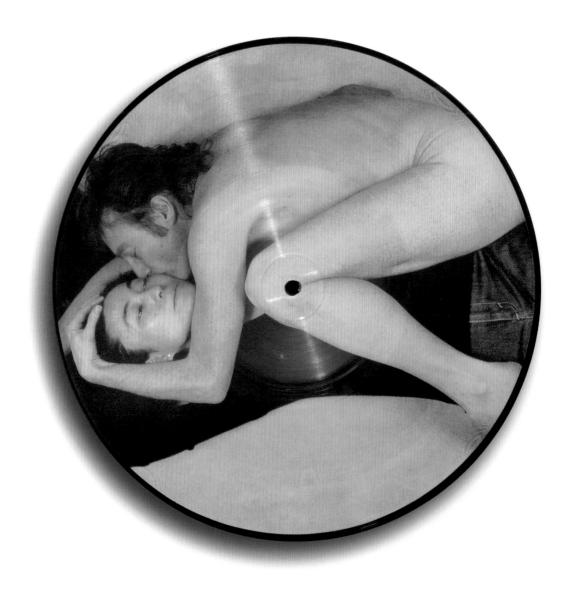

Artist. **John Lennon**
Title. **Interview 80**
Label. JL10PG
Country. Germany
Year. Unknown
Photo. Annie Leibovitz
Design. Unknown

ARTHUR DOYLE

NO MORE CRAZY WOMEN

Artist. **Arthur Doyle**
Title. **No More Crazy Women**
Label. Qbico - QBICO 33
Country. Italy
Year. 2005
Photo. Cindy Sherman
Design. Unknown

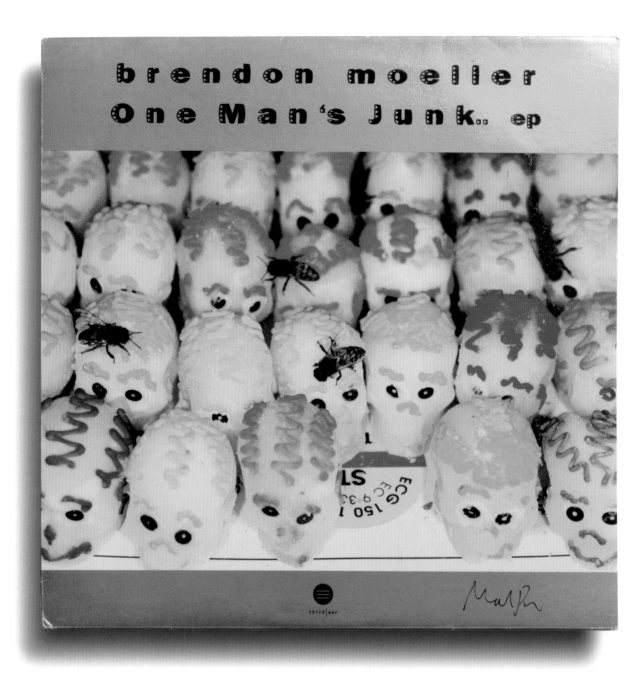

Artist. **Brendon Moeller**
Title. **One Man's Junk.. EP**
Label. Third Ear Recordings - 3EEP-088
Country. England
Year. 2008
Photo. Martin Parr
Design. Chidorigafuchi

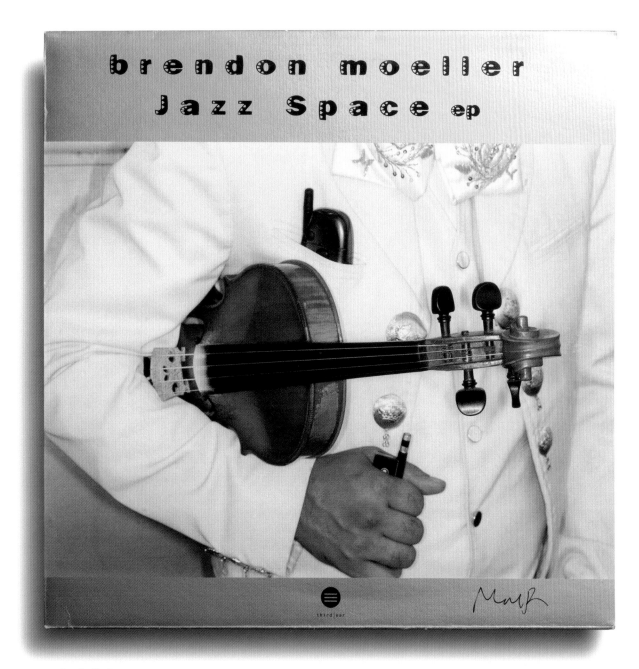

Artist. **Brendon Moeller**
Title. **Jazz Space EP**
Label. Third Ear Recordings - 3EEP-068
Country. England
Year. 2007
Photo. Martin Parr
Design. Chidorigafuchi

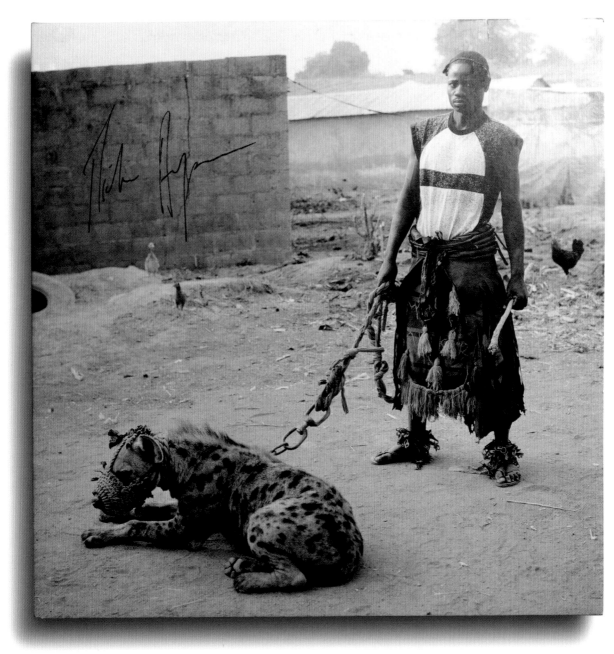

Artist. **Various**
Title. **Lagos Shake: A Tony Allen Chop Up**
Label. Honest Jon's Records - HJRLP34
Country. England
Year. 2008
Photo. Pieter Hugo
Design. Will Bankhead

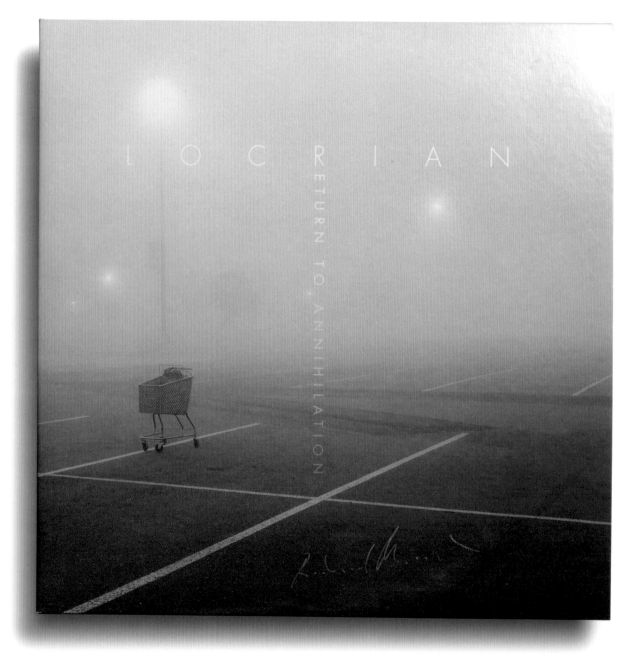

LOCRIAN

RETURN TO ANNIHILATION

Artist. **Locrian**
Title. **Return to Annihilation**
Label. Relapse Records - RR7204
Country. USA
Year. 2013
Photo. Richard Misrach
Design. Jacob Speis

Artist. **Raionbashi/Daniela Fromberg and Stefan Roigk**
Title. **Der Strick/Blowing Up the Master's Workshop**
Label. senufo editions - # seventeen
Country. Italy
Year. 2011
Photo. Roger Ballen
Design. Unknown

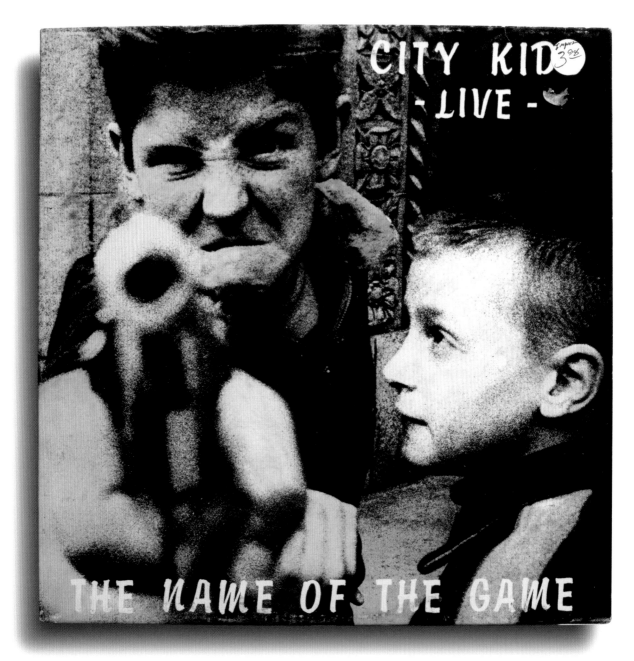

Artist. **City Kids**
Title. **The Name of the Game**
Label. City Kids Records - CIK01
Country. France
Year. 1983
Photo. William Klein
Design. City Kids

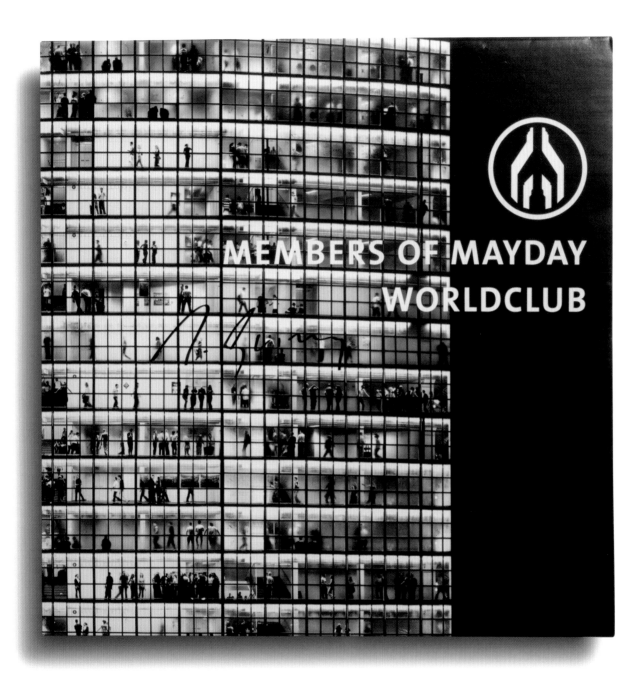

Artist. **Members of Mayday**
Title. **Worldclub**
Label. Low Spirit Recordings - LS DMD 06 001
Country. Germany
Year. 2006
Photo. Andreas Gursky
Design. Unknown

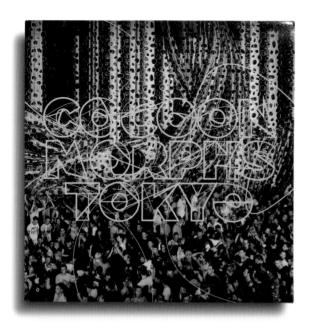

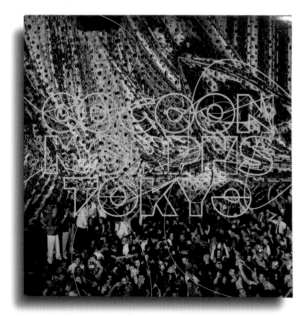

Artist. **Gerber & Kalbata/Pig & Dan**
Title. **Cocoon Morphs Tokyo: 50th 12"**
**Release Part II**
Label. Cocoon Recordings - COR12"050.2
Country. Germany
Year. 2008
Photo. Andreas Gursky
Design. Schultzschultz.com

Artist. **Väth vs. Rother/Ricardo Villalobos**
Title. **Cocoon Morphs Tokyo: 50th 12"**
**Release Part III**
Label. Cocoon Recordings - COR12"050.3
Country. Germany
Year. 2008
Photo. Andreas Gursky
Design. Schultzschultz.com

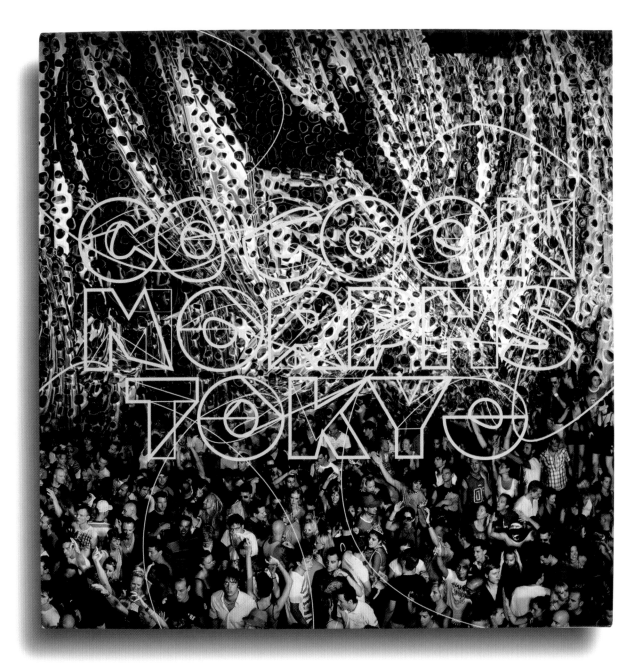

Artist. **Tiefschwarz/Scheider & Galluzzi**
Title. **Cocoon Morphs Tokyo: 50th 12" Release Part I**
Label. Cocoon Recordings - COP12"050.1
Country. Germany
Year. 2008
Photo. Andreas Gursky
Design. Schultzschultz.com

Artist. **George Michael**
Title. **Listen without Prejudice Vol. 1**
Label. Columbia - C 46898
Country. USA
Year. 1990
Photo. Weegee
Design. George Michael/Simon Halfon

Artist. **Erik Friedlander and Mitch Epstein**
Title. **American Power**
Label. Skipstone Records - #001
Country. USA
Year. 2012
Photo. Mitch Epstein
Design. Ryan Spencer/Takaaki Okada

# OCQ

## VALENTIN ALVAREZ   MARKUS A.BREUSS   TITI MORENO   JOSE VAZQUEZ

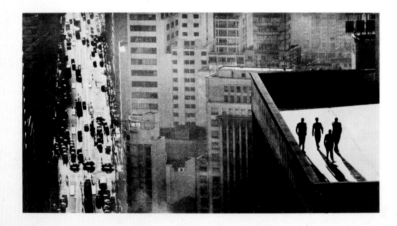

LINTERNA MUSICA
A1086-015

Artist. **OCQ**
Title. **OCQ**
Label. Linterna Música - A1086-015
Country. Spain
Year. 1986
Photo. René Burri
Design. Amalia Henn

Artist. **Johannes Wohnseifer**
Title. **Braunmusic**
Label. Tropenmusic – tropenmusic 1
Country. Germany
Year. 1997
Photo. Albrecht Fuchs
Design. Unknown

# Louis Sclavis Quintet
Rouge

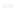

Artist. **Louis Sclavis Quintet**
Title. **Rouge**
Label. ECM Records - ECM 1458
Country. Germany
Year. 1992
Photo. Guy Le Querrec
Design. Barbara Wojirsch

# K I S S  I N  T H E  D A R K

SOMETHING SPECIAL

Artist. **Kiss in the Dark**
Title. **Something Special**
Label. Mercury - 872281-1
Country. Germany
Year. 1989
Photo. René Burri
Design. Werner Jeker

# Crafting Universes:
# Jean-Paul Goude and Anton Corbijn

Grace Jones and Jean-Paul
Goude: two names for one
sound. At the beginning of
the 1980s, New York's disco
mutations had yet to be invaded
by yuppies. When the model
and the photographer, who then
called himself an "author of
images," met in 1979, they hit it
off right away. In August 1982,
*The Face* named him "The Man
Who Made Grace Jones." It had
taken him three years to build
the androgynous, postindustrial
global mix icon, which led to
an LP and video. Like a fashion
designer or patternmaker
working on a picture disk
or close-up, Goude crafted
his creation by shooting her
from every angle. They were
both responsible for each
other's success.

In the late 1970s, Dutchman
Anton Corbijn hit his stride as
the English New Wave—Joy
Division, Echo & the Bunnymen,
Depeche Mode—hit the air.
He had already made a name
for himself with his full-page

photographs in the *New Musical
Express* (*NME*) and helped build
the U2 myth with his trademark
black-and-white pictures,
slick and documentary at the
same time. These contrasts
undoubtedly strengthened the
sociopolitical character of the
Irish band's music. Soon, Corbijn,
who also made sublime portraits
of Miles Davis, Joni Mitchell,
and Tom Waits, decided to start
making videos, including one for
U2, before devoting himself to
full-length films.

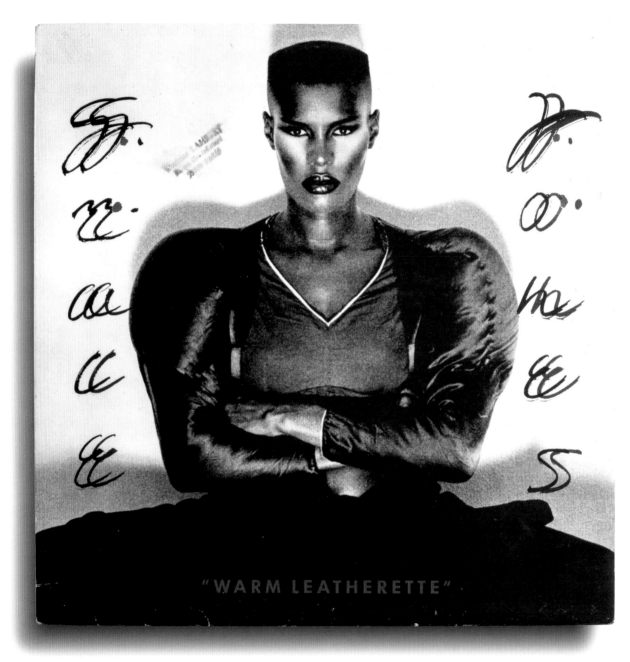

"WARM LEATHERETTE"

Artist. **Grace Jones**
Title. **Warm Leatherette**
Label. Island Records - 6313 042
Country. France
Year. 1980
Photo. Jean-Paul Goude
Design. Jean-Paul Goude

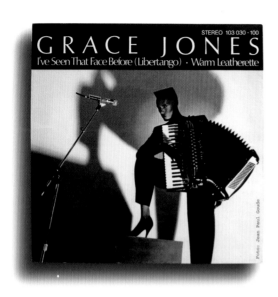

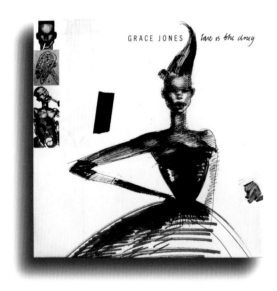

Artist. **Grace Jones**
Title. **I've Seen That Face Before (Libertango)/
Warm Leatherette**
Label. Island Records - 103 030-100
Country. Germany
Year. 1981
Photo. Jean-Paul Goude
Design. Unknown

Artist. **Grace Jones**
Title. **Love Is the Drug**
Label. Island Records - 12 IS 266
Country. England
Year. 1986
Photo. Jean-Paul Goude
Design. Island Art

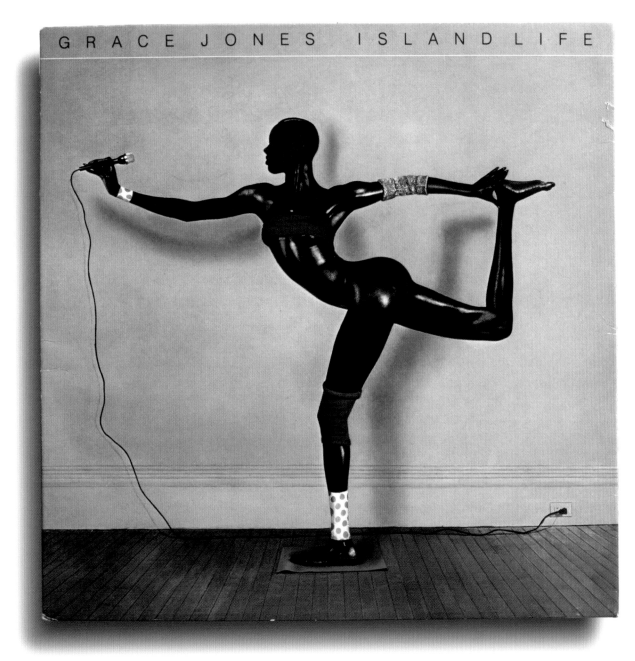

GRACE JONES ISLAND LIFE

Artist. **Grace Jones**
Title. **Island Life**
Label. Island Records - 207 472
Country. France
Year. 1985
Photo. Jean-Paul Goude
Design. Greg Porto

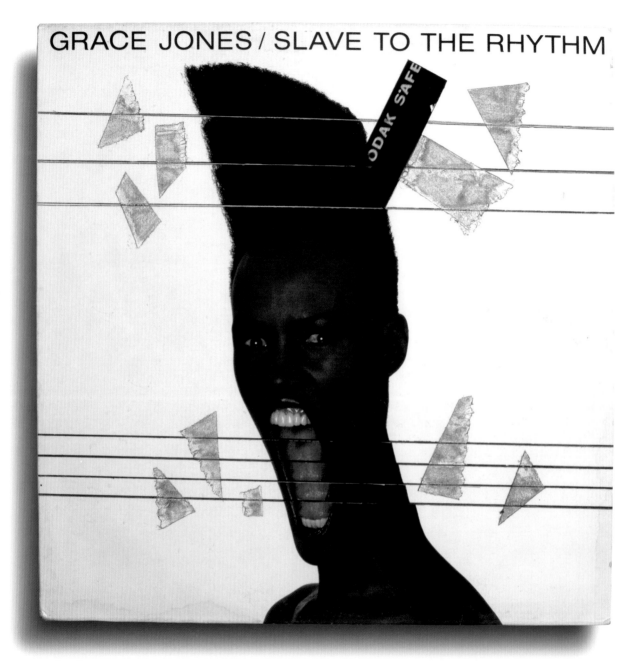

GRACE JONES / SLAVE TO THE RHYTHM

Artist. **Grace Jones**
Title. **Slave to the Rhythm**
Label. Manhattan Island Records - 24 0447 1
Country. France
Year. 1985
Photo. Jean-Paul Goude
Design. Jean-Paul Goude

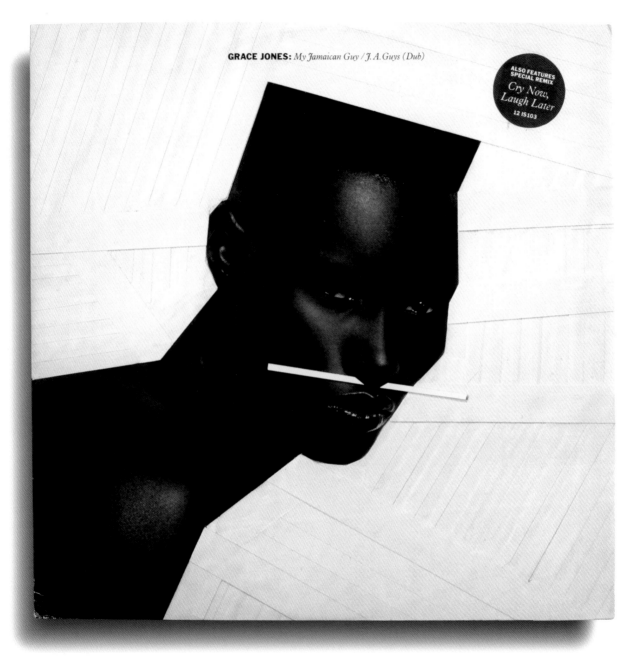

**GRACE JONES:** *My Jamaican Guy / J.A. Guys (Dub)*

ALSO FEATURES
SPECIAL REMIX
*Cry Now,*
*Laugh Later*
12 IS103

Artist. **Grace Jones**
Title. **My Jamaican Guy/J.A. Guys (Dub)**
Label. Island Records - 12 IS 103
Country. England
Year. 1983
Photo. Jean-Paul Goude
Design. Jean-Paul Goude

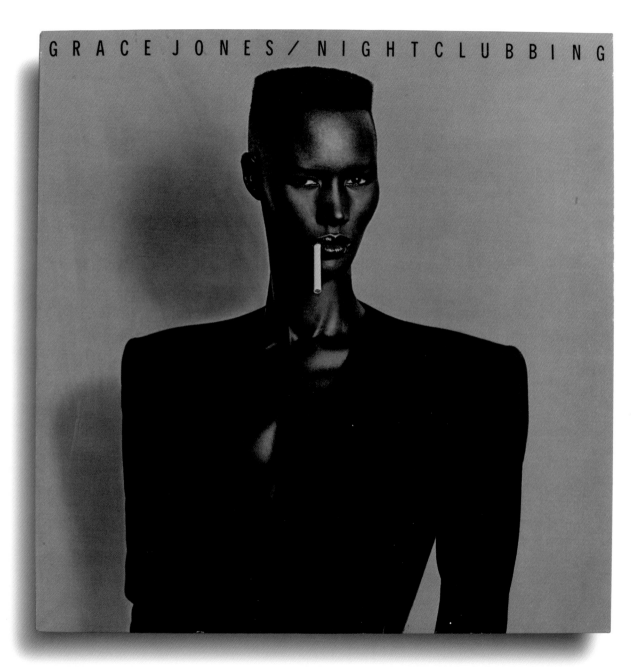

Artist. **Grace Jones**
Title. **Nightclubbing**
Label. Island Records - 203 481
Country. France
Year. 1981
Photo. Jean-Paul Goude
Design. Jean-Paul Goude

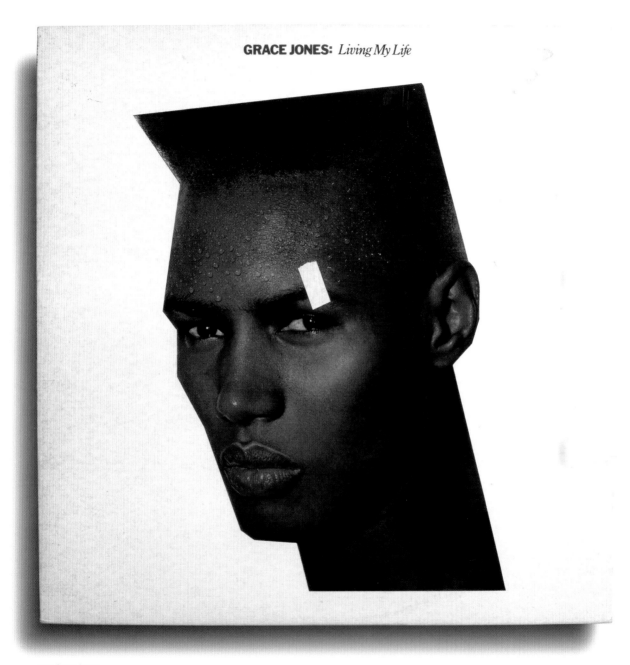

**GRACE JONES:** *Living My Life*

Artist. **Grace Jones**
Title. **Living My Life**
Label. Island Records - ILPS 9722
Country. England
Year. 1982
Photo. Jean-Paul Goude
Design. Jean-Paul Goude/Rob O'Connor

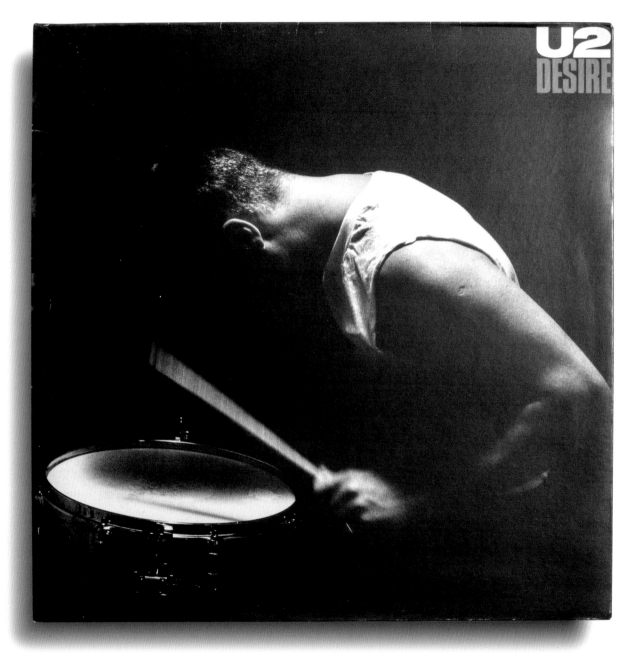

Artist. **U2**
Title. **Desire**
Label. Island Records - 12 ISG 400
Country. England
Year. 1988
Photo. Anton Corbijn
Design. DZN/The Design Group

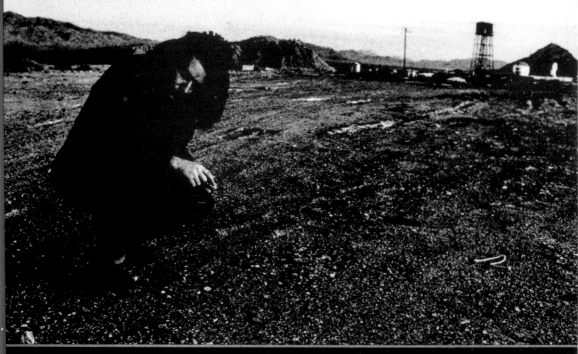

Artist. **U2**
Title. **In God's Country**
Label. Island Records - IS 1167
Country. Canada
Year. 1987
Photo. Anton Corbijn
Design. Steve Averill

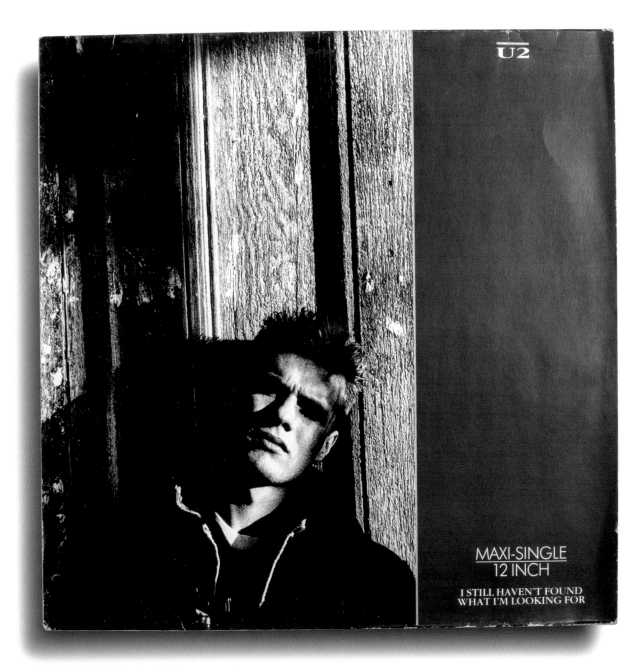

Artist. **U2**
Title. **I Still Haven't Found What I'm Looking For**
Label. Island Records - 609 152
Country. England
Year. 1987
Photo. Anton Corbijn
Design. Steve Averill

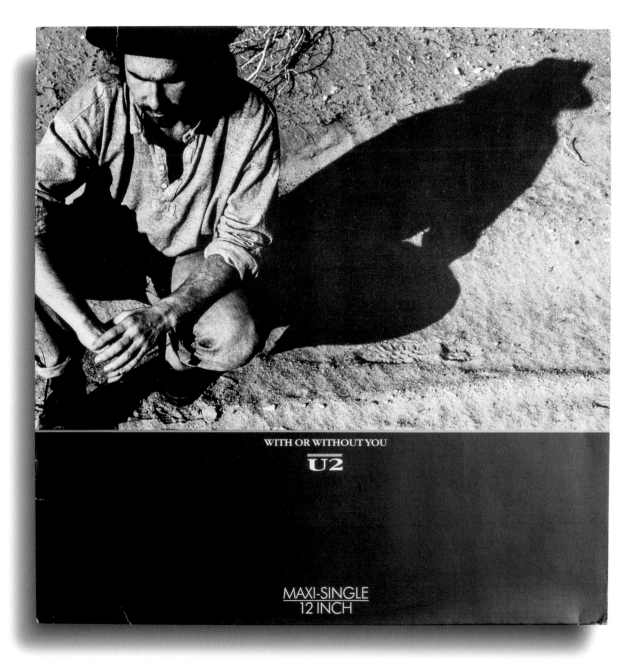

Artist. **U2**
Title. **With or Without You**
Label. Island Records - 608 922
Country. Europe
Year. 1987
Photo. Anton Corbijn
Design. Steve Averill

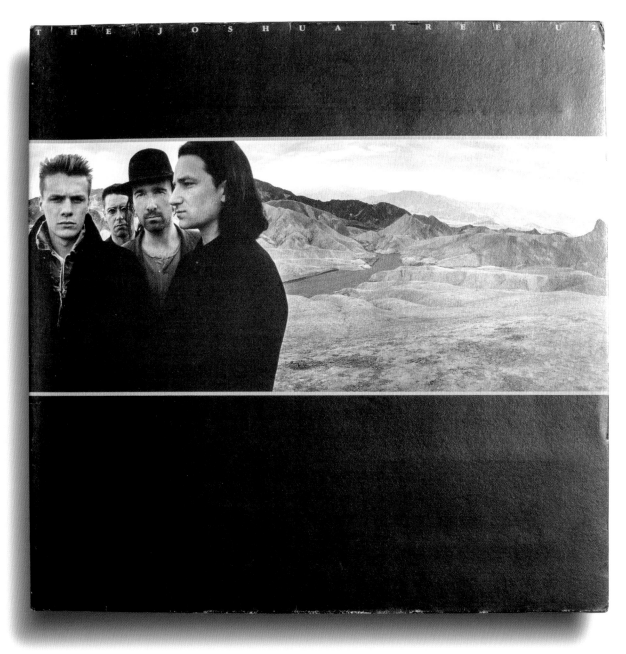

Artist. **U2**
Title. **The Joshua Tree**
Label. Island Records - U26
Country. England
Year. 1987
Photo. Anton Corbijn
Design. Steve Averill

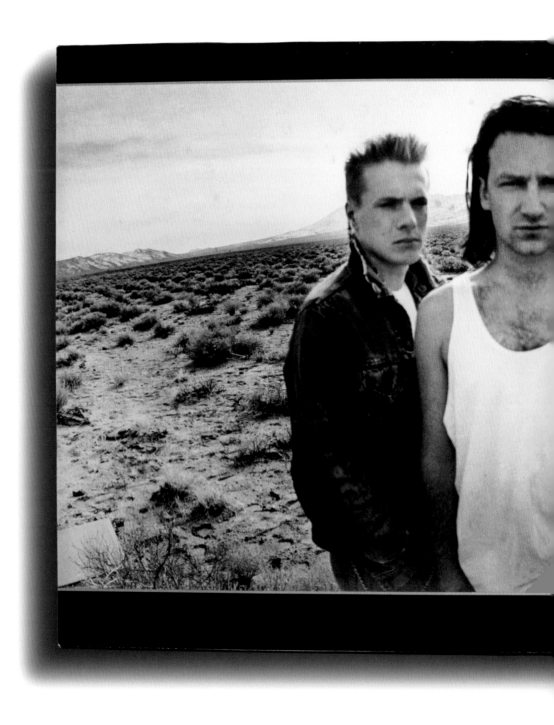

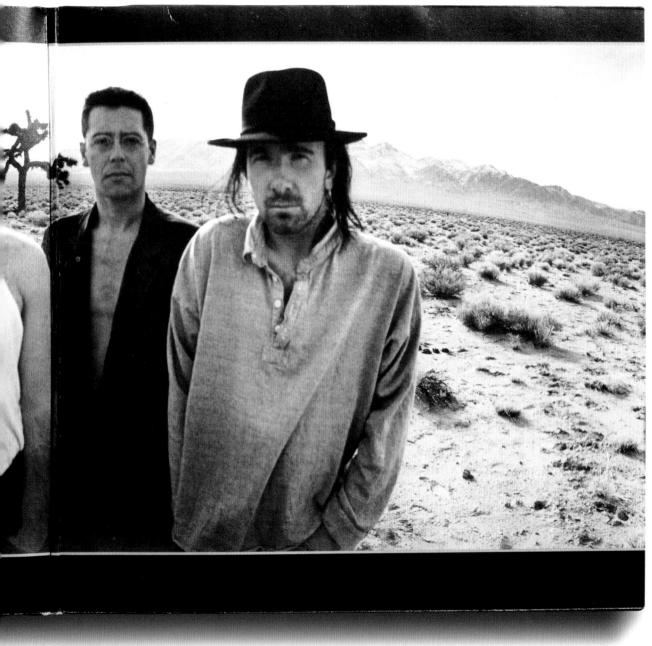

Artist. **U2**
Title. **The Joshua Tree**
Label. Island Records - U26
Country. England
Year. 1987
Photo. Anton Corbijn
Design. Steve Averill

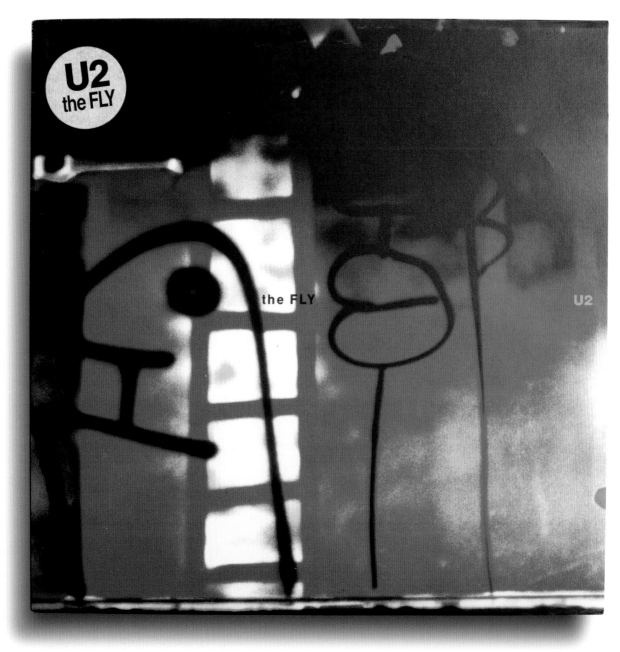

Artist. **U2**
Title. **The Fly**
Label. Island Records - IS 500
Country. England
Year. 1991
Photo. Anton Corbijn
Design. Works Associates

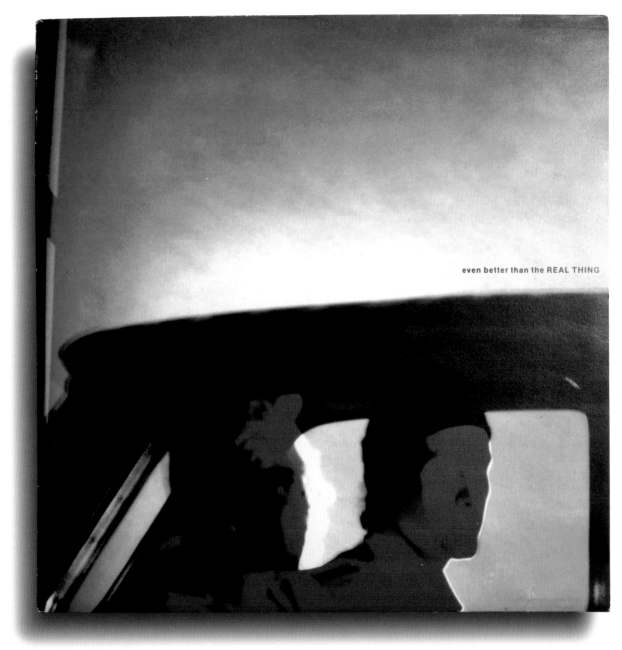

even better than the REAL THING

Artist. **U2**
Title. **Even Better Than the Real Thing**
Label. Island Records - IS 525
Country. England
Year. 1992
Photo. Anton Corbijn
Design. Works Associates

# Maker of Stars: Jean-Baptiste Mondino

Jean-Baptiste Mondino does not consider himself a photographer, but a creator of images. The Aubervilliers native likes to say that he came to photography by accident, or nearly so. It was neither a calling nor a revelation. He has an eye for it. His career, on the other hand, is undeniably intertwined with music: the sounds of Elvis thrilled him as a child; then he grew up in the LP era, coming of age in the eye of the world. The self-taught Hasselblad fan had an unprejudiced, receptive eye that allowed him to develop a unique, multifaceted aesthetic. Postwar religious iconography was a source of inspiration and ideas; it left visible traces in his portraits, but also in the penchant for transgression manifest in some of his work. In the past thirty years or so, Mondino has collaborated on a long list of albums, from *Play Blessures* and many others by Alain Bashung to Björk's *Debut*. Recently, he worked with the multifaceted Sébastien Tellier; Rocé, a socially committed rapper; and SebastiAn, from the trendy label Ed Banger. Mondino makes unlimited use of his palette, from photo-collages to close-up portraits, from flamboyant colors to black-and-white chiaroscuro, to capture the spirit of the times. Yet, despite real formal differences over the years, he has left his mark as an art director and creator of images. Is he an artist, an artisan, or an analyst? Mondino is all three things at once, and looking at his work puts these technical changes and shifting standards into perspective. Mondino's 6-by-6 pictures left their stamp on the 1970s and his music videos marked the following decade. Then the 16:9 format's forerunner became the standard for smartphones. "But the square is still in music," he says. "It's just smaller on the net." Mondino takes a humorous, distant view of his work. "I've always put myself at the service of the subject," he says. "I want it to have center stage." That is undoubtedly why he stays in the background, leaving the limelight to those he photographs in his own special way.

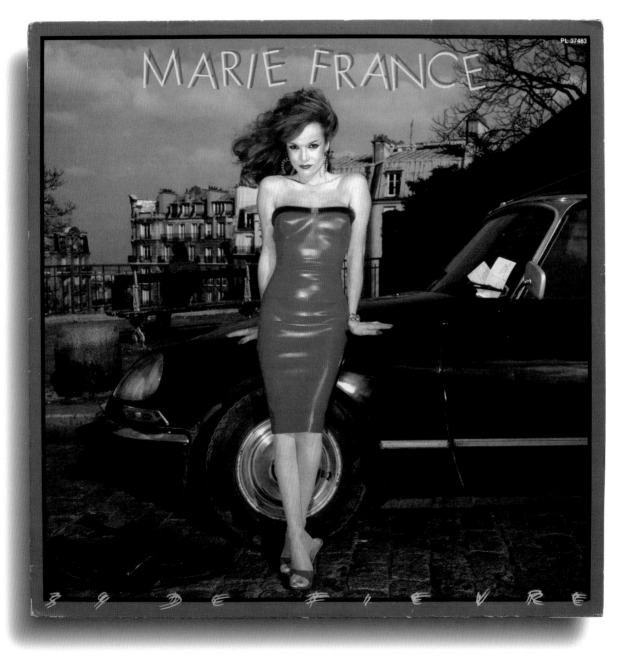

Artist. **Marie France**
Title. **39 De Fièvre**
Label. RCA - PL 37483
Country. France
Year. 1981
Photo. Jean-Baptiste Mondino
Design. Unknown

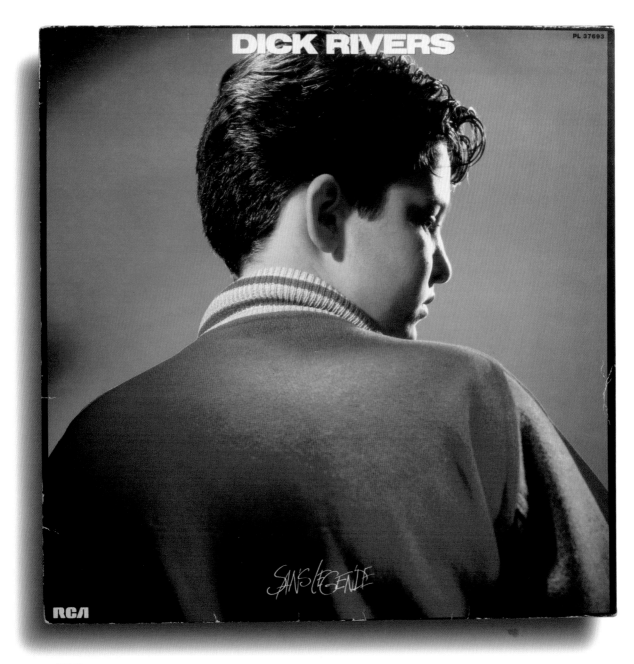

Artist. **Dick Rivers**
Title. **Sans Légende**
Label. RCA - PL 37693
Country. France
Year. 1982
Photo. Jean-Baptiste Mondino
Design. Unknown

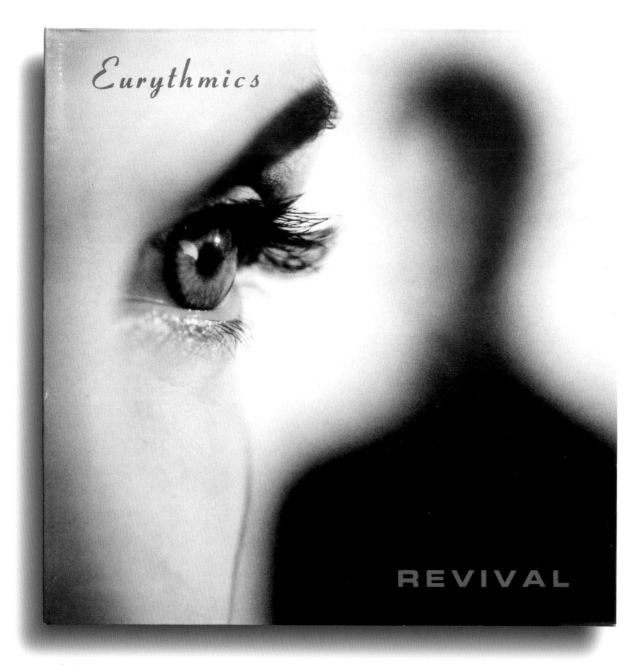

Artist. **Eurythmics**
Title. **Revival**
Label. RCA - DAT 17
Country. England
Year. 1989
Photo. Jean-Baptiste Mondino
Design. Laurence & Annie

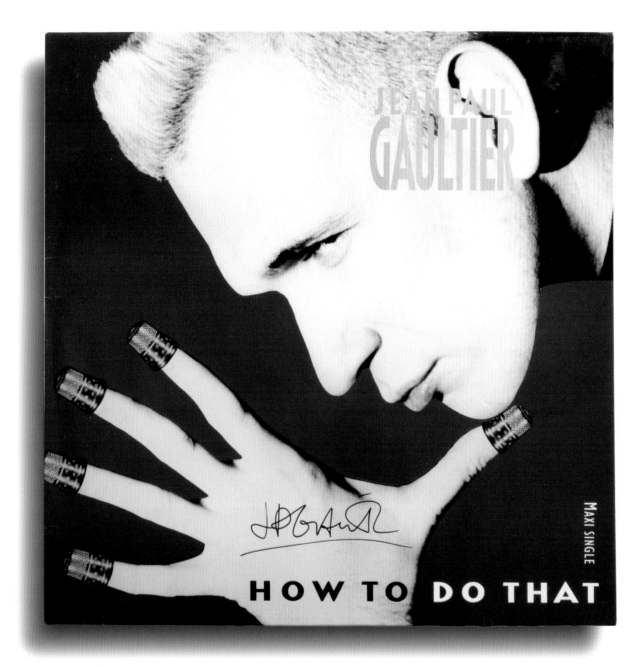

Artist. **Jean-Paul Gaultier**
Title. **How to Do That**
Label. Fontana - 872 423-1
Country. France
Year. 1988
Photo. Ken Nahoum/Jean-Baptiste Mondino
Design. Thierry Perez

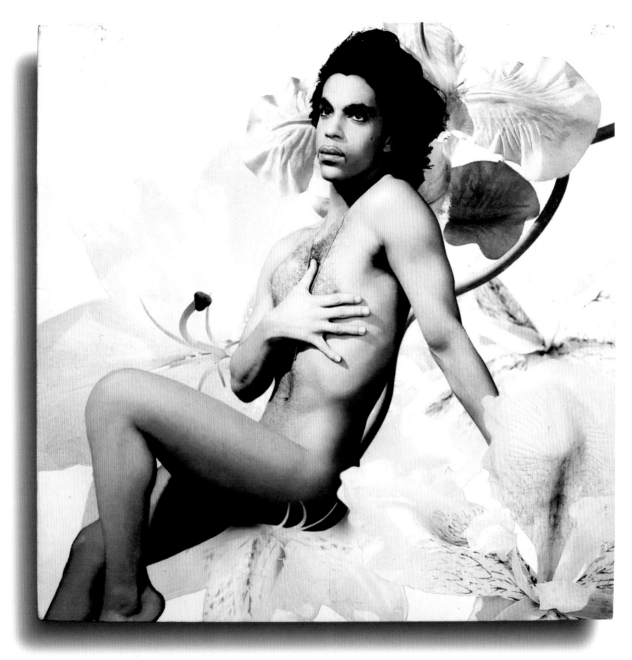

Artist. **Prince**
Title. **Lovesexy**
Label. Paisley Park - 9 25720-1
Country. USA
Year. 1988
Photo. Jean-Baptiste Mondino
Design. Laura LiPuma

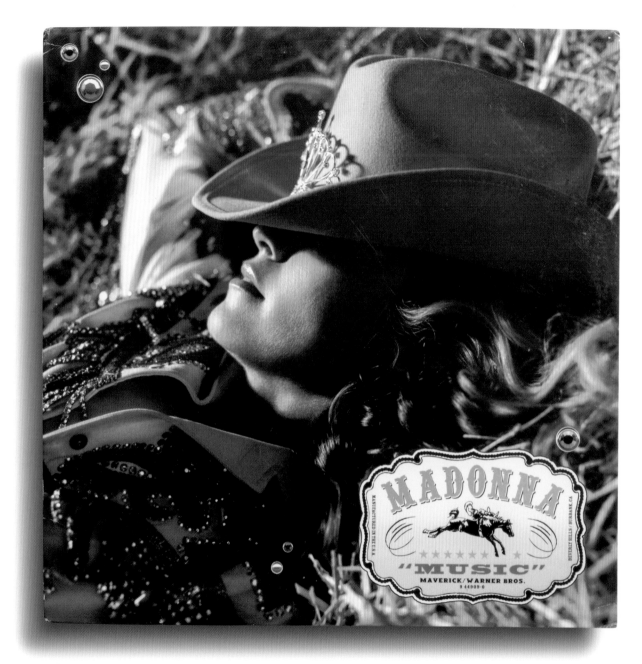

Artist. **Madonna**
Title. **Music**
Label. Maverick/Warner Bros. - 9 44909-0
Country. USA
Year. 2000
Photo. Jean-Baptiste Mondino
Design. Kevin Reagan

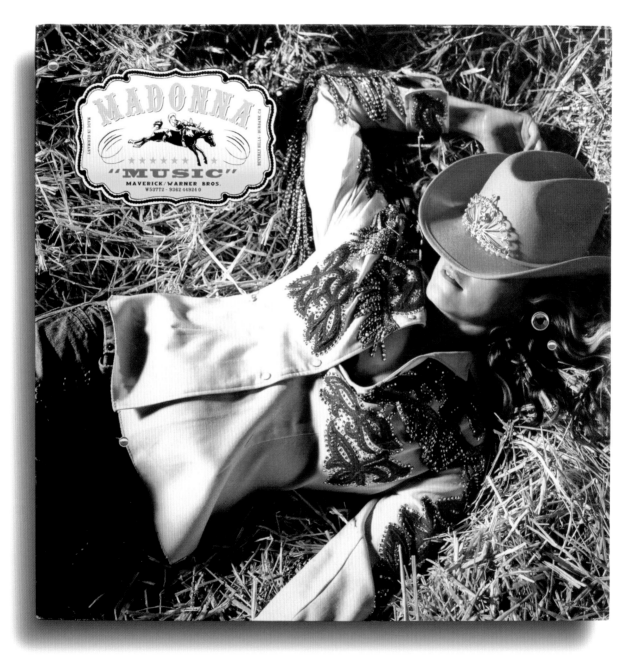

Artist. **Madonna**
Title. **Music**
Label. Maverick/Warner Bros. - W537T2 9362 44924 0
Country. Germany
Year. 2000
Photo. Jean-Baptiste Mondino
Design. Kevin Reagan

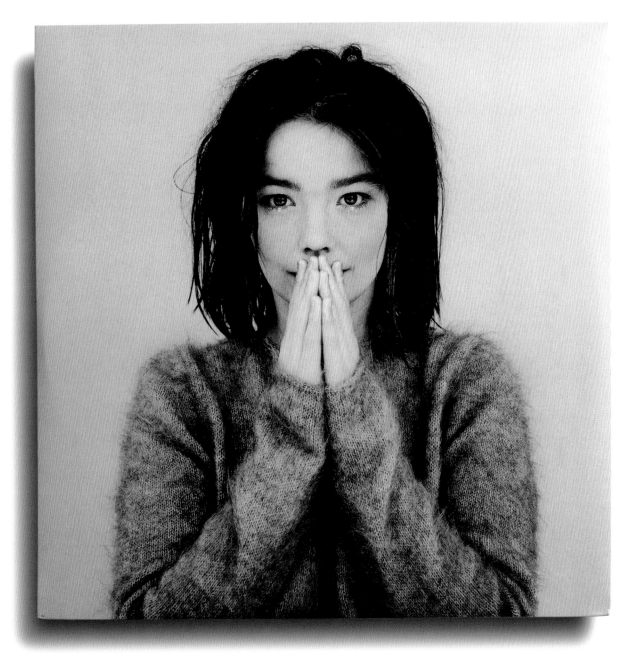

Artist. **Björk**
Title. **Debut**
Label. One Little Indian - TPLP31
Country. England
Year. 1993
Photo. Jean-Baptiste Mondino
Design. Me Company

# Iconoclast: Andy Warhol

Before becoming the prophet of pop, Andy Warhol was a graphic artist who made his living designing album sleeves. In the mid-1950s, he did a superb portrait of Count Basie, a record cover all in letters for Thelonious Monk, and a drawing of Johnny Griffin for Blue Note. Even after the New York jack-of-all-trades became famous, his artwork continued to appear on LP covers in a wide range of genres. Some, like the album sleeves featuring the Velvet Underground's banana and the Rolling Stones' zipper, have become classics.

A few years later, Warhol colored a black-and-white portrait of Mick Jagger for the front and back covers of *Love You Live*, a live Rolling Stones double LP. The record's story can be told through ephemera, including a poster, singles, and preparatory photos, which together weave the story of its creation, one not without drama: Warhol flew into a rage when Jagger made some additions to his artwork in pencil. The album led to an unofficial replica boxed set released in 2013 of live recordings from the late 1970s called *El Mocambo 1977+*; seven hundred copies were printed, with an alternative cover by Warhol.

This is not Warhol's only silk-screened photograph: John Lennon, Aretha Franklin, Diana Ross, and Paul Anka received the same treatment. These portraits have become collector's items, the works of an artist who found in this popular medium a way to make his mark and blaze his trail between calligraphy and silk-screening, drawing and photography.

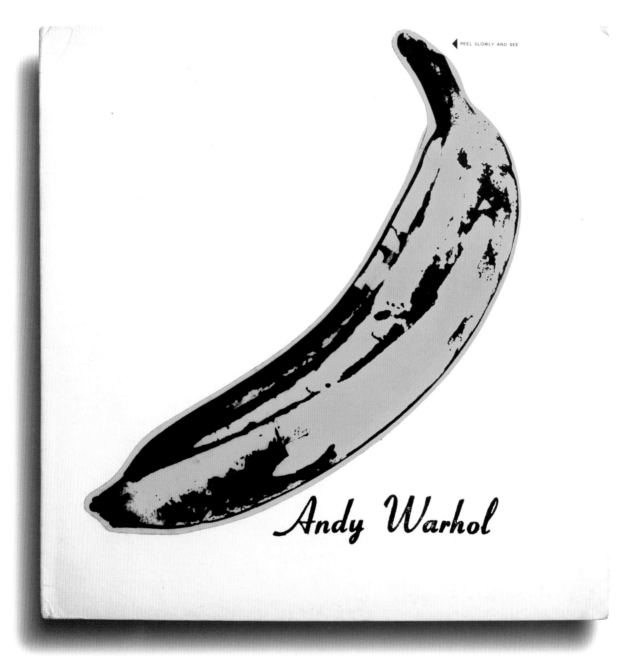

PEEL SLOWLY AND SEE

*Andy Warhol*

Artist. **The Velvet Underground & Nico**
Title. **The Velvet Underground & Nico**
Label. Verve Records - V6-5008
Country. USA
Year. 1967
Photo. Andy Warhol
Design. Andy Warhol

PRODUZIONE E REALIZZAZIONE: GIANCARLO LUCARIELLO ARRANGIAMENTI E DIREZIONE: MAURIZIO FABRIZIO

LATO A
A CHE SERVE LA NOTTE
DEI
CONCERTO
LETTERE
ANGELI CADUTI

LATO B
IO, TE TUTTI GLI AMICI
NON SIAMO SOLI
IN CAPO AL MONDO
VOGLIA MATTA
GENTE COME NOI

Musiche: Maurizio Fabrizio
Testi: Guido Morra

Edizioni: Parking
Tecnico del Suono per Registrazioni: Franco Finetti
Studio di Registrazione: Studio Quattro Uno di Roma
Tecnico del Suono per Missaggi: Samuele Barachetti
Studio di Missaggio: Idea Mix Milano

Transfert: Marco Inzadi
Studio Transfert: Idea Transfert—Milano
Hanno Suonato:
Maurizio Fabrizio: Pianoforte e Tastiere
Luigi Cappellotto: Basso
Andy Surdi: Batteria e Percussioni
Roberto Puleo: Chitarre
Massimo di Vecchio: Tastiere

Grafica: Andy Warhol © 1983
Busta Interna: Luciano Tallarini
Direzione Tipografica: John Berg
Management: Maurizio Salvadori—
Trident Agency—Milano

© 1983 CBS Inc / ℗ 1983 CBS Inc
CBS & ● are registered trademarks of CBS Inc
CBS Dischi S.p.A., Milano 1983

CBS
CBS 25450

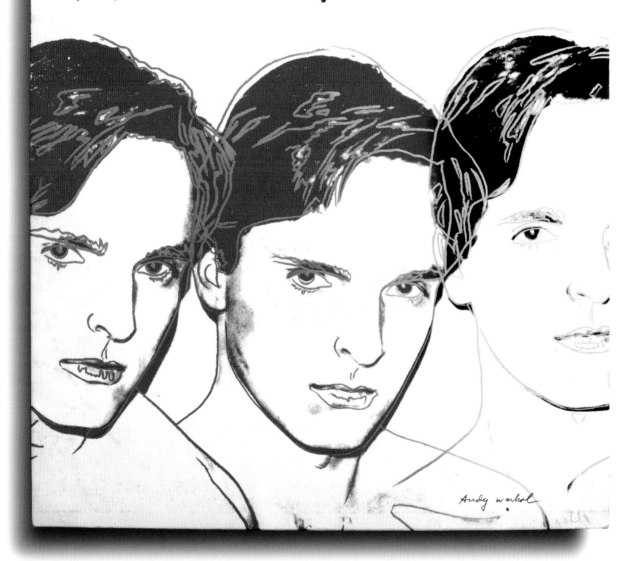

Artist. **Miguel Bosé**
Title. **Milano - Madrid**
Label. CBS - 25450
Country. Italy
Year. 1983
Photo. Andy Warhol
Design. Andy Warhol

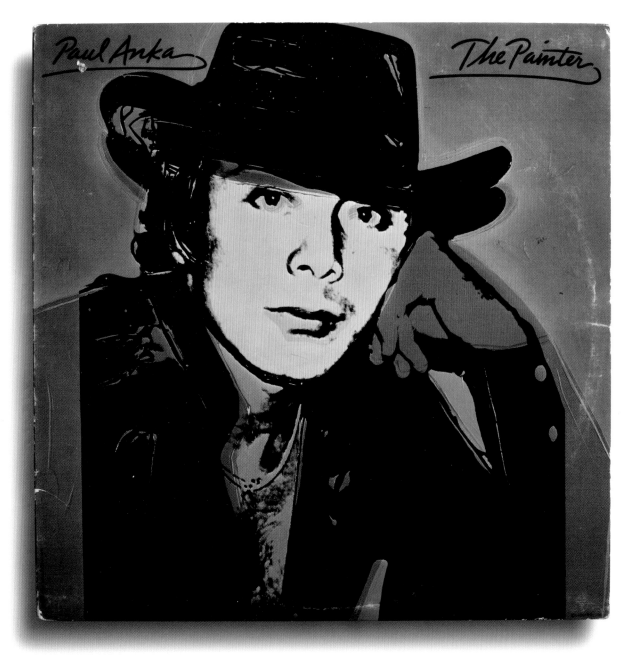

Artist. **Paul Anka**
Title. **The Painter**
Label. United Artists Records - UA-LA653-G
Country. USA
Year. 1976
Photo. Andy Warhol
Design. Andy Warhol

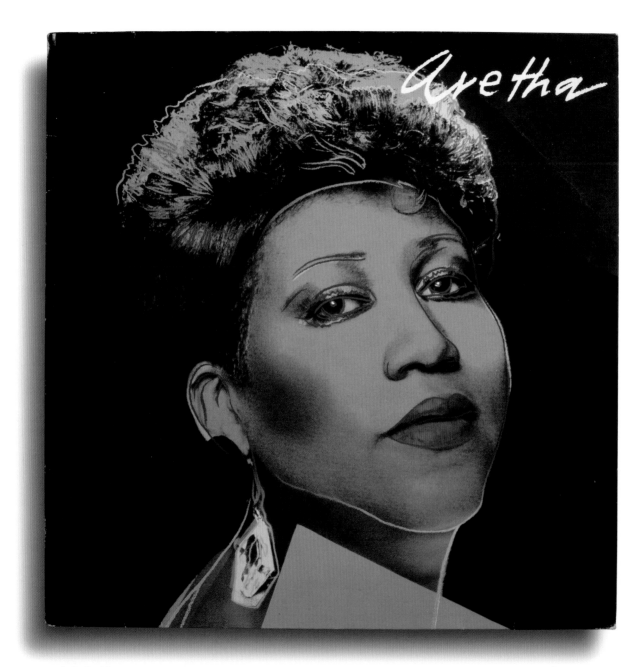

Artist. **Aretha Franklin**
Title. **Aretha**
Label. Arista - AL-8442
Country. USA
Year. 1986
Photo. Andy Warhol
Design. Maude Gilman

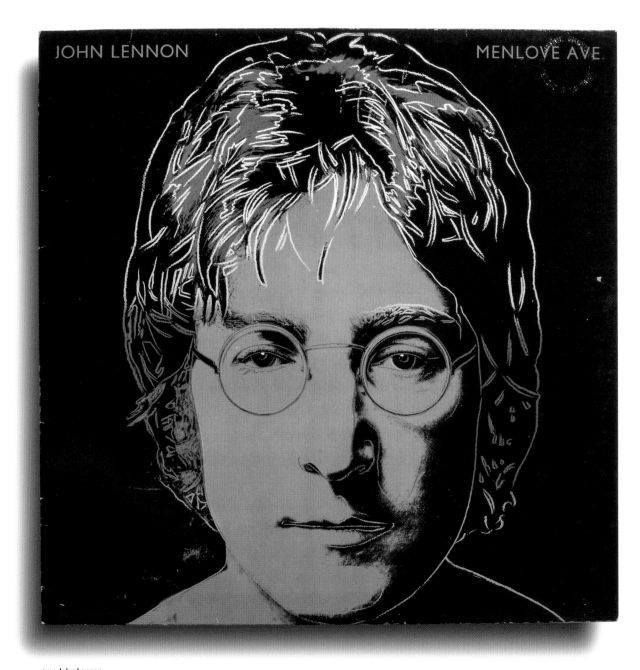

Artist. **John Lennon**
Title. **Menlove Ave.**
Label. Capitol Records - SJ-12533
Country. USA
Year. 1986
Photo. Andy Warhol
Design. Mark Shoolery/Roy Kohara

Artist. **Diana Ross**
Title. **Muscles**
Label. RCA - PB-13348
Country. USA
Year. 1982
Photo. Andy Warhol
Design. Andy Warhol

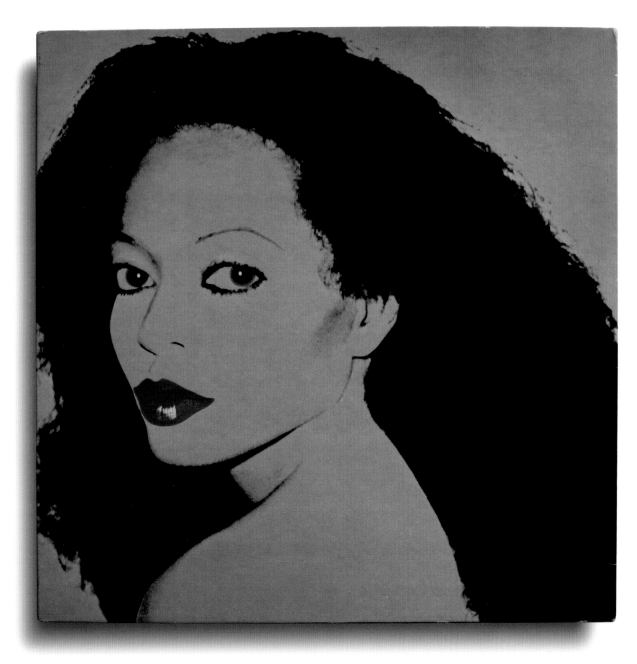

Artist. **Diana Ross**
Title. **Silk Electric**
Label. RCA - AFL1-4384
Country. USA
Year. 1982
Photo. Andy Warhol
Design. Andy Warhol

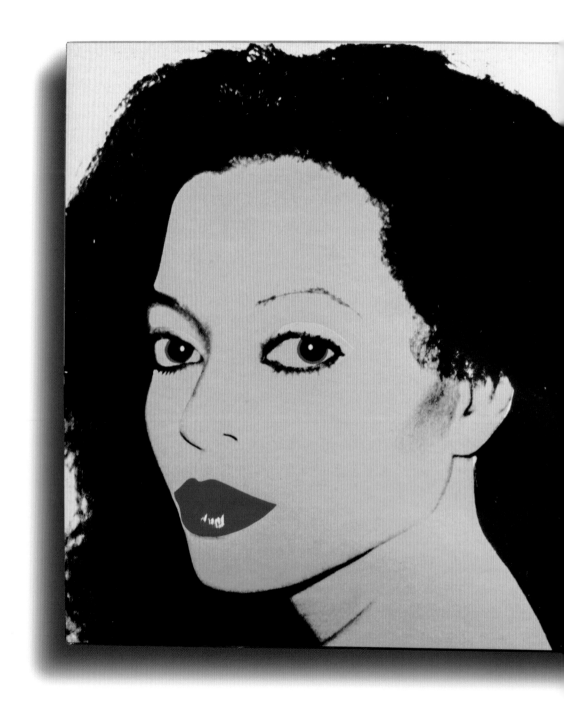

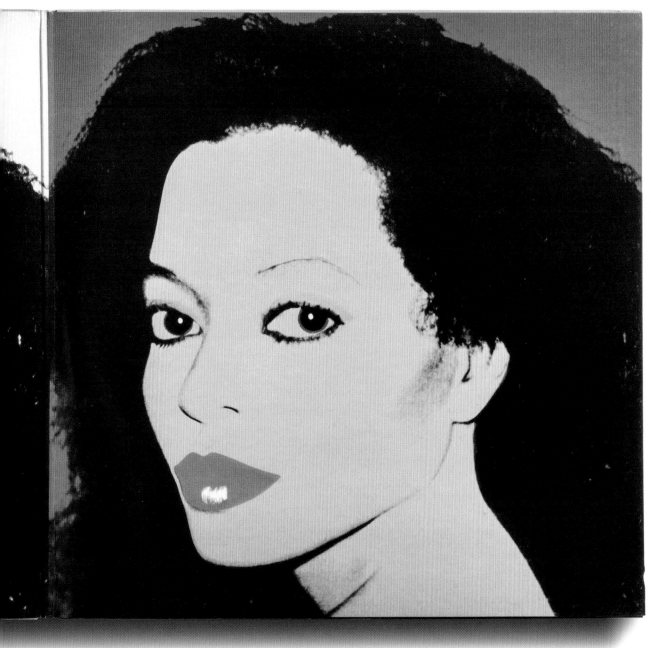

Artist. **Diana Ross**
Title. **Silk Electric**
Label. RCA - AFL1-4384
Country. USA
Year. 1982
Photo. Andy Warhol
Design. Andy Warhol

Side 1
Intro
Honky tonk Women
If you can't rock me
Get off of my cloud
Happy
Hot stuff
Star Star

Side 2
Tumbling dice
Fingerprint file
You gotta move

You can't always
get what you
want

Side 3
(El Mocambo Side)
Mannish boy
Crackin' up
Little red rooster
Around and around

Side
It's o
Brown
Jump
Symp

Musicians: Mick Jagger, vocals, occ. guitar, harmonica. Keith Richard - guitar, Vocal
Ron Wood- guitar and vocals and bass. Charlie Watts. Drums. Bill Wyman, Bass a
Billy Preston, Keyboards and vocals. Ian Stott Stewart, Piano. Ollie Brown, per

Recording Engineers: Keith Harwood - Eddie Kramer - Ron Neviison. Remix Engineers: Chris Jordan,
Eddie Kramer. Assistant Engineers: Mick Hc. Kenna, Tom Heid, Randy Mason, Barry Warner,
Team Tapani. Mastering: Lee Hulko at Sterling Sound.        Artwork: Andy Warhol.
PRODUCED BY THE GLIMMER TWINS / Recorded in Paris and Toronto. 1976-1977. Billy Preston court. A and M. Leik

WE WOULD LIKE TO DEDICATE THIS RECORD TO THE MEMORY OF KEITH HARWOOD "THOSE WHO
LOVE GROW YOUNG."

Excerpt from Fanfare For The Common Man by Aaron Copland, courtesy of Columbia Records.

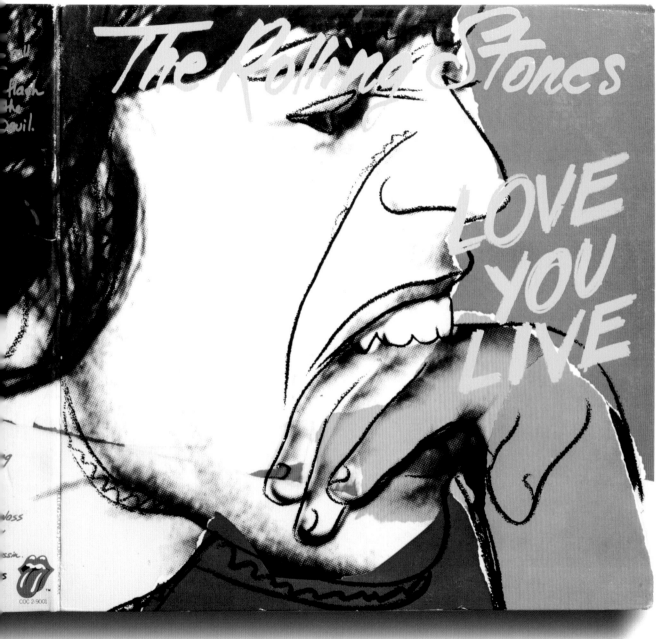

Artist. **The Rolling Stones**
Title. **Love You Live**
Label. Rolling Stones Records - COC 2-9001
Country. USA
Year. 1977
Photo. Andy Warhol
Design. Andy Warhol

Artist. **The Rolling Stones**
Title. **Love You Live**
Label. Rolling Stones Records - COC 2-9001
Country. USA
Year. 1977
Photo. Andy Warhol
Design. Andy Warhol

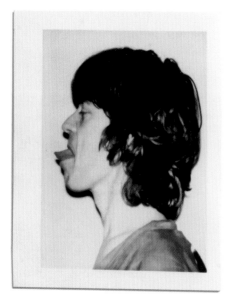
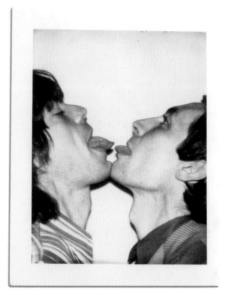

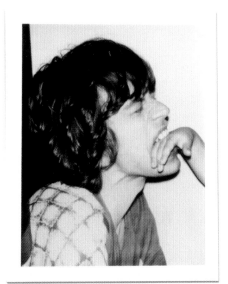

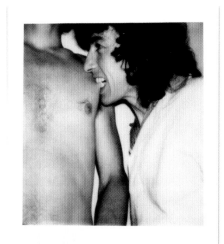
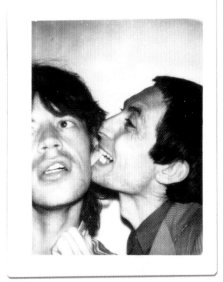

Photo. Original photography by Andy Warhol taken for
the album cover *Love You Live* by the Rolling Stones, 1977.

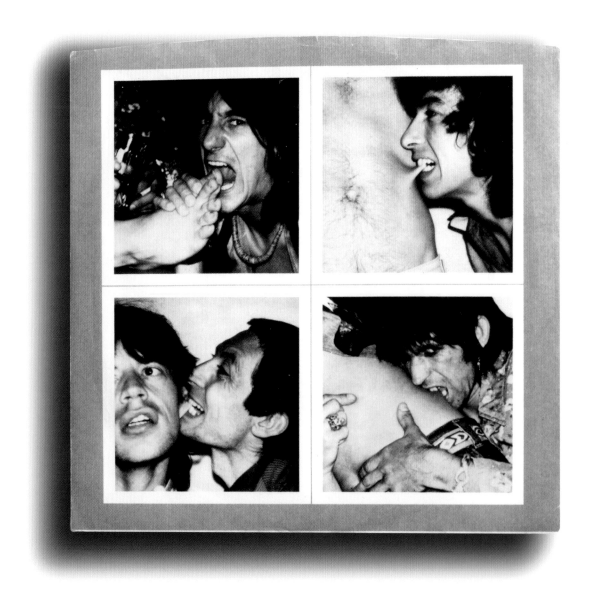

Artist. **The Rolling Stones**
Title. **The Rolling Stones**
Label. Rolling Stones Records - EP 287
Country. USA
Year. 1977
Photo. Andy Warhol
Design. Andy Warhol

Artist. **John Cale**
Title. **The Academy in Peril**
Label. Reprise Records - MS 2079
Country. USA
Year. 1972
Photo. Ed Thrasher
Design. Andy Warhol

# Building an Icon: David Bailey

David Bailey is far from the
only photographer to have
shot the Rolling Stones, but
he documented the British
band from its inception and for
nearly a decade. He started
illustrating most of their albums,
in black and white and soft
colors, in 1964. The pictures
were figurative until the more
off-the-wall cover for *"Get Yer
Ya-Ya's Out!": The Rolling Stones
in Concert*, which attested to the
Stones' evolution from the bad
boys of rock to tuned-in, spaced-
out, psychedelic nice guys. His
images echo musical choices
in tune with the changing times
while participating in the myth
he co-built with the artists. A
similarly ambiguous partnership
developed between Mick Rock
and David Bowie. The British
photographer's portraits of
Ziggy Stardust, as well as Iggy
Pop, Lou Reed, the Ramones,
and Queen, fixed the image
of glam rock for all time. But
the same question remains: do
photographers merely record
music trends or help shape
them?

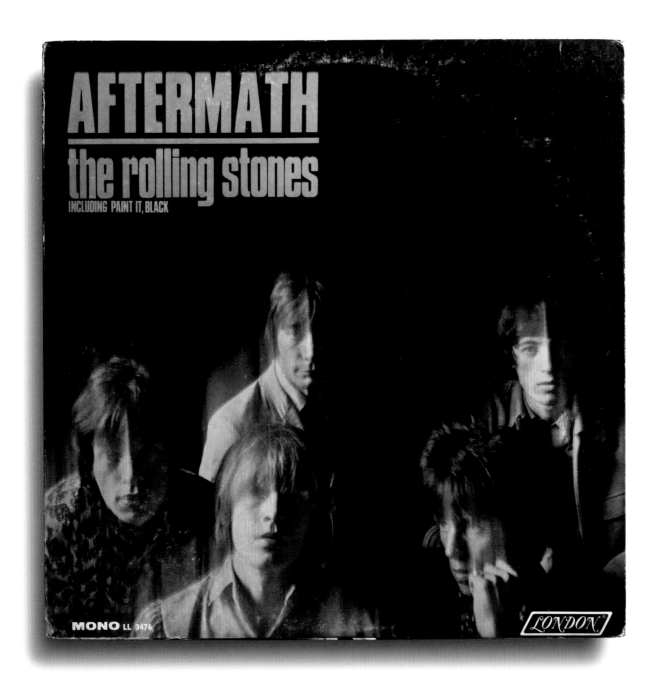

Artist. **The Rolling Stones**
Title. **Aftermath**
Label. London Records - LL 3476
Country. USA
Year. 1966
Photo. David Bailey
Design. Stephen Inglis

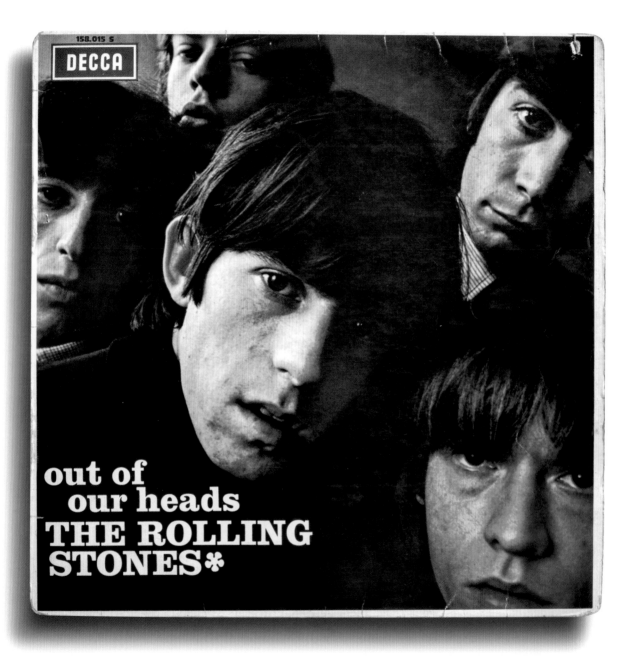

out of
    our heads
THE ROLLING
STONES*

Artist. **The Rolling Stones**
Title. **Out of Our Heads**
Label. Decca - 158.015 S
Country. France
Year. 1966
Photo. David Bailey
Design. Unknown

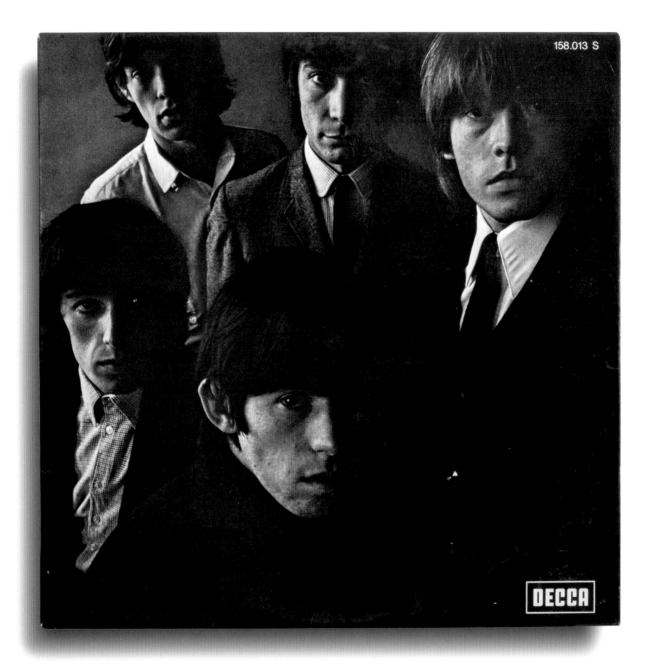

158.013 S

DECCA

Artist. **The Rolling Stones**
Title. **No. 3**
Label. Decca - 158.013
Country. France
Year. 1965
Photo. David Bailey
Design. Unknown

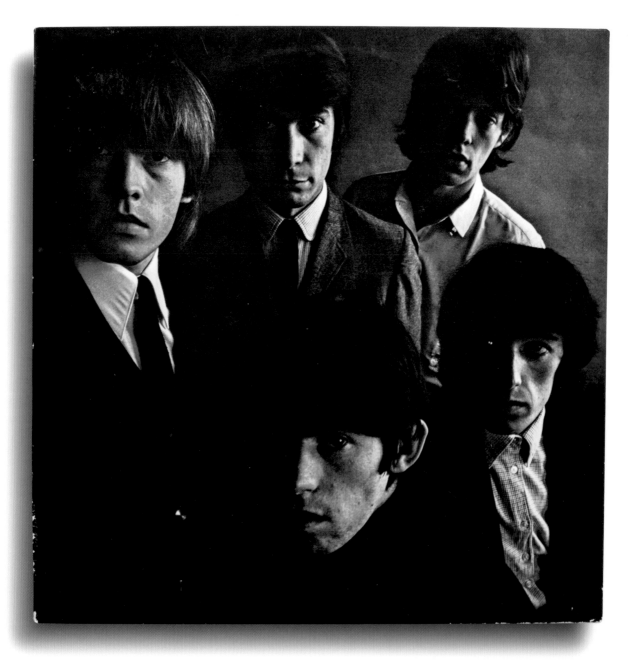

Artist. **The Rolling Stones**
Title. **No. 2**
Label. Decca - 219 005
Country. France
Year. 1965
Photo. David Bailey
Design. Unknown

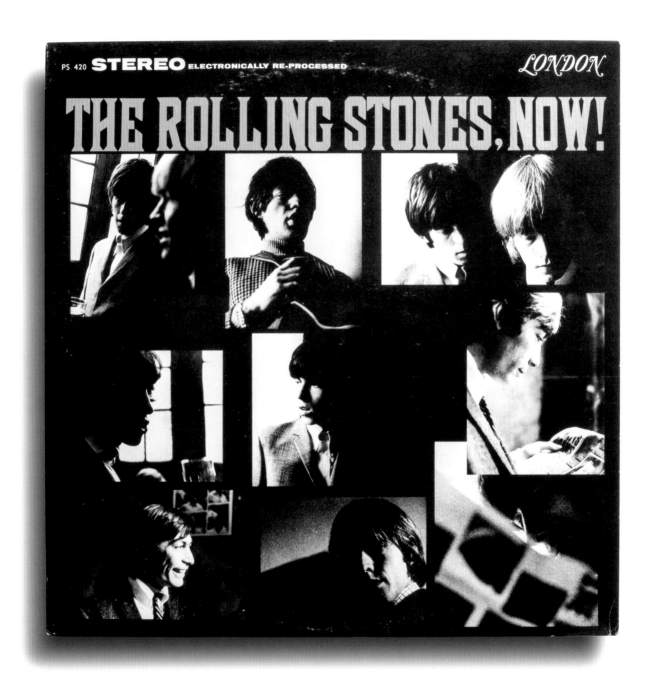

Artist. **The Rolling Stones**
Title. **The Rolling Stones, Now!**
Label. London Records - PS 420
Country. USA
Year. 1965
Photo. David Bailey
Design. Unknown

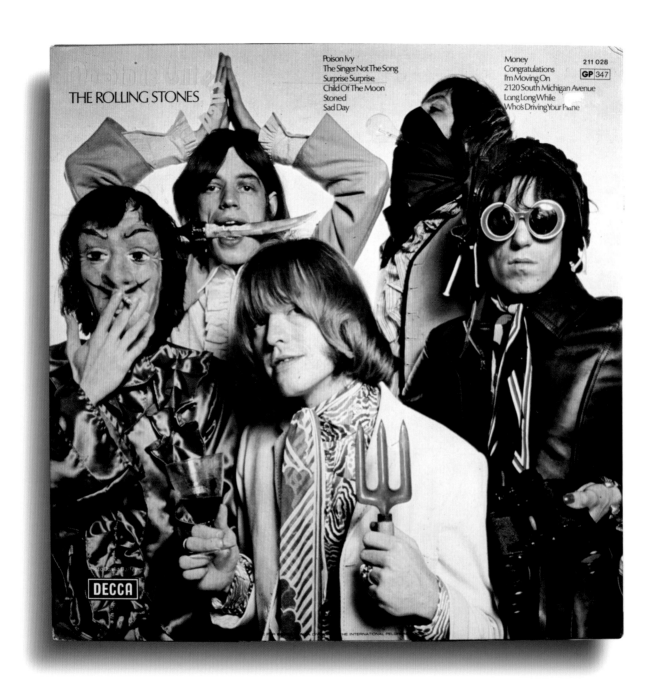

THE ROLLING STONES

Poison Ivy
The Singer Not The Song
Surprise Surprise
Child Of The Moon
Stoned
Sad Day

Money
Congratulations
I'm Moving On
2120 South Michigan Avenue
Long Long While
Who's Driving Your Plane

211 028
GP 347

DECCA

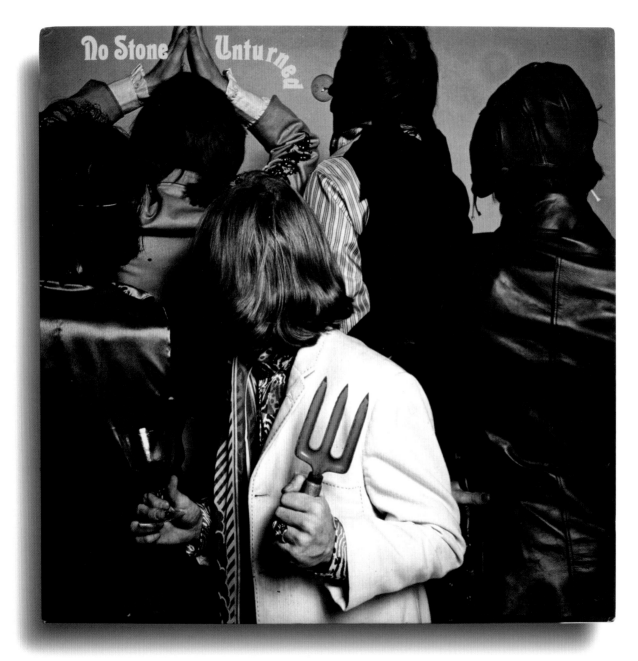

Artist. **The Rolling Stones**
Title. **No Stone Unturned**
Label. Decca - 211 028
Country. France
Year. 1973
Photo. David Bailey
Design. Unknown

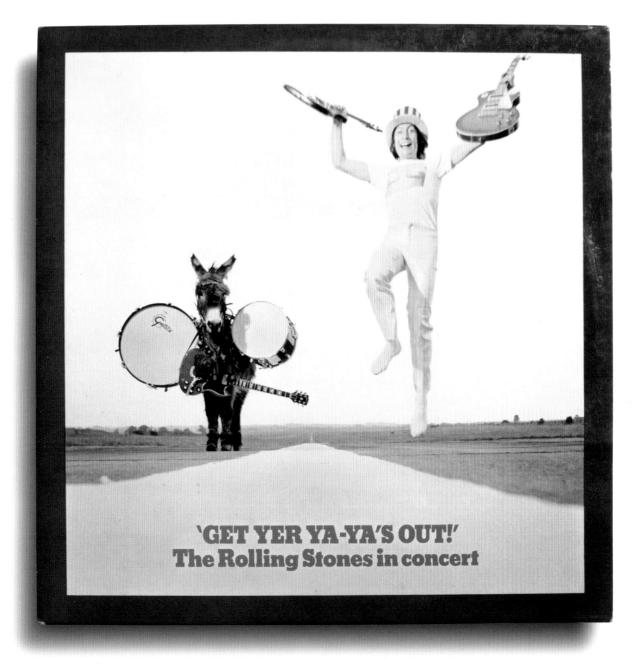

Artist. **The Rolling Stones**
Title. **"Get Yer Ya-Ya's Out!": The Rolling Stones in Concert**
Label. Decca - SKL 5065
Country. England
Year. 1970
Photo. David Bailey
Design. John Kosh/Steve Thomas Associates

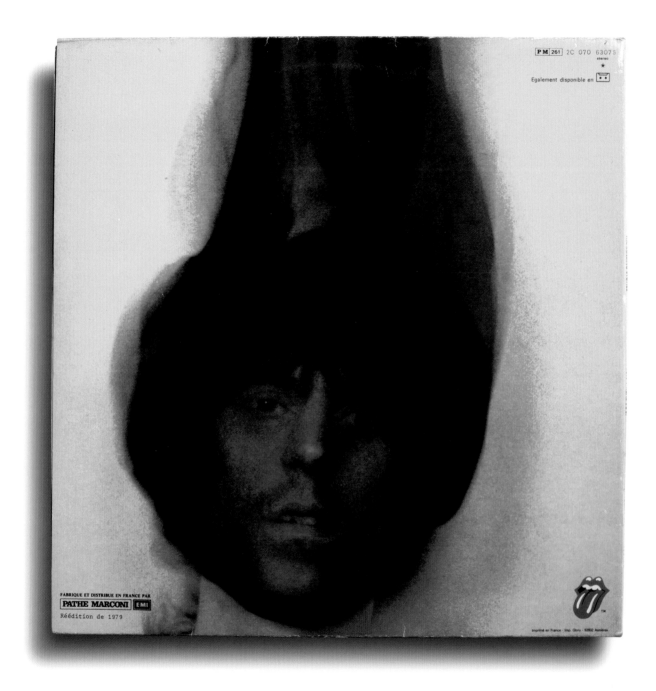

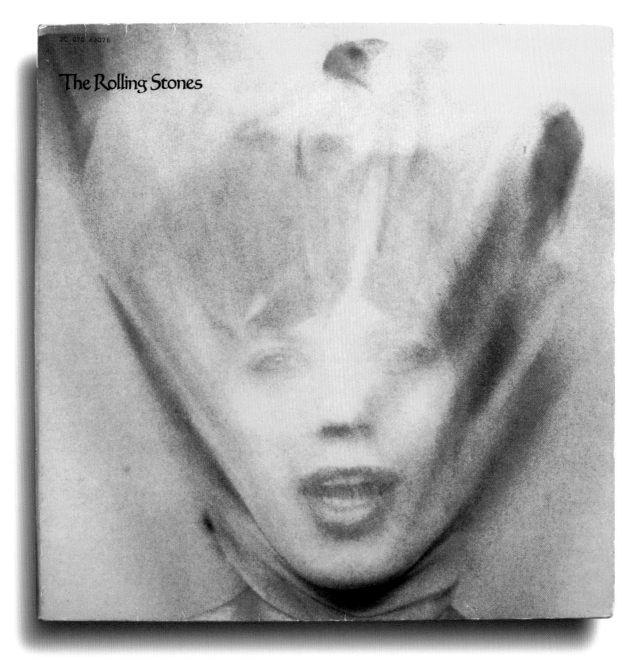

Artist. **The Rolling Stones**
Title. **Goats Head Soup**
Label. Rolling Stones Records - 2C 070 63076
Country. USA
Year. 1979
Photo. David Bailey
Design. Ray Lawrence

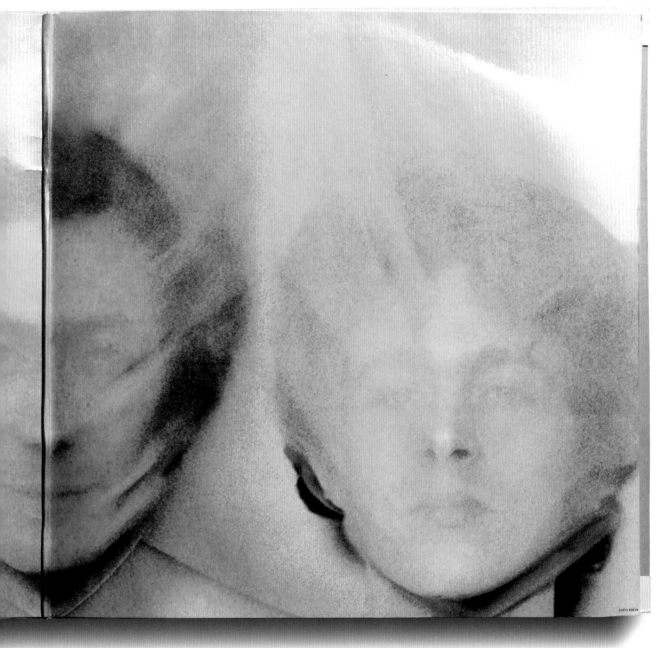

Artist. **The Rolling Stones**
Title. **Goats Head Soup**
Label. Rolling Stones Records - 2C 070 63076
Country. USA
Year. 1979
Photo. David Bailey
Design. Ray Lawrence

# In Life, in Death: Lucien Clergue

Manitas was on guitar, Pablo held the brush, Dominguín was with the bull . . . and Lucien Clergue had the Minolta. The photographer had met Manitas de Plata, from Séte, Saintes-Maries-de-la-Mer, in 1955 while he was making a record documenting Gypsy music. "The music completely won me over in a few minutes," Clergue said near the end of his life. "From then on, I saw Manitas regularly during the Saintes pilgrimage."

Clergue, the future founder of the Rencontres Internationales de la Photographie d'Arles [International Encounters of Photography], and Manitas, born Ricardo Baliardo but nicknamed "Little Hands of Silver," became friends. It marked the beginning of a long collaboration on many LPs, starting with *Juerga!*, a legendary album that featured different pictures on its covers, all signed by Clergue. Clergue then introduced Manitas to the head of Connoisseur Society, the label that issued a three-record set in 1965 called Flamenco Guitar. The guitarist, who had been born in a trailer, went on to a career in the United States, played Carnegie Hall, rose to international stardom, and sold over ninety million albums.

Their long relationship reveals a lesser-known aspect of Clergue's career: While the LP experience might seem surprising at first, it is not. The photographer also captured moments with Picasso, Brigitte Bardot, and a Gypsy dancer's energy, tightening the frame to make the shot more powerful. Clergue and Manitas were close until their deaths: Clergue died on November 15, 2014, ten days after his friend Manitas.

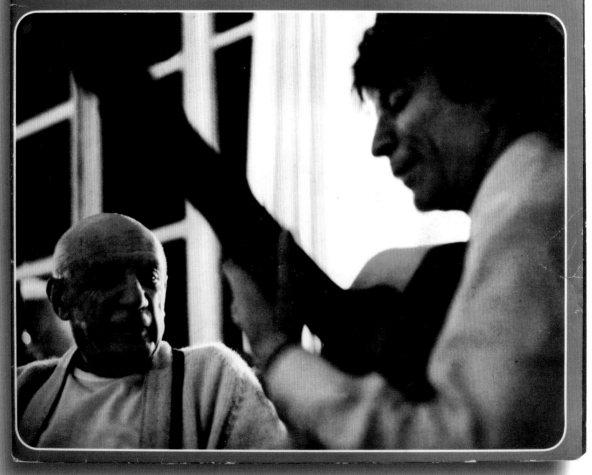

**MANITAS DE PLATA**
MUSIQUE ORIGINALE DU FILM DE LUCIEN CLERGUE
**PICASSO,** guerre, amour et paix

Artist. **Manitas de Plata**
Title. **Picasso: Guerre, Amour et Paix**
Label. CBS - S 64742
Country. England
Year. 1972
Photo. Lucien Clergue © Atelier Lucien Clergue
Design. Unknown

With the generous authorization
of the Clergue family © Atelier Lucien Clergue
(for all photographs).

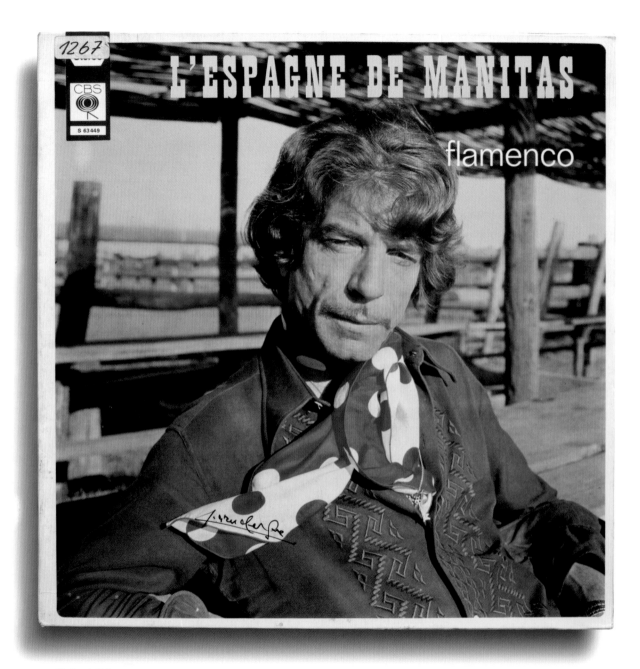

Artist. **Manitas de Plata**
Title. **L'Espagne de Manitas**
Label. CBS - S 63449
Country. France
Year. 1968
Photo. Lucien Clergue © Atelier Lucien Clergue
Design. Ariane Ségal

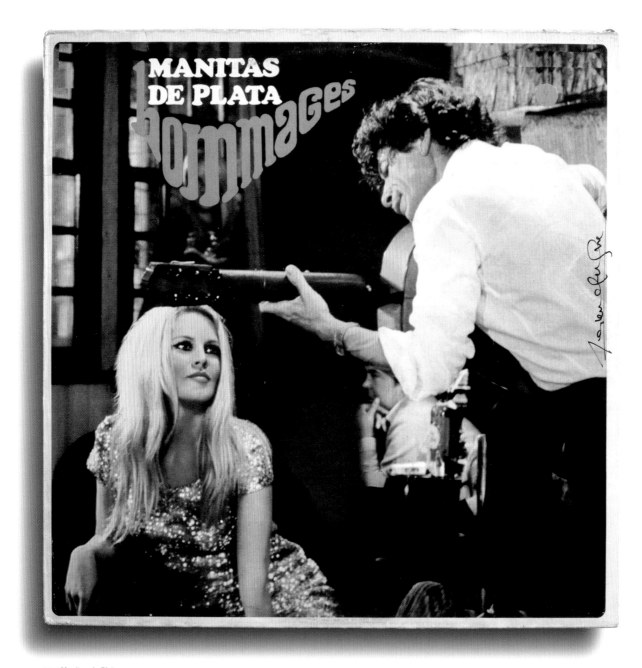

Artist. **Manitas de Plata**
Title. **Hommages**
Label. Embassy - EMB 31003
Country. England
Year. 1973
Photo. Lucien Clergue © Atelier Lucien Clergue
Design. Unknown

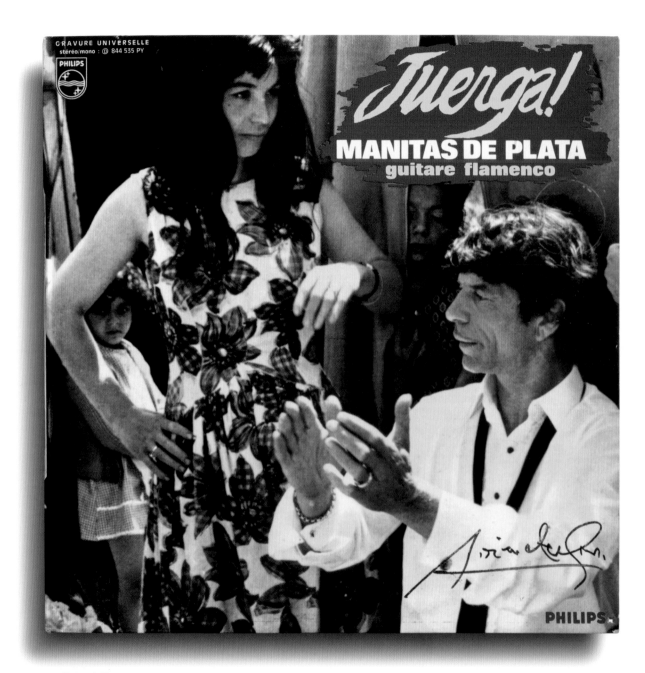

Artist. **Manitas de Plata**
Title. **Juerga!**
Label. Philips - 844 535 PY
Country. France
Year. 1963
Photo. Lucien Clergue © Atelier Lucien Clergue
Design. Unknown

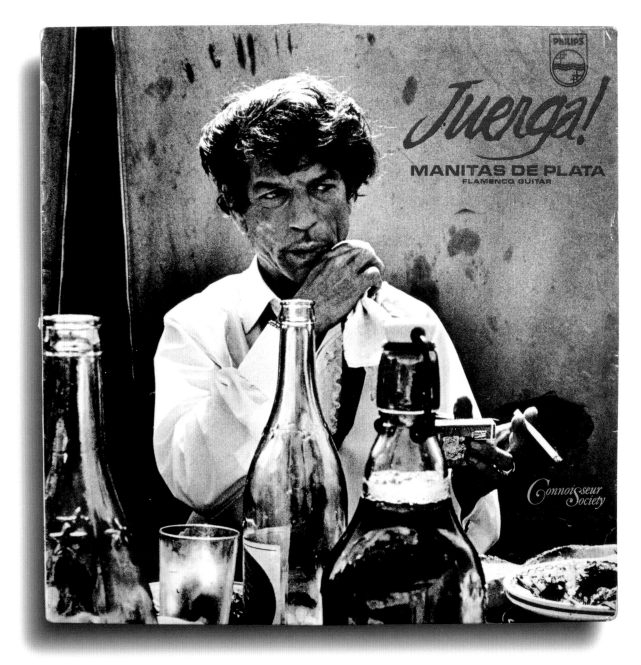

Artist. **Manitas de Plata**
Title. **Juerga!**
Label. Connoisseur Society - CS 2003
Country. USA
Year. 1967
Photo. Lucien Clergue © Atelier Lucien Clergue
Design. Unknown

# Hidden Side: Lee Friedlander

Jazz and recording technology both began at roughly the same time; they have gone hand-in-hand ever since. Many photographers have participated in this partnership. The great portraitist Carl Van Vechten photographed Bessie Smith and Billie Holiday with masks. In 1955, Roy DeCarava published *The Sweet Flypaper of Life*, which combined his pictures with Langston Hughes's poetry to tell the story of Harlem's inner life from a subjective viewpoint. Herman Leonard's shadows and nocturnal ambiances and William Claxton's black-and-white portraits abundantly illustrated magazines and record covers. In Europe, Jean-Pierre Leloir and Giuseppe Pino also stood out.

Lee Friedlander is emblematic because he became famous on both sides of the lens. For photo buffs and art dealers, he is a key figure in the history of photography. For jazz fans, his name is associated with the history of one of the greatest labels, Atlantic, where he launched his career with portraits of jazz men: John Coltrane for *My Favorite Things* and *Giant Steps*, Ray Charles for *What'd I Say*, and Charles Mingus for *Blues & Roots*, among others. He also worked for Capitol, Verve, and Columbia, which used his portrait of Miles Davis for the brilliant *In a Silent Way* in 1969. The image of the musician matches his music: feverishly serene, looking toward tomorrow. Stan Spiegel, a DJ and amateur photographer, introduced Friedlander to jazz and gave him his first camera. From jazz he retained the taste for improvisation, or rather, a sense for spur-of-the-moment compositions, which can be seen in his pictures of 1960s New York, in many self-portraits, and in the portraits of the musicians he met, especially those from New Orleans, to whom he would devote the book *American Musicians* (1998). From near and far, he seized the instant, the vibration of the moment. As Atlantic producer Joel Dorn aptly put it for MoMA's Friedlander retrospective in 2005, "Lee's pictures show who these people were when they weren't being who they were."

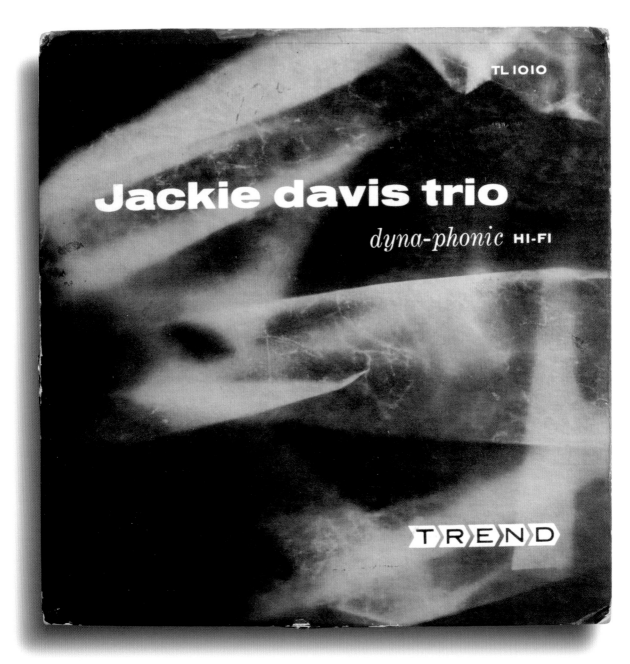

TL 1010

# Jackie davis trio

*dyna-phonic* HI-FI

TREND

Artist. **Jackie Davis**
Title. **Jackie Davis Trio**
Label. Trend - TL 1010
Country. USA
Year. 1954
Photo. Lee Friedlander
Design. Stuart Fox

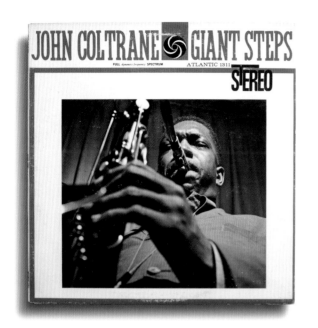

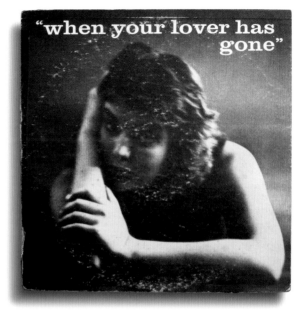

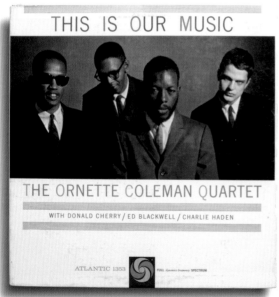

Artist. **John Coltrane**
Title. **Giant Steps**
Label. Atlantic - 1311
Country. USA
Year. 1959
Photo. Lee Friedlander
Design. Marvin Israel

Artist. **The Ornette Coleman Quartet**
Title. **This Is Our Music**
Label. Atlantic - 1353
Country. USA
Year. 1960
Photo. Lee Friedlander
Design. Loring Eutemey

Artist. **Claire Austin**
Title. **When Your Lover Has Gone**
Label. Contemporary Records - C 5002
Country. USA
Year. 1956
Photo. Lee Friedlander
Design. Guidi/Tri-Arts

Artist. **Freddie Hubbard**
Title. **Backlash**
Label. Atlantic - 1477
Country. USA
Year. 1967
Photo. Lee Friedlander
Design. Loring Eutemey

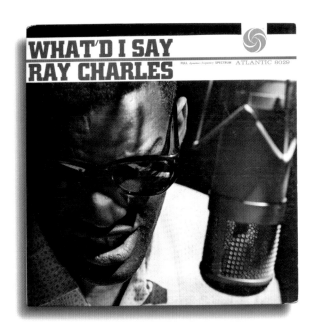

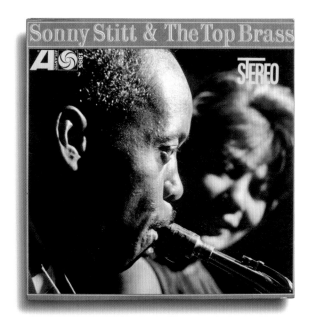

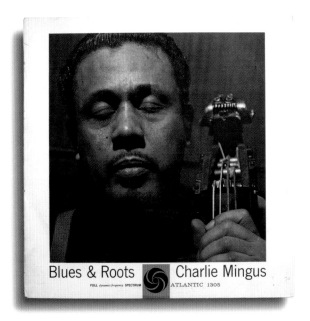

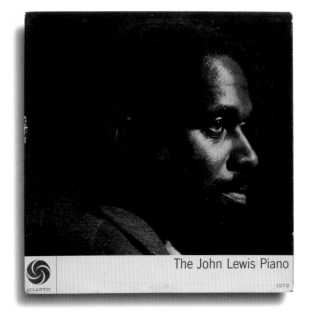

Artist. **Ray Charles**
Title. **What'd I Say**
Label. Atlantic - 8029
Country. USA
Year. 1959
Photo. Lee Friedlander
Design. Marvin Israel

Artist. **Charles Mingus**
Title. **Blues & Roots**
Label. Atlantic - 1305
Country. USA
Year. 1960
Photo. Lee Friedlander
Design. Unknown

Artist. **Sonny Stitt**
Title. **Sonny Stitt & The Top Brass**
Label. Atlantic - 1395
Country. USA
Year. 1962
Photo. Lee Friedlander
Design. Loring Eutemey

Artist. **John Lewis**
Title. **The John Lewis Piano**
Label. Atlantic - 1272
Country. USA
Year. 1957
Photo. Lee Friedlander
Design. Marvin Israel

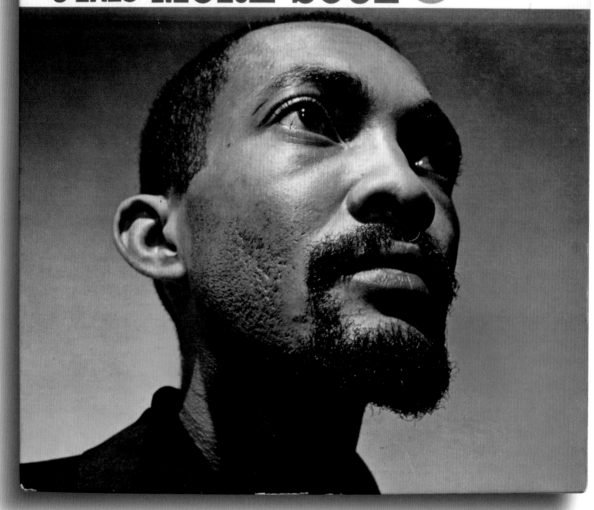

Artist. **Hank Crawford**
Title. **More Soul**
Label. Atlantic - 1356
Country. USA
Year. 1961
Photo. Lee Friedlander
Design. Loring Eutemey

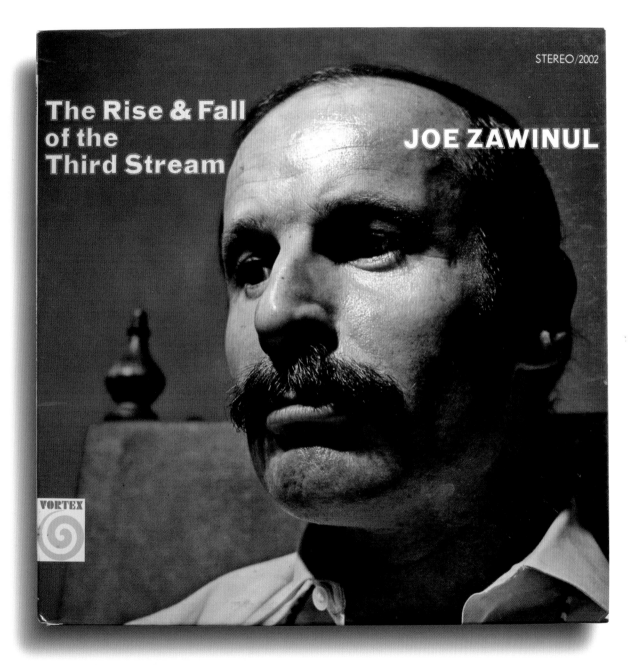

The Rise & Fall of the Third Stream

JOE ZAWINUL

STEREO/2002

VORTEX

Artist. **Joe Zawinul**
Title. **The Rise & Fall of the Third Stream**
Label. Vortex Records - 2002
Country. USA
Year. 1968
Photo. Lee Friedlander
Design. Marvin Israel

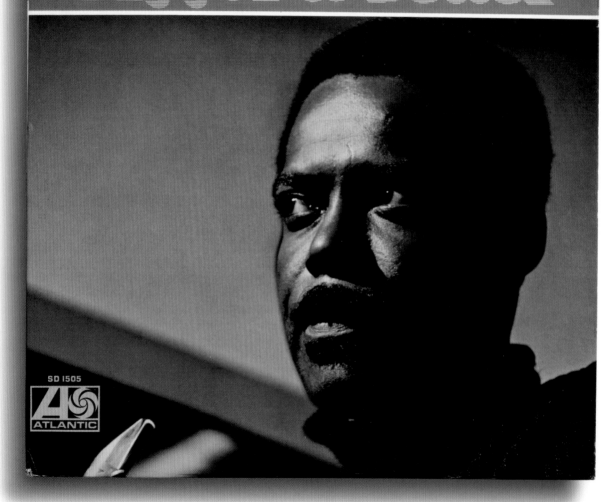

Artist. **David Newman**
Title. **Bigger & Better**
Label. Atlantic - 1505
Country. USA
Year. 1968
Photo. Lee Friedlander
Design. Marvin Israel

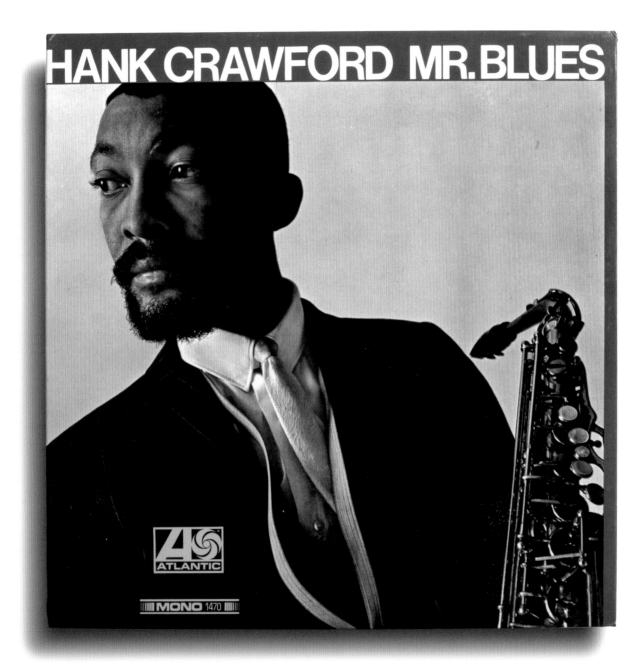

Artist. **Hank Crawford**
Title. **Mr. Blues**
Label. Atlantic - 1470
Country. USA
Year. 1967
Photo. Lee Friedlander
Design. Loring Eutemey

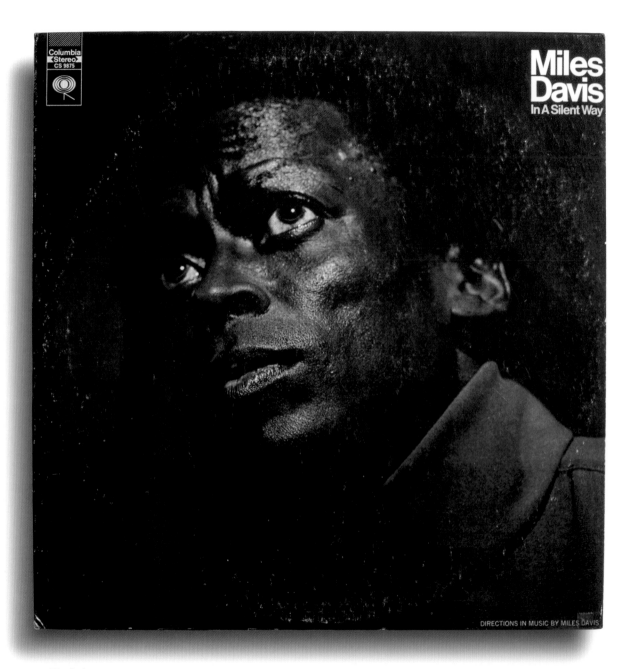

Artist. **Miles Davis**
Title. **In a Silent Way**
Label. Columbia - CS 9875
Country. USA
Year. 1969
Photo. Lee Friedlander
Design. Unknown

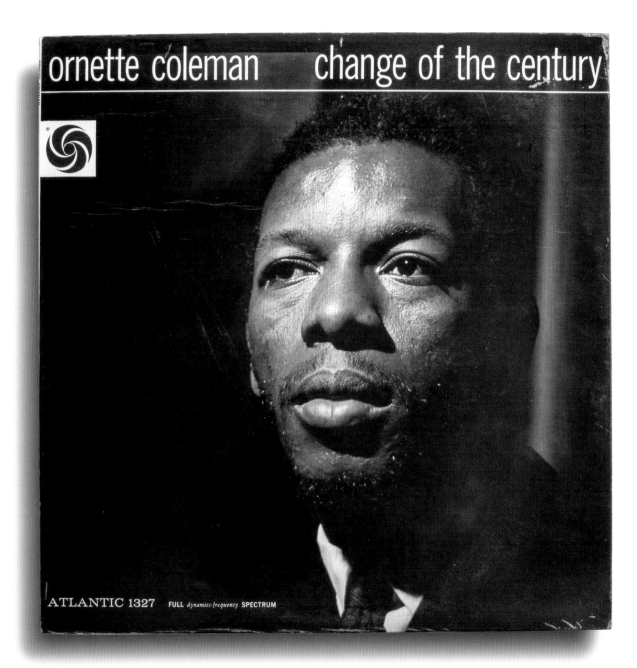

Artist. **Ornette Coleman**
Title. **Change of the Century**
Label. Atlantic - 1327
Country. USA
Year. 1960
Photo. Lee Friedlander
Design. Unknown

# The Ultimate Reference: Blue Note

"The Finest in Jazz Since 1939." The slogan is no exaggeration. It all started with Albert Ammons and Meade "Lux" Lewis during a long session on January 6, 1939. Producer Alfred Lion and photographer Francis Wolff, two German Jews who had fled the Nazis, cofounded the label; the talented designer Reid Miles and sound engineer Rudy Van Gelder joined them soon thereafter. They pooled their skills to produce an unrivaled catalogue, a visionary survey of jazz from A to Z, from avant-garde to mainstream, Duke Ellington to Ornette Coleman, Monk to Miles. They recorded the standards—aesthetic milestones that wrote the history of jazz on the legendary Blue Note Records.

Blue Note's success was based on a signature sound, a visual identity—a white and blue sticker on a black background—and an elegance that combined formal classicism with an original touch, like the lettering and Wolff's stylish, famous photographs. He took some of them during recording sessions, others outside in the city: Herbie Hancock on the streets of New York, Joe Henderson along a wall, Ornette Coleman in midwinter, and, probably the most beautiful one of all, Larry Young amid skyscrapers for *Into Somethin'*.

These covers were copied on numerous occasions and sometimes put to other uses. They inspired English mods (Paul Weller) and American rappers (Wu-Tang Clan). All of them allude to Blue Note's golden age, the glorious 1950s and 1960s. But by the early 1970s, times were changing: Liberty bought the label, Miles and Lion retired, and Wolff died in New York in 1971. However, the aura of the label and its photographer/producers only grew brighter. When Blue Note celebrated its seventy-fifth anniversary in 2014, producer Michael Cuscuna, who has kept the flame burning for over thirty years, analyzed its success. He said, "Blue Note's longevity is explained by the music's quality and attention to the smallest details. An outstanding synergy has enabled the label to make timeless works."

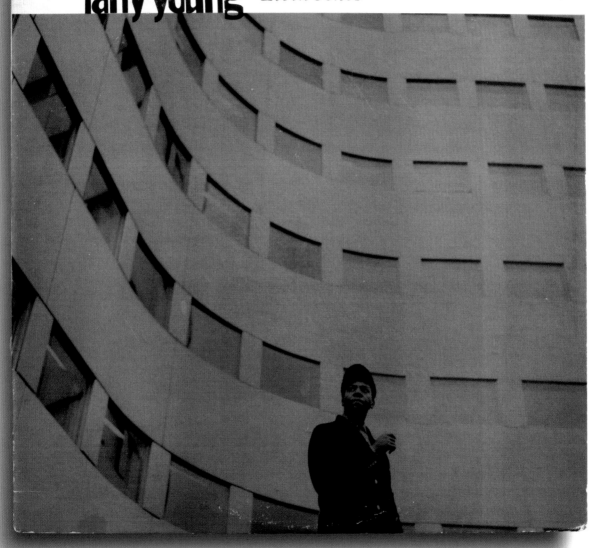

**into somethin'**
**larry young**

*Sam Rivers*
*Grant Green*
*Elvin Jones*

STEREO
84187 BLUE NOTE

Artist. **Larry Young**
Title. **Into Somethin'**
Label. Blue Note - BST 84187
Country. USA
Year. 1964
Photo. Francis Wolff
Design. Reid Miles

Photo. Original photography by Francis Wolff taken for
the album cover *Genius of Modern Music* by Thelonius Monk.
With the generous authorization of Mosaic Images LLC
(for all photographs).

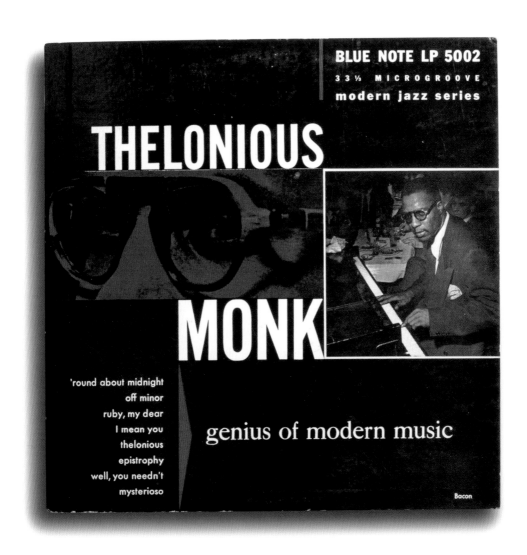

Artist. **Thelonious Monk**
Title. **Genius of Modern Music**
Label. Blue Note - BLP 5002
Country. USA
Year. 1952
Photo. Francis Wolff
Design. Paul Bacon

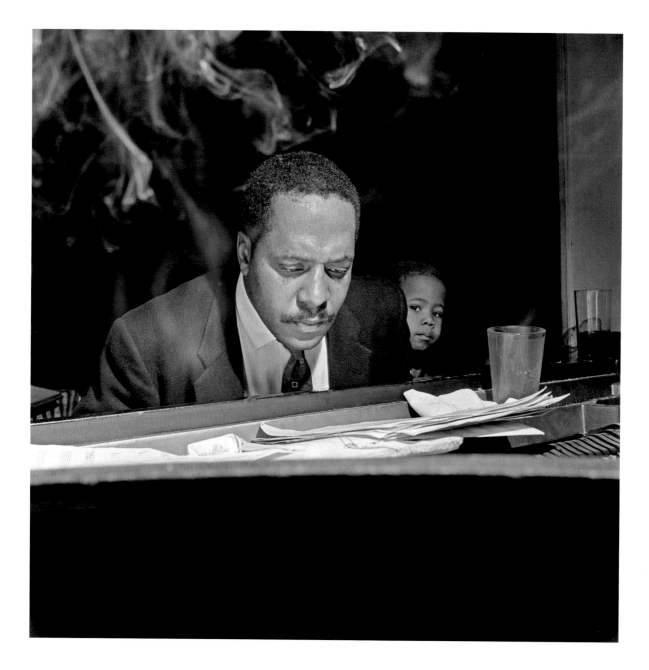

Photo. Original photography by Francis Wolff taken
for the album cover *The Scene Changes* by Bud Powell.
Bud Powell with his son at Birdland, December 1958,
rehearsing for his *The Scene Changes* album.

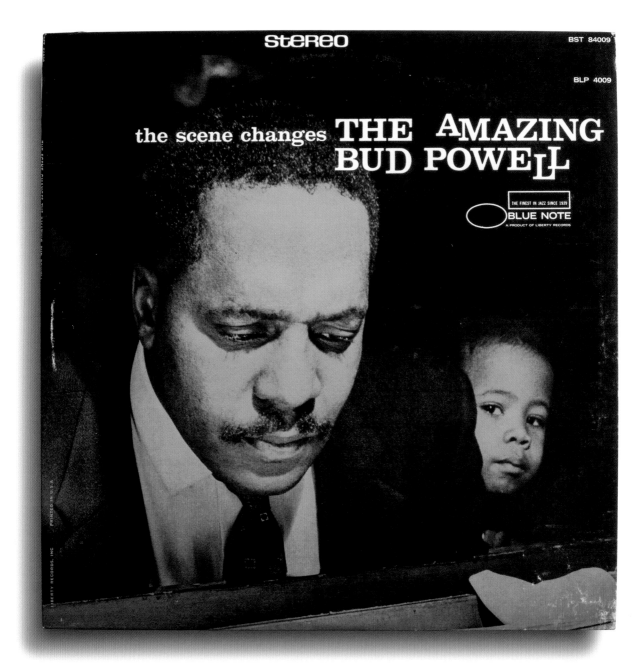

Artist. **Bud Powell**
Title. **The Scene Changes**
Label. Blue Note - BST 84009
Country. USA
Year. 1959
Photo. Francis Wolff
Design. Reid Miles

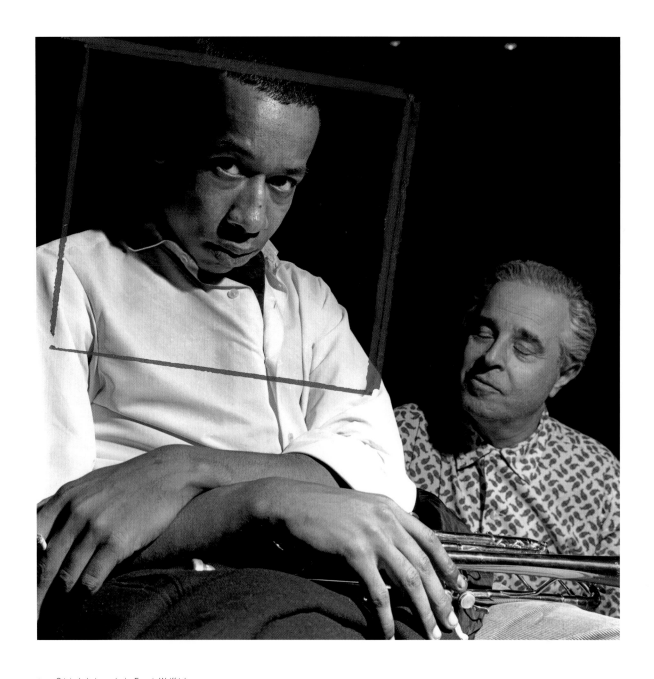

Photo. Original photography by Francis Wolff taken
for the album cover *Search for the New Land* by Lee Morgan.

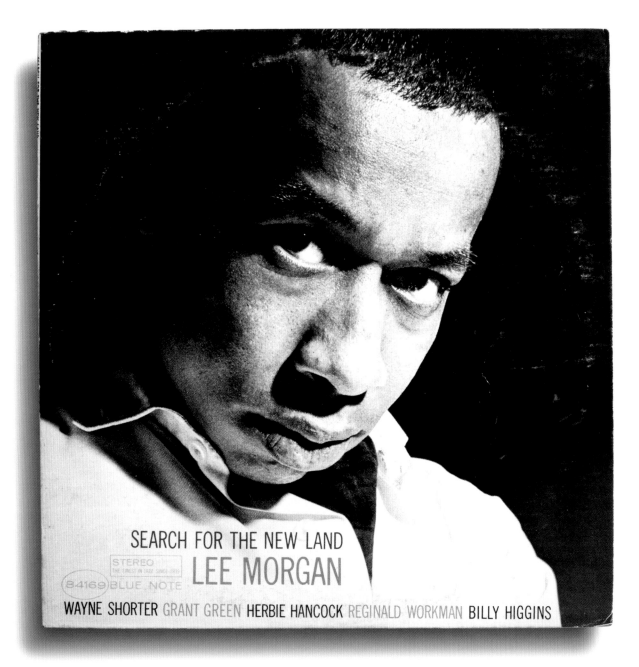

Artist. **Lee Morgan**
Title. **Search for the New Land**
Label. Blue Note - BST 84169
Country. USA
Year. 1964
Photo. Francis Wolff
Design. Reid Miles

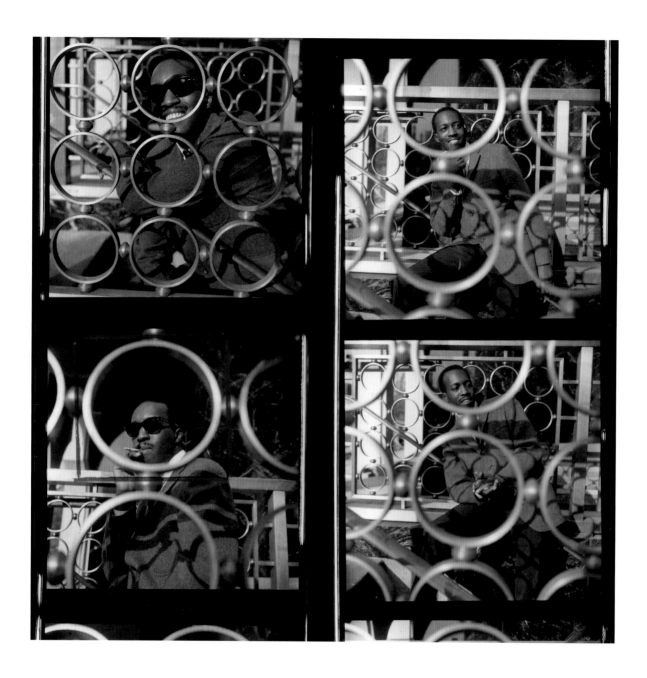

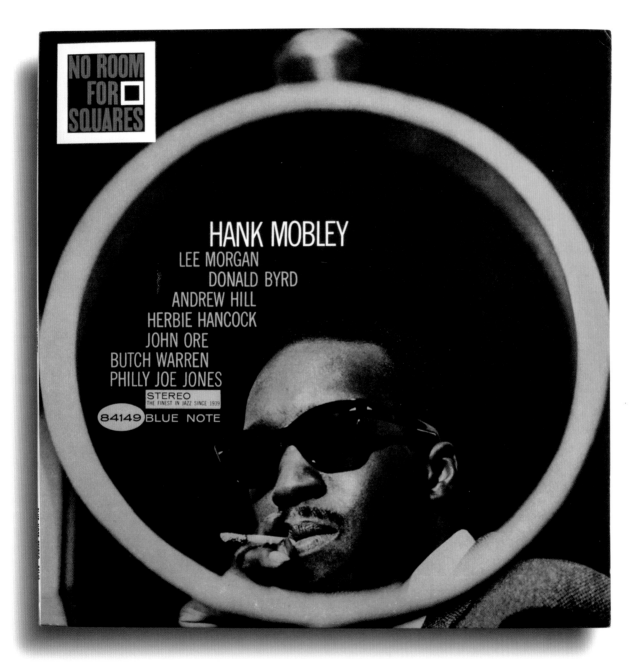

Artist. **Hank Mobley**
Title. **No Room for Squares**
Label. Blue Note - BST 84149
Country. USA
Year. 1963
Photo. Francis Wolff
Design. Reid Miles

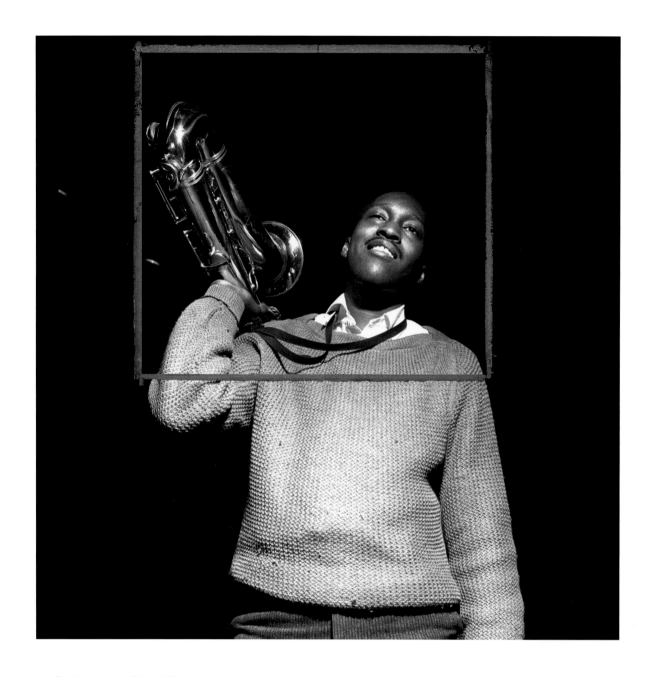

Photo. Original photography by Francis Wolff taken
for the album cover *Soul Station* by Hank Mobley.

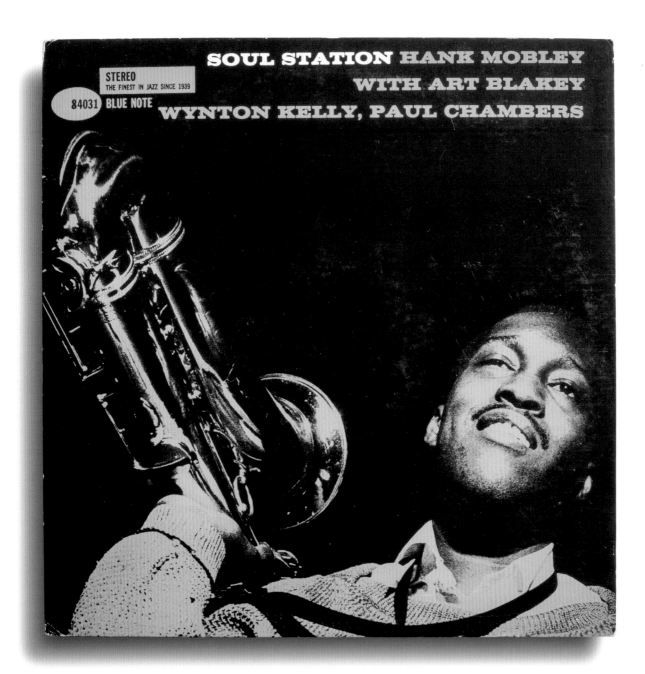

Artist. **Hank Mobley**
Title. **Soul Station**
Label. Blue Note - BST 84031
Country. USA
Year. 1960
Photo. Francis Wolff
Design. Reid Miles

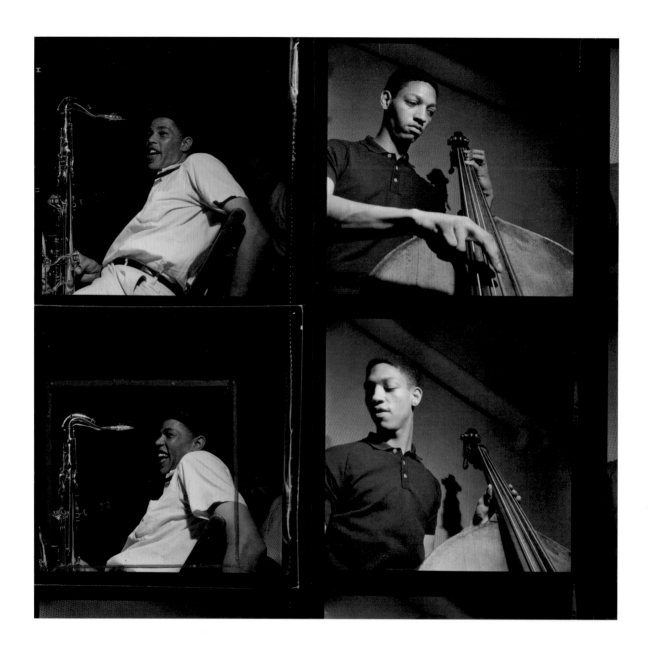

Photo. Original photography by Francis Wolff taken
for the album cover *A Swingin' Affair* by Dexter Gordon.

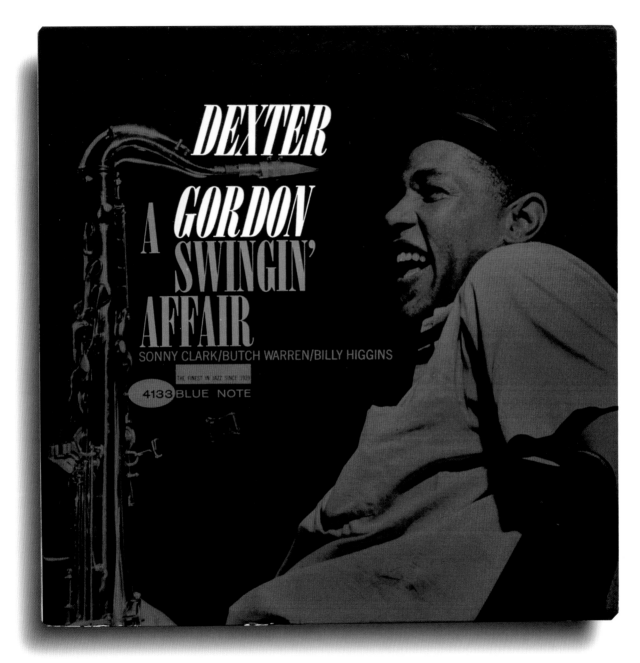

Artist. **Dexter Gordon**
Title. **A Swingin' Affair**
Label. Blue Note - BLP 4133
Country. USA
Year. 1962
Photo. Francis Wolff
Design. Reid Miles

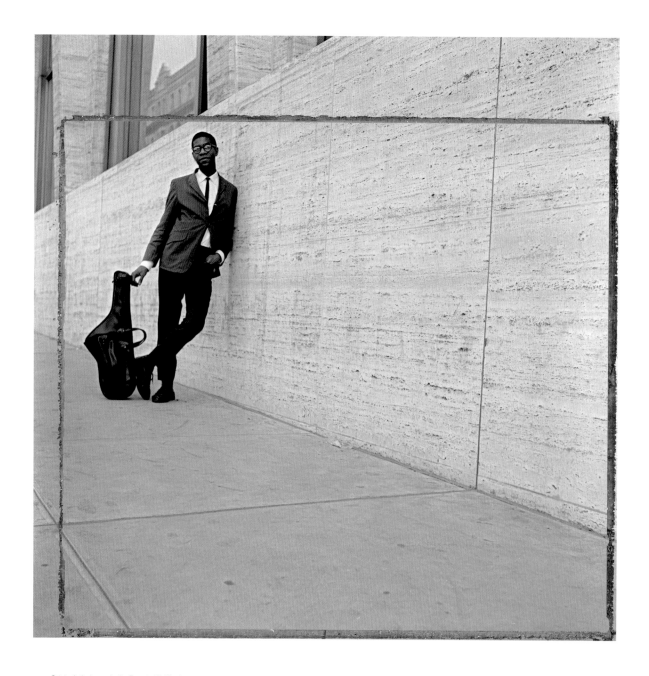

Photo. Original photography by Francis Wolff taken
for the album cover *Page One* by Joe Henderson.

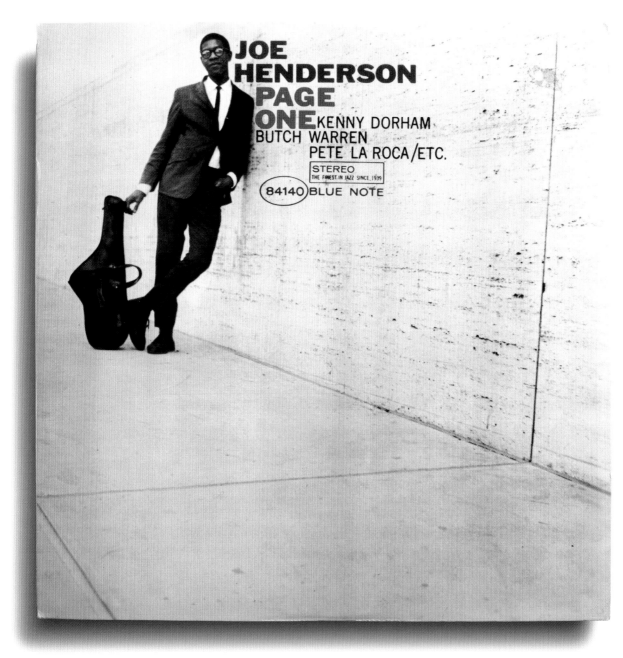

Artist. **Joe Henderson**
Title. **Page One**
Label. Blue Note - BST 84140
Country. USA
Year. 1963
Photo. Francis Wolff
Design. Reid Miles

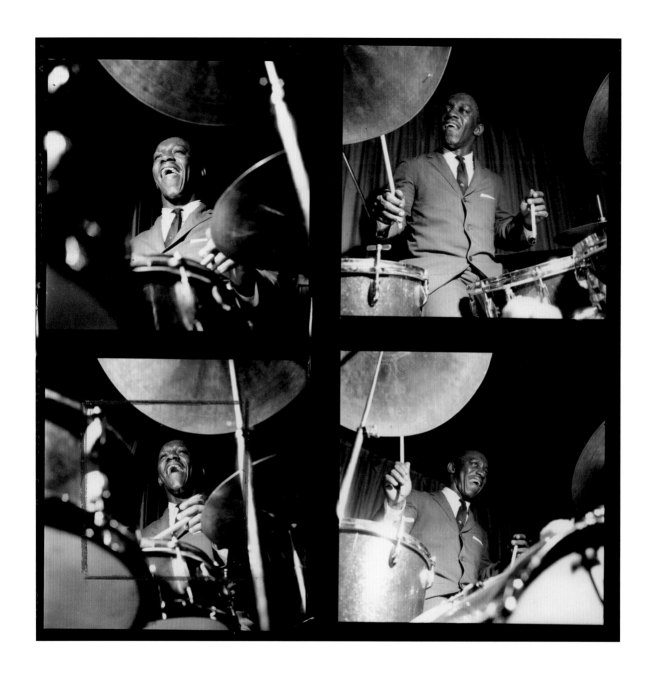

Photo. Original photography by Francis Wolff taken
for the album cover *The Big Beat* by Art Blakey & The Jazz Messengers.
Contact sheet of Art Blakey in performance at the Cork 'N' Bib
on Long Island in October 1958.

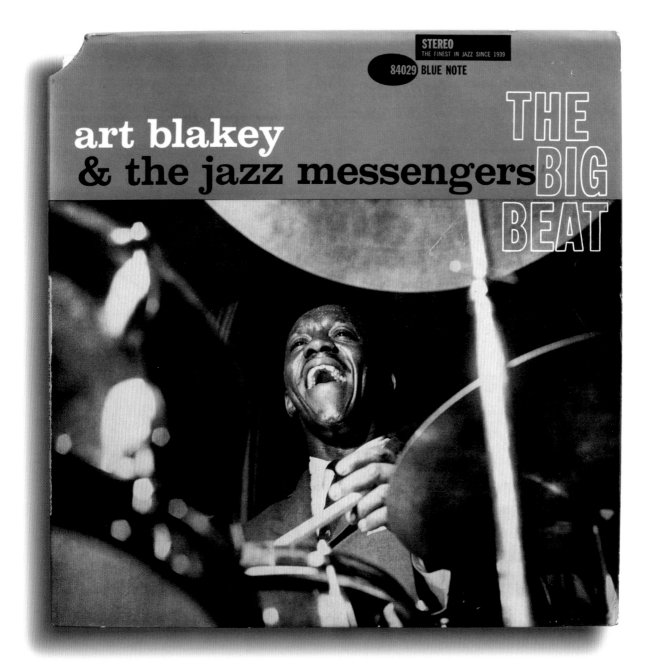

Artist. **Art Blakey & The Jazz Messengers**
Title. **The Big Beat**
Label. Blue Note - BST 84029
Country. USA
Year. 1960
Photo. Francis Wolff
Design. Reid Miles

Photo. Original photography by Francis Wolff taken
for the album cover *Bud!* by Bud Powell.

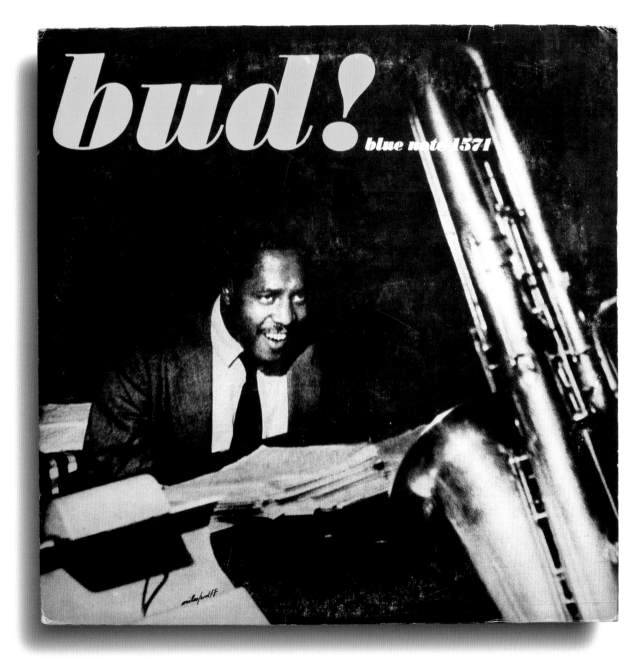

Artist. **Bud Powell**
Title. **Bud!**
Label. Blue Note - BLP 1571
Country. USA
Year. 1957
Photo. Francis Wolff
Design. Reid Miles

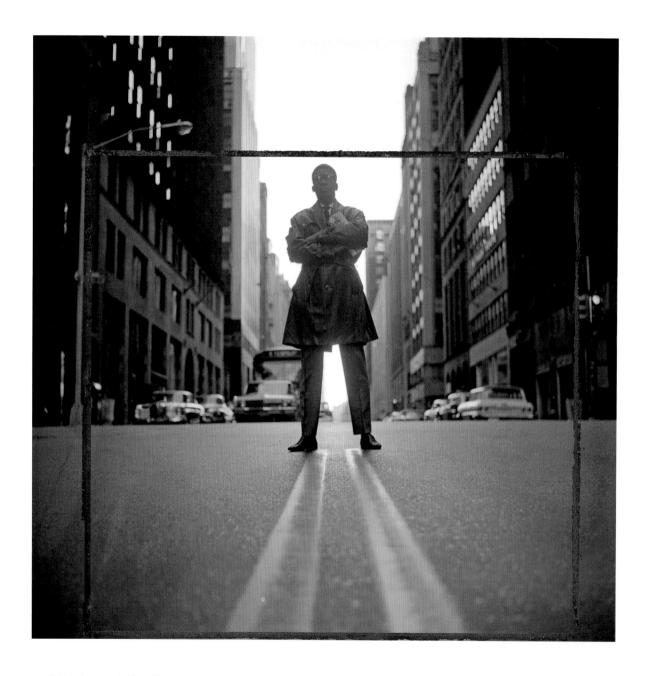

Photo. Original photography by Francis Wolff taken
for the album cover *Inventions & Dimensions* by Herbie Hancock.

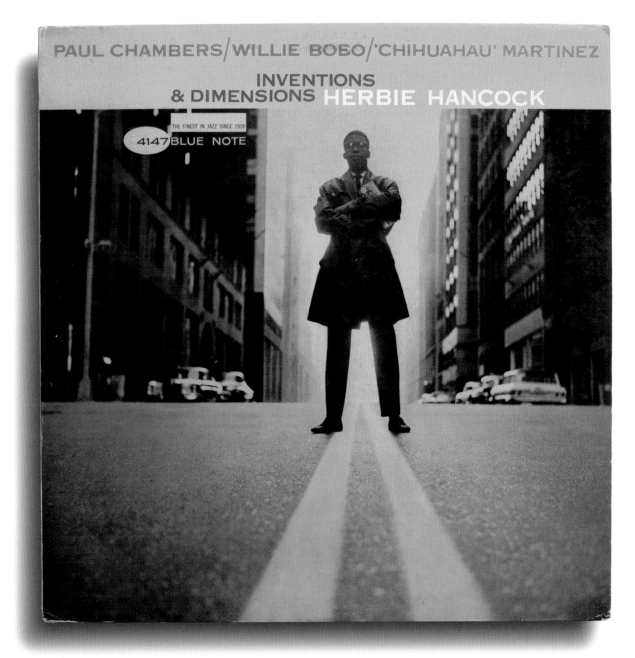

Artist. **Herbie Hancock**
Title. **Inventions & Dimensions**
Label. Blue Note - BLP 4147
Country. USA
Year. 1964
Photo. Francis Wolff
Design. Reid Miles

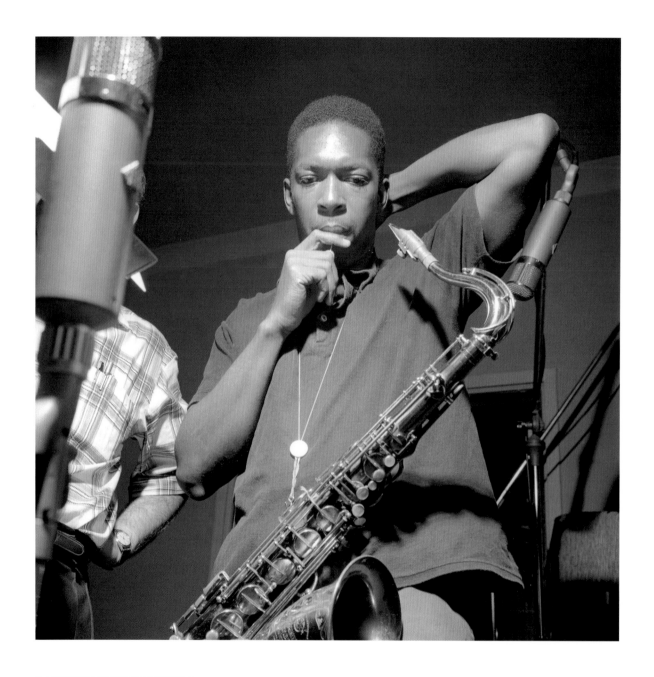

Photo. Original photography by Francis Wolff taken
for the album cover *Blue Train* by John Coltrane.
John Coltrane at his *Blue Train* session
of September 15, 1957.

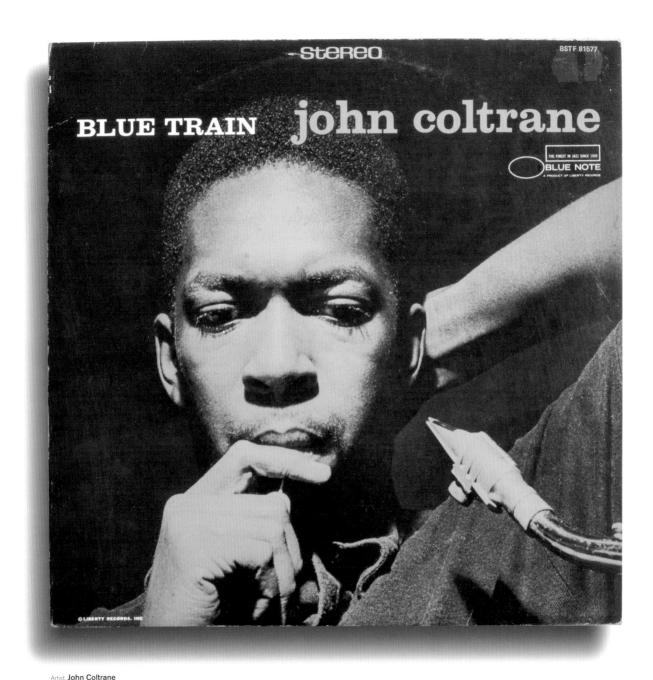

Artist. **John Coltrane**
Title. **Blue Train**
Label. Blue Note - BSTF 81577
Country. France
Year. 1957
Photo. Francis Wolff
Design. Reid Miles

# Sound Material: ECM

The late sixties were a thrilling time. Many independent record companies popped up in Europe, especially on the improvisational music scene. Manfred Eicher founded the ECM label at the movement's forefront and quickly developed trailblazing aesthetics, which the bassist-turned-producer summed up with the slogan, "The most beautiful sound next to silence."

The music is simultaneously heretic and holy, popular and scholarly, abstract and hyper-realist, freely improvisational and carefully scored, black and white, blurry and clear, contemporary and wistfully futuristic. Those words also describe ECM's visual identity: from pure illustration to total abstraction, each cover reflects and sheds light on Eicher's choices. An aesthetic artisan and austere artist, he radically changed the view of jazz and designed an unparalleled graphic charter, often eschewing photographs of musicians on glossy paper. Every album bearing those three letters (which stand for Edition of Contemporary Music) became a sophisticated object, a project from A to Z.

The covers' flat, minimalist, abstract images hint at the music inside. Graphic artist Barbara Wojirsch designed many of them, hand-written letters and shaded nuances distinguishing the house style. Photography was also very important and Dieter Rehm placed it at the center of his reflections. Numerous photographs punctuate the label's huge catalogue of forty-plus years, where unprecedented aesthetic intent does not mask a diversity of artistic horizons—if you look and listen closely enough. From close-ups of details (a footstep, a piece of bark or fabric) to wide-angle shots (stretches of pristine land, glassy seascapes, bright skies, and so on), they reveal the same world, composed of a thousand and one fragments.

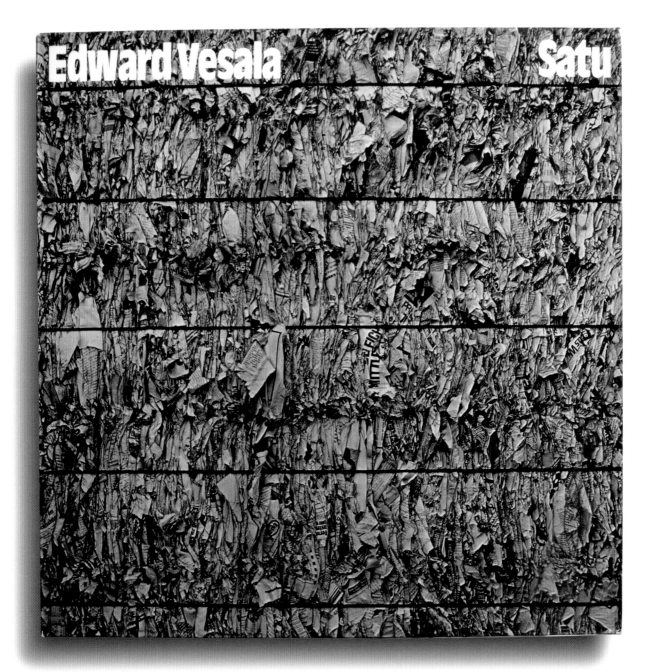

Artist. **Edward Vesala**
Title. **Satu**
Label. ECM Records - ECM 1088
Country. Germany
Year. 1977
Photo. Lajos Keresztes
Design. Dieter Bonhorst

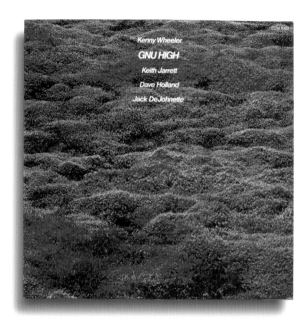

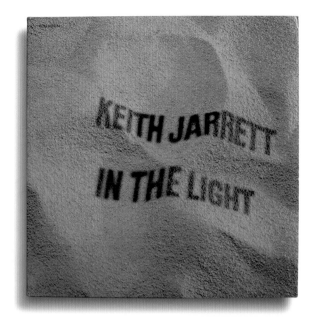

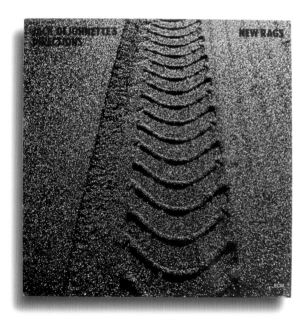

Artist. **Kenny Wheeler**
Title. **Gnu High**
Label. ECM Records - ECM 1069
Country. Germany
Year. 1976
Photo. Tadayuki Naitoh
Design. Barbara Wojirsch

Artist. **Jack DeJohnette's Directions**
Title. **New Rags**
Label. ECM Records - ECM 1103
Country. Germany
Year. 1977
Photo. Lajos Keresztes
Design. Dieter Bonhorst

Artist. **Keith Jarrett**
Title. **In the Light**
Label. ECM Records - ECM 1033/34
Country. Germany
Year. 1974
Photo. Georgyves Braunschweig
Design. Barbara & Burkhart Wojirsch

Artist. **Terje Rypdal**
Title. **What Comes After**
Label. ECM Records - ECM 1031 ST
Country. Germany
Year. 1974
Photo. Frieder Grindler
Design. Frieder Grindler

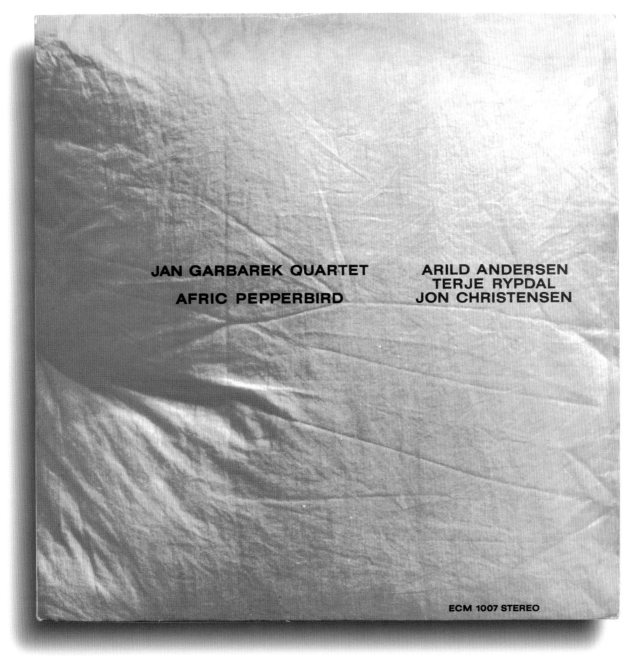

JAN GARBAREK QUARTET          ARILD ANDERSEN
                             TERJE RYPDAL
AFRIC PEPPERBIRD             JON CHRISTENSEN

ECM 1007 STEREO

Artist. **Jan Garbarek Quartet**
Title. **Afric Pepperbird**
Label. ECM Records - ECM 1007
Country. Germany
Year. 1970
Photo. Terje Engh
Design. Barbara & Burkhart Wojirsch

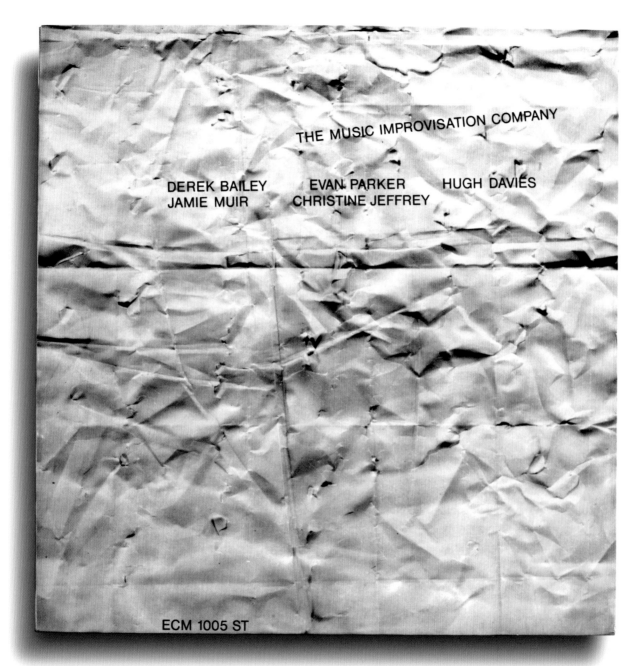

THE MUSIC IMPROVISATION COMPANY

DEREK BAILEY     EVAN PARKER     HUGH DAVIES
JAMIE MUIR     CHRISTINE JEFFREY

ECM 1005 ST

Artist. **The Music Improvisation Company**
Title. **The Music Improvisation Company**
Label. ECM Records - ECM 1005 ST
Country. Germany
Year. 1970
Photo. Werner Bethsold
Design. Barbara & Burkhart Wojirsch

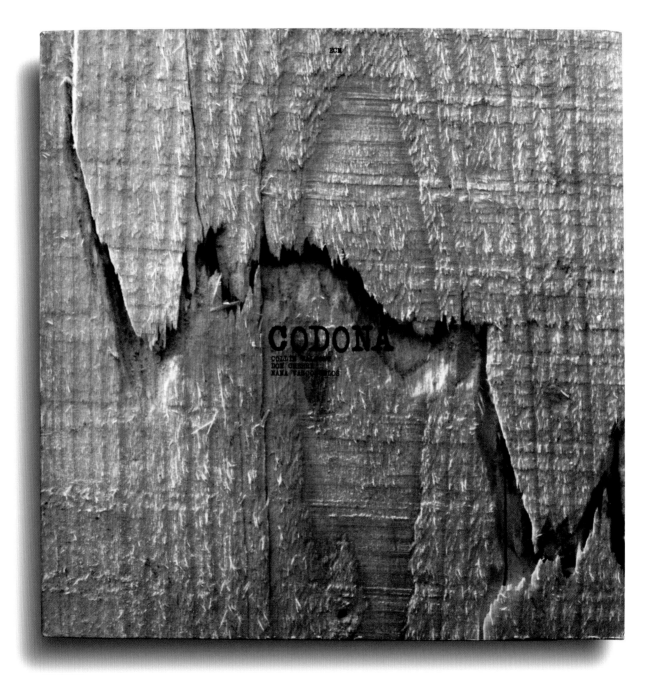

Artist. **Codona**
Title. **Codona**
Label. ECM Records - ECM 1132
Country. Germany
Year. 1979
Photo. Frieder Grindler
Design. Frieder Grindler

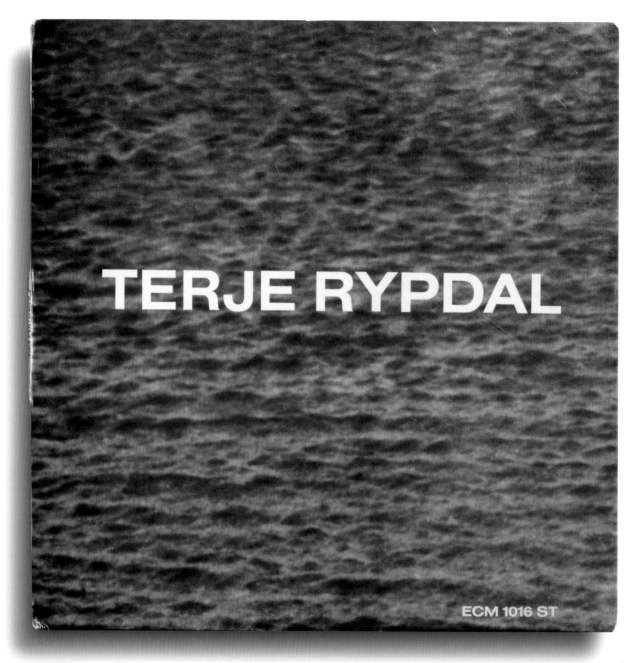

Artist. **Terje Rypdal**
Title. **Terje Rypdal**
Label. ECM Records - ECM 1016 ST
Country. Germany
Year. 1971
Photo. Unknown
Design. Barbara & Burkhart Wojirsch

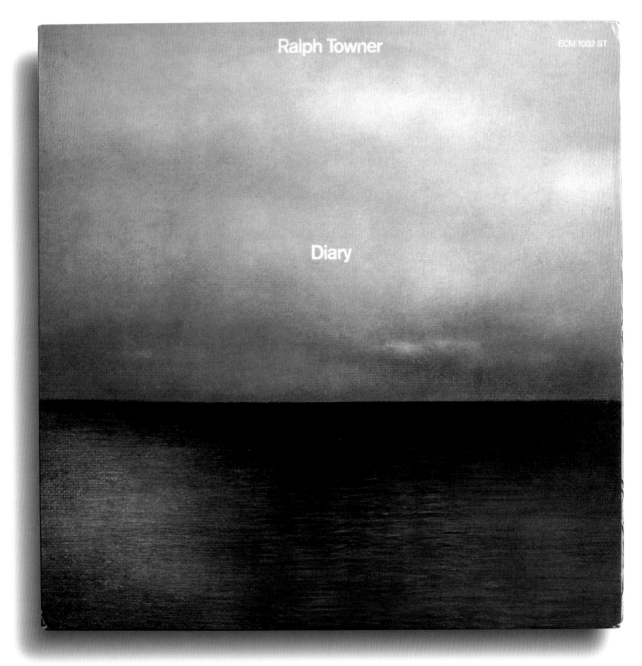

Ralph Towner

Diary

ECM 1032 ST

Artist. **Ralph Towner**
Title. **Diary**
Label. ECM Records - ECM 1032 ST
Country. Germany
Year. 1974
Photo. Unknown
Design. Barbara & Burkhart Wojirsch

# Nouvelle Vague: Elenco

In the late 1950s, Brazil's Nouvelle Vague swept through every area of creativity. Its musical manifestation was bossa nova, a low-tempo variation of samba, inspired by cool jazz from the United States. This gentle sound revolution coincided with the presidency of Juscelino Kubitschek, a bossa nova fan himself, who ushered Brazil into the postmodern age. And it's in this very groove that we find the label that became the emblem of bossa nova: Elenco, the ultimate carioca.

Founded in 1963 by Aloísio de Oliveira, Elenco looked north for inspiration, to Blue Note and the partnership between designer Reid Miles and photographer Francis Wolff. Their Rio counterparts were the learned designer and painter César Villela, a follower of Mondrian, and the photographer Francisco Pereira, a devotee of solarization. Together, they created a two-tone visual identity based on a red-and-black logo, an aesthetic choice that soon became a hallmark. The photos, mostly portraits featuring stark contrasts, were reworked to strengthen the impression of overexposed negatives, as though sketched in pencil, to which they added a touch of red to subtly underscore the depth of the black and white.

For five years, nearly all the movement's leading musicians—Antônio Carlos (Tom) Jobim, Sérgio Mendes, Edu Lobo, Baden Powell, Roberto Menescal, Vinícius de Moraes, Dorival Caymmi, and the young Nara Leão—recorded for Elenco, an exceptionally elegant label whose visual identity of striking contrasts was for decades a reference for record-lovers. The adventure ended in 1968 with the peak of the dazzling tropicália movement: colorful album covers based on pop and psychedelic art came into vogue as Brazil entered the dark days of dictatorship—another story of contrasts.

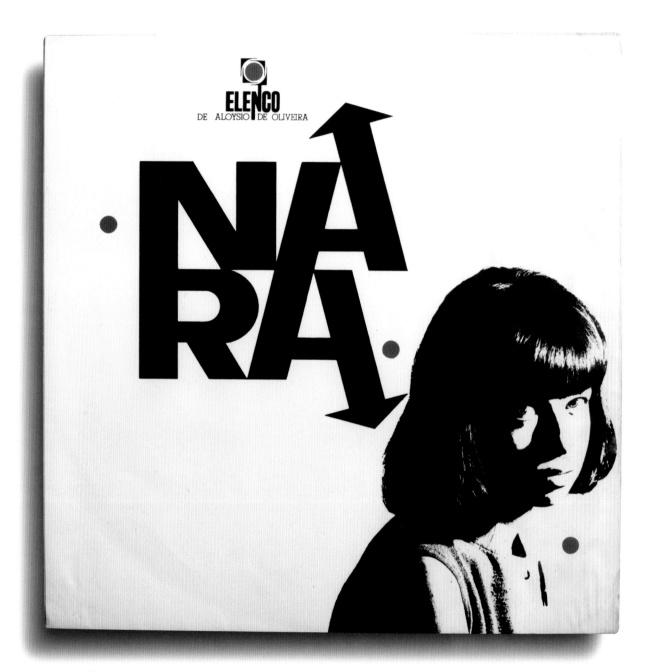

Artist. **Nara Leão**
Title. **Nara**
Label. Elenco - ME-10
Country. Brazil
Year. 1964
Photo. Francisco Pereira
Design. César G. Villela

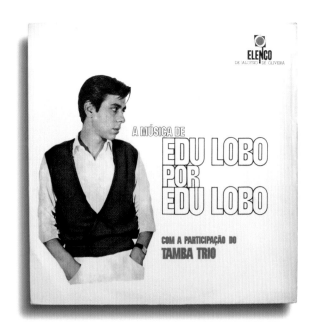

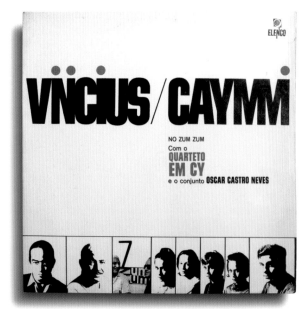

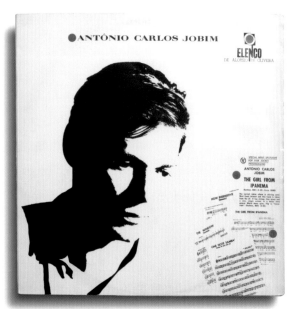

Artist. **Edu Lobo/Tamba Trio**
Title. **A Música de Edu Lobo por Edu Lobo**
Label. Elenco - ME-19
Country. Brazil
Year. 1965
Photo. Unknown
Design. Unknown

Artist. **Antônio Carlos Jobim**
Title. **Antônio Carlos Jobim**
Label. Elenco - ME-9
Country. Brazil
Year. 1963
Photo. Francisco Pereira
Design. Unknown

Artist. **Vinícius de Moraes/Dorival Caymmi/Quarteto Em Cy/Oscar Castro Neves**
Title. **No Zum Zum**
Label. Elenco - ME-23
Country. Brazil
Year. 1967
Photo. Francisco Pereira/Paulo Lorgus
Design. Eddie Moyna

Artist. **Rosinha de Valença**
Title. **Apresentando**
Label. Elenco - ME-16
Country. Brazil
Year. 1963
Photo. Unknown
Design. Unknown

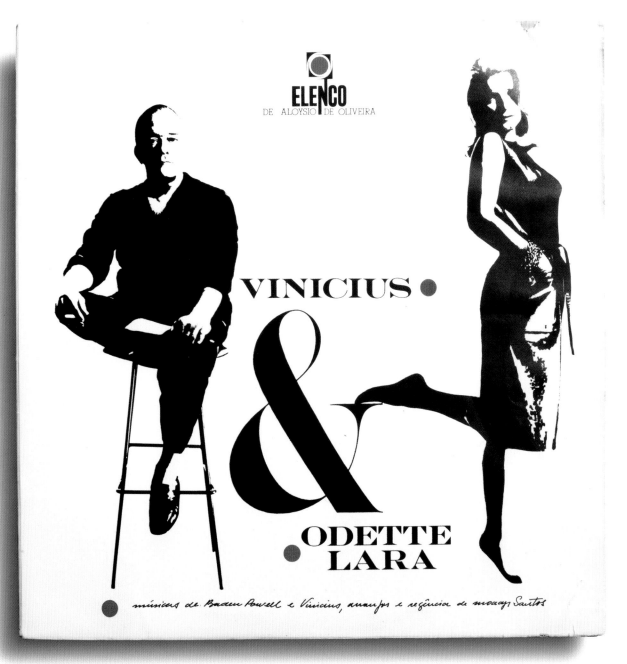

Artist. **Vinícius de Moraes/Odette Lara**
Title. **Vinícius and Odette Lara**
Label. Elenco - ME-1
Country. Brazil
Year.1963
Photo. Francisco Pereira
Design. Caetano Rodriguez/César G. Villela

# On the Spot: ESP-Disk'

"The artists alone decide what you will hear on their ESP-Disk'." Most of the major figures in free jazz and "The New Thing," which shocked the United States at the time, recorded for this label, founded in 1964 by lawyer Bernard Stollman, who died recently, in 2015. The music was radical and the covers, uncompromising: slightly blurry, often-untitled black-and-white close-ups of Henry Grimes, Charles Tyler, Burton Greene, Frank Wright, Sunny Murray, Noah Howard, Patty Waters, and others. Each portrait goes to the depth of the subject's soul. Most seem to have captured the heat of the moment. All reflect a closeness and intimacy between photographer and musician. The photograph, literally fading to black, of the "scandalous" Ornette Coleman for his *Town Hall, 1962* is emblematic of the series.

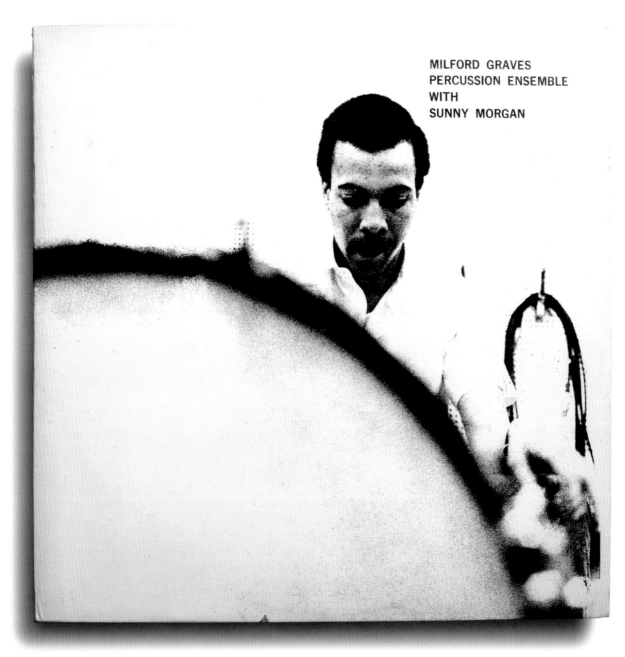

MILFORD GRAVES
PERCUSSION ENSEMBLE
WITH
SUNNY MORGAN

Artist. **Milford Graves with Sunny Morgan**
Title. **Percussion Ensemble**
Label. ESP-Disk' - 1015
Country. USA
Year. 1965
Photo. Bob Greene
Design. Unknown

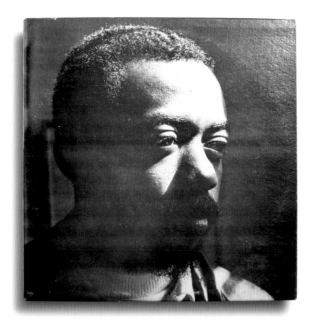

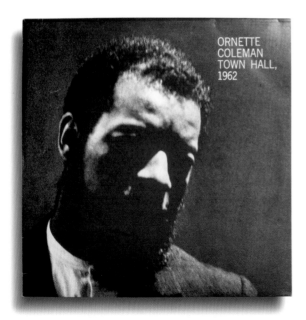

ORNETTE
COLEMAN
TOWN HALL,
1962

Artist. **Burton Greene Quartet**
Title. **Burton Greene Quartet**
Label. ESP-Disk' - 1024
Country. USA
Year. 1966
Photo. Ray Gibson
Design. Unknown

Artist. **Ornette Coleman**
Title. **Town Hall, December 1962**
Label. ESP-Disk' - 1006
Country. USA
Year. 1965
Photo. Charles Shabacon
Design. Jay Dillon

Artist. **Charles Tyler Ensemble**
Title. **Charles Tyler Ensemble**
Label. ESP-Disk' - 1029
Country. USA
Year. 1966
Photo. Raymond Ross
Design. Jay Dillon

Artist. **Marion Brown Quartet**
Title. **Marion Brown Quartet**
Label. ESP-Disk' - 1022
Country. USA
Year. 1966
Photo. Charles Shabacon
Design. Bert Glassberg

Artist. **Gato Barbieri Quartet**
Title. **In Search of the Mystery**
Label. ESP-Disk' - 1049
Country. USA
Year. 1967
Photo. Unknown
Design. Natasha Zapotoski

Artist. **Sonny Simmons**
Title. **Staying on the Watch**
Label. ESP-Disk' - 1030
Country. USA
Year. 1966
Photo. Sandra H. Stollman
Design. Jay Dillon

Artist. **Albert Ayler Quintet**
Title. **Spirits Rejoice**
Label. ESP-Disk' - 1020
Country. USA
Year. 1965
Photo. Sandra H. Stollman
Design. Bert Glassberg

# B-Side America:
# Riverside, Bluesville, and Yazoo

In the segregated United States of the first half of the twentieth century "race records" were a separate category primarily intended for African Americans. OKeh, Paramount, Emerson, and other labels recorded music echoing the spirit of the times and documenting idioms at the source of the twentieth-century sound track. Unwittingly or not, they became curators of the blues, preserving the work of historic musicians from the South. As the civil rights movement developed in the late 1950s, jazz labels in New York created subdivisions focusing on veterans of the blues and swing.

Riverside launched a series dedicated to "living legends" still active in New Orleans and Chicago, two of the blues and gospel communities' main cultural hubs. To illustrate these sound documents, the label chose images showing the daily lives of black people stigmatized as much by society as geography. In the early 1960s, Prestige went even further by creating Bluesville, a label that collected music in the Mississippi Delta, allowing fans of "roots music" to hear such great names as Tampa Red, Lightnin' Hopkins, Walter Brown "Brownie" McGhee, and Sonny Terry. All their faces appeared on the label's LPs. Oddly, Bluesville stopped in 1966, just as a blues revival was rocking both sides of the Atlantic.

In the late 1960s, Yazoo released historic blues recordings collected in the South, where racist attitudes were still rampant. Like the music, Farm Security Administration photographs by Jack Delano, Dorothea Lange, and others bore precious witness to the condition of black life in the Deep South—country life, prison, juke joints, and so on.

Artist. **Various**
Title. **East Coast Blues 1926–1935**
Label. Yazoo - L-1013
Country. USA
Year. 1968
Photo. Jack Delano
Design. Nick Perls

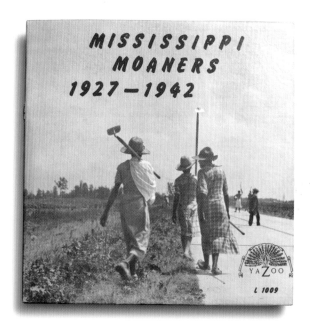

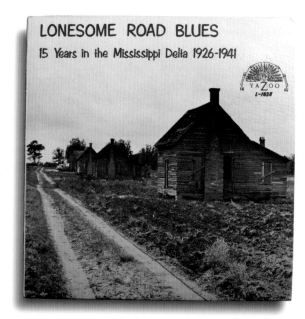

Artist. **Various**
Title. **Mississippi Moaners 1927–1942**
Label. Yazoo - L-1009
Country. USA
Year. 1968
Photo. Unknown
Design. Nick Perls

Artist. **Various**
Title. **The Georgia Blues 1927–1933**
Label. Yazoo - L-1012
Country. USA
Year. 1968
Photo. Dorothea Lange/
Fred McMullen/Curley Weaver
Design. Nick Perls

Artist. **Various**
Title. **Lonesome Road Blues: 15 Years
in the Mississippi Delta 1926–1941**
Label. Yazoo - L-1038
Country. USA
Year. 1974
Photo. Unknown
Design. Nick Perls

Artist. **Various**
Title. **Mississippi Blues 1927–1941**
Label. Yazoo - L-1001
Country. USA
Year. 1967
Photo. Unknown
Design. Michael Gruener/Nick Perls

YA ZOO

L 1007

Jackson
Blues

1928 – 1938

Artist. **Various**
Title. **Jackson Blues 1928–1938**
Label. Yazoo - L-1007
Country. USA
Year. 1968
Photo. Unknown
Design. Nick Perls

Artist. **Sunnyland Slim**
Title. **Slim's Shout**
Label. Prestige/Bluesville - BVLP 1016
Country. USA
Year. 1961
Photo. Esmond Edwards
Design. Unknown

**GOOD TIMES**

*the vocal & harmonica blues of*

**SHAKEY JAKE**

*prestige/bluesville 1008*

Artist. **Shakey Jake Harris**
Title. **Good Times**
Label. Prestige/Bluesville - BVLP 1008
Country. USA
Year. 1960
Photo. Esmond Edwards
Design. Unknown

PRESTIGE/BLUESVILLE 1015

BLIND
GARY
DAVIS
HARLEM
STREET
SINGER

Artist. **Blind Gary Davis**
Title. **Harlem Street Singer**
Label. Prestige/Bluesville - BVLP 1015
Country. USA
Year. 1961
Photo. Esmond Edwards
Design. Unknown

Artist. **Mercy Dee Walton**
Title. **Pity and a Shame**
Label. Prestige/Bluesville - BVLP 1039
Country. USA
Year. 1961
Photo. William Carter
Design. Don Schlitten

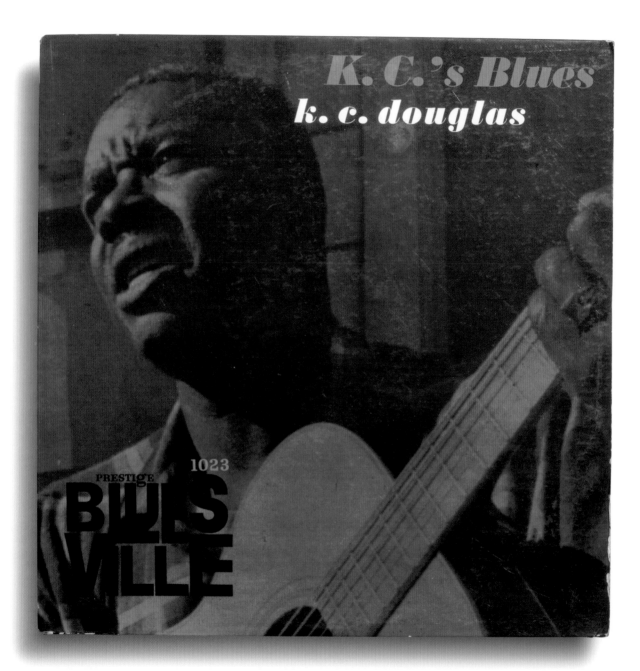

Artist. **K. C. Douglas**
Title. **K. C.'s Blues**
Label. Prestige/Bluesville - BVLP 1023
Country. USA
Year. 1961
Photo. Unknown
Design. Unknown

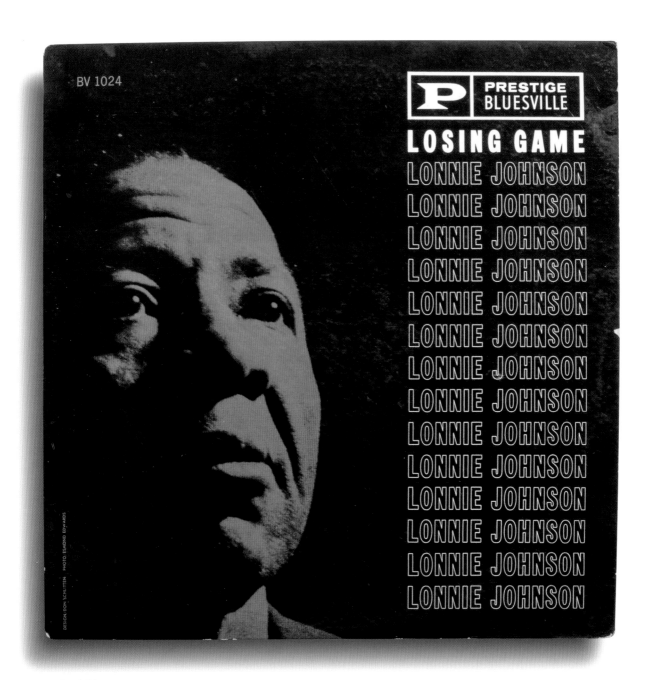

BV 1024

**PRESTIGE BLUESVILLE**

## LOSING GAME

LONNIE JOHNSON
LONNIE JOHNSON
LONNIE JOHNSON
LONNIE JOHNSON
LONNIE JOHNSON
LONNIE JOHNSON
LONNIE JOHNSON
LONNIE JOHNSON
LONNIE JOHNSON
LONNIE JOHNSON
LONNIE JOHNSON
LONNIE JOHNSON
LONNIE JOHNSON
LONNIE JOHNSON

DESIGN: DON SCHLITTEN    PHOTO: ESMOND EDWARDS

Artist. **Lonnie Johnson**
Title. **Losing Game**
Label. Prestige/Bluesville - BVLP 1024
Country. USA
Year. 1961
Photo. Esmond Edwards
Design. Don Schlitten

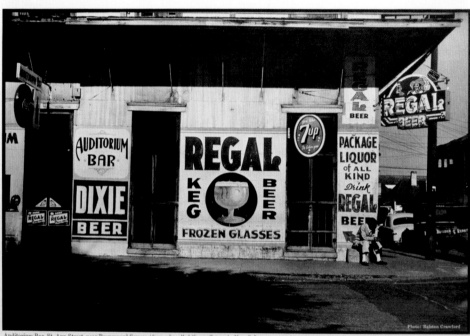

Auditorium Bar, St. Ann Street, near Beauregard Square (formerly called Congo Square), New Orleans

Photo: Ralston Crawford

378 RIVERSIDE

Series. **New Orleans: The Living Legends**
Title. **Percy Humprey's Crescent City Joy Makers**
Label. Riverside Records - RLP 378
Country. USA
Year. 1961
Photo. Ralston Crawford
Design. Ken Deardoff

NEW ORLEANS | THE LIVING LEGENDS
# JIM ROBINSON'S
## NEW ORLEANS BAND

St. Peter Street, New Orleans

Photo: Ralston Crawford

369 | RIVERSIDE

Series. **New Orleans: The Living Legends**
Title. **Jim Robinson's New Orleans Band**
Label. Riverside Records - RLP 369
Country. USA
Year. 1961
Photo. Ralston Crawford
Design. Ken Deardoff

STEREO 9365 RIVERSIDE

NEW ORLEANS THE LIVING LEGENDS
# KID THOMAS
## AND HIS ALGIERS STOMPERS

Burgundy Street, New Orleans

Series. **New Orleans: The Living Legends**
Title. **Kid Thomas and His Algiers Stompers**
Label. Riverside Records - 9386
Country. USA
Year. 1960
Photo. Ralston Crawford
Design. Ken Deardoff

STEREO 9393 RIVERSIDE

# NEW ORLEANS|THE LIVING LEGENDS
# JIM ROBINSON
## PLAYS SPIRITUALS AND BLUES

Downtown New Orleans

Series. **New Orleans: The Living Legends**
Title. **Jim Robinson Plays Spirituals and Blues**
Label. Riverside Records - 9393
Country. USA
Year. 1961
Photo. Ralston Crawford
Design. Ken Deardoff

# A Trademark: Hipgnosis

Hipgnosis, a collective of British graphic artists, set the tone from the get-go: flashy. In 1968, as the hippies' flower power revolution started petering out, Aubrey "Po" Powell and Storm Thorgerson laid the aesthetic groundwork of a movement that left its mark on the following decade. Their iconographic choices drew notice. Thorgerson, who met Roger Waters at Cambridge, designed the first album cover for Pink Floyd, *A Saucerful of Secrets*. It is a strange composition, still influenced by psychedelic art. It also marked the start of a long collaboration during which the graphic artists illustrated the progressive rock band's album covers with phantasmagorical images living up to their supersonic intentions: *Ummagumma* and its photographic *mise en abyme*, and, the following year, *Atom Heart Mother* with its sacred cow. They designed one classic after another.

The early 1970s were a prolific period and every new album cover was timeless yet of its time—it was the start of a fantastic decade. In 1974, Peter Christopherson, a member of the group Throbbing Gristle, joined Powell and Thorgerson, bringing a more industrial touch to the universe of outlandish people and landscapes. These weird, surrealistic, utopian imaginary worlds have haunted the collective unconscious ever since. *Rolling Stone* magazine ranked two Hipgnosis album covers among the best one hundred of all time: Pink Floyd's *The Dark Side of the Moon*, whose prism became a hallmark, and Led Zeppelin's *Houses of the Holy*, with its esoteric photomontage. They both offered ways to move to the other side of the mirror, and achieved even more resonance when listening to the music. The agency's last cover, before shutting down in 1983, was for Led Zeppelin's final album, *Coda*, and was entirely made up of letters. In musical terms, the coda is the final resolution of a theme.

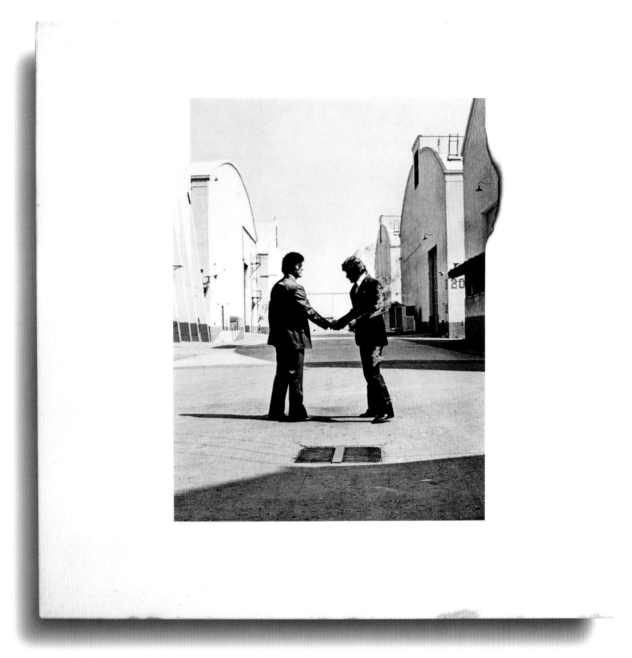

Artist. **Pink Floyd**
Title. **Wish You Were Here**
Label. Harvest - SHVL 814
Country. England
Year. 1975
Photo. Hipgnosis/Aubrey "Po" Powell
Design. Hipgnosis/Storm Thorgerson

Artist. **Montrose**
Title. **Jump On It**
Label. Warner Bros. Records - BS 2963
Country. USA
Year. 1976
Photo. Unknown
Design. Hipgnosis

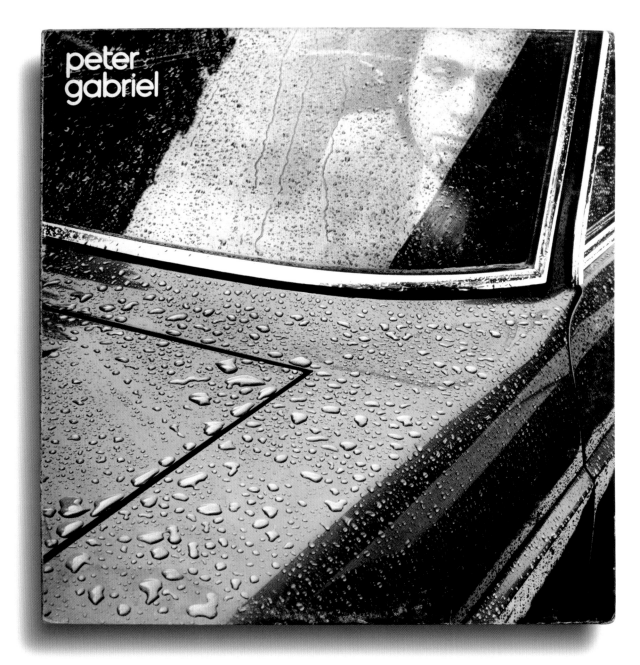

Artist. **Peter Gabriel**
Title. **Peter Gabriel**
Label. Charisma - CDS 4006
Country. England
Year. 1977
Photo. Unknown
Design. Hipgnosis/Richard Manning

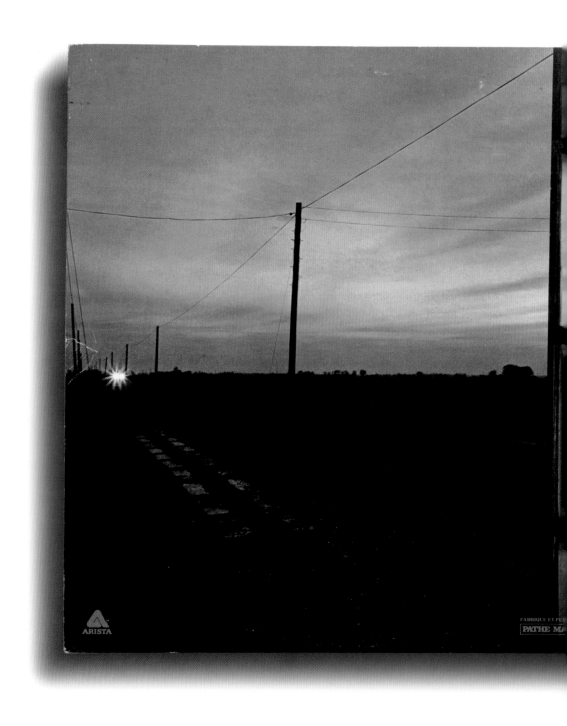

Artist. **Strawbs**
Title. **Deadlines**
Label. Arista - 2C 068 60370
Country. France
Year. 1978
Photo. Unknown
Design. Hipgnosis

Artist. **UFO**
Title. **Force It**
Label. Chrysalis - CHR 1074
Country. England
Year. 1975
Photo. Hipgnosis
Design. Hipgnosis

Artist. **Alvin Lee and Ten Years Later**
Title. **Rocket Fuel**
Label. Polydor - 2310 605
Country. Italy
Year. 1978
Photo. Rob Brimson
Design. Hipgnosis

Artist. **String Driven Thing**
Title. **Please Mind Your Head**
Label. Charisma - CAS 1097
Country. England
Year. 1974
Photo. Unknown
Design. Hipgnosis/Peter Christopherson

Artist. **10cc**
Title. **How Dare You!**
Label. Mercury - 9102 501
Country. England
Year. 1976
Photo. Hipgnosis/Howard Bartrop
Design. Hipgnosis/George Hardie

Artist. **Styx**
Title. **Pieces of Eight**
Label. A&M Records - SP-4724
Country. USA
Year. 1978
Photo. Unknown
Design. Hipgnosis

Artist. **AC/DC**
Title. **Dirty Deeds Done Dirt Cheap**
Label. Atlantic - SD 16033
Country. USA
Year. 1981
Photo. Hipgnosis
Design. Hipgnosis

Artist. **Bethnal**
Title. **Crash Landing**
Label Phonogram-Vertigo - 9102 029
Country. England
Year. 1978
Photo. Hipgnosis
Design. Hipgnosis

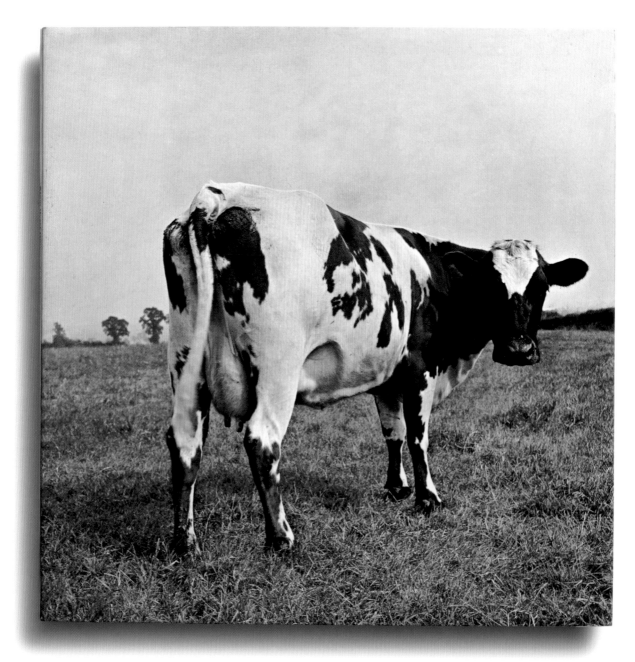

Artist. **Pink Floyd**
Title. **Atom Heart Mother**
Label. Harvest - SHVL 781
Country. England
Year. 1970
Photo. Hipgnosis/John Blake
Design. Hipgnosis

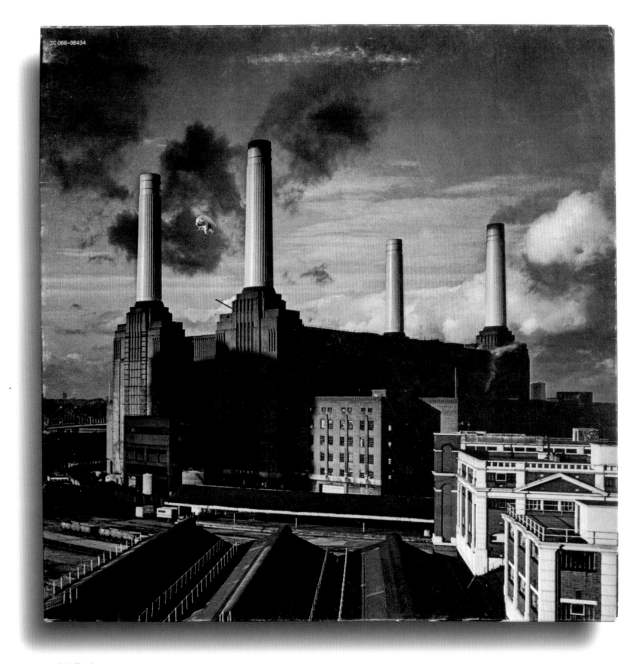

2C 068-98434

Artist. **Pink Floyd**
Title. **Animals**
Label. Harvest - 2C 068-98434
Country. France
Year. 1977
Photo. Hipgnosis/Howard Bartrop
Design. Roger Waters

# Transartistic

Album sleeves constitute veritable photography grammar and vocabulary textbooks. They have featured every technique, from photomontage to solarization, and every main art movement can be found on this format, whether commissioned or not. Jackson Pollock's *White Light* (1954) illustrates the cover of Ornette Coleman's *Free Jazz*, and the number of quattrocento paintings on baroque and classical record covers is countless. LP sleeves feature work by many visual artists, including Yves Klein, Richard Prince, Christopher Wool, Joan Miró, Jean Dubuffet, and Pablo Picasso; some even became musicians in their own right. But Jean-Michel Basquiat probably took the conversation between music and the visual arts the furthest: many of his paintings feature references to musicians— such as Charlie Parker and Louis Armstrong—who influenced his style. The other seminal figure remains Andy Warhol, who explored this relationship in all its forms, illustrating his vision of interconnected art. One of the most radical examples is the index book about the Factory, which includes many pop-ups, such as a 1967 LP portrait of Lou Reed (of the Velvet Underground) and a flexible vinyl record that needed to be ripped out in order to be played. Robert Rauschenberg, pop art's other leading figure, also worked with musicians, especially the Talking Heads: for *Speaking in Tongues*, a photograph printed on acetate literally and figuratively enriches the colorful vinyl record. But Warhol and Rauschenberg are not the only visual artists who used photography to illustrate their tastes in music. So did Allan Kaprow, who listened to a lot of John Cage. Another famous artist, Joseph Beuys, created highly sought-after silk-screen prints for long, improvisational sound tracks. Photographer and visual artist Dieter Roth worked in every possible medium, pushing his boundaries and becoming a musician on the edge of noise. Martin Kippenberger "illuminated" a self-produced record echoing his transgender performances. A hundred copies were made of this unidentified sound object (garage? rock? punk?) that came accompanied by a booklet with his photos. He put everything together by hand, which means no two covers were alike: the artist became an artisan. Harry Bertoia assembled metal rods to make sound sculptures and create atmospheric flows, and made a series of eleven albums soberly called Sonambient, based on public concerts. In the following century, Jeff Koons would do the opposite. His reconceived Venus sums up the iconic star of the 2.0 years: the artist's vision and industrial production were now one and the same.

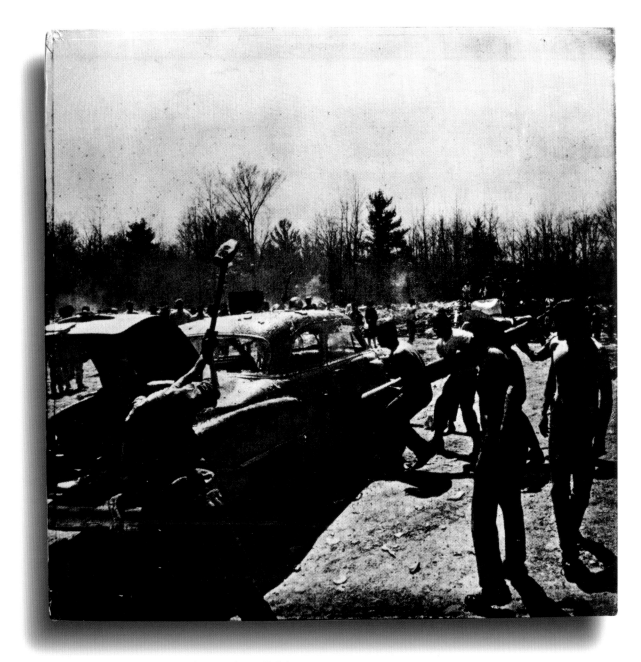

Artist. **Allan Kaprow**
Title. **How to Make a Happening**
Label. Mass Art Inc. - M-132
Country. USA
Year. 1966
Photo. Sol Goldberg
Design. Unknown

Silk-screened cover with photo
from Allan Kaprow's happening
*Household*, Cornell University, 1964.

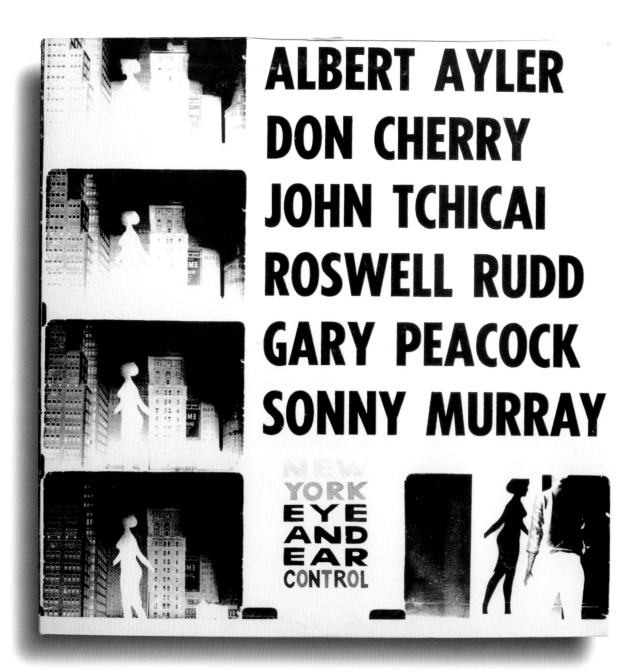

Artist. **Various**
Title. **New York Eye and Ear Control**
Label. ESP-Disk' - 1016
Country. USA
Year. 1966
Photo. Michael Snow
Design. Michael Snow

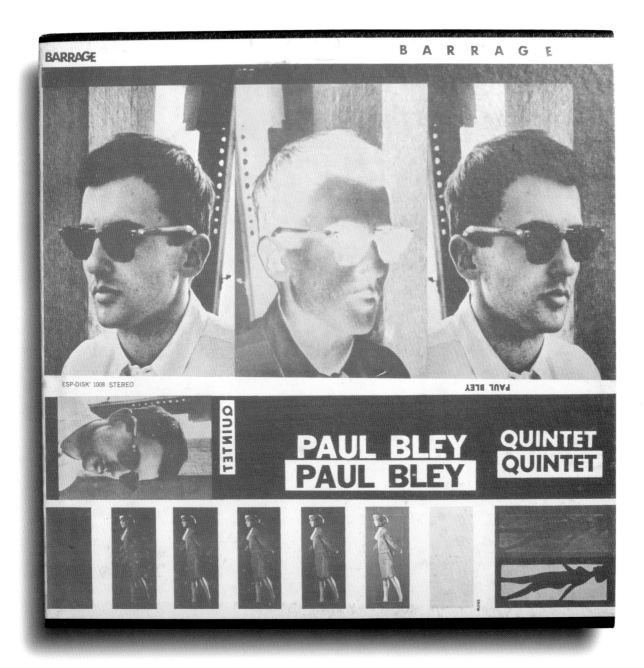

Artist. **Paul Bley Quintet**
Title. **Barrage**
Label. ESP-Disk' - 1008
Country. USA
Year. 1965
Photo. Sy Johnson
Design. Michael Snow

Artist. **Andy Warhol**
Title. **Andy Warhol's Index (Book)**
Publisher. Random House
Country. USA
Year. 1967
Photo. Andy Warhol
Design. Andy Warhol

Book including many pop-ups.
Among them, a flexi disk by Lou Reed.

Artist. **Talking Heads**
Title. **Speaking in Tongues**
Label. Sire - 92-3771-1
Country. USA
Year. 1983
Artwork. Robert Rauschenberg
Design. Unknown

Artist. **Albrecht/d. and Joseph Beuys**
Title. **Performance at the ICA London 1.Nov.1974**
Label. Samadhi Records - 1003
Country. Germany
Year. 1976
Photo. Chris Schwarz
Artwork. Joseph Beuys
Design. Unknown

Edition of 99 copies,
all signed and numbered.
Original silk-screen on cardboard.

Artist. **George Segal**
Title. **Remembrance of Marcel**
Label. Experiments in Art
and Technology, Inc.
Country. USA
Year. 1973
Photo. Walter Russell
Design. George Segal

Edition of 25 copies, all signed
and numbered.

Artist. **Martin Kippenberger**
Title. **Luxus**
Label. S. O. 36 Records
Country. USA
Year. 1979
Photo. Martin Kippenberger
Design. Unknown

6-page stapled booklet.
Each page can be a cover.

BERNARD HEIDSIECK        FRANCOISE JANICOT

# ENCOCONNAGE

Guy Schraenen
éditeur

Artist. **Bernard Heidsieck / Françoise Janicot**
Title. **Encoconnage**
Label. Guy Schraenen Éditeur - GSCH 002
Country. Belgium
Year. 1974
Photo. Guy Schraenen
Design. Françoise Janicot

Artist. **Harry Bertoia**
Title. **Sonambient: Ocean Mysteries/Softly Played**
Label. Self-released - F/W 1031
Country. USA
Year. 1979
Photo. Beverly Twitchell
Design. Unknown

Artist. **Harry Bertoia**
Title. **Sonambient: Bellissima Bellissima Bellissima/Nova**
Label. Self-released - LPS 10570
Country. USA
Year. 1970
Photo. Guy Tomme
Design. Unknown

Artist. **Harry Bertoia**
Title. **Sonambient: Unfolding/ Sounds Beyond**
Label. Self-released - F/W 1025
Country. USA
Year. 1979
Photo. Beverly Twitchell
Design. Unknown

Artist. **Harry Bertoia**
Title. **Sonambient: All and More/ Passage**
Label. Self-released - F/W 1027
Country. USA
Year. 1979
Photo. Beverly Twitchell
Design. Unknown

Artist. **Harry Bertoia**
Title. **Sonambient: Swift Sounds/ Phosphorescence**
Label. Self-released - F/W 1024
Country. USA
Year. 1979
Photo. Beverly Twitchell
Design. Unknown

Artist. **Harry Bertoia**
Title. **Sonambient: Space Voyage/
Echoes of Other Times**
Label. Self-released - F/W 1023
Country. USA
Year. 1979
Photo. Beverly Twitchell
Design. Unknown

Artist. **Harry Bertoia**
Title. **Sonambient: Here and Now/
Unknown**
Label. Self-released - F/W 1032
Country. USA
Year. 1979
Photo. Beverly Twitchell
Design. Unknown

Artist. **Harry Bertoia**
Title. **Sonambient: Gong Gong/
Elemental**
Label. Self-released - F/W 1026
Country. USA
Year. 1979
Photo. Beverly Twitchell
Design. Unknown

Artist. **Harry Bertoia**
Title. **Sonambient: Continuum/
Near and Far**
Label. Self-released - F/W 1029
Country. USA
Year. 1979
Photo. Beverly Twitchell
Design. Unknown

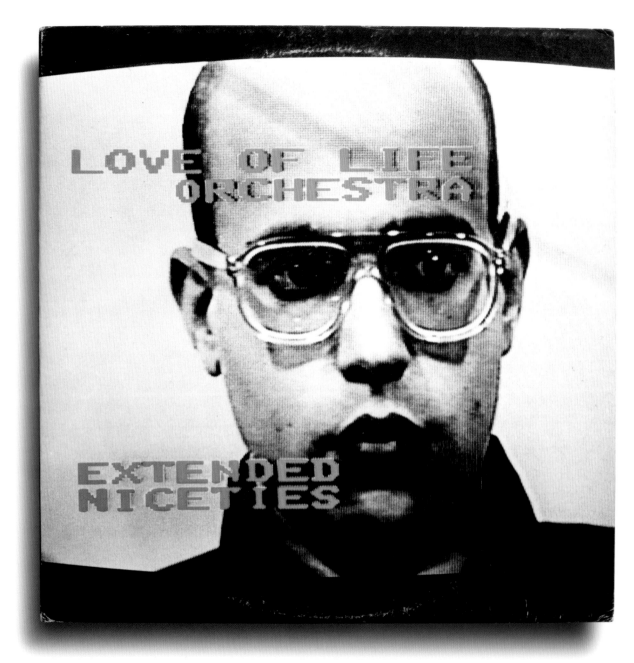

Artist. **Love of Life Orchestra**
Title. **Extended Niceties**
Label. Infidelity - JMB 227
Country. USA
Year. 1980
Photo. John Sanborn
Artwork. Peter Gordon/Laurie Anderson/Catherine Churko
Design. Unknown

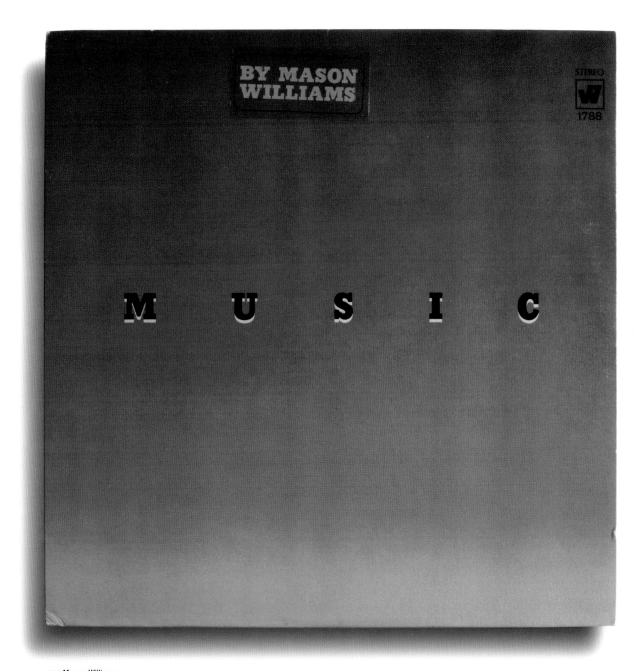

Artist. **Mason Williams**
Title. **Music**
Label. Warner Bros.-Seven Arts Records (W7) - WS 1788
Country. USA
Year. 1969
Artwork. Ed Ruscha
Design. Unknown

Artist. **Dieter Roth/Arnulf Rainer**
Title. **Misch- U. Trennkunst:**
**Autonom-dialogische Thematik**
Label. Dieter Roth's Verlag/Edition
Lebeer-Hossmann - DR 1180
Country. Germany/Austria/Switzerland
Year. 1978
Artwork. Dieter Roth/Arnulf Rainer
Design. Unknown

Edition of 102 copies, all
signed and numbered,
including an original drawing
on the front cover.

Artist. **Dieter Roth/Björn Roth**
Title. **Autofahrt**
Label. Dieter Roth's Verlag/Edition Hansjörg Mayer
Country. Germany
Year. 1979
Artwork. Dieter Roth
Design. Unknown

Edition of 300 copies.

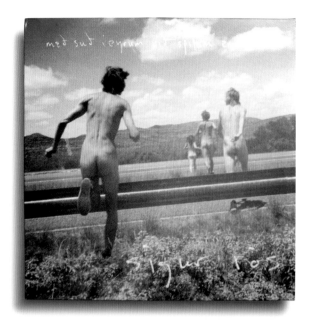

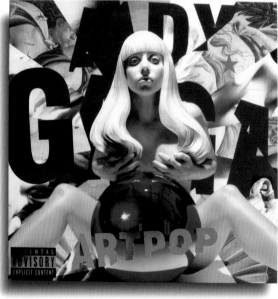

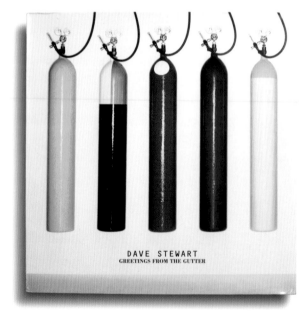

Artist. **Die Sterne**
Title. **Wo Ist Hier**
Label. L'Age d'Or - LADO 17065
Country. Germany
Year. 1999
Artwork. John Baldessari
Design. Bianca Gabriel

Artist. **Lady Gaga**
Title. **Artpop**
Label. Interscope Records/Streamline
Records - B0019295-01
Country. Europe
Year. 2014
Artwork. Jeff Koons
Design. Unknown

Artist. **Sigur Rós**
Title. **Með Suð í Eyrum Við Spilum Endalaust**
Label. XL Recordings/Krúnk - XLLP364
Country. USA
Year. 2008
Photo. Ryan McGinley
Design. Ryan McGinley

Artist. **Dave Stewart**
Title. **Greetings from the Gutter**
Label. EastWest - 4509-97546-1
Country. Germany
Year. 1994
Photo. Mike Parsons
Design. Damien Hirst

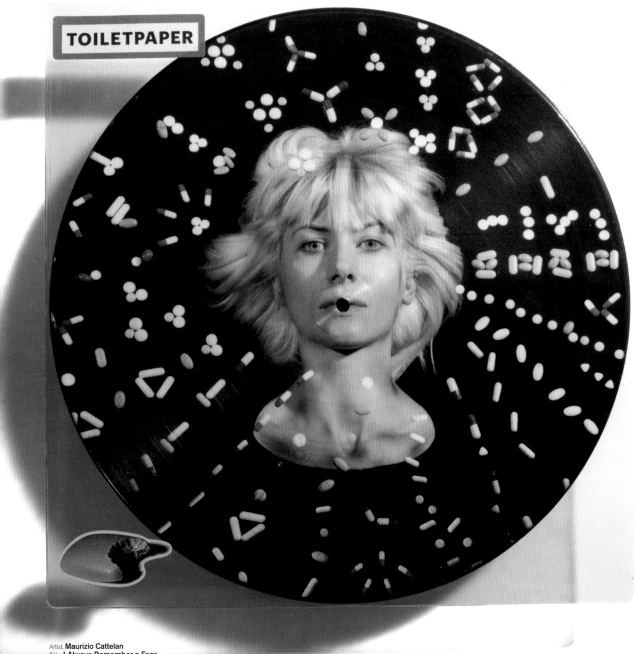

Artist. **Maurizio Cattelan**
Title. **I Always Remember a Face,**
**Especially When I've Sat on It**
Label. The Vinyl Factory - VF081
Country. England
Year. 2013
Photo. Pierpaolo Ferrari
Design. Maurizio Cattelan

Edition of 1000 copies.

# Experimentations: Wojciech Zamecznik

Though little known outside
his native Poland, photographer
Wojciech Zamecznik was also
a designer and graphic artist
who walked in the footsteps of
the Bauhaus and constructivism.
His thought and aesthetic,
at the crossroads of all three
forms of expression, were a
source of inspiration for what
became known as the Polish
School of Posters. A Warsaw
native, Zamecznik intertwined
the graphic arts and
photography, which placed him
at the forefront of the movement
that began in the 1950s. His
work on light included abstract
forms, diaphanous lines, and
diffracted circles, like the
ephemeral traces that can be
seen in this selection of records
made not long before his death
in 1967. Half a century later,
these fascinating images are as
compelling as ever, still offering
multiple perspectives: their
dreamlike magnetism could
accompany electronic music
as well as Maurice Ravel's
enigmatic compositions.

międzynarodowy
festiwal
muzyki
współczesnej
**warszawska**
**jesień**

festival
international
de musique
contempo-
raine
**automne**
**de**
**varsovie**

MUZA
*Polskie Nagrania*
HI-FI

Artist. **Henryk Mikolaj Górecki/Zbigniew Turski**
Title. **Warszawska Jesień 1966: Automne de Varsovie**
Label. Polskie Nagrania Muza
Country. Poland
Year. 1966
Photo. Unknown
Design. Wojciech Zamecznik

Artist. **Krzysztof Penderecki/Grazyna Bacewicz/Artur Malawski**
Title. **Tren Pamieci Ofiar Hiroszmy/Muzyka Na**
**Smyczki Trabki I Perkusje/Etiudy Symfoniczne**
Label. Polskie Nagrania Muza - XL 0171
Country. Poland
Year. 1962
Photo. Unknown
Design. Wojciech Zamecznik

WARSAW NATIONAL PHILHARMONIA
WITOLD ROWICKI – CONDUCTOR

MUZA
Polskie Nagrania
XL 0101     HI-FI

# MENDELSSOHN-BARTHOLDY
## A MIDSUMMER NIGHT'S DREAM
## SEN NOCY LETNIEJ
## RAVEL BOLERO

Artist. **Warsaw National Philharmonia/
Witold Rowicki**
Title. **Mendelssohn-Bartholdy: Suita "Sen
Nocy Letniej"/Ravel: Bolero**
Label. Polskie Nagrania Muza - XL 0101
Country. Poland
Year. 1961
Photo. Unknown
Design. Wojciech Zamecznik

317

# Propaganda and Slogans

The relationship between politics and music has led to every form of expression. There is a long list of LPs with covers showing musicians' positions vis à vis the Spanish Civil War, the Algerian war of independence, the Vietnam War, the Palestinian question, resistance to dictatorships, the Black Panthers, and so on.

Understood as a strong tool for propaganda, records were also a support for every type of discourse, including those of Nation of Islam founder Louis Farrakhan, Ethiopia's Haile Selassie I, Zaire's Mobutu Sese Seko, Chile's Salvador Allende, Richard Nixon, Martin Luther King, Jr., Malcolm X, and Fidel Castro. The history of the twentieth century is inscribed on vinyl, and the image is often controlled. Examples include French music labels on opposite sides of the political divide: in 1938 Léon Moussinac, writer and film critic of the Communist Party, founded Le Chant du Monde, a label that recorded music from the Soviet people's republics and songs by the politically committed singer Colette Magny. Meanwhile, Jean-Marie Le Pen and former Waffen-SS officer Léon Gaultier created SERP (Société d'Études et de Relations Publiques, or Society of Public Relations and Studies) which made albums of military songs, including those by the Third Reich and the Red Army.

In 1941, Woody Guthrie taped a piece of paper to his guitar that said, "This machine kills fascists." Thirty years later, when militant music was the sound track of decolonization, the opposition leader and pan-African advocate Fela Kuti said, "Music is the weapon of the future." The 2.0 generation often took the same side as their elders. Nobody doubts the power of songs such as Boris Vian's "Le déserteur" (The deserter) and Carver Neblett's rendition of "If You Miss Me at the Back of the Bus": "If you miss me in the cotton field,/ and you can't find me nowhere,/ Come on down to the court house,/I'll be voting right there . . ." Many record covers stressed the struggle against oppression and the fight for civil rights; soul and jazz were on the front lines.

The late 1960s were a particularly fertile period; many 1968 slogans inspired music records. Ten years later, the global economic crisis resounded in punk music, which also sought out shocking imagery. Rage Against the Machine chose the image of a self-immolating monk to protest the Chinese regime's violence and as a symbol to denounce an unjust world. A world in the nuclear age, as Count Basie's atomic big band attests, and a world that ground men down by the thousands, as Salgado showed in the mines of Minas Gerais, Brazil. Pictures of the moon opened up other horizons. Numerous images that marked the history of the twentieth century were taken up, some distorted, such as the image of GIs planting the flag of victory.

Artist. **The Black Voices**
Title. **On the Street in Watts**
Label. ALA Records - ALA 1970
Country. USA
Year. 1969
Photo. Dominic Belmonte
Design. Howard Goldstein

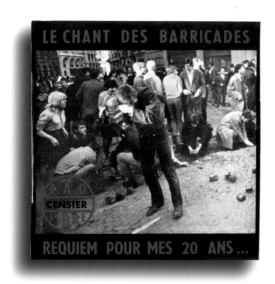

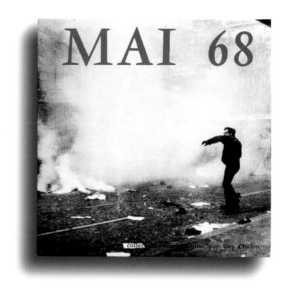

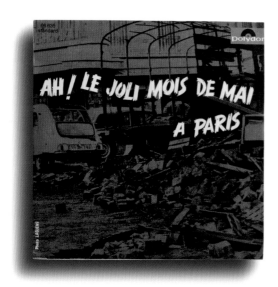

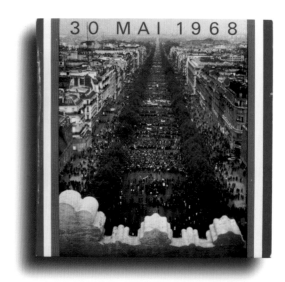

Artist. **C. A. D. Libre**
Title. **Le Chant des Barricades/ Requiem pour Mes 20 Ans**
Label. C. A. D. Censier – 005
Country. France
Year. 1968
Photo. Paris-Match
Design. Unknown

Artist. **Comité d'Action du Théâtre de l'Épée de Bois**
Title. **Ah! Le Joli Mois de Mai à Paris/ Les Bons Citoyens**
Label. Polydor – 66 635
Country. France
Year. 1968
Photo. Laguens
Design. Unknown

Artist. **Guy Chalon/Yuri Korolkoff**
Title. **Mai 68**
Label. Acousti Yuri Korolkoff
Country. France
Year. 1968
Photo. Élie Kagan
Design. Unknown

Artist. **Général de Gaulle**
Title. **30 Mai 1968**
Label. Disques Déesse – DDP 119
Country. France
Year. 1968
Photo. Unknown
Design. Unknown

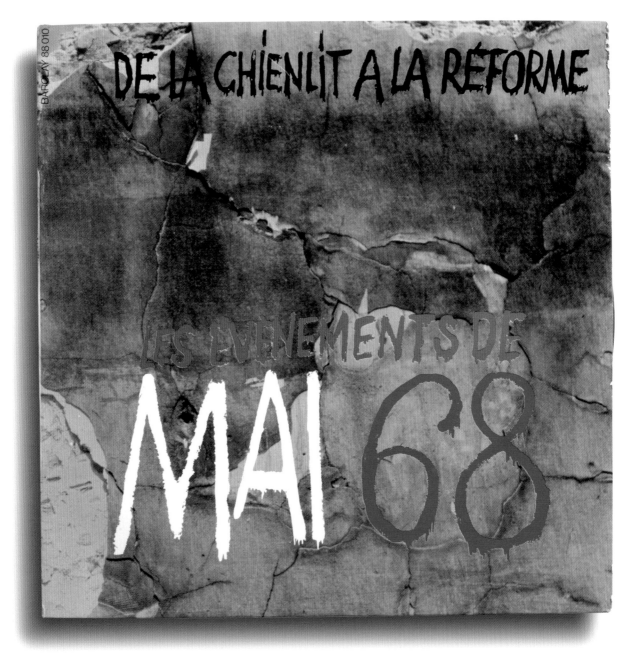

Artist. **De la Chienlit à la Reforme**
Title. **Les Événements de Mai 68**
Label. Barclay - 88010
Country. France
Year. 1968
Photo. Unknown
Design. Unknown

Artist. **Glasgow Song Guild**
Title. **Ding Dong Dollar: Anti-Polaris and Scottish Republican Songs**
Label. Folkways Records - FD 5444
Country. USA
Year. 1962
Photo. Unknown
Design. Ronald Clyne

Artist. **Mario Buffa Moncalvo/Luigi Nono**
Title. **San Vittore 1969**
Label. Ricordi - SMRP 9080
Country. Italy
Year. 1971
Photo. Unknown
Design. Unknown

Artist. **Dick Gregory**
Title. **At Kent State**
Label. Poppy - PYS 5600
Country. USA
Year. 1971
Photo. United Press International
Design. Milton Glaser/Push Pin Studios

Artist. **Luigi Nono**
Title. **Un Volto, E Del Mare/
Non Consumiamo Marx**
Label. Philips - 6521 027
Country. France
Year. 1969
Photo. Paris-Match
Design. Unknown

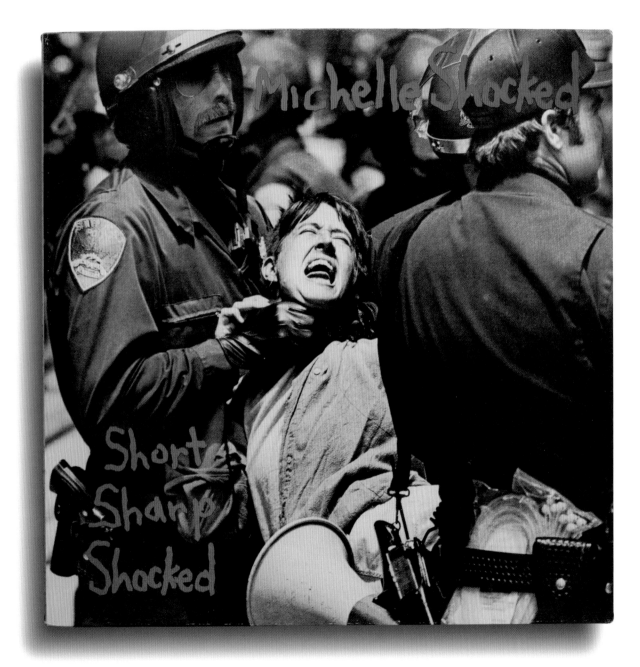

Artist. **Michelle Shocked**
Title. **Short Sharp Shocked**
Label. Mercury - 834 924-1
Country. USA
Year. 1988
Photo. Chris Hardy
Design. Helen Namm

Artist. **Various**
Title. **Compañero Presidente**
Label. Casa de las Américas - LD-CA-M-20
Country. Cuba
Year. 1975
Photo. Unknown
Design. Umberto Peña

Artist. **Maurice Bitter**
Title. **Chants Révolutionnaires de Cuba**
Label. Visages du Monde - A1339
Country. France
Year. Unknown
Photo. Unknown
Design. Unknown

Artist. **Various**
Title. **闘争の詩: "Who is a Leader?"**
Label. Elec Records - LP-1004
Country. Japan
Year. 1973
Photo. T. Kurihara/F. Ishikawa/H. Tanaka
Design. Unknown

Artist. **Che Guevara**
Title. **The Voice of the Revolution**
Label. Cleopatra Records - CLP 2430
Country. USA
Year. 2008
Photo. Alberto Korda
Design. Unknown

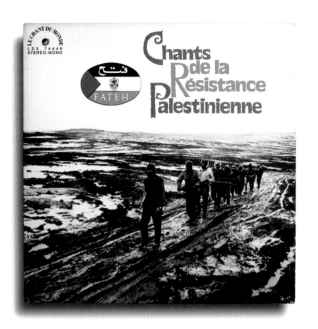

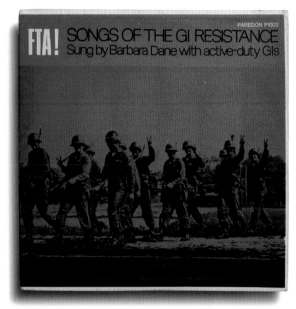

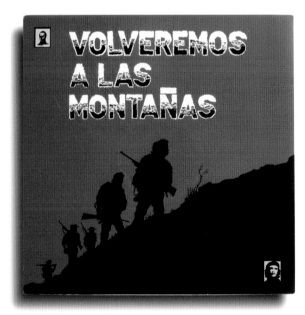

Artist. **Fateh**
Title. **Chants de la Résistance Palestinienne**
Label. Le Chant du Monde - LDX 74446
Country. France
Year. Unknown
Photo. Bruno Barbey
Design. Roland Gonzalez

Artist. **Various**
Title. **Volveremos a las Montañas**
Label. ELN
Country. France
Year. 1969
Photo. Unknown
Design. Unknown

Artist. **Barbara Dane**
Title. **FTA! Songs of the GI Resistance**
Label. Paredon Records - P1003
Country. USA
Year. 1970
Photo. Carolyn Mugar
Design. Ronald Clyne

Series. **Hommes et Faits du XXᵉ Siècle**
Title. **La Guerre d'Espagne (1936–1939)**
Label. SERP Disques - HF07
Country. France
Year. Unknown
Photo. Unknown
Design. Unknown

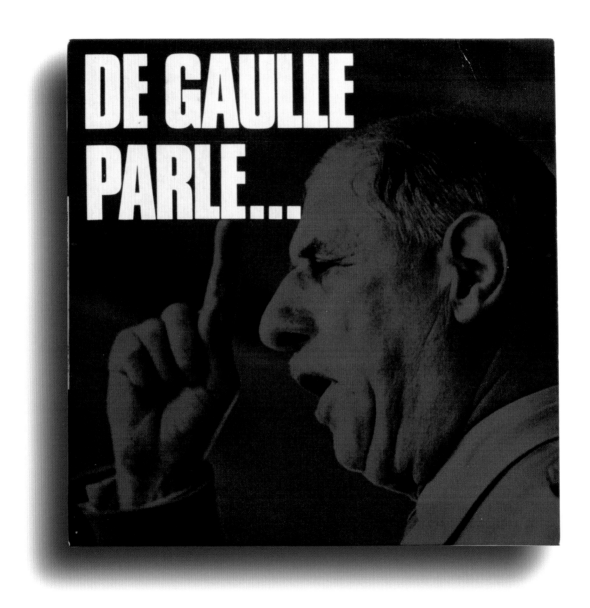

Artist. **Charles de Gaulle**
Title. **De Gaulle Parle . . .**
Label. Guilde Internationale du Disque - SMS 600
Country. France
Year. 1965
Photo. Magnum Photos
Design. Unknown

HOMMES ET FAITS DU XX<sup>e</sup> SIÈCLE
## LA GUERRE D'ALGÉRIE
I - LE 13 MAI 1958

HOMMES ET FAITS DU XX<sup>e</sup> SIÈCLE
## LA GUERRE D'ALGÉRIE
II - LES BARRICADES

HOMMES ET FAITS DU XX<sup>e</sup> SIÈCLE
## LA GUERRE D'ALGÉRIE
III - LE PUTSCH

HOMMES ET FAITS DU XX<sup>e</sup> SIÈCLE
## LA GUERRE D'ALGÉRIE
IV - L'O. A. S.

Series. **Hommes et Faits du XX<sup>e</sup> Siècle**
Title. **La Guerre d'Algérie Vol. I:**
**Le 13 Mai 1958**
Label. SERP Disques - HF09/1
Country. France
Year. Unknown
Photo. Unknown
Design. Unknown

Series. **Hommes et Faits du XX<sup>e</sup> Siècle**
Title. **La Guerre d'Algérie Vol. III:**
**Le Putsch d'Avril 1961**
Label. SERP Disques - HF09/3
Country. France
Year. Unknown
Photo. Magnum Photos
Design. Unknown

Series. **Hommes et Faits du XX<sup>e</sup> Siècle**
Title. **La Guerre d'Algérie Vol. II:**
**Les Barricades**
Label. SERP Disques - HF09/2
Country. France
Year. Unknown
Photo. Dalmas
Design. Unknown

Series. **Hommes et Faits du XX<sup>e</sup> Siècle**
Title. **La Guerre d'Algérie**
**Vol. IV: L'O.A.S.**
Label. SERP Disques - HF09/4
Country. France
Year. Unknown
Photo. A. F. P.
Design. Unknown

Artist. **Charles de Gaulle**
Title. **Oui à la France et à l'Algérie**
Label. Unknown
Country. France
Year. 1960
Photo. Unknown
Design. Unknown

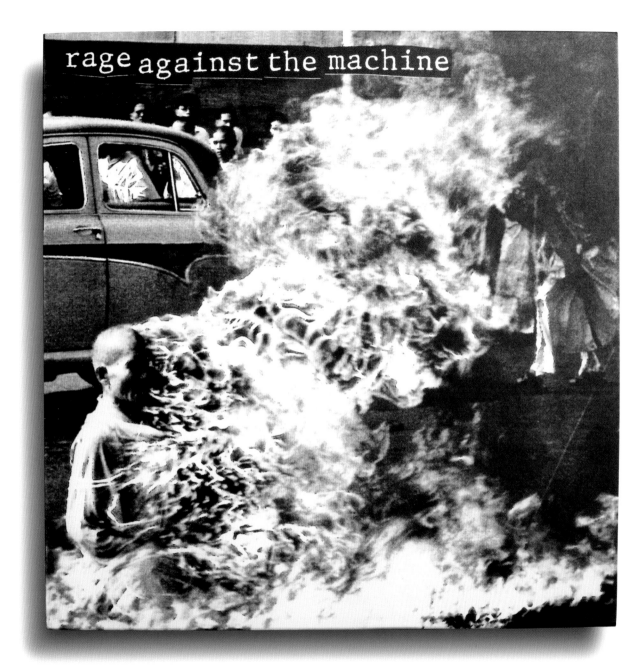

Artist. **Rage Against the Machine**
Title. **Rage Against the Machine**
Label. Epic Records - 52959
Country. USA
Year. 1992
Photo. Malcolm Browne
Design. Nicky Lindeman

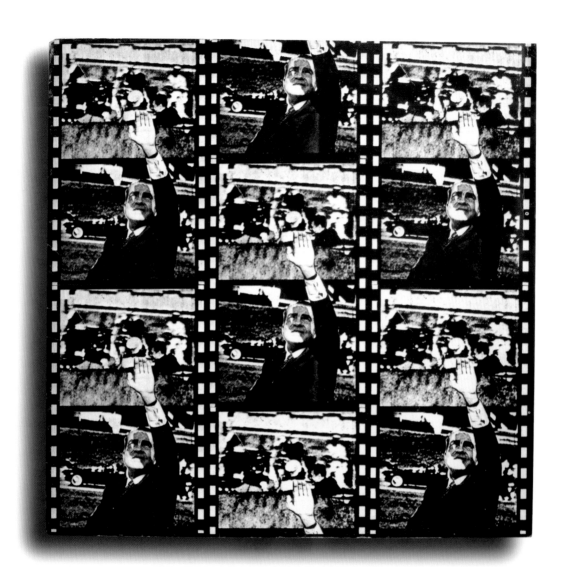

Artist. **Jan Herman**
Title. **Election Day Tape**
Label. Nova Broadcast - WRS-371
Country. USA
Year. 1969
Photo. Unknown
Design. Unknown

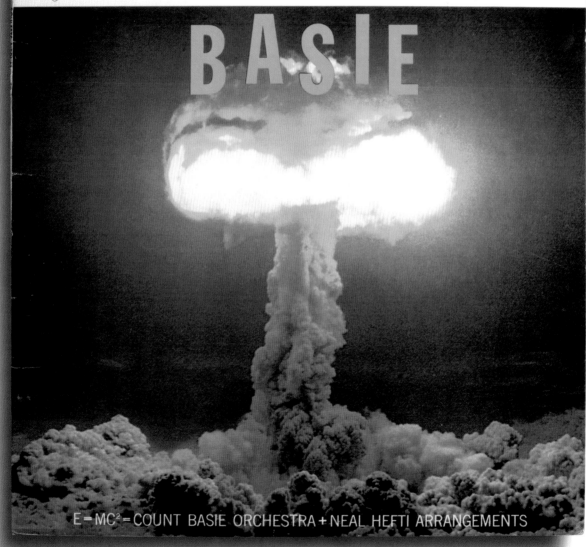

DYNAMIC STEREO

ROULETTE
DYNAMIC HIGH FIDELITY
BIRDLAND SERIES
SR-52003

BASIE

$E = MC^2 = $ COUNT BASIE ORCHESTRA + NEAL HEFTI ARRANGEMENTS

Artist. **Count Basie**
Title. **Basie**
Label. Roulette Records - SR-52003
Country. USA
Year. 1958
Photo. Unknown
Design. Unknown

Artist. **Wu-Tang Clan**
Title. **Iron Flag**
Label. Loud Records - C2 86236
Country. USA
Year. 2001
Photo. Michael Lavine
Design. Julian Alexander

Artist. **Uriah Heep**
Title. **Conquest**
Label. Bronze - BRONX 524
Country. England
Year. 1980
Photo. Martin Poole
Design. Martin Poole/Karl Bosley/Lindy Curry

Artist. **Canned Heat**
Title. **Future Blues**
Label. Liberty - LST-11002
Country. USA
Year. 1970
Photo. Skip Taylor
Design. Ron Wolin

Artist. **Savatage**
Title. **Fight for the Rock**
Label. Atlantic - 81634-1
Country. USA
Year. 1986
Photo. Andrew Unangst
Design. Bob Defrin

One Small Step

Narrated by Dr. Wernher von Braun and Chet Huntley

Artist. **Wernher von Braun/Chet Huntley**
Title. **One Small Step**
Label. RCA Red Seal - X4RM-1283
Country. USA
Year. 1969
Photo. NASA Photos
Design. Unknown

Artist. **Various**
Title. **I Have a Dream: The Rev. Dr. Martin Luther King, Jr. 1929–1968**
Label. 20th Century Fox Records - TSF-3201
Country. USA
Year. 1968
Photo. Unknown
Design. William Duevell/Henry Epstein

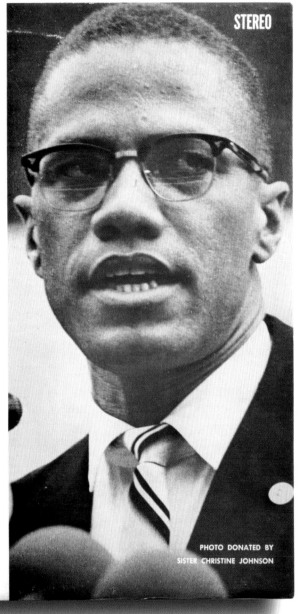

# The MALCOLM X MEMORIAL
## (A TRIBUTE IN MUSIC)

PHILIP COHRAN AND THE
ARTISTIC HERITAGE ENSEMBLE

ZULU RECORD CO.
942 EAST 75TH STREET • CHICAGO, ILLINOIS 60619
312 / 846-9090

Distributed Exclusively By The RECORD CENTER 811 WEST 79TH STREET • CHICAGO, ILLINOIS 60620

STEREO

PHOTO DONATED BY
SISTER CHRISTINE JOHNSON

Artist. **Philip Cohran and the Artistic Heritage Ensemble**
Title. **The Malcolm X Memorial (A Tribute in Music)**
Label. Zulu Records - MR-016
Country. USA
Year. 1970
Photo. Christine Johnson
Design. Unknown

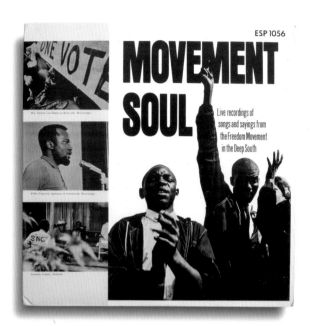

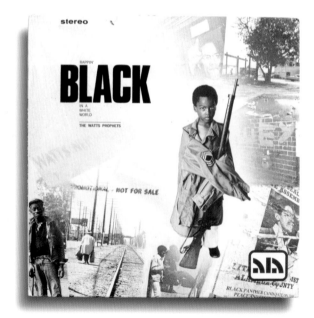

Artist. **Various**
Title. **Movement Soul: Live Recordings of Songs and Sayings from the Freedom Movement in the Deep South**
Label. ESP-Disk' - 1056
Country. USA
Year. 1967
Photo. Danny Lyon
Design. Unknown

Artist. **Minister Louis Farrakhan**
Title. **Heed the Call Ya'll**
Label. Final Call Records - FCR-101
Country. USA
Year. 1980
Photo. Raz Enterprises
Design. Larry X. Prescott

Artist. **Angela Davis**
Title. **Soul and Soledad**
Label. Flying Dutchman Records - FD-10141
Country. USA
Year. 1971
Photo. B. B. M. Associates
Design. Ultura Concepts

Artist. **The Watts Prophets**
Title. **Rappin' Black in a White World**
Label. ALA Records - ALA 1971
Country. USA
Year. 1971
Photo. Dominic Belmonte
Design. Howard Goldstein

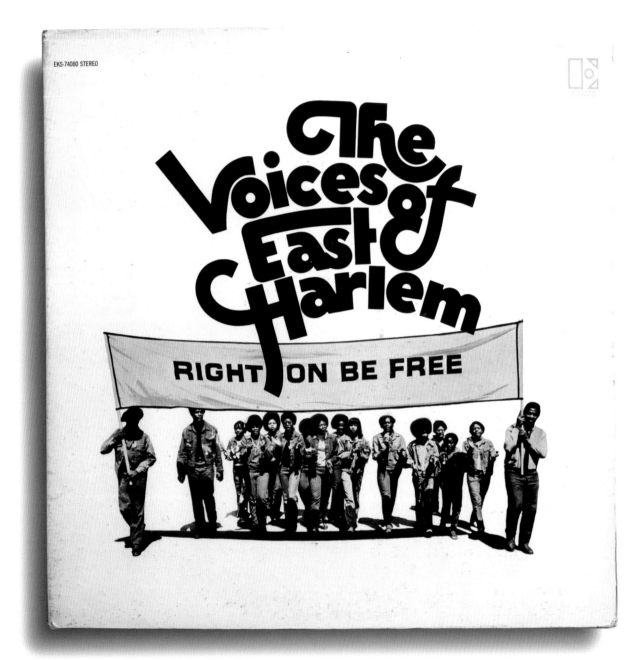

EKS-74080 STEREO

Artist. **The Voices of East Harlem**
Title. **Right On Be Free**
Label. Elektra Records - EKS-74080
Country. USA
Year. 1970
Photo. Jan Blom/Bruce Davidson/Carl Samrock
Design. Unknown

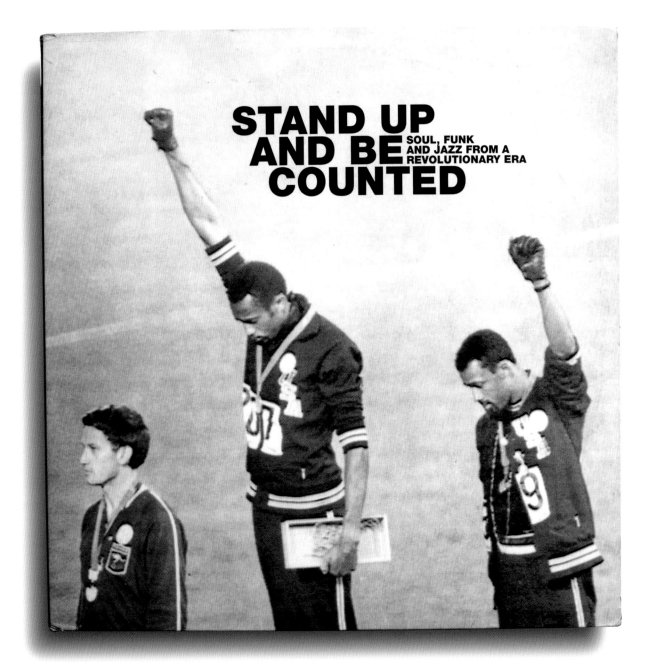

STAND UP
AND BE SOUL, FUNK
COUNTED AND JAZZ FROM A
REVOLUTIONARY ERA

Artist. **Various**
Title. **Stand Up and Be Counted: Soul,**
**Funk, and Jazz from a Revolutionary Era**
Label. Harmless - HURTLP 020
Country. England
Year. 1999
Photo. Unknown
Design. Unknown

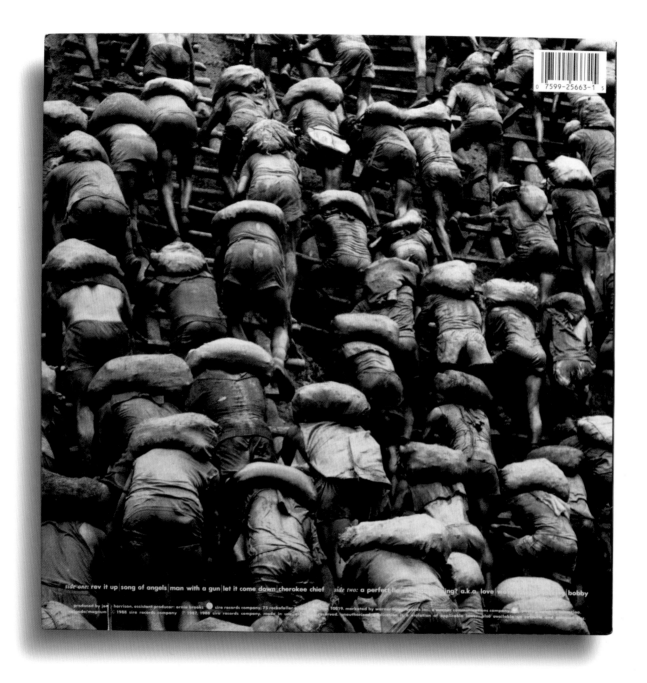

side one: rev it up | song of angels | man with a gun | let it come down | cherokee chief    side two: a perfect li........ing? | a.k.a. love | w........................ bobby

produced by jac..... harrison, assistant producer: arnie brooks ● sira records company, 75 rockefeller .................. 10019. marketed by warner ............ inc, a warner .......munications company ● ............................ cinc.
......da/magnum ☐ 1988 sira records company. ℗ 1987, 1988 sira records company. made in usa, all .......reserved. unauthorized ..plication is a violation of applicable laws. also available ......n cassette and ...............

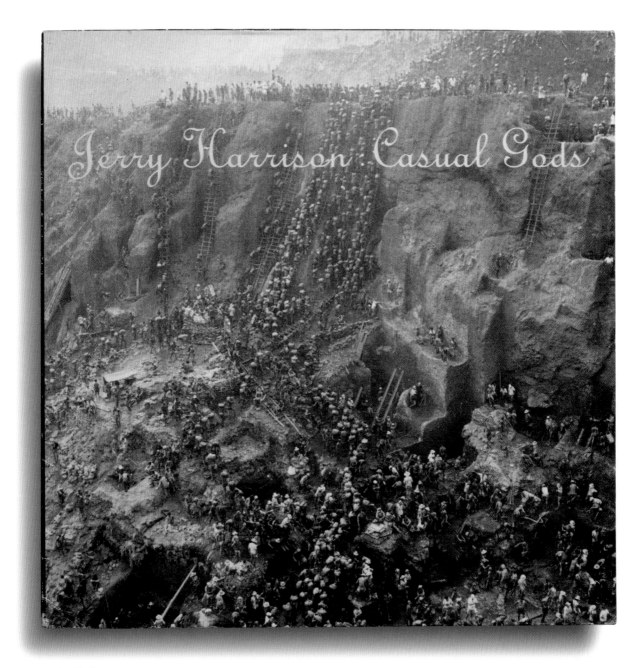

Artist. **Jerry Harrison**
Title. **Casual Gods**
Label. Sire - 9 25663-1
Country. USA
Year. 1988
Photo. Sebastião Salgado
Design. M & Co.

# Photo Shock: Below the Belt

"Out of every material, it's wax she prefers." Record covers do not escape the inquiring gazes of the aesthetic police taking it upon themselves to enforce morality, although some bands managed to avoid them. An example is *Crache Ton Venin* by Téléphone: you have to slide up the record sleeve to see the naked musicians. A rat on the shoulder of pop's future icon, a bunch of hippies in a bathtub, and invitations to suicide: nothing should shock the public. That's why Capitol withdrew the Beatles' "butcher cover," featuring the band dressed in white smocks and covered with decapitated baby dolls and pieces of meat. And what

about the iconic Nirvana, whose "one-dollar baby" helped build their legend? (And remember Alice Cooper, who was also censored?) *Never Mind the Bollocks*. Puritans hold their noses.

Controversial at best, censored at worst. Of course, sex is always in the eye of the storm, but totems and taboos differ depending on countries, mores, and customs. Photos have been reframed, trimmed, even replaced. When Yoko Ono and John Lennon posed naked, a political gesture to protest the world's crudeness, American moralists had the "scandalous" album cover banned. Richard

Dumas was confronted with prudishness for his image with Étienne Daho. Keep those breasts under wraps. The same drill goes for Roxy Music. Jimi Hendrix disapproved of the sleeve of *Electric Ladyland*, the legendary flower power album. Then there are David Bowie, the Velvet Underground, the Black Crowes, Herb Alpert, Shakira, Scorpions, and others. No period or genre has a monopoly on "transgression," but a few key artists turned it into a powerful communications tool.

Artist. **The Jimi Hendrix Experience**
Title. **Electric Ladyland**
Label. Reprise Records - 2RS 6307
Country. USA
Year. 1968
Photo. Karl Ferris
Design. Ed Thrasher

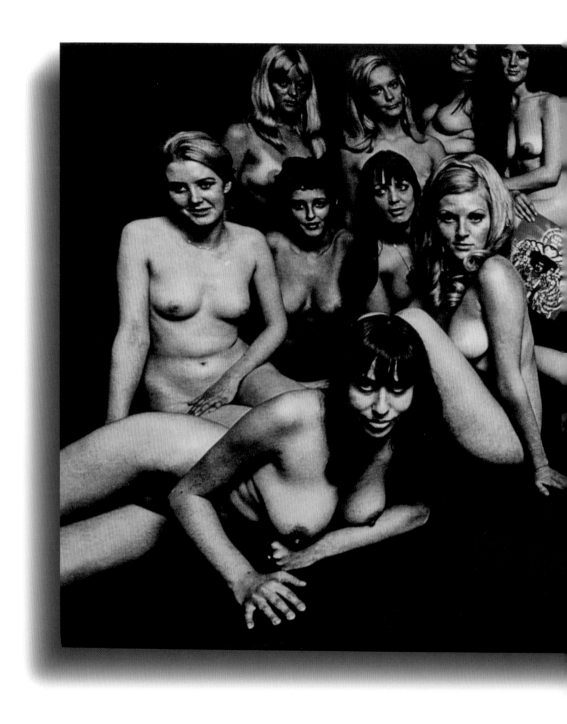

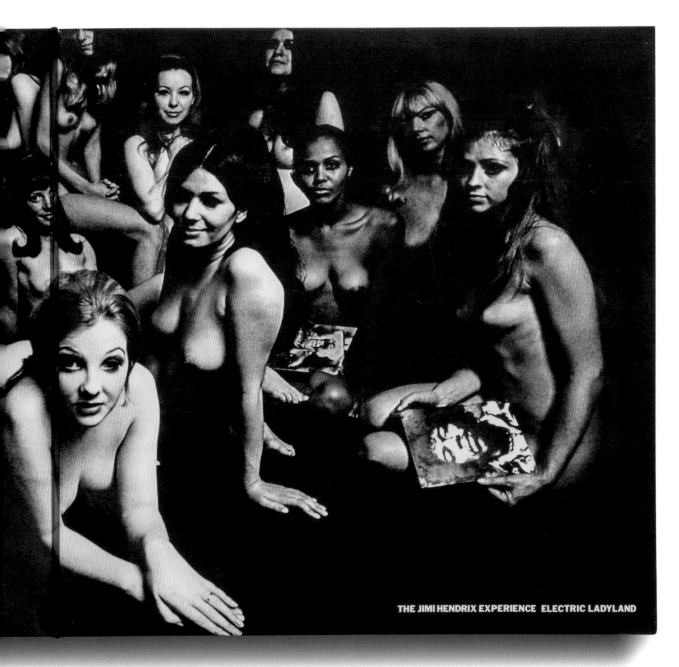

THE JIMI HENDRIX EXPERIENCE ELECTRIC LADYLAND

Artist. **The Jimi Hendrix Experience**
Title. **Electric Ladyland**
Label. Track Record – 613008/9
Country. England
Year. 1968
Photo. David Montgomery
Design. David King

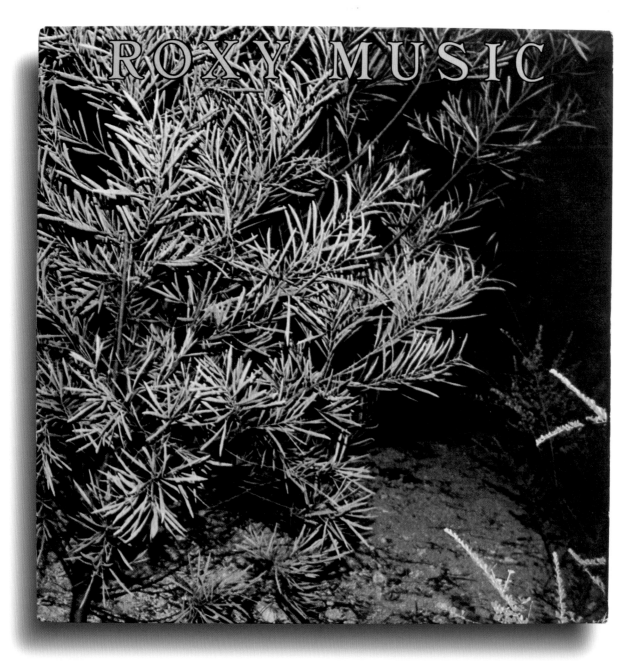

Artist. **Roxy Music**
Title. **Country Life**
Label. ATCO Records - SD 36-106
Country. USA
Year. 1974
Photo. Eric Boman
Design. Nicholas de Ville/Bryan Ferry

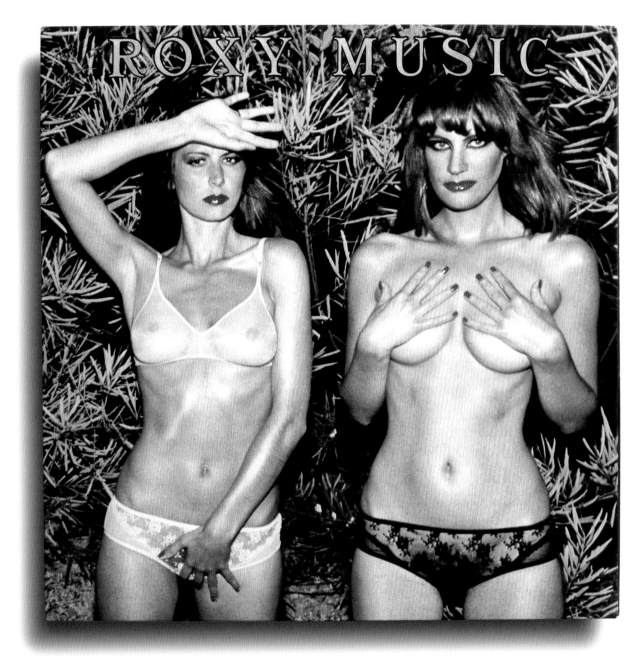

Artist. **Roxy Music**
Title. **Country Life**
Label. Island Records - ILPS 9303
Country. England
Year. 1974
Photo. Eric Boman
Design. Nicholas de Ville/Bryan Ferry

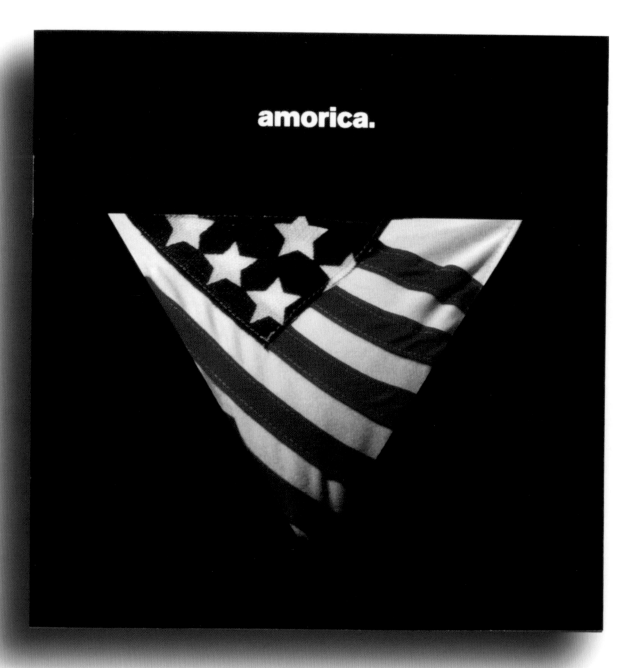

Artist. **The Black Crowes**
Title. **Amorica.**
Label. American Recordings - 74321 24194 2
Country. USA
Year. 1994
Photo. Unknown
Design. Chris Robinson/Janet Levinson

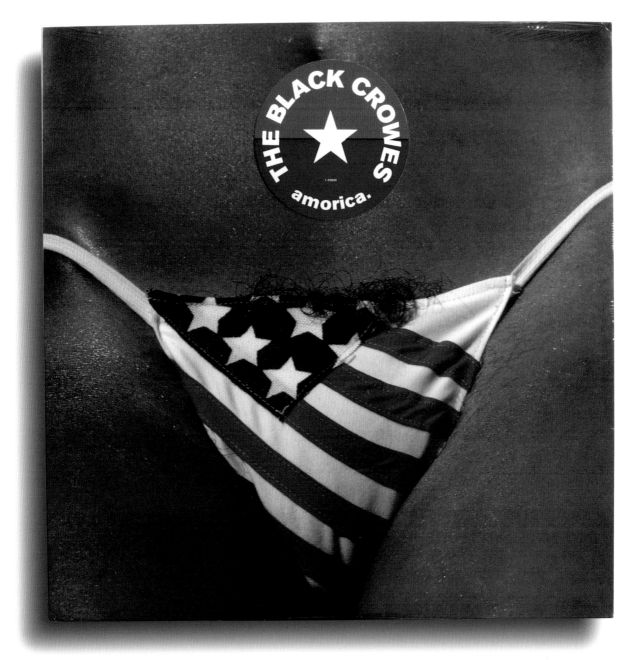

Artist. **The Black Crowes**
Title. **Amorica.**
Label. American Recordings - 9 43000-1
Country. USA
Year. 1994
Photo. Unknown
Design. Chris Robinson/Janet Levinson

# WELCOME TO

# THE BEAUTIFUL SOUTH

Artist. **The Beautiful South**
Title. **Welcome to the Beautiful South**
Label. Go! Discs - FGOLP 16
Country. England
Year. 1989
Photo. Jan Saudek
Design. Unknown

# WELCOME TO

# THE BEAUTIFUL SOUTH

Artist. **The Beautiful South**
Title. **Welcome to the Beautiful South**
Label. Go! Discs - AGOLP 16
Country. England
Year. 1989
Photo. Jan Saudek
Design. Unknown

Artist. **The Rolling Stones**
Title. **Beggars Banquet**
Label. Decca – LK 4955
Country. England
Year. 1968
Design. Unknown

Artist. **The Rolling Stones**
Title. **Beggars Banquet**
Label. ABKCO - 844 471-1
Country. USA
Year. 1986
Photo. Barry Feinstein
Design. Michael Vosse/Tom Wilkes

SCORPIONS SCORPIONS SCORPIONS SCORPIONS SCORPIONS

Rudolf Schenker    Ulrich Roth    Klaus Meine    Herman  Rarebell    Francis Buchholz

TAKEN
BY
FORCE

Artist. **Scorpions**
Title. **Taken by Force**
Label. RCA Victor - PL 28309
Country. Germany
Year. 1977
Photo. Unknown
Design. Unknown

356

Artist. **Scorpions**
Title. **Taken by Force**
Label. RCA - RVP-6232
Country. Japan
Year. 1977
Photo. Michael von Gimbut
Design. Franzl Froeb

# Photo-Copy

The history of music is laden with all kinds of remakes: new versions, called covers, true either in letter or in spirit to the originals. Album sleeves, too, have been imitated; the derivative products becoming a part of the wider range. These "covers" can either be tributes or, conversely, present an opportunity to break away from the historical reference.

In 1984, Joe Jackson, a hard-core jazz lover, opted for the former when he copied Sonny Rollins's famous Blue Note record for his *Body and Soul*—the ultimate standard, note for note. Similarly, the Clash paid tribute to Elvis's legendary album in their manifesto *London Calling*, except for one detail: the guitar is no longer being embraced but smashed. The band released four singles in the same vein, each featuring a different member.

*Sgt. Pepper's Lonely Hearts Club Band* was a breakthrough record packed with conceptual and technical innovations. The album sleeve shattered conventions: in the photo-collage, the Beatles appear in military band uniforms amid a crowd of cultural icons, including Bob Dylan, Lewis Carroll, Carl Jung, Fred Astaire, Marilyn Monroe, Karl Marx, and, in a touch of irony, even wax figures of themselves. A cynical Frank Zappa went further, taking the same idea but choosing the title *We're Only in It for the Money*. And the sleeve of the Sex Pistols' *Bad Boys* featured the world of punk.

Another legendary album sleeve, *Sticky Fingers*, supposedly featuring Joe Dallesandro's crotch photographed by Billy Name, has been adapted worldwide: the Russian mafia made a suggestive bootleg, Mötley Crüe did an all-leather version, and so on. The zipper was zapped in Spain: because of censorship, it was replaced with bloody fingers sticking out of a can.

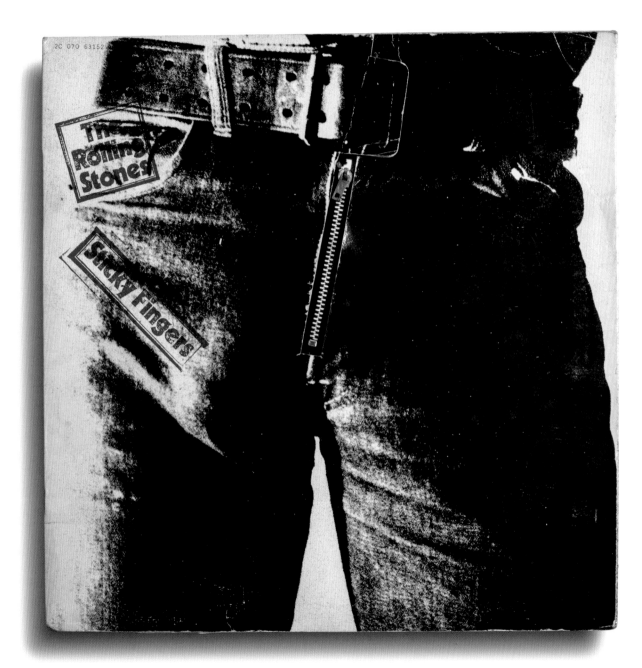

2C 070 63152

Artist. **The Rolling Stones**
Title. **Sticky Fingers**
Label. Rolling Stones Records - COC 59100
Country. England
Year. 1971
Photo. Billy Name
Design. Andy Warhol/Craig Braun

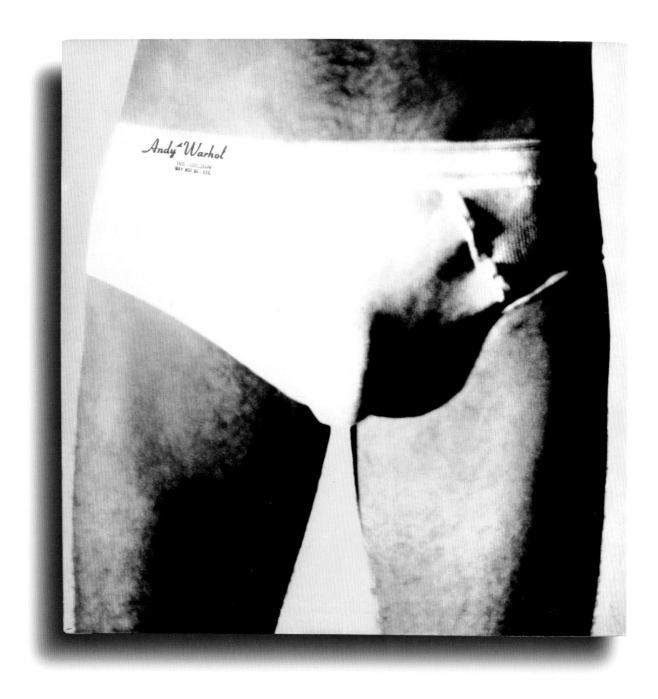

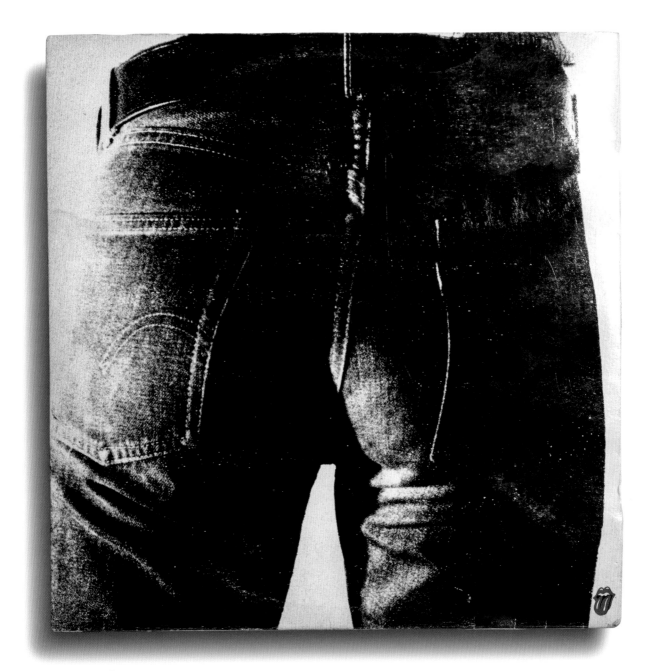

Artist. **The Rolling Stones**
Title. **Sticky Fingers**
Label. Rolling Stones Records - COC 59100
Country. England
Year. 1971
Photo. Billy Name
Design. Andy Warhol/Craig Braun

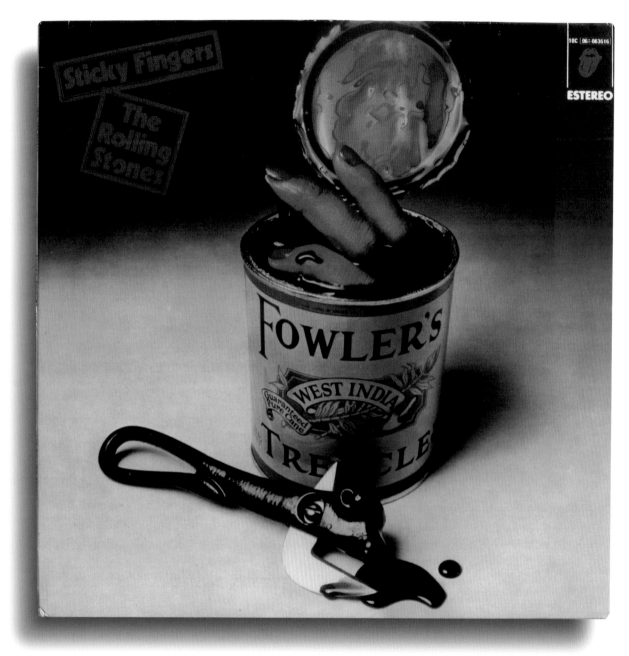

Artist. **The Rolling Stones**
Title. **Sticky Fingers**
Label. Rolling Stones Records - HRSS 591-01
Country. Spain
Year. 1971
Photo. Unknown
Design. John Pasche/Phil Jude

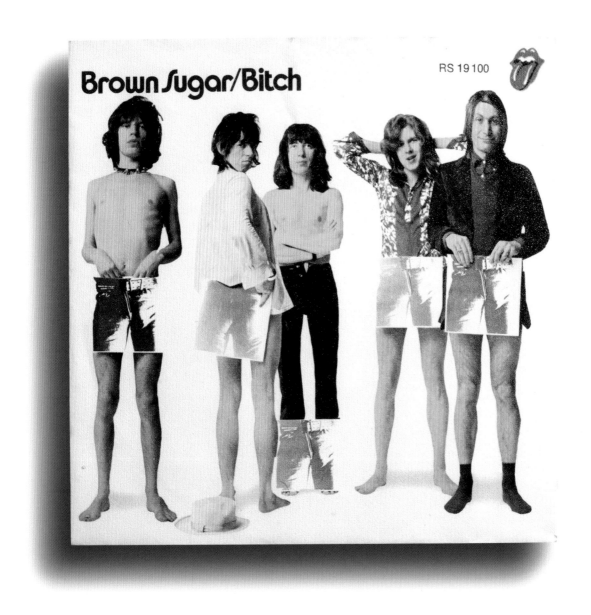

Artist. **The Rolling Stones**
Title. **Brown Sugar/Bitch**
Label. Rolling Stones Records - RS 19100
Country. Germany
Year. 1971
Photo. David Montgomery
Design. Unknown

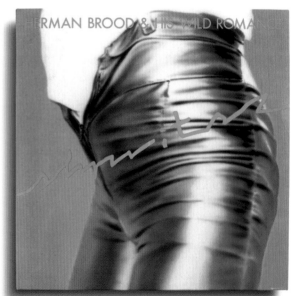

Artist. **ZZ Top**
Title. **Velcro Fly**
Label. Warner Bros. Records - W8650S
Country. England
Year. 1986
Photo. Bob Alford
Design. A. D. Consultants

Artist. **Deep Purple**
Title. **Mark I & II**
Label. Purple Records - 2C 154-94865/6
Country. France
Year. 1974
Photo. Unknown
Design. Unknown

Artist. **The Rolling Stones**
Title. **Sticky Fingers**
Label. AnTrop - П91 00109
Country. Russia
Year. 1992
Photo. Unknown
Design. Unknown

Artist. **Herman Brood & His Wild Romance**
Title. **Shpritsz**
Label. Bubble - 26122 XOT
Country. The Netherlands
Year. 1978
Photo. Unknown
Design. Sylvia Wiggers/Dick van der Weyden

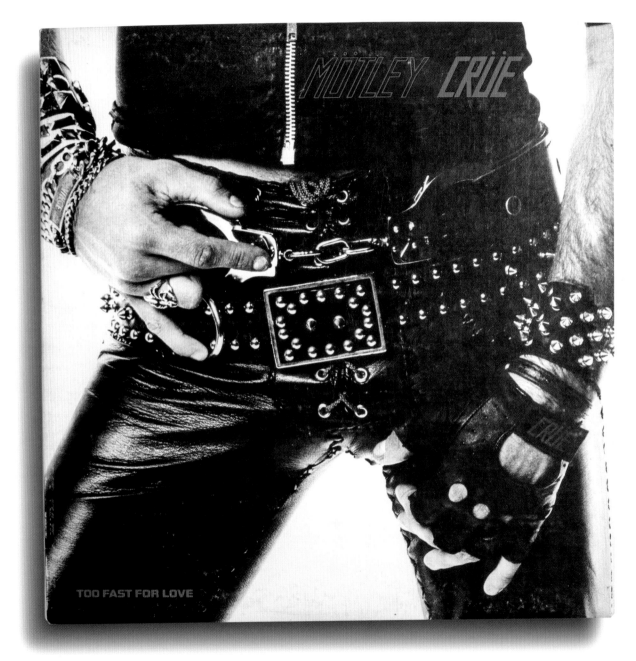

Artist. **Mötley Crüe**
Title. **Too Fast for Love**
Label. Leathür Records - LR/1281-2
Country. USA
Year. 1981
Photo. Michael Pinter
Design. Coffman and Coffman Productions

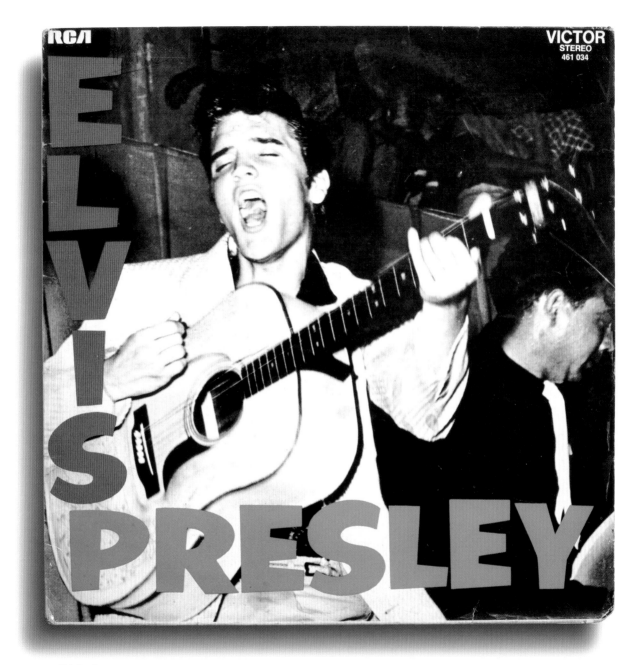

Artist. **Elvis Presley**
Title. **Elvis Presley**
Label. RCA Victor - 461 034
Country. France
Year. 1973 (original release USA,1956)
Photo. William V. "Red" Robertson
Design. Unknown

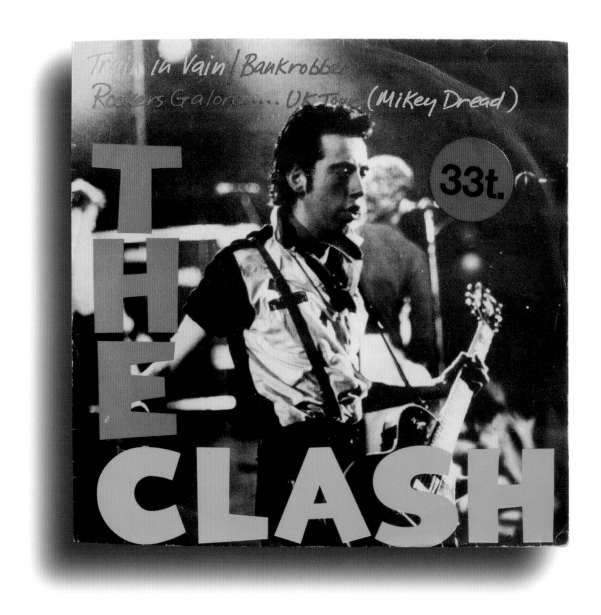

Artist. **The Clash**
Title. **Train in Vain/Bankrobber**
Label. CBS - CBS 8370
Country. France
Year. 1980
Photo. Debra Kronick
Design. Unknown

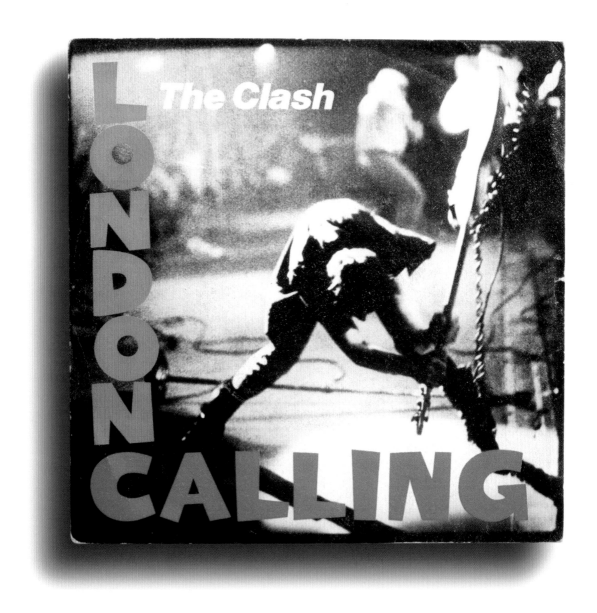

Artist. **The Clash**
Title. **London Calling**
Label. CBS - CBS CLASH 3
Country. England
Year. 1979
Photo. Pennie Smith
Design. Ray Lowry

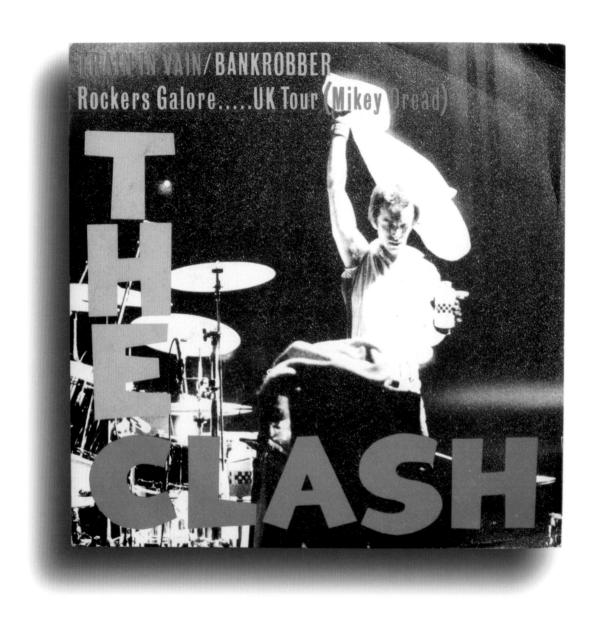

Artist. **The Clash**
Title. **Train in Vain/Bankrobber**
Label. CBS - CBS 8370
Country. Spain
Year. 1980
Photo. Pennie Smith
Design. Ray Lowry

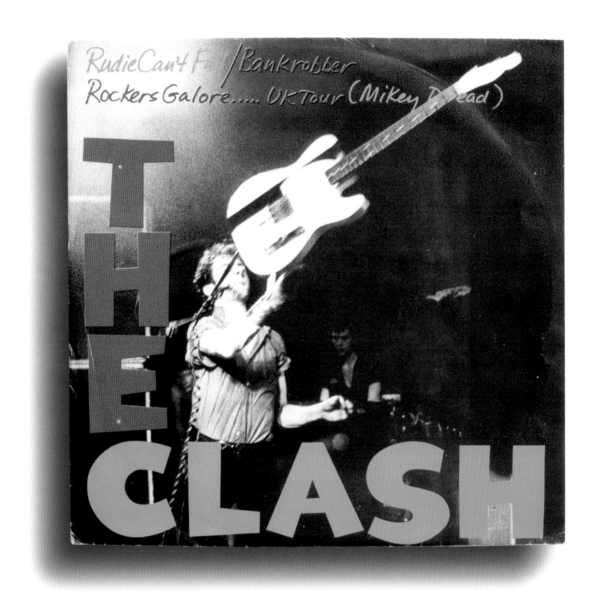

Artist. **The Clash**
Title. **Rudie Can't Fail**
Label. CBS - CBS 8383
Country. The Netherlands
Year. 1979
Photo. Pennie Smith
Design. Ray Lowry

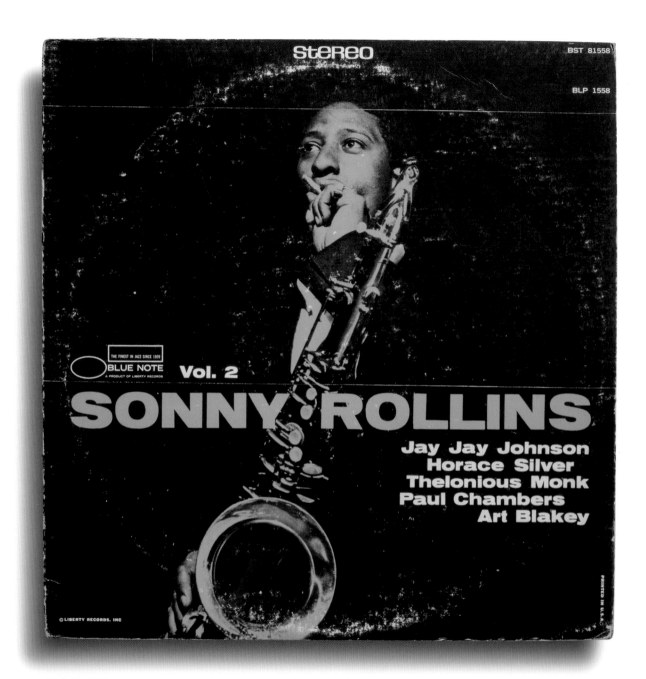

Artist. **Sonny Rollins**
Title. **Volume 2**
Label. Blue Note – BST 81558
Country. USA
Year. 1957
Photo. Francis Wolff
Design. Harold Feinstein

372

A&M SP5000

# JOE JACKSON
### Body and Soul

Artist. **Joe Jackson**
Title. **Body and Soul**
Label. A&M Records - SP5000
Country. USA
Year. 1984
Photo. Charles Reilly
Design. Quantum

Artist. **The Mothers of Invention**
Title. **We're Only in It for the Money**
Label. Verve Records - V6-5045
Country. USA
Year. 1968
Photo. Jerry Schatzberg
Design. Cal Schenkel/Frank Zappa

Artist. **The Beatles**
Title. **Sgt. Pepper's Lonely Hearts Club Band**
Label. Parlophone - PMC 7027
Country. England
Year. 1967
Photo. Michael Cooper
Design. Peter Blake/Jann Haworth

Artist. **The Beatles**
Title. **Sgt. Pepper's Lonely Hearts Club Band**
Label. Parlophone - PMC 7027
Country. England
Year. 1967
Photo. Michael Cooper
Design. Peter Blake/Jann Haworth

Artist. **The Mothers of Invention**
Title. **We're Only in It for the Money**
Label. Verve Records - V6-5045
Country. USA
Year. 1968
Photo. Jerry Schatzberg
Design. Cal Schenkel/Frank Zappa

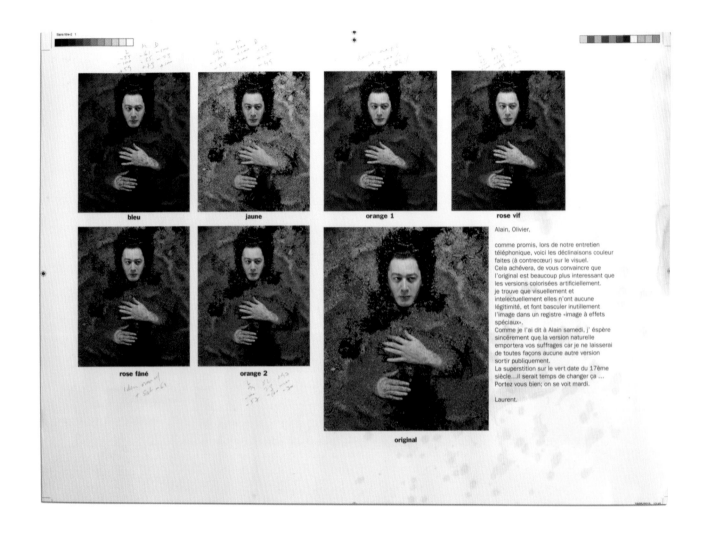

bleu    jaune    orange 1    rose vif

rose fâné    orange 2

original

Alain, Olivier,

comme promis, lors de notre entretien
téléphonique, voici les déclinaisons couleur
faites (à contrecœur) sur le visuel.
Cela achévera, de vous convaincre que
l'original est beaucoup plus interessant que
les versions colorisées artificiellement.
je trouve que visuellement et
intelectuellement elles n'ont aucune
légitimité, et font basculer inutillement
l'image dans un registre «image à effets
spéciaux».
Comme je l'ai dit à Alain samedi, j' éspère
sincérement que la version naturelle
emportera vos suffrages car je ne laisserai
de toutes façons aucune autre version
sortir publiquement.
La superstition sur le vert date du 17ème
siècle...il serait temps de changer ça ...
Portez vous bien; on se voit mardi.

Laurent.

Photo. Color proof by Laurent Seroussi taken for the album cover
*Fantaise Militaire* by Alain Bashung, 1998.

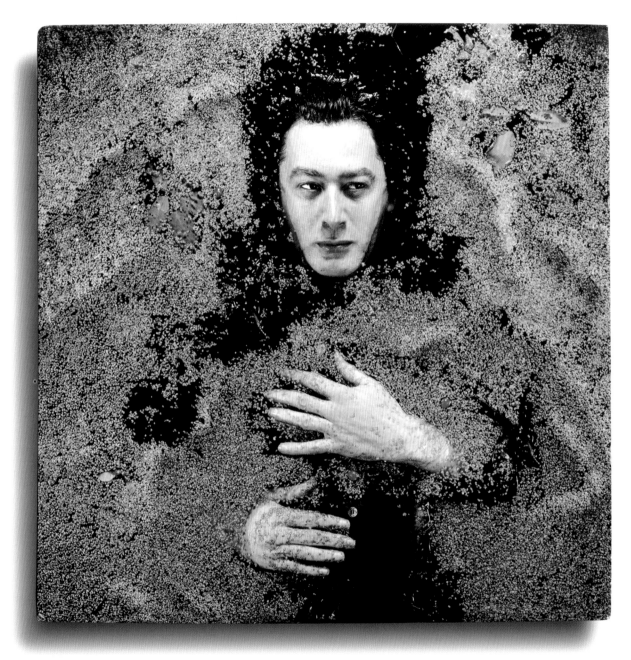

Artist. **Alain Bashung**
Title. **Fantaisie Militaire**
Label. Barclay - 539 488
Country. France
Year. 1998
Photo. Laurent Seroussi
Design. Laurent Seroussi

# The Great Crossing

*Abbey Road*, the last album the Beatles recorded together, has gone down in music history—in more ways than one, and perhaps most notably for its record sleeve. The crosswalk outside London's legendary recording studio has become a place of pilgrimage. Photographer Iain Macmillan's picture sparked extrapolations and wild rumors. On the basis of clues that were supposedly inserted into the picture, it was said that Paul McCartney (the only Beatle walking barefoot, with his right leg forward, etc.) was dead and had been replaced by a lookalike. These stories didn't stop copycats following in their footsteps and doing their own versions: Booker T. & The M. G.'s on a street in New Orleans, Red Hot Chili Peppers in the nude, and George Benson on "the other side." McCartney crossed the road again himself, this time pulled by his dog.

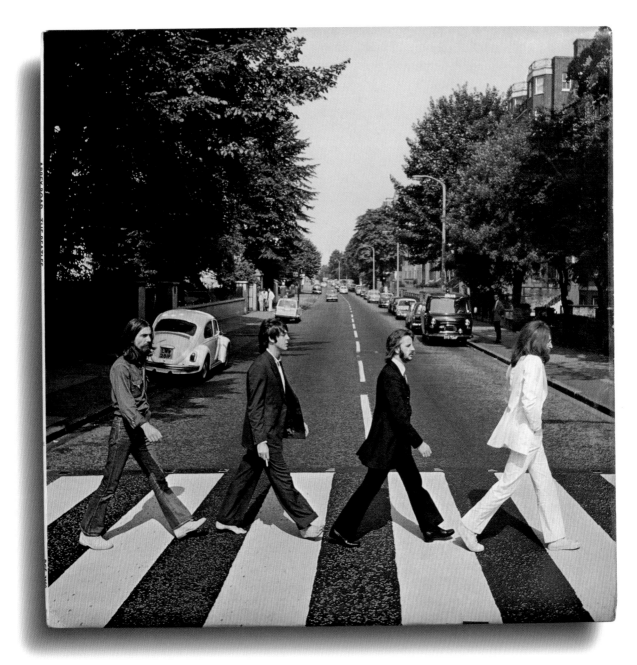

Artist. **The Beatles**
Title. **Abbey Road**
Label. Apple Records - PCS 7088
Country. England
Year. 1969
Photo. Iain Macmillan
Design. John Kosh

Artist. **Booker T. & The M. G.'s**
Title. **McLemore Avenue**
Label. Stax Records - STS-2027
Country. USA
Year. 1970
Photo. Joel Brodsky
Design. The Graffiteria/David Krieger

Artist. **The Heshoo Beshoo Group**
Title. **Armitage Road**
Label. Columbia – C 062 80842
Country. France
Year. 1971
Photo. Jörg Genzmer
Design. John S. Norwell

Artist. **Red Hot Chili Peppers**
Title. **The Abbey Road E. P.**
Label. EMI-Manhattan Records - 12MT 41
Country. England
Year. 1988
Photo. Chris Clunn
Design. Abrahams Pants

Artist. **The Beatles**
Title. **Abbey Road:**
**The Rockband Remixes 2009**
Label. Unofficial release
Country. Austria
Year. 2009
Photo. Iain Macmillan
Design. Unknown

Artist. **New York City**
Title. **Soulful Road**
Label. Chelsea Records - CHL 500
Country. USA
Year. 1974
Photo. Iain Macmillan
Design. Big Cigar

Artist. **The Shadows**
Title. **"Live" at Abbey Road**
Label. Polydor - SHADS 1
Country. England
Year. 1982
Photo. Michael Dunn
Design. Alwyn Clayden

Artist. **The Beatles**
Title. **Something/Come Together**
Label. Apple Records - 2 C 006-04266 M
Country. France
Year. 1969
Photo. Iain Macmillan
Design. Unknown

# THE OTHER SIDE OF ABBEY ROAD
# GEORGE
# BENSON

GOLDEN SLUMBERS
YOU NEVER GIVE ME YOUR MONEY
BECAUSE
COME TOGETHER
OH! DARLING
HERE COMES THE SUN
I WANT YOU (She's So Heavy)
SOMETHING
OCTOPUS'S GARDEN
THE END

STEREO A&M SP 3028

# GEORGE BENSON:
# THE OTHER SIDE OF ABBEY ROAD

A&M RECORDS

ARRANGED BY DON SEBESKY

CTi

Artist. **George Benson**
Title. **The Other Side of Abbey Road**
Label. A&M Records - SP-3028
Country. USA
Year. 1970
Photo. Eric Meola
Design. Sam Antupit

# A Life on Vinyl:
# David Bowie and Johnny Hallyday

David Bowie was the master of disguise, constantly changing his look without ever breaking his spell. Perhaps that is one of the keys to his longevity: each mask revealed a facet of his personality; each piece of the puzzle strengthens the attraction of "the man who fell to Earth." There are almost as many Bowies as there are albums, and every record breaks new ground. From Ziggy Stardust to Halloween Jack and Aladdin Sane, the Brixton native was a multifaceted mutant, as manifested in this selection of nine picture-disc singles from the 1970s.

Is it the image or the subject that sets the tone? A look at a half-century of Johnny Hallyday's album covers fails to answer the question. Whether in a black jacket or a three-piece suit, the Frenchman adapted to generations and reflected the image of his time, borrowing the dominant codes to embody the period's mainstreams: teen idol, rebellious rocker, long-haired hippie, tanned face, helmet, boots. The handsome face of French rock put on many masks to create his persona.

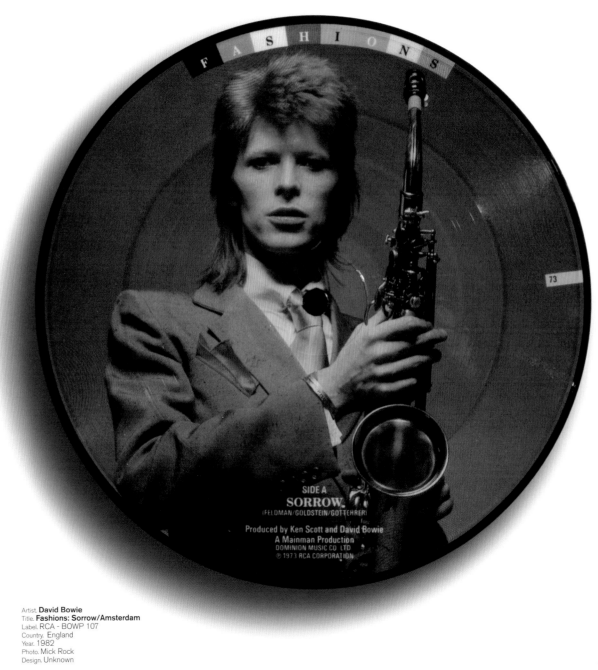

Artist. **David Bowie**
Title. **Fashions: Sorrow/Amsterdam**
Label. RCA - BOWP 107
Country. England
Year. 1982
Photo. Mick Rock
Design. Unknown

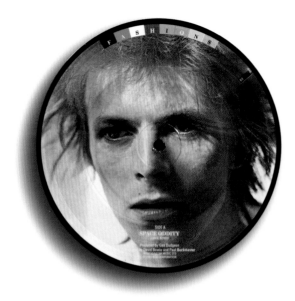

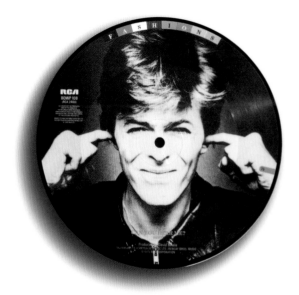

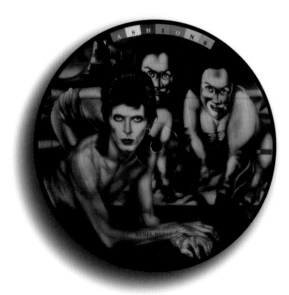

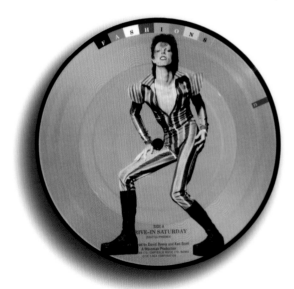

Artist. **David Bowie**
Title. **Fashions: Space Oddity/Changes/
Velvet Goldmine**
Label. RCA - BOWP 101
Country. England
Year. 1982
Photo. Mick Rock
Design. Unknown

Artist. **David Bowie**
Title. **Fashions: Rebel Rebel/Queen Bitch**
Label. RCA - BOWP 104
Country. England
Year. 1982
Photo. Terry O'Neill/Guy Peellaert
Design. Unknown

Artist. **David Bowie**
Title. **Fashions: Golden Years/Can You
Hear Me?**
Label. RCA - BOWP 108
Country. England
Year. 1982
Photo. Masayoshi Sukita
Design. Unknown

Artist. **David Bowie**
Title. **Fashions: Drive-In Saturday/Round
and Round**
Label. RCA - BOWP 106
Country. England
Year. 1982
Photo. Masayoshi Sukita
Design. Unknown

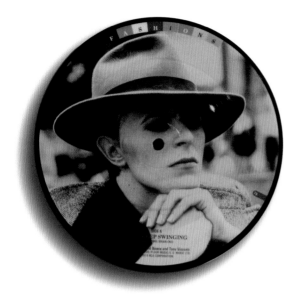

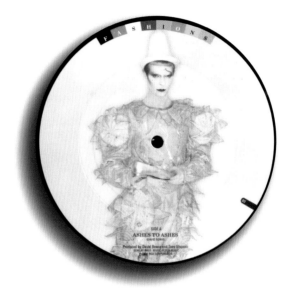

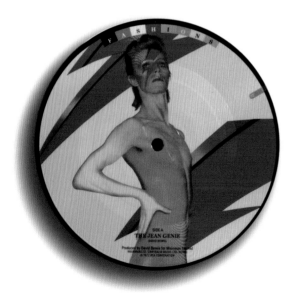

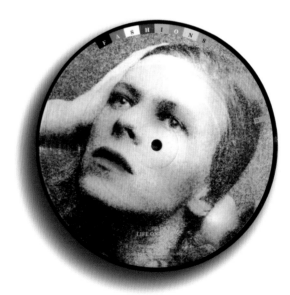

Artist. **David Bowie**
Title. **Fashions: Boys Keep Swinging/ Fantastic Voyage**
Label. RCA - BOWP 109
Country. England
Year. 1982
Photo. David James
Design. Unknown

Artist. **David Bowie**
Title. **Fashions: The Jean Genie/ Ziggy Stardust**
Label. RCA - BOWP 103
Country. England
Year. 1982
Photo. Brian Duffy
Design. Unknown

Artist. **David Bowie**
Title. **Fashions: Ashes to Ashes/Move On**
Label. RCA - BOWP 110
Country. England
Year. 1982
Photo. Brian Duffy
Design. Unknown

Artist. **David Bowie**
Title. **Fashions: Life on Mars/ The Man Who Sold the World**
Label. RCA - BOWP 102
Country. England
Year. 1982
Photo. Brian Ward
Design. Unknown

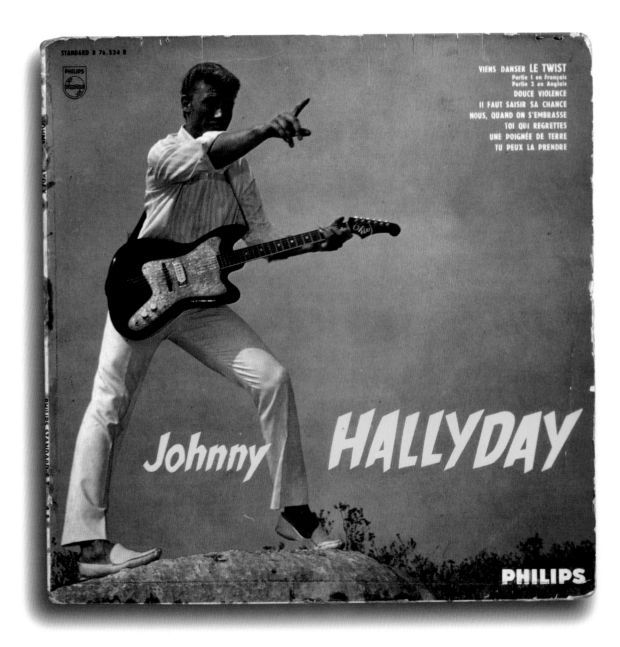

Artist. **Johnny Hallyday**
Title. **Viens Danser le Twist**
Label. Philips - B 76.534 R
Country. France
Year. 1961
Photo. Fournier
Design. Unknown

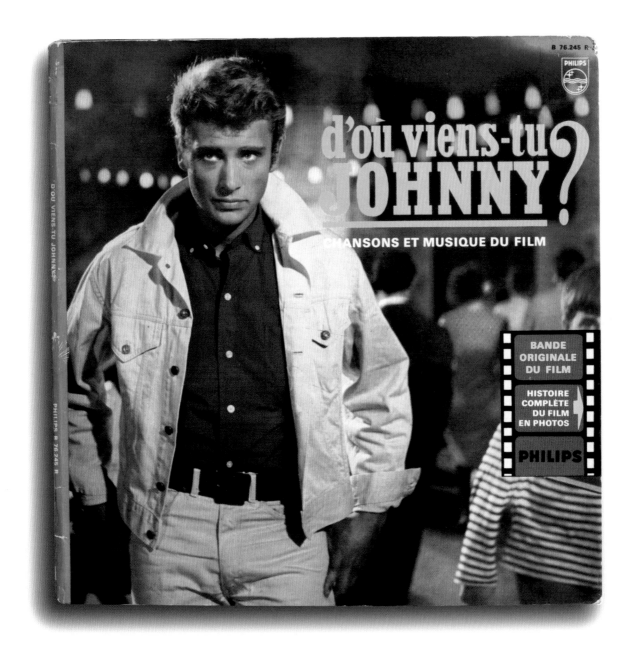

Artist. **Johnny Hallyday**
Title. **D'où Viens-tu Johnny?**
Label. Philips - B 76.245 R
Country. France
Year. 1963
Photo. Claude Schwartz
Design. Unknown

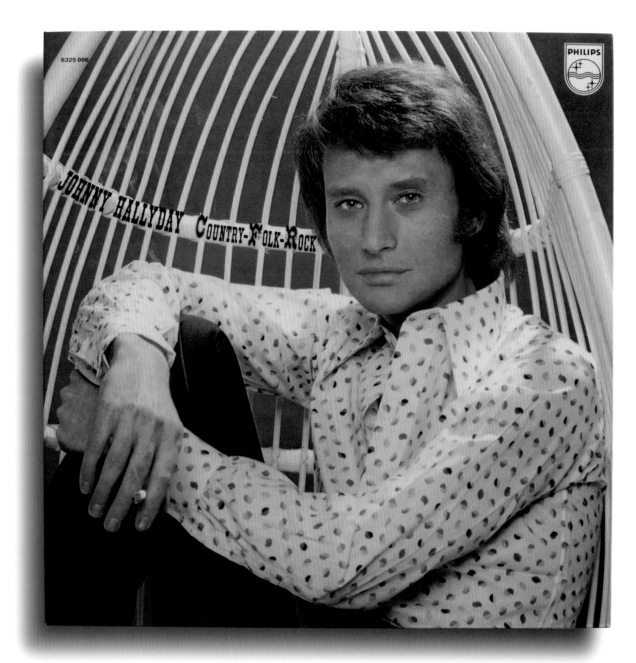

Artist. **Johnny Hallyday**
Title. **Country-Folk-Rock**
Label. Philips - 6325 006
Country. France
Year. 1972
Photo. Tony Frank
Design. Unknown

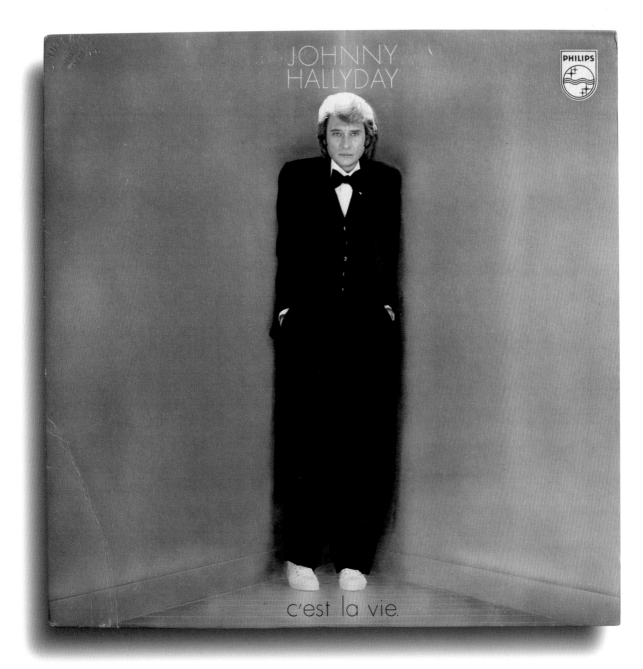

Artist. **Johnny Hallyday**
Title. **C'est la Vie**
Label. Philips - 9120 245
Country. France
Year. 1977
Photo. Francis Giacobetti
Design. Unknown

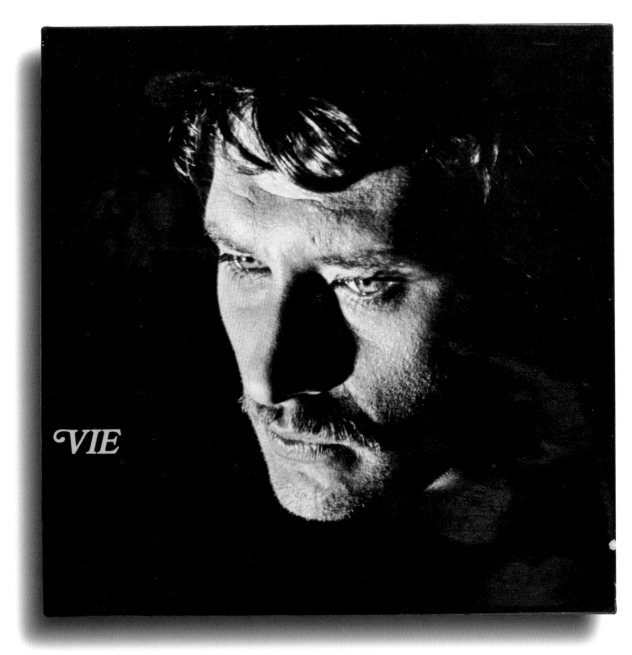

VIE

Artist. **Johnny Hallyday**
Title. **Vie**
Label. Philips - 6397 018
Country. France
Year. 1970
Photo. Jean-Marie Périer/Tony Frank
Design. Unknown

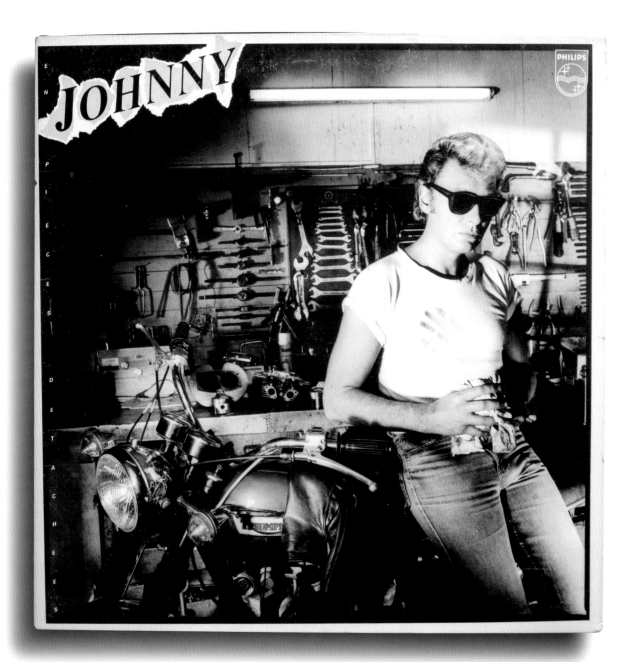

Artist. **Johnny Hallyday**
Title. **En Pièces Détachées**
Label. Philips - 6313 126
Country. France
Year. 1981
Photo. Jean-Baptiste Mondino
Design. Unknown

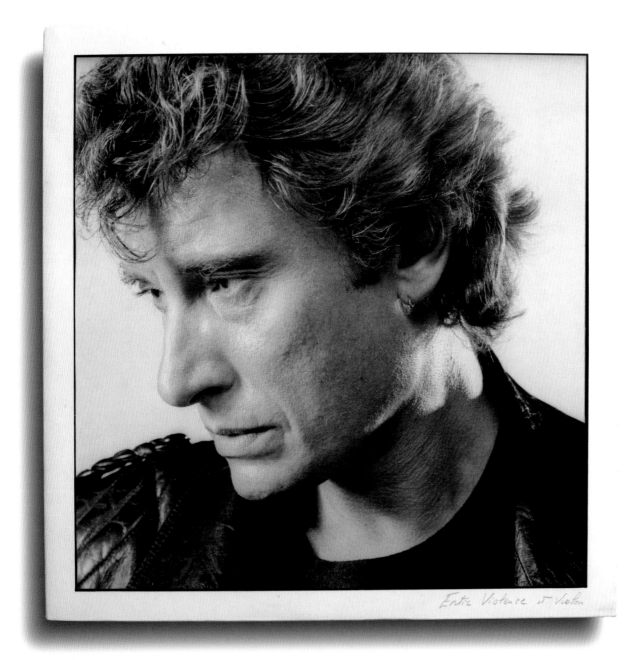

Entre Violence et Violon

Artist. **Johnny Hallyday**
Title. **Entre Violence et Violon**
Label. Philips - 814374
Country. France
Year. 1983
Photo. Tony Frank
Design. Jean-Baptiste Mondino

# Word and Image

"I have always thought that writing was close to music, only much less pure." These words by Patrick Modiano, winner of the 2014 Nobel Prize in literature, sum up the close ties between two major art forms. Doesn't Calliope, the muse of rhetoric, have a tablet and a trumpet as her attributes? Whether storytellers or troubadours, poets see their thoughts as words to be spoken. "Jazz is my religion," said trumpeter and Beat writer Ted Joans. He was not the only member of that generation who was plugged into the energy of improvisation and hung out with boppers of every stripe. One of his heirs, Ishmael Reed, wrote *Mumbo Jumbo*, a surrealistic soul novel with a cult following that was recorded with black music's greatest names. William S. Burroughs dabbled in music more than once, notably with Neneh Cherry. So did Jack Kerouac, with cool jazz musicians, and Allen Ginsberg, who was photographed by Richard Avedon. In the 1950s and 1960s, the blues inhabited the work of many writers, including Louis-Ferdinand Céline, Albert Camus, Henry Miller, Hermann Hesse, Pier Paolo Pasolini, Samuel Beckett, and Albertine Sarrazin, who made news with her autobiographical writings.

Allen Ginsberg

Reads Kaddish

A 20th Century

American Ecstatic

Narrative Poem

4001

ATLANTIC

VERBUM SERIES

RICHARD AVEDON

Artist. **Allen Ginsberg**
Title. **Reads Kaddish**
Label. Atlantic - 4001
Country. USA
Year. 1966
Photo. Richard Avedon
Design. Marvin Israel

# BUKOWSKI

# 90 MINUTES IN HELL

Artist. **Charles Bukowski**
Title. **90 Minutes in Hell**
Label. Earth Books
Country. USA
Year. 1977
Photo. Lawrence Robbin
Design. Unknown

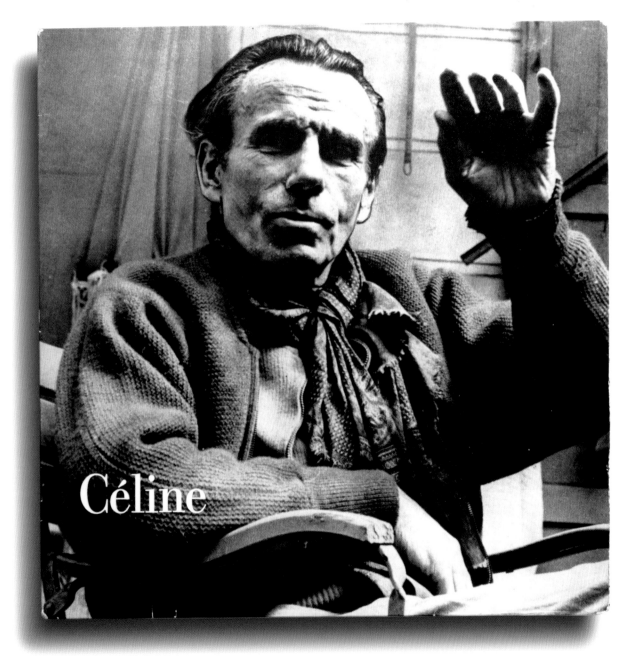

Céline

Artist. **Louis-Ferdinand Céline**
Title. **Entretien avec Albert Zbinden**
Label. Vega - B. I. 6004
Country. France
Year. 1958
Photo. Philippe Charpentier
Design. Unknown

Artist. **Hermann Hesse**
Title. **Hermann Hesse Liest**
Label. Suhrkamp Verlag - SV 319809
Country. Germany
Year. 1980
Photo. Unknown
Design. Unknown

Artist. **Henry Miller**
Title. **To Paint Is to Love Again**
Label. La Voix de l'Auteur - LVA 1005-1006
Country. Switzerland
Year. 1963
Photo. Unknown
Design. Unknown

Artist. **Albertine Sarrazin**
Title. **Entretiens**
Label. Adès Disques - 10.039
Country. France
Year. 1983
Photo. Martine Cambessedes
Design. Unknown

Artist. **Giovanna Marini**
Title. **Pour Pier Paolo Pasolini**
Label. Le Chant du Monde - LDX 74826
Country. France
Year. 1984
Photo. Unknown
Design. Unknown

# ALBERT CAMUS VOUS PARLE

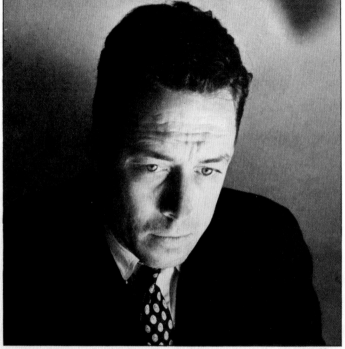

DOCUMENT N.R.F.

PHOTO IZIS

# "LEUR ŒUVRE & LEUR VOIX"

Artist. **Albert Camus**
Title. **Vous Parle**
Label. Disques Festival - FLD 19 M
Country. France
Year. 1958
Photo. Izis Bidermanas
Design. Unknown

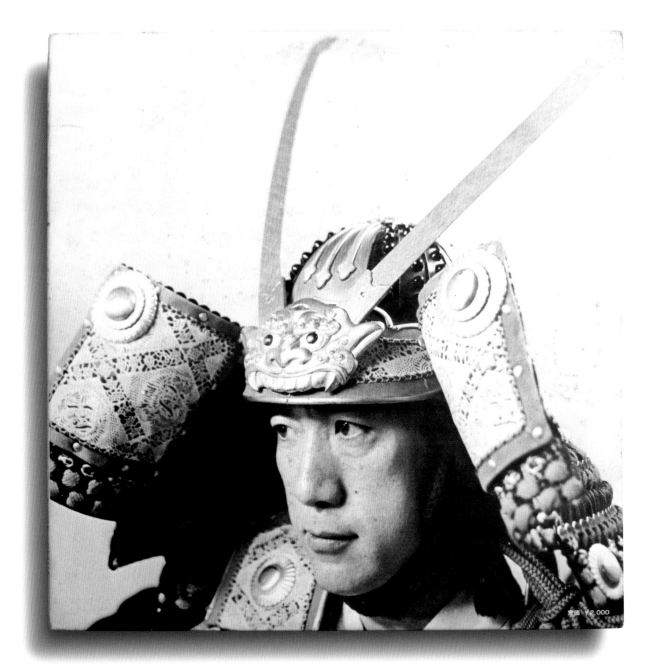

Artist. **Yukio Mishima**
Title. **Chisetsu Yumiharizuki**
Label. Nippon Columbia - CLS-5112
Country. Japan
Year. 1971
Photo. Unknown
Design. Tadanori Yokoo

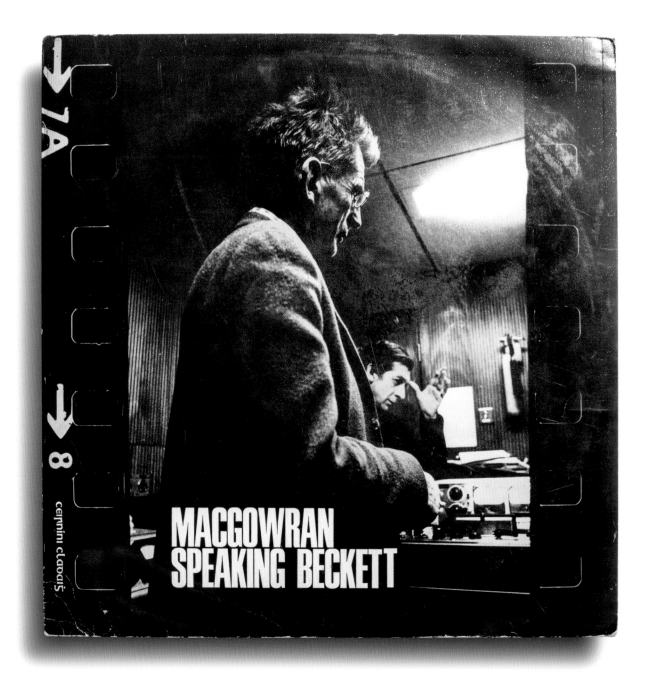

Artist. **Jack MacGowran**
Title. **MacGowran Speaking Beckett**
Label. Claddagh Records - CCT3
Country. Ireland
Year. 1966
Photo. Jeffrey Craig
Design. Doreen Kennedy

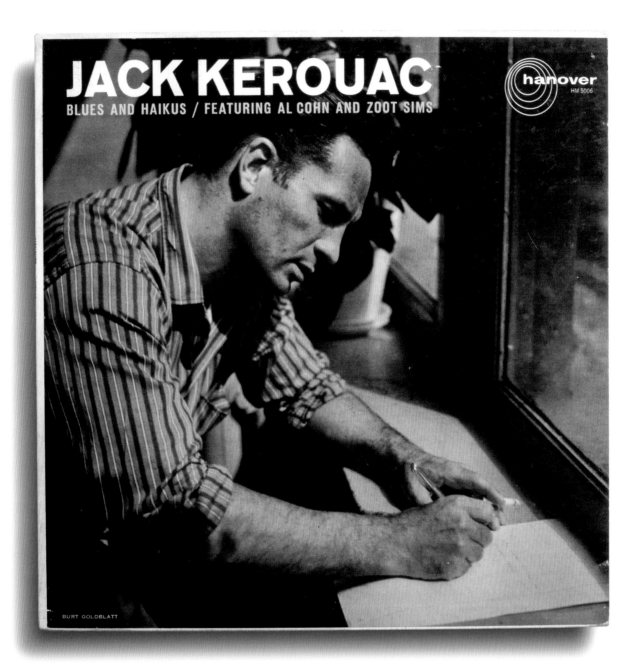

Artist. **Jack Kerouac**
Title. **Blues and Haikus**
Label. Hanover Records - HM 5006
Country. USA
Year. 1959
Photo. Burt Goldblatt
Design. Dick Hendler

# From Grain to Groove

For over a century, film scores have offered a different, somewhat out-of-focus way of looking at images. They are not merely added value or an afterthought but a key part of films. They have marked the history of cinema, and many LP collectors have tried to find everything they can by composers and arrangers in this genre, such as Bernard Herrmann, Lalo Schifrin, Michel Legrand, Ennio Morricone, Maurice Jarre, John Barry, and Henry Mancini. Others, like the pianist Herbie Hancock, have recorded beautiful scores. This small selection features photographic album covers of sound tracks that have become part of the collective consciousness, including *Last Tango in Paris*, *A Man and a Woman*, and *The Thomas Crown Affair*—three films carried in perfect harmony by their

sound tracks. There's also William Klein's surprising *Who Are You, Polly Maggoo?* and of course *Blow-Up*, with its English and French versions of the album. Whether figurative or more abstract, the record sleeve as much as the poster has a place in cinematographic imagery: if it succeeds, it conveys the narrative intention.

To grasp the melodramatic plots of Bollywood movies, you just have to look at the photomontages and collages on the sound tracks' record sleeves. Most of the time, star-crossed lovers, juicy intrigues, and sixties romances are merely pretexts for lush scores.

Artist. **Georges Delerue**
Title. **"Viva Maria"! (Original Motion Picture Sound Track)**
Label. United Artists Records - UAS 5135
Country. USA
Year. 1965
Photo. Unknown
Design. Unknown

SE-4447 ST

sounds great in STEREO

THE ORIGINAL SOUND TRACK ALBUM

A CARLO PONTI
PRODUCTION

# BLOW-UP

Directed by
**MICHELANGELO ANTONIONI**

Music composed, conducted and played by
**HERBIE HANCOCK**

A Premiere Productions Release

MGM
RECORDS

Artist. **Herbie Hancock**
Title. **Blow-Up (The Original Sound Track
Album)**
Label. MGM Records - SE-4447 ST
Country. USA
Year. 1966
Photo. Arthur Evans
Design. Acy R. Lehman

Artist. **Herbie Hancock**
Title. **Blow-Up (Bande Originale du Film)**
Label. MGM Records - 665 072
Country. France
Year. 1967
Photo. Arthur Evans
Design. Unknown

Artist. **Francis Lai**
Title. **Un Homme et Une Femme (Bande Originale du Film)**
Label. Disc'AZ - LPS 7
Country. France
Year. 1966
Photo. Unknown
Design. René Ferracci

Artist. **Michel Legrand**
Title. **Les Parapluies de Cherbourg (Bande Originale du Film)**
Label. Philips - B 2 L 0054
Country. France
Year. 1964
Photo. Léo Weisse
Design. Unknown

Artist. **Simon & Garfunkel/David Grusin**
Title. **The Graduate (Original Sound Track Recording)**
Label. CBS - 70.042
Country. France
Year. 1968
Photo. Frank Shugrue
Design. Unknown

Artist. **Ennio Morricone**
Title. **Il Était une Fois Dans l'Ouest (Bande Originale du Film)**
Label. RCA Victor - 440.751
Country. France
Year. 1969
Photo. Angelo Novi
Design. Unknown

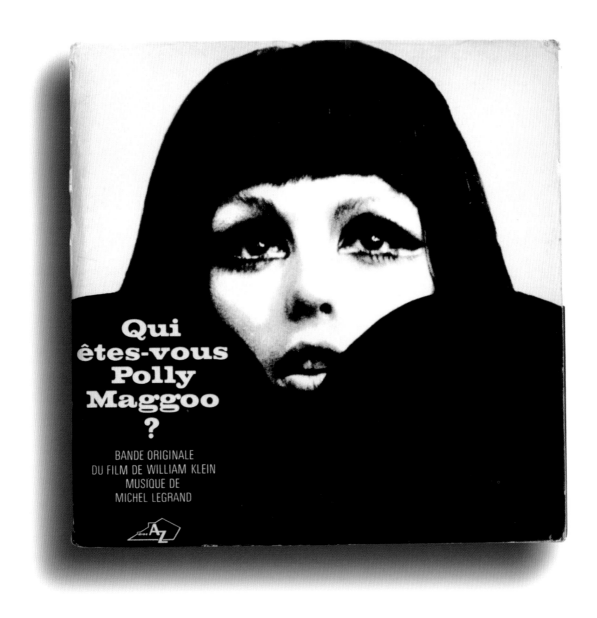

Artist. **Michel Legrand**
Title. **Qui Êtes-vous Polly Maggoo? (Bande Originale du Film)**
Label. Disc'Az - EP 1062
Country. France
Year. 1966
Photo. William Klein
Design. Unknown

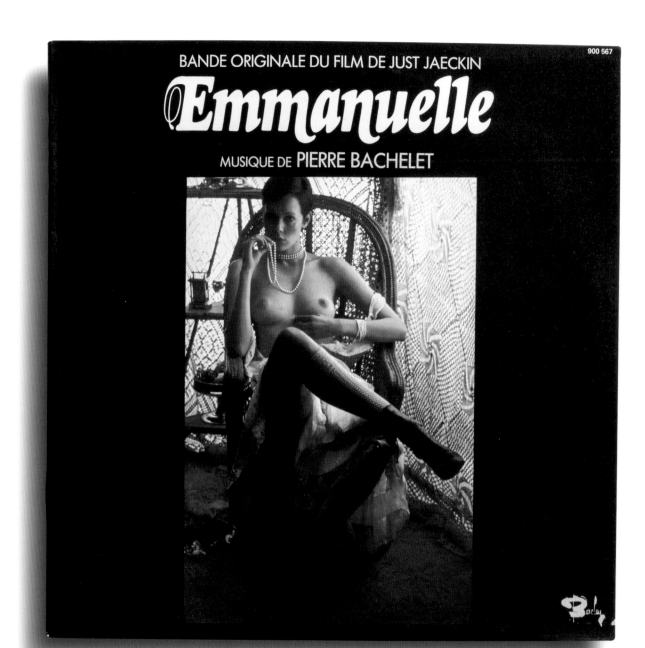

Artist. **Pierre Bachelet**
Title. **Emmanuelle (Bande Originale du Film)**
Label. Barclay - 900 567
Country. France
Year. 1978
Photo. Francis Giacobetti
Design. Unknown

Artist. **Gato Barbieri**
Title. **Last Tango in Paris (Original Motion
Picture Score)**
Label. United Artists Records - UA-LA045-F
Country. USA
Year. 1973
Photo. Angelo Novi
Design. Unknown

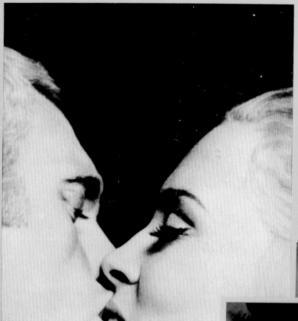

STEREO UAS 5182

ORIGINAL MOTION PICTURE SCORE

# The Thomas Crown Affair

Music Composed And Conducted By
**Michel Legrand**

Main Theme Sung By
Noel Harrison

UNITED ARTISTS

Artist. **Michel Legrand**
Title. **The Thomas Crown Affair (Original Motion Picture Score)**
Label. United Artists Records - UAS 5182
Country. USA
Year. 1968
Photo. Unknown
Design. Unknown

422

Artist. **George and Ira Gershwin**
Title. **Funny Face (Original Sound Track Recording)**
Label. Verve Records - MGV-15001
Country. USA
Year. 1967
Photo. Richard Avedon
Design. Sheldon Marks

423

Artist. **Kalyanji-Anandji**
Title. **Geet (Original Sound Track)**
Label. Odeon - 3AEX 5325
Country. India
Year. 1970
Photo. K. Vaikunth
Design. Sudhendu Roy

Artist. **Rahul Dev Burman**
Title. **Mere Jeevan Saathi (Original Sound Track)**
Label. Odeon - MOCE 4147
Country. India
Year. 1972
Photo. Unknown
Design. Mohan Murali

Artist. **Kalyanji-Anandji**
Title. **Samjhauta (Original Sound Track)**
Label. Odeon - D/MOCE 4195
Country. India
Year. 1972
Photo. Unknown
Design. Mohan Wagh/Kamal

Artist. **Laxmikant/Pyarelal**
Title. **Haathi Mere Saathi (Original Sound Track)**
Label. Odeon - MOCEC.7519
Country. India
Year. 1971
Photo. Unknown
Design. Bimal Mozumdar

Artist. **Madan Mohan/Jaidev**
Title. **Laila Majnu (Original Sound Track)**
Label. EMI - ECLP 5477
Country. India
Year. 1976
Photo. Unknown
Design. Unknown

# Afro Caribbean Assembly

Dominated by two producers, Henri Debs and Raymond Célini, the French West Indian recording industry was rediscovered by English DJs and so-called "crate diggers," American fans who scoured used-record shops, hunted down antiquated records, dug up quality labels, rediscovered forgotten talents, and kept their old vinyl records in milk crates. Together, they have participated in a reexamination of catalogues and rereleases of B-sides that had been languishing beneath coats of dust. As evidenced in this selection of original singles, these handmade record covers, featuring drawings and cut-out photos, foreshadow the DIY methods that punk bands would put into practice a few years later.

Artist. **Maurice Alcindor**
Title. **Tuma Tu M'as Eue**
Label. Aux Ondes - RC 24
Country. Guadeloupe
Year. 1966
Photo. Unknown
Design. B. Bocage

Artist. **Astasie Philogène**
Title. **Alberta**
Label. Disques Debs International - DD 110
Country. Guadeloupe
Year. Unknown
Photo. Unknown
Design. Unknown

Artist. **Maurice Alcindor**
Title. **Sékirité**
Label. Célini Disques - RCG 5040
Country. Guadeloupe
Year. Unknown
Photo. Unknown
Design. Unknown

Artist. **Les Anges Noirs du Go-Ka**
Title. **Série Folklorique Vol. 4**
Label. Kaloukera - KEP 04
Country. Guadeloupe
Year. Unknown
Photo. Unknown
Design. Charles Arnassalon

Artist. **Orchestre Karukean/Michel Edom**
Title. **Voleu' Cochon La**
Label. Kaloukera - KEP 14
Country. Guadeloupe
Year. Unknown
Photo. Unknown
Design. Unknown

Artist. **Rémy Mondey**
Title. **Misic Cho Pour Danser**
Label. Disques Debs International - DD 101
Country. Guadeloupe
Year. Unknown
Photo. Loulou Poitou
Design. Unknown

Artist. **L'Ensemble Gopego**
Title. **L'Ensemble Gopego**
Label. Hit Parade - GR 20
Country. Martinique
Year. Unknown
Photo. Fernand Bibas
Design. Guy Roy-Larentry

Artist. **Romuld "Mister" Lof**
Title. **Mister Lof**
Label. Célini Disques - RCG 5033
Country. Guadeloupe
Year. Unknown
Photo. Unknown
Design. Unknown

Artist. **Michel Desgrottes**
Title. **Maestro Michel Desgrottes**
Label. Disque Jojo - 107
Country. Martinique
Year. Unknown
Photo. Loulou Poitou
Design. Unknown

Artist. **Casino Mbilia & The Opels**
Title. **Hip Hit Hurrah**
Label. Hit Parade - GR 010
Country. Martinique
Year. Unknown
Photo. Fernand Bibas
Design. Guy Roy-Larentry

Artist. **Typical Combo**
Title. **Bobiner**
Label. Duli Disc - JD 102
Country. Guadeloupe
Year. Unknown
Photo. Unknown
Design. Unknown

Artist. **Claude Charles Gervais**
Title. **C. Ch. Gervais**
Label. Disques Debs International - DD 104
Country. Guadeloupe
Year. Unknown
Photo. Unknown
Design. Daniel Gargar

Artist. **Rémy Mondey**
Title. **Meringue çe Misic en Moin**
Label. Disques Debs International - DD 179
Country. Guadeloupe
Year. Unknown
Photo. André Catan
Design. Daniel Gargar

Artist. **Nadine Saint Eloi**
Title. **Au Revoir**
Label. Disques Debs International - DD 234
Country. Guadeloupe
Year. Unknown
Photo. José Mischer
Design. Daniel Gargar

# Une histoire de la photographie au prisme du vinyle

## Première pochette

Une histoire de la photographie au prisme du vinyle, une photographie de l'histoire du disque. L'un et l'autre. Ces deux médias qui auront marqué le XX$^e$ siècle furent associés sous toutes les formes, de la création d'œuvre d'art à l'illustration, de la figuration à l'expérimentation. Cette diversité d'intentions, de propositions, guide cette exposition. D'ailleurs, les deux « premières » images publiées sur un support phonographique suggèrent déjà que tout sera possible : une vision «arty» de Broadway et un cliché plus naturaliste d'un cow-boy. Toute l'histoire de la photographie — ou presque — tient dans ce format.

33 tours, un rond dans un carré. Ils sont nombreux à avoir posé leurs empreintes dans ces 30 cm de côté. Dans cette histoire musicale, la photographie joue le premier rôle. Quand on regarde une pochette, on entend presque ce que l'on voit. Combien de classiques portent la griffe d'un photographe ! Qui n'a pas acheté un disque sur la foi de sa couverture !? L'image d'Abbey Road a traversé ce demi-siècle tout autant que la musique des Beatles qu'elle illustre. Ce n'est pas la seule : la braguette d'Andy Warhol colle aux doigts des Rolling Stones. Et la discographie de ces derniers est jalonnée de grandes signatures : David Bailey bien sûr, mais aussi Hiro, Annie Leibovitz, Robert Frank…

Des photographes se sont fait un style, d'autres ont bâti des icônes ; des labels ont construit leur identité sur une charte graphique où la photo prime : les noirs et blancs de Francis Wolff pour Blue Note, les nuances de gris d'ECM, les flashs surréalistes d'Hipgnosis… Des productions maison qui, là encore, préfigurent un son. Et inversement, de nombreuses images, symboles du siècle, ornent les pochettes : un portrait de Céline, la grande dépression vue par les photographes missionnés par la Farm Security Administration, des clichés de Mai 68, le Black Power aux Etats-Unis… Photoreportage, photomontage, photomaton, photos détournées, sur-exposées, photo dans la photo, toutes les techniques se retrouvent dans ces 30 cm. Clic clac, plus on creuse le sillon, plus le sujet semble infini.

## La photographie, création originale sur vinyle

Garry Winogrand, Raymond Depardon, Paolo Roversi, Norman Seeff, Martin Parr, Franco Fontana… Combien de pièces aurait-il fallu pour tous les exposer ? Comment faire l'impasse sur Pierre Verger comme sur Herman Leonard ? Ceux-là n'y sont pas. Le choix s'avère sévère. Tout comme vous ne retrouverez pas nombre de classiques de l'histoire de la musique, dont les images sont devenues iconiques : A Love Supreme de Coltrane, Melody Nelson de Gainsbourg, le premier Ramones… Pas même Barbara, elle qui chantait pourtant : « Si la photo est bonne, qu'on m'amène ce jeune homme… »

Petit format, grandes conséquences. En déroulant le fil de la musique, c'est tout le livre de la photo qui se déploie : chaque chapitre, des abstraits aux portraits, trouve un écho dans ce carré. De Robert Doisneau à William Wegman. Tous, ou presque, ont vu un jour ou l'autre une de leurs œuvres sur une pochette de disque. Et tous ceux-là constituent un vrai diaporama panoramique de l'histoire de la photographie. Un carnet de bord en temps réel de la conjonction de ces deux médias.

Combien de fois la photographie aura-t-elle été le sujet d'une chanson ? Sure Shot selon les Beastie Boys. Combien d'albums sont-ils intitulés Photograph ? Justement, les portraits de musiciens jalonnent cette histoire : Gainsbourg, ambigu, par William Klein ; Miles par Irving Penn, recto, yeux grands ouverts, verso, les yeux plissés ; Yoko Ono par Albert Watson, plan serré, lunettes sombres, effets saturés ; Monk, fondu au noir signé Eugene Smith, et Araki, dans les tons bleus ; Hiro fait passer Mick Jagger au premier plan ; David Hamilton immortalise le juvénile Claude François… Quant à Pierre & Gilles, les deux apôtres de l'onirisme, ils enluminent les égéries de la culture pop pour mieux les

sublimer. La variété d'approches renvoie à la diversité de regards : face objectif, tendance oblique. Voire de profil, lorsque Robert Mapplethorpe sculpte le superbe Taj Mahal.

« Pense avec tes oreilles comme avec tes yeux. » Le bon mot attribué à Gertrude Stein prend tout son double sens. La musique : une autre manière de voir. La photo : une autre façon d'entendre. Les deux se font écho depuis un siècle. Le médium transmet le message, lorsque Bruce Davidson choisit d'afficher un « Vote » explicite pour porter l'album de Father Father. Et la pyramide poétique de Bernard Plossu fait bien mieux que simplement illustrer le propos de Faton Cahen, *Piano Rêves*. Elle le prolonge, le devance. Tout comme les travaux du couple Becher annoncent la musique post-industrielle de Kratfwerk ou, dans un tout autre registre, le clinquant tape-à-l'œil de David LaChapelle fournit une clef d'écoute de la rappeuse Lil' Kim. Image et musique, les deux faces d'une même pile.

Pour graver dans le marbre leur *Physical Graffiti*, les membres de Led Zeppelin choisiront le grain d'Elliott Erwitt, qui habite la photographie des deux immeubles de l'East Village new-yorkais… Par-delà les apparences, l'image « sanctuarisée » n'est pas sans faire songer à celle de Robert Frank lorsqu'il tapisse la pochette d'*Exile On Main Street* de multiples personnages, à la manière des grotesques… Avec le recul, impossible d'imaginer une autre couverture. Les visions plus conceptuelles de Guy Bourdin et les dérisions postmodernistes de Cindy Sherman ont tout autant trouvé naturellement leur place dans cette grande galerie de l'évolution photographique,

qui défie le sens de lecture cartésien, qui recompose des affinités esthétiques par-delà les époques et les écoles. Saul Leiter, le pionnier de la couleur teintée de reflets et flous artistiques, et Nan Goldin, la papesse de la réalité crue, encore deux références qui ont ici laissé leur empreinte. À l'image des photoreportages de Josef Koudelka et René Burri, témoignages sociétaux à hauteur d'homme qui eux aussi sont raccord avec la bande-son qu'ils accompagnent. « Le son que j'ai vu », pour paraphraser Roy DeCarava, dont le triptyque est emblématique de cette sélection…

### Réappropriation subliminale

Si les photographes se sont mis au service des musiciens, pour composer des couvertures dédiées, les musiciens sont aussi allés creuser dans le riche fonds iconographique pour associer une image forte à leur musique. Pour un simple maxi, Steven Brown, fondateur de Tuxedomoon, choisit ainsi la fameuse vue de New York de Berenice Abbott, censée capter un moment donné selon son auteure, un instantané fixé en fait pour l'éternité. Cette nostalgie du futur concerne les deux médias : la photographie comme la musique s'écrivent au présent de l'objectif, en saisissant l'essence, mais s'inscrivent forcément dans l'avenir.

Demain est hier. Voilà comment le couple parisien croisé par Brassaï en 1933 se retrouve projeté au début des années 1980, par la jeune égérie américaine Rickie Lee Jones. Voilà pourquoi on redécouvre le subtil baiser sublimé par Elliott Erwitt sur la couverture de *The First of a Million Kisses*, en 1989. Le météorique

groupe britannique Fairground Attraction choisit même de recadrer cet instant surgi de la Californie des fifties, au risque d'être trop explicite, contrairement à l'original. Montrer le propos musical, c'est aussi l'intention du groupe Kiss In The Dark lorsqu'en 1989 il choisit un fameux cliché signé René Burri. Quant au couple du Café Lehmitz, extrait de la série réalisée par le Suédois Anders Petersen à Hambourg à la fin des années 1960, il fait, quinze ans plus tard, la une d'un album de Tom Waits.

L'image iconique de William Klein ou celle, moins classique, de Guy Le Querrec, le réalisme poignant de Dorothea Lange au cœur de la Grande Dépression comme le portrait « surréaliste » de Pieter Hugo, qui valut au Sud-Africain le World Press en 2005 : le monde de la musique colonise la photographie pour afficher ses intentions discursives. Mais qui osera se réapproprier le monumental Jeff Wall, une photo rétro illuminée d'après le prologue d'« Invisible Man ». En 2000, le photographe compose une image à partir des moindres détails décrits par l'écrivain Ralph Ellison, avec au beau milieu de l'image la pointe du tourne-disque !

### Jean-Paul Goude, Anton Corbijn, façonneurs d'univers

Grace Jones et Jean-Paul Goude, deux noms pour un son. L'orée des années 1980, les mutations disco du New York pas encore converti yuppie. Le photographe, qui se définit alors comme un « auteur d'images », rencontre le mannequin en 1979. C'est le déclic, immortalisé après coup par *The Face*, en août 1982 : « The man who made GraceJones ». En trois ans, il aura effective-ment construit l'icône du global

mix, androgyne post-industriel, et cette édification va passer par le LP, avant même le vidéoclip. En mode modéliste ou façon taille patron, sur picture disc ou dans une portée, le Français multiplie les angles pour façonner *Rhythm*. Goude sculpte ses photos comme il ausculte Grace Jones, par toutes les faces. Qui de nous deux ?

Au sortir des années 1970, le Néerlandais Anton Corbijn va lui se distinguer alors que la nouvelle vague anglaise débarque sur les ondes : Joy Division, Echo & the Bunnymen, Depeche Mode… Celui qui se fit remarquer pour ses pleines pages dans le *New Musical Express* participe notamment à la construction du mythe U2, en posant sa marque de fabrique, des noirs et blancs à la fois extrêmement travaillés et très documentaires, des contrastes qui renforcent sans conteste le caractère sociopolitique de la bande-son de Bono&co. Très vite, le photographe, à qui l'on doit de sublimes portraits de Miles Davis, Joni Mitchell ou encore Tom Waits, va comme d'autres choisir de réaliser des clips, entre autres au service des Irlandais, avant de se consacrer à des longs métrages.

### Jean-Baptiste Mondino, révélateur de star

Non, il ne se voit pas comme un photographe, il se considère plutôt comme un metteur en images. D'ailleurs, comme le natif d'Aubervilliers aime à le dire, il est arrivé à la photographie par hasard, ou presque. Pas une vocation, ni de révélation. Un regard, c'est certain. Oui, le parcours de Jean-Baptiste Mondino est en revanche intimement lié à la musique, enfant découvrant ses premiers émois aux sons d'Elvis, bientôt élevé à l'univers du LP où il va se

révéler aux yeux du monde entier. C'est sans doute ce regard, sans préjugés, cette focale volontiers ouverte, qui a permis à l'autodidacte, fan d'Hasselblad, de dessiner une esthétique singulière, et pourtant résolument multiple. On ne peut manquer d'évoquer aussi l'iconographie religieuse, celle que l'on pratiquait dans les années d'après-guerre, comme source d'inspiration, de réflexions. Il en a conservé des traces visibles dans ses portraits, mais aussi dans son goût pour la transgression, que renvoient certains de ses clichés.

*Play Blessures* et bien d'autres de Bashung, mais aussi *Marcia Baila* des Rita Mitsouko, mais encore *Debut* de Björk… La liste de ses collaborations donne le tournis et, après plus de trente ans, elle n'a rien du banal carnet mondain. Encore récemment, il a pu enchaîner Sébastien Tellier, hydre à multiples facettes, Rocé, rappeur à textes concernés, Sebastian du très branché label Ed Banger… Du collage au portrait serré, de la flamboyance colorée au clair-obscur en noir et blanc, Jean-Baptiste Mondino aura utilisé sa palette sans restrictions pour capter l'époque. Et pourtant, malgré de réelles différences formelles au fil du temps, il aura posé sa marque, tout à la fois directeur artistique et créateur d'images. Artiste ? Artisan ? Analyste ? Il est tous ceux-là à la fois, et dérouler son travail remet en perspective les évolutions techniques, les changements de normes. Bien entendu, il y a ce 6x6 qui scanda les années 1970, tout autant que ces clips, qui vont envahir la musique au cours des années 1980, les prémices du 16:9 devenu la norme des Smartphones. *« Mais le carré demeure dans la musique, il est simplement plus petit, sur le Net. »*

Mondino ne manque pas d'humour, ni de recul sur son travail. *« Je me suis toujours mis au service du sujet. Je veux qu'il s'y retrouve. »* Voilà sans doute pourquoi il se fait rare, laissant la lumière à ceux et celles qu'il éclaire à sa manière toute particulière.

## Andy Warhol, iconoclaste

Avant de devenir le prophète du pop art, Andy Warhol s'est fait la main comme graphiste, entre autres pour les pochettes de disques… Au milieu des années 1950, il signe pour des firmes de jazz : un superbe portrait de Count Basie, une couverture tout en lettrage pour Monk, un dessin de Johnny Griffin pour Blue Note… Et même s'il va se distinguer dans bien d'autres domaines, le touche-à-tout new-yorkais continuera à produire régulièrement des couvertures de LP, là encore dans une grande variété de genres. Certaines sont devenues fameuses, notamment la surprenante banane du Velvet Underground ou la provocante braguette des Rolling Stones…

Quelques années plus tard, c'est Mick Jagger qui fait la une de *Love You Live*. Un portrait en noir et blanc, que Warhol colorie pour réaliser un artwork qui s'étale sur le recto et le verso de ce double album live des Rolling Stones. À travers la somme de documents exposés (ephemeras dont une affiche promotionnelle, 45 tours, photos préparatoires…), on assiste à la genèse de cette création, qui suscita la polémique lorsque l'artiste polymorphe reprocha notamment à Mick Jagger d'avoir mis un coup de crayon sur son travail ! L'album donnera même lieu à un disque replica, cette fois non officiel, des enregistrements live datés de la fin 1970 intitulés *El Mocambo*. La couverture de ce coffret, tiré à 700 exemplaires,

n'est autre qu'une version alternative d'Andy Warhol.

Ce n'est pas la seule photographie sérigraphiée que l'artiste réalisa ainsi : John Lennon, Aretha Franklin, Diana Ross, Paul Anka eurent ainsi droit au même retraitement. Ces portraits réalisés pour l'industrie du disque sont devenus des pièces de collection, les œuvres d'un artiste qui aura sans nul doute trouvé dans ce médium très populaire le moyen d'apposer sa vision, de tracer sa propre voie, entre calligraphie et sérigraphie, entre dessins et photos.

## David Bailey, construction d'une icone

S'il n'est pas le seul, loin s'en faut, à avoir shooté les Rolling Stones, David Bailey a documenté pendant près d'une décennie la carrière du groupe britannique, à ses débuts. À partir de 1964, il va illustrer la plupart de leurs albums, noir et blanc ou couleurs voilées, de clichés figuratifs puis plus décalés, comme avec *Get Yer Ya-Ya's Out!*, qui témoignent en filigrane de l'évolution des Rolling Stones, de mauvais garçons du rock aux gentils illuminés du psychédélique. Ses images, si elles sont l'écho de choix musicaux en phase avec l'ère changeante, participent tout autant du mythe qu'il construit avec les artistes. L'ambiguïté sera d'ailleurs la même pour l'association entre Mick Rock et David Bowie. Le photographe britannique fixe pour la postérité l'image glam rock, avec « Ziggy Stardust » et quelques autres stars dont Iggy Pop et Lou Reed, voire les Ramones et Queen. En filigrane, la même question : le photographe est-il le relais de la tendance musicale ou la façonne-t-il à travers ses mises en scène ?

## Lucien Clergue, à la vie, à la mort

Dans la bande, il y avait Manitas à la guitare, Pablo au pinceau, Dominguin avec le taureau… Et Lucien Clergue, au Minolta. Le photographe arlésien rencontre le Sétois Manitas de Plata aux Saintes-Maries-de-la-Mer en 1955 alors qu'il participe à un disque ethnographique pour documenter la scène gitane. *« En quelques minutes, j'ai été enthousiasmé par la musique que j'ai entendue. À partir de là, j'ai vu Manitas régulièrement lors du pèlerinage des Saintes »*, se souvenait à l'hiver de sa vie Lucien Clergue.

Une amitié naît entre le futur fondateur des Rencontres Internationales de la Photographie et celui qui, pour l'état-civil, se nomme Ricardo Baliardo, surnommé « petites mains d'argent ». Elle sera le socle d'une longue collaboration, dont témoignent de nombreux recueils vinyle. À commencer par *Juerga !*, disque mythique sorti avec différentes images suivant les éditions, mais toutes signées Lucien Clergue. Ce dernier introduit le guitariste auprès du directeur de la maison de disques Connoisseur, qui publiera un coffret de 3 LP dès 1965. Ce sera le début d'une carrière américaine – au Carnegie Hall ! – pour le guitariste né dans une caravane, élevé au rang d'étoile internationale. À la clef, plus de 90 millions d'albums écoulés. Cette longue entente documente un aspect moins connu de la carrière de Lucien Clergue. D'ailleurs, si cette expérience sur LP peut surprendre, elle apparaît très vite comme une évidence. Le photographe saisit le moment avec Picasso, avec Bardot, l'énergie d'une danseuse… Il rétrécit même le cadre, comme pour resserrer le propos. Les deux hommes resteront toujours

proches, jusque dans la mort : Lucien Clergue est décédé le 15 novembre 2014, dix jours après son éternel ami Manitas de Plata.

### Lee Friedlander, face cachée

Le jazz reste l'un des styles matrices de l'industrie du disque, la bande-son des premières années, et de nombreux professionnels de la photographie en donnent leur vision. Parmi ceux-ci, Carl Van Vechten fut par exemple un très grand portraitiste ; en témoignent notamment les clichés de Bessie Smith et Billie Holiday avec des masques, Roy DeCarava se fit remarquer en publiant en 1955 *The Sweet Flypaper of Life*, où ses photographies s'associent aux mots du poète Langston Hughes pour raconter de l'intérieur la vie du Harlem d'alors, en mode caméra subjective…
Les contre-jours et ambiances nocturnes d'Herman Leonard, les portraits en noir et blanc de William Claxton, ont alors illustré abondamment magazines et pochettes de disques…
En Europe, Jean-Pierre Leloir et Giuseppe Pino vont aussi se distinguer. Le cas de Lee Friedlander demeure l'un des plus emblématiques, car il est parvenu à faire référence des deux côtés de l'objectif. Pour les amateurs de photographie et marchands d'art, l'Américain est une figure de premier plan de l'histoire de la photographie. À l'inverse, pour les fondus de cire noire, il est avant tout associé à l'histoire de l'un des grands labels américains : Atlantic, où il a débuté sa carrière avec des portraits de jazzmen.
Et pas des moindres : John Coltrane pour *My Favorite Things* et *Giant Steps*, Ray Charles pour *What'd I Say*, Mingus pour *Blues and Roots*… Ses images se retrouvent sur d'autres étiquettes, Capitol, Verve

ou encore Columbia, dont le portrait de Miles utilisé pour le génial *In a Silent Way* en 1969. Le musicien s'y montre à l'image de sa musique : fébrilement serein, les yeux tournés vers demain. Le jazz, Lee Friedlander y fut initié par Stan Spiegel, DJ et photographe à ses heures, qui fut l'un de ses premiers mentors et lui fournit son premier boîtier. Du jazz, il a gardé ce goût de l'improvisation, ou plutôt le sens de la composition en direct, que l'on devine dans ses clichés sur le New York des années 1960, dans nombre de ses autoportraits… Et bien sûr, tous les musiciens qu'il aura croisés, en particulier ceux de La Nouvelle-Orléans, auxquels il va consacrer un livre. De près comme de plus loin, il saisit l'instantané, la vibration du moment. Comme l'analysa si justement Joel Dorn, le producteur d'Atlantic, lors d'une rétrospective que lui consacra voici dix ans le MoMA : « *Les images de Lee montrent qui étaient ces gens quand ils n'étaient pas qui ils étaient* ».

### Blue Note, la référence ultime

« The Finest in Jazz Since 1939. » Le slogan a fait date. Tout a commencé le 6 janvier 1939, lors d'une session qui réunit Albert Ammons et Meade Lux Lewis. La première d'une très longue fondé par le producteur Alfred Lion et le photographe Francis Wolff, deux juifs allemands ayant fui les nazis, ce label va bientôt bénéficier du talent du designer Reid Miles puis de celui de l'ingénieur du son Rudy Van Gelder. Toutes ces compétences réunies seront dès lors mises en commun pour produire un catalogue unique, un état des lieux visionnaire du jazz, de l'avant-garde au mainstream, de Duke Ellington à Ornette Coleman, de Monk à Miles… La plupart ont posé sur Blue

Note des jalons esthétiques, ces standards qui ont fait l'histoire de cette musique.

Blue Note, c'est donc une marque de fabrique – un macaron blanc/bleu connu de tous les fondus au noir – qui va entrer dans la légende de la musique. Celle-ci repose sur un trépied essentiel : une signature sonore, une identité visuelle, un univers graphique. Une élégance qui combine le classicisme formel à une touche originale, à l'image du lettrage, à l'instar du regard de Francis Wolff, dont les clichés grande classe deviendront des classiques. À ceux réalisés lors des séances d'enregistrement, s'ajoutent ceux qui ont pour arrière-plan la ville : Herbie Hancock dans les rues de New York, Joe Henderson le long d'un mur, Ornette Coleman en plein hiver, et sans doute la plus belle, Larry Young au milieu des buildings, pour *Into Something!*…

Maintes fois copiées, parfois même détournées, ces couvertures vont inspirer aussi bien les mods (Paul Weller) que les rappeurs américains (le Wu Tang Clan en fera même une série de covers). Tous se réfèrent à l'âge d'or de cette « maison bleue », les glorieuses années 1950 et 1960. Seconde partie des années 1960, changement d'ère : Reid Miles et Alfred Lion s'effacent, le label est racheté par la firme Liberty, Francis Wolff meurt à New York en 1971. L'aura du label comme de son photographe/producteur ne fera pourtant plus que grandir. Fin 2014, au moment de célébrer les 75 ans de ce label, le producteur Michael Cuscuna, chargé depuis trente ans de mettre en valeur l'héritage maison, analysait ainsi cette réussite : « *La longévité de Blue Note s'explique par la qualité de la musique qu'ils ont posée sur bandes, mais aussi par le soin apporté dans leurs moindres*

*détails aux albums. Il y avait une synergie exceptionnelle qui a permis de réaliser des œuvres intemporelles.* »

### ECM, la matière son

L'effervescente fin des années 1960 voit l'essor de nombreux labels indépendants en Europe, notamment dans les musiques improvisées. À l'avant-garde de ce mouvement, la maison de disques fondée par Manfred Eicher impose très vite une esthétique originale que le contrebassiste devenu producteur résume par ce slogan : « Le plus beau son après le silence. » Cette bande-son joue tout à la fois avec l'hérétique et le sacré, le populaire et le savant, l'abstrait et l'hyperréaliste, la libre improvisation et la partition, le noir et le blanc, le flou et la clarté, l'instant présent et une mélancolie du futur… Autant de qualificatifs qui tracent tout autant les contours de l'identité visuelle d'ECM : de la pure illustration à la totale abstraction, chaque couverture éclaire – reflète – les choix de Manfred Eicher, esthète artisan et austère artiste. Tout comme il changera radicalement la vision du jazz, le Munichois va se distinguer par une charte graphique sans équivalent, délaissant bien souvent le cliché sur papier glacé du musicien. Chaque album estampillé de ces trois lettres (Edition Contemporary Music) devient un objet sophistiqué, un projet de A à Z.

Minimalisme épuré et à-plats abstraits, les images qui ornent les pochettes laissent déjà deviner ce qu'il s'y joue. Beaucoup seront « designées » par la graphiste Barbara Wojirsch, dont les typographies à main levée et les nuanciers délavés impriment le style maison. La photographie y est aussi très présente, à commencer par Dieter Rehm qui place la matière

au cœur des réflexions. De nombreux clichés jalonnent depuis plus de quatre décennies l'immense catalogue de cette maison d'édition dont la singularité d'intention esthétique ne doit pas masquer une diversité d'horizons artistiques. Si l'on tend l'oreille, si l'on y regarde de plus près … Cette sélection zoome sur un détail (une trace, une écorce, une étoffe…), des plein champ (des étendues vierges, des marines vitrifiées, des ciels éclairés…), et offre à voir un mêmeunivers, composéde mille et un fragments.

### Elenco, la nouvelle vague

À la fin des années 1950, le Brésil connaît lui aussi sa nouvelle vague, dans tous les domaines. En musique ce sera la bossa nova, qui a pour modèle le jazz cool nord-américain. Cette douce révolution sonore correspond à l'accession au pouvoir de Juscelino Kubitschek, lui-même amateur de bossa nova. Il sera le Président bâtisseur qui fait entrer le Brésil dans l'ère postmoderne. C'est dans ce même sillon que s'inscrit le label qui va devenir l'emblème de la bossa : Elenco, le nec plus ultra carioca.

Fondée en 1963 par Aloysio de Oliveira, cette maison de disques va elle aussi prendre comme référence une expérience nord-américaine, le label Blue Note connu pour son association entre le designer Reid Miles et le photographe Francis Wolff. À Rio, le cadre est confié à une paire d'experts : l'érudit designer/peintre Cesar Villela, disciple de Mondrian, et le photographe Francisco Pereira, adepte de la solarisation. Ensemble, ils posent comme charte la bichromie, à l'image du logo rouge et noir, une cohérence esthétique qui impose vite cette marque de fabrique. Les photos, pour la plupart des portraits fortement contrastés, sont ainsi

retravaillées, afin de renforcer cette impression de négatifs surexposés, comme crayonnés, auxquels s'ajoute la touche de rouge qui souligne subtilement la profondeur du noir et blanc.

Pendant cinq ans, sous cette étiquette d'une rare élégance, de ceux qui comptent dans le mouvement de la bossa, une variation low tempo de la samba : Tom Jobim, Sergio Mendes, Edu Lobo, Baden Powell, Roberto Menescal, Vinicius de Moraes, Dorival Caymmi, ou encore la jeune égérie Nara Leão… Tous au diapason de cette identité visuelle, de saisissants contrastes, qui fera référence pendant les décennies à venir pour les amateurs de vinyles. L'aventure se termine pourtant dès 1964, alors que le fulgurant mouvement tropicaliste atteint son apogée : cette fois, place aux couvertures de toutes les couleurs, inspirées du pop art et du psychédélique, au moment même où le pays s'apprête à plonger dans les années noires de sa dictature. Encore une histoire de contraste…

### ESP, On the Spot

"The artists alone decide what you listen to on ESP records." Most of the major figures in free jazz and new thing, which shocked the United States at the time, recorded for the label founded in 1964 by lawyer Bernard Stollman, who recently died. The music was radical and the covers were uncompromising: slightly blurry, often untitled black-and-white close-ups of Henry Grimes, Charles Tyler, Burton Greene, Frank Wright, Sunny Murray, Noah Howard, Patty Waters, etc. The portraits go to the depth of the subject's soul. Most seem to have captured the heat of the moment. All reflect a closeness/intimacy

between photographer and musician. The photograph, literally fading to black, of the "scandalous" Ornette Coleman for his 1962 concert at Town Hall is emblematic of the series.

### Riverside, Bluesville, Yazoo : l'Amérique Face B

Dans les États-Unis largement ségrégués de la première moitié du XXe siècle, les « race records » vont constituer un style à part, avant tout destiné à la « communauté » afroaméricaine. Estampillées Okeh, Paramount, Emerson…, les productions se font l'écho de l'air du temps et documentent des idiomes qui sont à la source de la bande-son du XXe siècle. Ces labels deviennent ainsi des conservatoires du blues, gravant les traces de certains musiciens fondateurs, originaires du Sud. À la fin des années 1950, alors que la société civile change enfin, d'autres maisons de disques, installées à New York et spécialisées dans le jazz, ouvrent elles aussi des sous-divisions consacrées aux vétérans du blues et du swing.

Riverside lance une série dédiée aux « légendes vivantes » encore en activité. Direction La Nouvelle-Orléans, et bientôt Chicago, deux des grands foyers culturels de cette « communauté », qu'il s'agisse de blues ou de gospel… Pour illustrer ces documents sonores, le producteur choisit des images témoignant du quotidien d'une population stigmatisée, tant sur le plan social que géographique. Toujours à l'orée des années 1960, la firme Prestige va encore plus loin, en initiant une étiquette centrée sur le collectage dans le delta du Mississippi. Ce sera Bluesville, un titre des plus explicites, où les amateurs de « musiques racines » vont pouvoir creuser le fertile sillon de grands noms : Tampa Red,

Lightnin' Hopkins, Brownie McGhee et Sonny Terry… Tous ceux dont les visages ornent les LP du label qui, c'est curieux, s'arrête en 1966, alors même que, des deux côtés de l'Atlantique, la jeunesse vibre au blues revival, un mouvement auquel ont participé ces productions.

C'est d'ailleurs dans ce creuset culturel que s'inscrit, à la fin de la même décennie, Yazoo, en publiant des enregistrements historiques du blues, là encore collectés dans les États sudistes où la discrimination raciale a longtemps perduré dans les mentalités. Au diapason de la musique, les photographies plein champ sont issues du fond de la Farm Security Administration (Jack Delano, Dorothea Lange…). Elles forment un précieux témoignage de la condition noire dans le Sud profond. La vie à la campagne, la prison, les juke-joints… Et là encore, cette nouvelle exposition permet la redécouverte de figures historiques, tel Charley Patton, pour les plus jeunes.

### Hipgnosis, une marque de fabrique

Hipgnosis, le nom de ce collectif de graphistes britanniques, annonce d'emblée la couleur. Flash. C'est en 1968, au sortir de la révolution fleurie portée par les hippies, qu'Aubrey Powell et Storm Thorgerson posent les fondations esthétiques de ce mouvement qui va marquer la prochaine décennie. Très vite, leurs choix iconographiques les distinguent : *A Saucerful of Secrets* sera leur première réalisation, signée Thorgerson qui a fait ses classes à Cambridge avec Roger Waters. On y découvre les Pink Floyd dans une composition étrange, encore marquée

par le psychédélisme. C'est aussi le début d'une longue collaboration avec les apôtres du rock progressif, que les graphistes vont sublimer à travers des réalisations fantasmagoriques, à l'image des intentions supersoniques : *Ummagumma* et ses mises en abyme photographiques, dès l'année suivante, *Atom Heart Mother* et sa sacrée vache… Ils enchaînent les classiques.

Le début des années 1970 est d'ailleurs prolifique, et chaque nouvelle pochette s'inscrit tout à la fois hors du temps et dans l'époque, le début d'une décennie fantastique. En 1973, Peter Christopherson, membre du groupe Throbbing Gristle, rejoint les deux créateurs. Il va apporter une touche plus industrielle dans cet univers peuplé de paysages et de personnages au-delà du réel. Surréalistes, utopistes, étranges, ces mondes imaginaires ont depuis hanté l'inconscient collectif, ce que ne manque pas de souligner le magazine *Rolling Stones*, bible des rockeurs d'alors, en célébrant deux couvertures signées Hipgnosis parmi les 50 meilleures pochettes du siècle : *Dark Side of the Moon* de Pink Floyd, dont le prisme va devenir une marque de fabrique, et *Houses of the Holy* de Led Zeppelin, montage photo des plus ésotériques. Deux manières de passer de l'autre côté du miroir, qui ne manquent pas de résonner à l'écoute de la musique. Deux images fabriquées, parmi tant de classiques, par l'agence qui baisse le rideau en 1983, avec *Coda*. Une ultime double pirouette : pour ce dernier recueil de Led Zeppelin, la pochette se compose uniquement de lettrage, et la coda, en musique, est la

résolution finale d'un thème…

## Transartistique

Les pochettes des vinyles constituent un véritable abécédaire de la grammaire et du vocabulaire photographiques. Toutes les techniques ont été utilisées sur LP, des photomontages aux solarisations. De même, tous les grands courants picturaux ont trouvé leur place sur ce format prédéfini : pour des œuvres de commande ou non. Le *White Light* de Jackson Pollock orne la couverture du *Free Jazz* d'Ornette Coleman, et on ne compte plus les tableaux du Quattrocento censés illustrer les œuvres baroques, voire classiques. Yves Klein, Richard Prince, Christopher Wool, Joan Miró, Jean Dubuffet, Picasso… De nombreux plasticiens, certains se faisant même musiciens, se sont ainsi retrouvés exposés sur vinyle, mais dans ce dialogue entre musique et arts plastiques, Jean-Michel Basquiat est sans doute celui qui a poussé le plus loin la relation l'interaction : nombre de ses compositions compilent les références (Charlie Parker, King Zulu !) qui ont façonné son style. L'autre figure tutélaire reste Andy Warhol, qui a exploré cette relation sous toutes ses formes, illustrant de fait sa vision de l'art interconnecté : une des plus radicales est cet index book dédié à l'aventure de la Factory, un livre constitué d'une quantité de pop-up, dont un single portrait de Lou Reed daté de 1967, un vinyle en flexi qu'il faut arracher pour pouvoir l'écouter ! Robert Rauschenberg, l'autre pape du pop art, a aussi collaboré avec des artistes, notamment les Talking Heads… Ici, une simple photographie imprimée sur plusieurs feuilles rhodoïde enrichit, au propre comme au figuré, ce vinyle translucide. Ils ne sont les seuls plasticiens

à se saisir de la photographie comme outil, pour « dépeindre » leurs goûts musicaux. C'est le cas d'Allan Kaprow, qui écouta beaucoup John Cage. Autre célèbre actionniste, Joseph Beuys signe quelques pièces sérigraphiées, très recherchées, qui collent parfaitement aux longues improvisations de la bande-son. Il en va de même des photos de Dieter Roth, qui imprima sa marque sur tous les supports possibles : le plasticien repousse ses limites, et devient musicien au bord du bruit. Martin Kippenberger, lui, « enlumine » un disque qui fait écho à ses performances transgenres : autoproduit édité à 100 exemplaires, cet objet sonore non identifié (garage ? rock ?? punk !?) s'accompagne d'un booklet avec ses photos, le tout monté à la main. Résultat : chaque couverture est aléatoire, l'artiste devient artisan. Ce que sous-tend aussi Harry Bertoia, avec ses sculptures sonores, ses tiges en métal qu'il assemble pour créer des flux atmosphériques… À partir de concerts publiques, il réalisera une série de onze albums, sobrement intitulés Sonambient. Un siècle plus tard, la démarche est inverse pour Jeff Koons, dont la Vénus « relookée » résume l'iconique star des années 2.0 : les visions de l'artiste rejoignent cette fois les productions de l'industrie.

## Wojciech Zamecznik, experimentations

Peu connu du grand public au-delà de sa Pologne natale, le photographe Wojciech Zamecznik fut par ailleurs designer et graphiste, marchant sur les pas du Bauhaus et du constructivisme. Ses réflexions, à la croisée de ces trois expressions, auront été l'une des sources d'inspiration de ce qui va devenir la Polish School of Posters. En faisant s'interpénétrer

les problématiques des arts graphiques et photographiques, le natif de Varsovie se situe à l'avant-garde de ce mouvement débuté dans les années 1950. Son travail sur la lumière accouche de formes abstraites, de lignes diaphanes ou de cercles diffractés, comme des empreintes éphémères dont on peut voir les traces sur cette sélection de disques, réalisés en 1965, c'est-à-dire deux ans avant la mort de Wojciech Zamecznik. Un demi-siècle plus tard, ces fascinantes images conservent toute leur force d'attraction, ouvrant toujours autant de perspectives : leur magnétique onirisme pourrait très bien accompagner un maxi de musiques électroniques comme il a su hier saisir à merveille l'énigmatique âme de Ravel.

## L'arme à l'œil, propagande et slogans

Politique et musique, cette association a donné lieu à toutes les formes d'expression. Pour preuve cette sélection où s'affiche tout et son contraire… La guerre d'Espagne, les « événements » d'Algérie, le bourbier du Vietnam, la question palestinienne, la résistance contre les dictatures, le Black Panther Party, la liste est longue des LP où les musiciens affirment leur engagement en couverture.

Entendu tel un puissant outil de propagande, le vinyle se fait aussi le relais des discours de tout bord : le fondateur de la Nation of Islam Louis Farrakhan et le négus Haïlé Sélassié, le Zaïrois Mobutu et le Chilien Allende, Richard Nixon et Luther King, Malcom X et Fidel Castro. L'histoire du siècle écoulé y est consignée, l'image souvent contrôlée. La preuve par ces maisons d'édition françaises que tout oppose : *Le Chant du Monde* créé en 1938 par Léon

Moussinac, écrivain et critique de cinéma membre du Parti communiste où sont éditées, entre autres, des musiques des républiques populaires soviétiques, mais aussi la chanteuse engagée Colette Magny, et la SERP (Société d'Études et de Relations publiques) créée par Jean-Marie Le Pen et Léon Gaultier, un ancien des Waffen SS, qui va publier des chants militaires, dont ceux du Troisième Reich et de l'Armée Rouge.

Dès les années 1930, Woody Guthrie inscrit sur sa guitare : «Cette machine tue les fascistes.» Dans les années 1970, alors que la décolonisation s'accompagne d'une bande-son des plus militants, Fela Kuti, véritable contre-pouvoir de l'État nigérian et adepte d'une solution panafricaine, déclare : « La musique est l'arme du futur. » Et dans les années 2.0, la nouvelle génération du rock prend aussi souvent parti que celle de ses aînés. Si nul ne doute du contre-pouvoir d'une chanson, celle-ci peut appeler à la démobilisation, à l'instar du Déserteur de Vian, ou à l'inverse comme le Back On The Bus de Carver Neblett. « Si tu ne me trouves pas à l'arrière du bus, si tu ne me trouves pas dans les champs de coton, si tu ne me trouves nulle part, viens donc au bureau de vote, j'y serai en train de voter. » Bien souvent, les pochettes soulignent le message… notamment en faveur des droits civiques, contre les répressions. La soul et le jazz sont en première ligne.

La fin des années 1960 est d'ailleurs une période particulièrement féconde, à l'instar des slogans de mai 1968 qui inspirent bien des disques. Dix ans plus tard, la crise qui secoue l'économie mondiale va résonner à travers le punk, qui lui aussi ira chercher des

images chocs. C'est encore le cas lorsque Rage Against the Machine choisit le symbole du moine qui s'immole pour rendre patente la violence du régime chinois, et par-delà, dénoncer un monde qui ne tourne pas toujours bien rond. Une terre à l'heure nucléaire, comme le montre l'atomique big band de Count Basie. Une terre qui broie des hommes par milliers, comme l'éprouve Salgado dans les mines du Minas Gerais. Une lune aussi qui annonce d'autres horizons… Nombre de clichés, véritables symboles qui ont marqué l'histoire du XXe siècle, ont été repris, voire détournés, dont le plus fameux demeure l'image des GI plantant le drapeau de la victoire !

### Dessous chics, photos choc

« De toutes les matières, c'est la wax qu'elle préfère. » Le vinyle n'échappe pas à la règle des regards inquisiteurs, des polices esthétiques qui veillent aux bonnes mœurs. Cela permet toutefois à certains de les contourner : sur le Crache Ton Venin de Téléphone, il faut faire coulisser la pochette pour découvrir les musiciens nus. Un rat sur l'épaule du futur Bambie de la pop, une bande de hippies vautrés dans une baignoire, des invitations au suicide… Rien ne doit heurter le public. Voilà pourquoi la pochette dite « the butcher cover » – les Beatles en potaches trash – restera une face cachée du groupe, puisque retirée du circuit par Capitol. Et que dire de l'iconique Nirvana, dont le One Dollar Baby (remember Alice Cooper, lui-même sujet de censure…) a participé à la légende… Nevermind Mind the Bollocks. Les puritains se pincent le nez.

Controverses au mieux, censures au pire. Forcément, le sexe dans l'œil du cyclone,

et puis tous les totems et tabous en fonction des pays, des us et coutumes. Des photos ont dû être recadrées, d'autres coupées, voire remplacées. Lorsque Yoko Ono et John Lennon choisissent de poser nus, geste politique face à la crudité du monde, les moralistes américains interdisent la diffusion de l'objet « scandaleux » à leurs yeux. Même Richard Dumas a été confronté à une pudibonderie de certains pour son image avec Étienne Daho. Cachez ces seins… Même topo pour Roxy Music, le doigt sur la couture. Quant à Electric Ladyland, pochette mythique en plein flower power, elle n'eut pas l'aval du guitariste Jimi Hendrix ! David Bowie, le Velvet Underground, Black Crowes… La « transgression » n'est pas l'apanage d'une époque, ni d'un genre, mais Scorpions en a fait un puissant outil de promotion.

### Photo-copie

L'histoire de la musique est jonchée de reprises en tous genres : ce sont de nouvelles versions, à la lettre ou plus dans l'esprit, que l'on nomme les covers. Justement, les couvertures du disque ont aussi été l'objet de nombreuses répliques, le produit dérivé faisant partie de la gamme thématique. Là aussi, ce peut être le sujet d'un hommage appuyé, ou bien au contraire l'occasion de se démarquer de la référence historique.

Dans le cas de Joe Jackson, amateur de jazz patenté, on optera pour la première solution quand il choisit en 1984 de reprendre trait pour trait un fameux Blue Note de Sonny Rollins pour son album intitulé Body & Soul, le standard ultime. Tout comme les Clash qui saluent le mythique album d'Elvis pour leur

manifeste London Calling, à une nuance près, la guitare n'est plus enlacée, mais fracassée. Mieux, les punk rockeurs publieront quatre 45 tours avec cette même déclinaison, chacune arborant un membre différent du quatuor anglais.

L'album de la « fanfare du club des cœurs solitaires du sergent Poivre », manifeste du disque-concept qui compile une somme d'innovations techniques et dont la pochette fait exploser tous les cadres et conventions, n'aura pas droit aux mêmes égards de la part de Frank Zappa. Certes, le collage photo où les quatre garçons dans le vent posaient en costume de fanfare militaire aux côtés d'une foule de célébrités – Bob Dylan, Lewis Carroll, Jung, Fred Astaire, Marilyn, Marx… et même leurs propres statues de cire – ne manquait pas d'une pointe d'ironie. Suivant sa critique acerbe du mouvement hippie déclenché aux Etats-Unis par les Fab Four, le perspicace Américain pousse le pitch plus loin : il reprend le même principe graphique, affublé d'un titre plutôt cash : We're Only in It for the Money. « Nous ne faisons ça que pour l'argent. » Quant aux Sex Pistols, ils y vont de leurs Bad Boys, trônant avec tout le gotha punk…

Autre pochette entrée dans la mythologie, Sticky Fingers, dont il se murmure qu'elle serait en fait l'entrejambe de Joe Dallesandro, photographié par Billy Name, sera revisitée sous toutes les latitudes : la mafia russe ose un bootleg suggestif, Mötley Crüe se la joue plutôt cuir, et ainsi de suite… La braguette zippée est même zappée en Espagne : au motif de la censure, elle est ainsi remplacée par des doigts gluants… tranchés dans le vif.

### La grande traversée

*Abbey Road*, dernier véritable album des Fab Four, est entré dans l'histoire de la musique. À plus d'un titre, notamment pour sa pochette. On en découvre ici l'envers du décor, des documents rares photographiés par Linda McCartney elle-même, avant que le groupe ne fasse la grande traversée. Ce passage piétons face aux mythiques studios d'enregistrement est devenu à Londres un lieu de pèlerinage ! Et le cliché du photographe Iain MacMillan va donner lieu à diverses extrapolations, affabulations. Paul McCartney, suivant de nombreux indices (le seul aux pieds nus, avec la jambe droit en avant…) insérés dans l'image, serait ainsi mort et remplacé par un sosie. La rumeur n'empêchera pas les exégètes de s'adonner eux aussi aux plaisirs de marcher dans ces traces, à travers leurs propres sillons : Booker T & The MG's sur l'une des artères de La Nouvelle-Orléans, Red Hot Chili Peppers tous nus, George Benson de «l'autre côté». Paul McCartney lui-même refera la traversée, cette fois tiré par son chien…

### Une vie sur vinyle, David Bowie, metamorphose Johnny Hallyday, histoires d'homme

Est-ce l'image qui imprime le diapason ou est-ce le sujet qui donne le la ? La question demeure lorsqu'on met à plat le demi-siècle discographique de Johnny Hallyday, ainsi remis en perspective. Blouson noir ou costard trois-pièces, le Français s'adapte aux générations en reflétant à chaque fois une image de son temps, empruntant les codes dominants afin d'incarner le « mainstream » d'une époque : idole des jeunes, rockeur rebelle, cheveux longs, visage buriné, casqué, botté… La belle gueule du rock en version française aura multiplié les visages, comme les virages, pour composer son personnage.

Dans ce registre, mais plus à l'avant-garde – moins terre à terre ? – David Bowie demeure le maître, changeant sans cesse de look sans jamais rompre le charme. Peut-être même est-ce là l'une des clefs de sa longévité : chaque masque dévoile un trait de sa personnalité, chaque pièce de ce puzzle renforce l'attrait pour cet « homme qui venait d'ailleurs ». Il y a quasiment autant de Bowie qu'il y a d'albums, et chaque disque ouvre des pistes musicales inexplorées. Ziggy Stardust, Halloween Jack, Alladin Sane… le natif de Brixton est un mutant multiple, à l'image de cette sélection de neuf picture-discs 45 tours au cours des années 1970.

### La voix des maîtres

« J'ai toujours pensé que l'écriture était proche de la musique mais beaucoup moins pure que celle-ci. » Ces mots de Patrick Modiano, prix Nobel de littérature 2014, esquissent le rapport intime qu'entretiennent ces deux arts majuscules. Calliope, la muse de la rhétorique, n'a-t-elle pas comme attribut une tablette et une trompette ? Qu'il soit griot ou troubadour, le poète pense ses écrits pour qu'on les déclame. « Le jazz est ma religion », insistait Ted Joans, écrivain Beat qui fut aussi trompettiste. Il n'est pas le seul de cette génération branchée sur l'énergie de l'improvisation à avoir fréquenté les boppeurs de tout bord. Un de ses héritiers, Ishmael Reed, écrira une soul fiction des plus cultes : *Mumbo Jumbo*, roman surréaliste qui fut transposé sur disque avec tout le gotha de la great black music. William Burroughs fricota aussi plus d'une fois avec la musique, notamment avec Neneh Cherry, tout comme Kerouac avec les cracks du jazz cool ou encore Ginsberg, que l'on retrouve sous l'œil de Richard Avedon. Mots dits blues…Ce sont ces mots qui habitent les lectures de nombreux auteurs dans les années 1950 et 1960. Céline et Camus, Henry Miller et Hermann Hesse, Pasolini et Beckett, sans oublier Albertine Sarrazin, qui défraya la chronique avec ses écrits autobiographiques.

### De la bande au sillon

Depuis un siècle, la musique au cinéma offre un certain regard, décadré, qui éclaire autrement les images. Ce n'est pas une simple valeur ajoutée, ni un nécessaire additif, mais un indispensable ressort à la mécanique filmique. Pas de doute, les bandes originales scandent l'histoire du cinéma, et nombre de collectionneurs de LP se sont fait pour spécialité de traquer les compositeurs, de pister les arrangeurs de ce genre à part entière en musique. Bernard Herrmann, Lalo Schifrin, Michel Legrand, Ennio Morricone, Maurice Jarre, John Barry, Henry Mancini… D'autres, comme le pianiste Herbie Hancock, y ont inscrit quelques jolis scores. La courte sélection permet de le rappeler, à travers des clichés qui portent déjà en eux toute la charge mémorielle, notamment le *Dernier tango à Paris*, *Un homme et une femme*, et *L'affaire Thomas Crown* : trois films portés par trois bandes-son au diapason. Mais aussi l'étonnante *Polly Maggoo* de William Klein, et deux différentes scènes de *Blow-Up*, illustrant les versions française et américaine du disque. Rien à voir avec une simple illustration : qu'elle soit figurative ou plus abstraite, la photographie – comme pochette comme sur affiche – a bien entendu toute sa place dans l'imagerie cinématographique. Une affiche réussie, une couverture de disque raccord, portent l'intention narrative.

D'ailleurs, on imagine aisément sur quels ressorts mélodramatiques se jouent les films made in Bollywood en regardant les photomontages, les collages de photos, qui servent de couvertures. Des histoires d'amour contrariées, des intrigues de couples savoureux, des romances sorties des sixties, qui sont la plupart du temps prétexte à de fantastiques bandes originales.

### Assemblage antillais

Dominée par deux producteurs, Henri Debs et Raymond Cellini, la production antillaise a largement été redécouverte par des DJ anglais et crate diggers, texto les « fouilleurs de caisses », ou plus précisément, les caisses de bouteilles de lait dans lesquelles nombre d'amateurs américains stockaient leurs bons vieux vinyles. Fouineurs de bacs essorés, chasseurs de disques antidatés, exhumeurs de labels de qualité, découvreurs de talents oubliés… Tous ceux-là participent au réexamen de catalogues dont ils rééditent certaines faces oubliées sous des piles de poussière. Comme cette sélection de 45 tours originaux, des pochettes artisanales qui assemblent dessins et photosdécoupées, du fait-main qui annonce étrangement les techniques pratiquées quelques années plus tard par la génération punk… Do it yourself ?

# Index

# Acknowledgments

**Record Labels and Publishers**

A&M Records, ABC-Paramount, ABKCO, Acousti Yuri Korolkoff, Adès Disques, ALA Records, American Recordings, Antilles New Directions, AnTrop, Apple Records, Archivi Sonori, Ardent Records, Ariola, Arista, ATCO Records, Atlantic, Aura, Aux Ondes, BAM, Barclay, Beggars Banquet, Blue Note, Blue Sky, Bronze, Bubble, C.A.D. Censier, Capitol Records, Carrere, Casa de las Américas, CBS, Célini Disques, Charisma, Chelsea Records, Chrysalis, City Kids Records, Claddagh Records, Cleopatra Records, Cocoon Recordings, Columbia, Connoisseur Society, Contemporary Records, Creation Records, Cryonic Inc., Decca, Dieter Roth's Verlag, Disc'AZ, Disque Jojo, Disques Debs International, Disques Déesse, Disques Festival, Disques Flèche, Duli Disc, Dunhill, Earth Books, EastWest, ECM Records, Edition Hansjörg Mayer, Edition Lebeer-Hossmann, Elec Records, Elektra Nonesuch, Elektra Records, Elenco, ELN, Embassy, EMI, EMI-Manhattan Records, The English Bookshop, Epic Records, ESP-Disk', Experiments in Art and Technology, Inc., Fargo Records, Final Call Records, Flying Dutchman Records, Folkways Records, Fontana, Gambler Records, Go! Discs, Gramavision, Guilde Internationale du Disque, Guy Schraenen Éditeur, Hanover Records, Harmless, Harvest, Hit Parade, Honest Jon's Records, IDA Records, Infidelity, Interscope Records, Island Records, Island Red Label, Jochens Kleine Plattenfirma, Kaloukera, KillEmAllNKeepMoving, Krúnk, Lacrymal Records, L'Age d'Or, La Voix de l'Auteur, Leathür Records, Le Chant du Monde, Liberty, Linterna Música, London Records, Loud Records, Low Spirit Recordings, LVA, The Making of Americans, Manhattan Island Records, MAPS, Mass Art Inc., Maverick, MCA Records, Mercury, MGM Records, Music On Vinyl, Nippon Columbia, Nova Broadcast, Object Music, Odeon, One Little Indian, Pacific Jazz Records, Paisley Park, Panton, Paredon Records, Parlophone, Partisan, Passport Records, Peabody, Peter, Paul & Mary, Philips, Phonogram, Phonogram-Vertigo, Polskie Nagrania Muza, Polydor, PolyGram, Poppy, Portrait, Power Shovel Audio, Prestige/Bluesville, Purple Records, Qbico, Random House, RCA, RCA Red Seal, RCA Victor, Relapse Records, Reprise Records, Ricordi, Riverside Records, Rocco, Rolling Stones Records, Roulette Records, Ruin Your Fun, Samadhi Records, senufo editions, Serenus Records, SERP Disques, Sire, Skipstone Records, SMS Records, S.O. 36 Records, Sovereign, SRP Records, Stax Records, Streamline Records, Sub Rosa, Suhrkamp Verlag, Swan Song, Tender Productions, Tetragrammaton Records, Third Ear Recordings, Torso, Track Record, Trend, Tropenmusic, 20th Century Fox Records, Ulysse Musique, United Artists Records, Vanguard, Vega, Vertigo, Verve Records, The Vinyl Factory, Virgin, Visages du Monde, Vogue, Vortex Records, Warner Bros. Records, Warner Bros.-Seven Arts Records (W7), Warner Music UK Ltd., WEA, XL Recordings, Yazoo, Zulu Records

**Photographers**

Berenice Abbott, A. F. P., Bob Alford, Nobuyoshi Araki, Richard Avedon, David Bailey, John Baldessari, Roger Ballen, Bruno Barbey, Howard Bartrop, B. B. M. Associates, Bernd and Hilla Becher, Dominic Belmonte, Werner Bethsold, Fernand Bibas, Izis Bidermanas, John Blake, Jan Blom, Eric Boman, Guy Bourdin, Brassaï, Georgyves Braunschweig, Rob Brimson, Joel Brodsky, Malcolm Browne, René Burri, Martine Cambessedes, William Carter, André Catan, Philippe Charpentier, Larry Clark, Lucien Clergue, Chris Clunn, Michael Cooper, Anton Corbijn, Jeffrey Craig, Ralston Crawford, Harriet Crowther, Dalmas, Bruce Davidson, Roy DeCarava, Jack Delano, Raymond Depardon, Robert Doisneau, Brian Duffy, Michael Dunn, Esmond Edwards, William Eggleston, Terje Engh, Mitch Epstein, Elliott Erwitt, Arthur Evans, Barry Feinstein, Pierpaolo Ferrari, Karl Ferris, Franco Fontana, Joan Fontcuberta, Fournier, Robert Frank, Tony Frank, Lee Friedlander, Albrecht Fuchs, Alberto Garcia-Alix, Jörg Genzmer, Luigi Ghirri, Francis Giacobetti, Ray Gibson, Sol Goldberg, Burt Goldblatt, Nan Goldin, Greg Gorman, Jean-Paul Goude, Emmet Gowin, Bob Greene, Brian Griffin, Frieder Grindler, Andreas Gursky, David Hamilton, Chris Hardy, Martin Hesse, Todd Hido, Hipgnosis, Hiro, Michel Holtz, Pieter Hugo, George Hurrell, F. Ishikawa, Just Jaeckin, David James, Christine Johnson, Sy Johnson, Jean-François Jonvelle, Élie Kagan, Jeffrey Katz, Lajos Keresztes, Martin Kippenberger, William Klein, Jeff Koons, Alberto Korda, Josef Koudelka, Debra Kronick, T. Kurihara, David LaChapelle, Laguens, Dorothea Lange, Michael Lavine, Annie Leibovitz, Saul Leiter, Bernard Leloup, John Lennon, Guy Le Querrec, Helen Levitt, Peter Lindbergh, Paulo Lorgus, Danny Lyon, Iain Macmillan, Chema Madoz, Magnum Photos, Robert Mapplethorpe, Linda McCartney, Ryan McGinley, Fred McMullen, Susan Meiselas, Eric Meola, Joel Meyerowitz, Duane Michals, José Mischer, Richard Misrach, Jean-Baptiste Mondino, David Montgomery, Daido Moriyama, Carolyn Mugar, Ken Nahoum, Tadayuki Naitoh, Billy Name, NASA Photos, Helmut Newton, Angelo Novi, Terry O'Neill, Yoko Ono, Paris Match, Martin Parr, Mike Parsons, Guy Peellaert, Irving Penn, Francisco Pereira, Jean-Marie Périer, Anders Petersen, Pierre et Gilles, Michael Pinter, Bernard Plossu, Nina Pohl, Edouard Poitou, Loulou Poitou, Martin Poole, Aubrey "Po" Powell, Arnulf Rainer, Raz Enterprises, Dieter Rehm, Charles Reilly, Dan Richter, Herb Ritts, Lawrence Robbin, William V. "Red" Robertson, Mick Rock, Raymond Ross, Dieter Roth, Paolo Roversi, Raeanne Rubenstein, Ed Ruscha, Walter Russell, Sebastião Salgado, Carl Samrock, John Sanborn, Jan Saudek, Jerry Schatzberg, Guy Schraenen, Chris Schwarz, Claude Schwartz, George Segal, Laurent Seroussi, Charles Shabacon, Cindy Sherman, Frank Shugrue, Jeanloup Sieff, Pennie Smith, W. Eugene Smith, Michael Snow, Alec Soth, Joel Sternfeld, Dennis Stock, Sandra H. Stollman, Studio Catan, Jock Sturges, Masayoshi Sukita, H. Tanaka, Dorothy Tanous, Skip Taylor, Juergen Teller, Ed Thrasher, Guy Tomme, Beverly Twitchell, Andrew Unangst, United Press International, K. Vaikunth, Ed van der Elsken, Michael von Gimbut, Jeff Wall, Brian Ward, Andy Warhol, Albert Watson, Curley Weaver, Guy Webster, Weegee, William Wegman, Léo Weisse, Robert Whitaker, Garry Winogrand, Francis Wolff, Stanisław Zamecznik, Wojciech Zamecznik

Samuel Bourdin © The Guy Bourdin
    Estate, 2015
Anne, Yolande and Olivia Clergue
    © Atelier Lucien Clergue
Antoine de Beaupré's Collection, Paris
Greg de Villanova's Collection, Paris
Jacques Denis's Collection, Paris
Denis Ozanne and Tissato Nakahara's
    Collection, Paris
Karolina Puchala-Rojek, President,
    Archeology of Photography Foundation
Laurent Seroussi
Manue and Paulo @ Superfly Records
Stefan Thull's Collection, Germany
Serge Vincendet's Collection, Paris
Juliusz Zamecznik © Archeology
    of Photography Foundation

The section dedicated to the Blue
Note label is a production of the
KYOTOGRAPHIE Festival. Michael
Cuscuna (Mosaic Records) and
Lucille Reyboz & Yusuke Nakanishi
(KYOTOGRAPHIE) curated the
exhibition. Paul McCartney's record
covers were photographed by Linda
McCartney. Commissioned by Paul
and Mary McCartney and produced
by Linda Enterprises Ltd, London.

**For the exhibition:**
Serge Vincendet @ Monster Melodies, Paris
Antoine de Beaupré, Paris
Stefan Thull's Collection, Germany
Manu and Paulo @ Superflyrecords.com, Paris
Jacques Denis, Paris
Denis Ozanne and Tissato Nakahara, Paris
Greg de Villanova, Paris
Album Covers · The Bigger Picture,
    Aptitude Agency

Discographisme Récréatif, Patrice Caillet
    Pop Spots, Bob Egan
Vania Heymann for Roy Kafri's
    *Mayokero* video
Live! I see dead people, Jim und Hatim
Samuel Kirszenbaum's Collection, Paris
Carl Morris and John Rostron, sleeveface.com
Ronan Pierre, Vinyl Office
Karolina Lewandowska,
    Curator, Cabinet de la photographie,
    Centre George Pompidou
Stéphane Richard (artistic director)
    and Matthieu Raffard (photographer),
    Jésus & Gabriel Agency (ex-leg)
    for the series of announcements
    for rock radio station Ouï FM (2010)
Erik van Empel's Collection, Amsterdam

The first edition of *Total Records*
would not have been made
possible without the support of:

Sam Stourdzé and all the team at
Rencontres d'Arles, including
Exhibition production supervisor:
Safia Belmenouar,
assisted by Florine Garcin

Scenography:
Olivier Etcheverry,
assisted by Flavie Guignard

Romain Rivière, Julien Crozet,
Henrik Jessen @ Bellanopolis

Our thanks
to ALL photographers,
and long live the music.

Total Records:
Photography and the Art of the Album Cover

Edited by Antoine de Beaupré, Serge Vincendet, Sam Stourdzé
Text by Jacques Denis
Interview with Jean-Baptiste Mondino

This catalogue was first published by Editions 213 to accompany
the *Total Records* exhibition, curated by Antoine de Beaupré, Sam
Stourdzé, and Serge Vincendet and held at Rencontres d'Arles,
France, 2015.

The Editions 213 staff for this book:
**Art Director and Record Cover Photography:** Romain Rivière
**Design Concept:** Romain Rivière, Caroline Dauvois
**Copy Editor:** Sophie de Kayser
**Translators:** Glenn Naumovitz, Rebecca de Volkovitch

The Aperture staff for this book:
**Creative Director:** Lesley A. Martin
**Cover Design and Typesetting:** Brian Berding
**Design Assistant:** Andrea Gottardy
**Production Director:** Nicole Moulaison
**Production Manager:** Thomas Bollier
**Assistant Editor:** Samantha Marlow
**Senior Text Editor:** Susan Ciccotti
**Copy Editor:** Paula Kupfer .
**Proofreader:** Sally Knapp
**Work Scholars:** Simon Hunegs, Minchai Lee, Melissa Welikson

Additional staff of the Aperture book program includes:
Chris Boot, Executive Director; Sarah McNear, Deputy Director; Amelia
Lang, Managing Editor; Kellie McLaughlin, Director of Sales and Marketing;
Richard Gregg, Sales Director, Books; Taia Kwinter, Assistant to the
Managing Editor

First Aperture edition, 2016
Printed by Midas in China
10 9 8 7 6 5 4 3 2 1

Library of Congress Cataloging-in-Publication Data

Names: Denis, Jacques, interviewer (expression) writer of added
commentary.
   | Mondino, Jean-Baptiste, 1949- interviewee (expression)
photographer (expression).
Title: Total records : photography and the art of the album cover /
   text by Jacques Denis ; interview with Jean-Baptiste Mondino.
Other titles: Total records. English
Description: 1st Aperture edition. | New York : Aperture, 2016. |
Translation
   into English of the French work by the same title.
Identifiers: LCCN 2016020312 | ISBN 9781597113847 (alk. paper)
Subjects: LCSH: Photography, Artistic. | Musicians--Portraits. | Sound
   recordings--Album covers.
Classification: LCC TR655 .T68513 2016 | DDC 770--dc23
LC record available at https://lccn.loc.gov/2016020312

To order Aperture books, contact:
+1 212.946.7154
orders@aperture.org

For information about Aperture trade distribution worldwide, visit:
www.aperture.org/distribution

*aperture*
Aperture Foundation
547 West 27th Street, 4th Floor
New York, N.Y. 10001
www.aperture.org

Aperture, a not-for-profit foundation, connects the photo community
and its audiences with the most inspiring work, the sharpest ideas,
and with each other—in print, in person, and online.